P9-DVH-767

THE PAINTER AND THE PHOTOGRAPH

THE PAINTER AND THE PHOTOGRAPH

from Delacroix to Warhol / Van Deren Coke

Albuquerque / University of New Mexico Press

For Eleanor

ACKNOWLEDGMENTS

I am indebted to the many institutions, collectors, and artists who gave permission to reproduce the paintings, prints, and photographs included in the book.

I am also very grateful to the large number of artists who answered my questions regarding their use of photographs. Their frank answers to my queries about their use of photographs provided valuable insight into the sources of inspiration and imagery of much that is exciting in art today.

A great deal of information and encouragement was received from Dr. Aaron Scharf, Professor of Fine Arts at the Open University in England; from Beaumont Newhall, former Director of the George Eastman House, Rochester, New York; from Jerald Maddox, Curator of Photography, the Library of Congress, Washington, D.C.; from Helmut Gernsheim, photography historian; and from many other scholars who supplied me with information related to their specialized fields. Their assistance is gratefully appreciated and is acknowledged individually in footnotes.

Some of the material in the book first appeared in *The Painter and the Photograph*, a catalog published by the University of New Mexico Press in 1964, and in articles published in *Art News Annual*, *Art Journal*, *Art in America*, and *Creative Camera*.

I wish to express my gratitude to the University of New Mexico Research Committees, chaired by Professors Ralph Norman and Lee Hansen, who awarded me two grants for research and travel so that I might collect photographs and examine pertinent material in various libraries and art museums.

Professor Clinton Adams, Dean of the College of Fine Arts of the University of New Mexico, has made valuable comments about the content of the book and its presentation. Assistance by Jeanette Sanchez, University of New Mexico Department of Art secretary, is also acknowledged with great appreciation. Professor Robert M. Ellis, former Director of the University of New Mexico Art Museum, did an outstanding job of integrating the text with the many illustrations, resulting in a book that is not only attractive but easy to read.

Finally I wish to record my great debt to my wife Eleanor who made immensely useful suggestions and who patiently read the manuscript many times.

Van Deren Coke

PREFACE

In 1934 Beaumont Newhall, then on the staff of the Museum of Modern Art, wrote in *Parnassus*, "It is surprising that so little attention has been paid to the effect on artists of the discovery of photography." Fifteen years later, in the *Magazine of Art*, he expressed astonishment "that today's art historians, with their delight in probing into prototypes of every artist's work, should so generally fail to recognize that photography has ever since 1839 been to a host of artists both a source and an influence." In the same issue the distinguished art historian Heinrich Schwarz wrote, "It is surprising that the history of art has hardly devoted any attention to the question of art and photography, actually one of the paramount problems of 19th Century Art."

For many years Newhall and Schwarz were virtually the only historians who published articles on this important subject, although A. Hyatt Mayor, Helmut Gernsheim, R. H. Wilenski, and a few others mentioned in their writings that artists in the last century and a half painted from photographs.

In the past five years a number of books and articles have appeared dealing with various aspects of this subject. The most important of these is Aaron Scharf's *Art and Photography*. Dr. Scharf, a Californian trained in art history at London's Courtauld Institute of Art and now Professor of Fine Arts at the Open University in England, has produced an unusually clear and concise summary of the major problems involved in the relationship between painters and photography. All who investigate this subject in the future will benefit greatly from the detailed examination he has made of a great variety of sources and from the evidence he presents that many artists worked from photographs when painting portraits, landscapes, and even imaginative compositions.

Otto Stelzer's *Kunst und Photographie* is another book dealing with the topic. His conclusion was that the camera's greatest influence has come from its ability to record in detail for publication the appearance of paintings being executed in the art capitals of the world and thus to foster international art styles.

André Vigneau's *Une brève histoire de l'art de Niepce à nos jours* touches

on the various ways photography has interacted with art but cites few concrete links that had not already been discovered.

Also of great interest are some recent monographs on artists who made wide use of their own photographs as models for their paintings: Charles W. Millard's *Charles Sheeler, American Photographer*; J. A. Schmoll's *Malerei nach Fotografie*, a catalog of the Münchner Stadtmuseum; P. H. Hefting and C. C. G. Quarles van Ufford's *Breitner also fotograaf*; and Friedrich Luft's *Mein Photo-Milljoh* dealing with the use of photographs by Heinrich Zille. There has now been at least one doctoral dissertation on the subject, as well as a master's thesis, and other theses and research papers are in preparation.

In 1964 I published an exhibition catalog *The Painter and the Photograph*. This catalog and the accompanying exhibition made many scholars and artists aware for the first time of the extent to which photographs were used by major artists in the nineteenth and twentieth centuries. In 1964 many pictures painted from photographs that would have been appropriately included in this exhibition were unavailable because dealers and collectors were then (and in some cases still are) reluctant to make public the fact that pictures in their collections were from photographs. That attitude, which limited the scope of the exhibition and the catalog, has changed sufficiently in the past eight years so that a more complete and adequate presentation of the various relationships of the traditional arts to photography is now possible.

When Emily Genauer, the critic for the New York *Herald Tribune*, saw the exhibition and the catalog *The Painter and the Photograph* in 1964, she was startled by the revelation that so many prominent artists had liberally borrowed their imagery from photographs. Miss Genauer was willing to concede that a painter might with justification use a photograph as a starting point for a picture. She was, however, very unsure about artists whose work was obviously dependent on photographs to a major extent. She wrote: "Has the painter who relies strongly on photographs without absorbing them into a fresh, intensified,

transcendent statement, any more right to be called an artist than the journalist who composes an article with facts, or the editor who works on someone else's manuscript? What would happen to a writer who found in someone else's writing a fresh image, a provocative idea, an effective turn of phrase, and simply lifted them without quotes? He'd be sued for plagiarism, or even worse ignominy, he'd be exposed by the owl-eyed *New Yorker* magazine in its 'Funny Coincidence Department.' "

Miss Genauer's views have a history as long as photography is old. She was just more frank than most and stated her opinions in public. Her criticism, however, revealed a basic lack of understanding of the way artists' minds work. Like many critics, art historians, and dealers, she could not grasp the simple fact that throughout the history of art it has been art itself—in all its forms—that has inspired art. Artists are interested in pictures as sources of ideas for their work. Where the pictures come from and how they are made are of little concern to them.

The present volume is, therefore, essentially a history, pictorial and verbal, of various ways in which artists of many countries have used photographs directly or indirectly in their work since the perfection of photography in 1837. Many more examples could have been included, but I believe that the major theme of the book is best served by illustrating and briefly discussing a few examples of the many uses that artists have made of photographs rather than trying to include every example known. It is my hope that with this amount of information available further investigation of the subject will be stimulated.

CONTENTS

The Painter and the Photograph INTRODUCTION

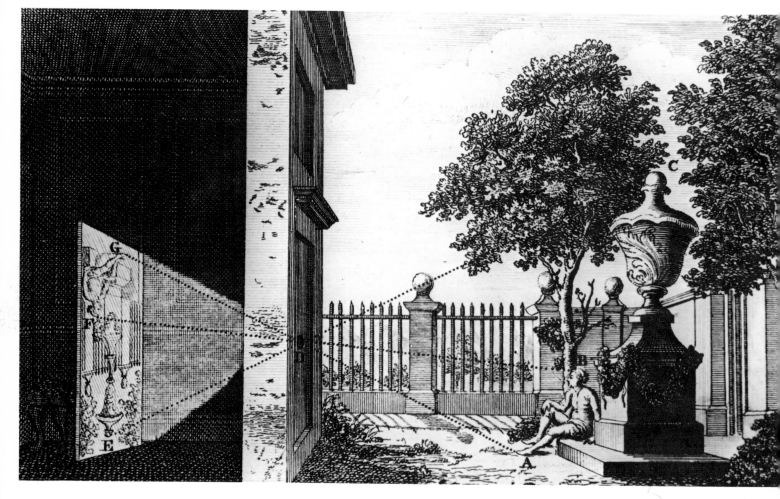

1.

1. *The Camera Obscura* from the *Universal* Magazine.

2. De M. Brisson. Plate 85, "Optique" from *Planches du Dictionnaire de Physique* (detail). 1781. Engraving, 8¾ x 6 inches. Coke Collection, Rochester, N.Y.

2.

INTRODUCTION

The camera created a new way of seeing and opened to artists a range of pictorial imagery quite unlike that of direct experience. No study of the art of the past hundred and fifty years, and even earlier, can be made without taking into consideration the influence of the unique qualities of camera vision on artists and their patrons.

Artists used camera images in the nineteenth century much as sketches had traditionally been used in earlier periods, either as notations when copying from nature or as a means of authenticating details. Photographs also served to expand the vision of artists. Aspects of scenes, events, or subjects previously overlooked or beyond the range of the human eye could be incorporated in pictures using photographs as a guide. A prime example of that is the way in which painters represented horses in motion after they became acquainted with the stop-action photographs of Eadweard Muybridge. These photographs made it possible to see for the first time what actually takes place when a horse runs or moves at a rate more rapid than the eye can follow.

Regardless of intent, those who painted from photographs were inexorably subject to the peculiarities of camera vision, which affected their work and led to new pictorial forms that were accepted by both artists and public without a clear awareness of their origins. Subsequently, as artists became conscious of the difference between eyesight and camera sight, the differences between the two kinds of vision played a part in developing the idea that painting is more than a record of what the eye sees.

Through a comparison of paintings and their photographic sources we gain a better understanding of how the camera affects an artist's work. Much is revealed about the artist when we see what he keeps, what he omits, what he modifies. We can see how, for clarity or for expression, pictorial choices were exercised and we become privy to the process whereby a physical inventory of facts yields to artistic sensibility. The disparities between a photograph and a painting can illuminate the nature of the artists's *modus operandi*, thus shedding light on the creative process.

When introduced in 1839, the daguerreotype, with its silvery reflecting surface, evoked something of the age-old magic associated with the mirror. First to recognize this were the painters, who both reacted against and sought inspiration from the simulated realism produced by the camera. In a few years photography changed the artist's viewpoint, both technically and philosophically. Inexact views and flagrantly flattering portraits were tolerated less often, and the role of the artist as a recorder of nature was encouraged, as standards for judging art began to be based on the kind of exactitude found in photographs.

Many nineteenth-century artists of note felt that the process developed by the realist painter Louis Jacques Mandé Daguerre would serve the arts. Few foresaw the wide-ranging effect that would accompany the popularity of the new invention. That the mechanical image maker should have been regarded as a proper aid to artists is understandable in a period when new machines were being invented for many purposes. Daguerre and William Henry Fox Talbot, the English inventor of the negative-positive photographic process, both used the camera obscura when making their pioneering photographs. This instrument, forerunner of all photographic cameras, influenced the vision of artists as early as the Renaissance. (1-2)

Beginning in the fifteenth century, painting became increasingly realistic in response to changes in man's views of his environment and position in the universe. He became less spiritually oriented and began to develop a new awareness of the actuality of his physical surroundings. From this concern an artistic tradition arose that centered on the systematic reconstruction of familiar objects and views with meticulous exactitude. Then, as now, men who could successfully simulate on a flat surface the expanse and depth of the three-dimensional world with its light and shade were held

3.

3. De M. Brisson. Plate 47, "Physique" from *Planches du Dictionnaire de Physique* (detail). 1781. Engraving, 8¾ x 6 inches. Coke Collection, Rochester, N.Y.

4. J. G. Bergmüller. *Portrait of the Court Painter Joachim Franz Beich* (detail). 18th Century. Mezzotint by Johann Jakob Haid, 15¾ x 10⅛ inches. George Eastman House, Rochester, N.Y.
(Note camera obscura on pedestal in lower right.)

5. Jan Vermeer. *View of Delft* (detail). c1658. Oil, 38¾ x 46¼ inches. Royal Picture Gallery, Mauritshuis, The Hague, Netherlands.

5.

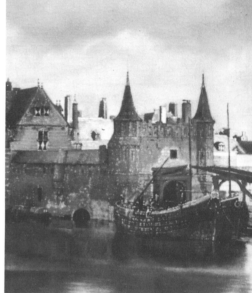

4.

2

in high regard. Representing the objective appearance of nature and rendering one-point perspective in mathematically accurate terms required great skill.

Consequently, various kinds of drawing machines and lenticular devices were developed to assist artists in making accurate descriptive copies of nature. The camera obscura was the most successful device used for this purpose. (3) With this apparatus it was relatively easy to refashion deep space into a form that was flat and reduced in scale so that artists could make accurate perspective drawings, render details precisely, and truly represent light and shade.

The action of light, as it enters a small aperture into a dark room to project an image, has a history that extends back to the ancient Greeks. During the Middle Ages, Arab scholars noted this effect and constructed camera obscuras to study the heavens. The literature of the Renaissance contains a number of descriptions of this curious mechanism, including that of Leonardo da Vinci, who sketched a camera obscura in his *Codex Atlanticus.* Da Vinci said that the images created by the device "will actually seem painted upon paper."

In 1550 Girolamo Cardano, a Milanese mathematician, noted the improvements that could be made by fitting a lens to a camera obscura to give greater sharpness and luminosity to the image projected on the screen of this device. Eight years after Cardano wrote of this improvement Giovanni Battista della Porta suggested that the camera obscura would be valuable as an aid for draftsmen and artists. Further developments, such as the use of a 45-degree mirror in portable units, were introduced in the seventeenth century. These innovations made it possible for an artist to use the instrument in the field and to see the image that was shown on the ground-glass screen in an upright position so that he could render the objects before him as they appeared in nature.

Although the camera obscura was used principally as a copying tool for draftsmen, there is extensive evidence to indicate that a number of prominent seven-

teenth- and eighteenth-century portrait and landscape painters also were aided by this device. (4)

Some art historians think that Jan Vermeer used a camera obscura when composing his *View of Delft* (5) and *Young Girl with a Flute* (6), as well as other paintings. In these two pictures elements are incorporated in the compositions that are not usually observed by the unaided eye. The "bloom" of light around the rigging of the boat in the first painting and the out-of-focus quality of the carved lion head on a chair in the second are optical rather than retinal in nature. (5-7)

As Charles Seymour has noted regarding the dots of heavily loaded pigment in Vermeer's *View of Delft:*

The highlights spread into small circles, and in such images the solidity of the form of a barge for example is disintegrated in a way that is very close to the well-known effect of circles (or discs) of confusion in optical or photographic terms. This effect results when a pencil of light reflected as a point from an object in nature passes through a lens and is not resolved, or "brought into focus" on a plane set up on the image side of the lens. In order to paint this optical phenomenon Vermeer must have seen it, and it must be assumed that he could not have seen it with direct vision, for this is a phenomenon of refracted light.

In addition to *View of Delft* a number of other compositions by Vermeer may owe their extremely wide angle of view to optical phenomena associated with the camera obscura, as these effects are not experienced in normal vision.

Among the baroque and rococo Italian painters who used the camera obscura for rendering panoramic views of cities and the countryside were Giuseppe Maria Crespi, Guardi, the Canaletto—Antonio Canale and Bernardo Bellotto—Zuccarelli, and Vanvitelli. (8-9) Such factors as compressed perspective, exaggeratedly wide foregrounds, somewhat limited sense of depth, and selective focus indicate that their paintings were prepared in a number of instances with the aid of a camera obscura.

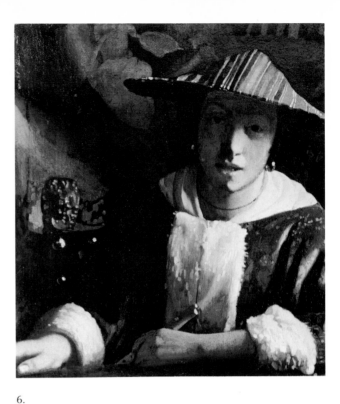

7.

6.

8.

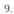

9.

6. Jan Vermeer. *Young Girl with a Flute.* c1665.
Oil, 7⅞ x 7 inches. National Gallery of Art, Washington, D.C.

7. Jan Vermeer. *Young Girl with a Flute* (detail).

8. Canaletto. *Two Views of the Waterfront at the Lido.*
Pen and ink on white paper, 8-11/16 x 11½ inches.
Courtesy Fogg Art Museum, Harvard University.
Bequest of Charles A. Loeser.

9. Canaletto. *San Nicolo at the Lido.* Pen and ink over
graphite on white paper, 7⅝ x 11½ inches.
Courtesy Fogg Art Museum, Harvard University.
Bequest of Charles A. Loeser.

4

In the north of Europe the images registered on the screens of various kinds of camera obscuras were also widely used. M. G. J. Gravesande mentioned this fact and warned artists not to be deceived by the difference between camera vision and the way the eye sees:

several Flemish painters (according to what is said about them) have studied and copied in their paintings, the effects of the camera obscura and the way in which it presents nature. It cannot be denied that certain lessons can in fact be drawn from [the camera obscura] of chiaroscuro and light: and *yet too exact an imitation would be a distortion, because the way in which we see natural objects in the camera obscura is different from the way in which we see them naturally.* [Italics by the author.] The glass [lens] interposed between objects and their representation on the paper [or screen] intercepts the rays of the reflected light which render shadows darker by it than would be the case in nature.

Artists who used the camera also found that it altered their views of nature in other ways. Antonio Canale recognized this:

il canal taught the correct way of using the camera and how to understand the errors that occur on the picture surface when the artist follows too closely the lines of the perspective, and even more the aerial perspective, as it appears in the camera itself and does not know how to modify them where scientific accuracy offends against common sense.

When Canale said, "where scientific accuracy offends against common sense," he was referring to what were considered to be distortions of scale in camera obscura images. Camera obscuras were usually equipped with lenses that created a foreshortened image at odds with Renaissance concepts of what were considered proper proportions in one-point perspective views.

Throughout the eighteenth century, artists used camera obscuras. Confirmation of this is found in Count Francesco Algarotti's *Essay on Painting*, published in 1764. He wrote:

the best modern painters among the Italians have availed themselves greatly of this contrivance; nor is it possible they should have otherwise represented things so much to life. Every one knows of what service it has been to Spagnoletto of Bologna [Ribera?] some of whose pictures have a grand and most wonderful effect.

The camera used by Daguerre in the late 1830s to make his daguerreotypes was only a slight improvement over the "contrivance" referred to by Algarotti. Daguerre was able, however, to produce by the action of light unerringly precise and realistic images, which could be made permanent with chemicals, thus replacing the hand tracing of views cast on the ground-glass screen of a camera obscura.

Despite the widespread use of the camera obscura by artists, its use to make daguerreotypes stirred up a storm of controversy among illustrators and graphic artists. They feared daguerreotypes would compete with their work, for through the new use of the camera very accurate pictures could be made by operators having little or no training. "Will the artist not be driven to starvation when a machine usurps his functions?" a Viennese reporter asked in September 1839 and at once furnished his own reply: "The daguerreotype does not deprive the landscape painter of his bread and butter; on the contrary he can make it yield profitable returns. He can photograph a locality with the daguerreotype in a few minutes, to serve as a sketch for a painting in any desired proportions at home."

This echoed the comments of François Arago, the distinguished scientist and member of the French Chamber of Deputies who was the spirited advocate of Daguerre's process. He said, "the ease and accuracy of the new process, far from damaging the interests of the draughtsman, will procure for him an increase in work. He will certainly work less in the open air, and more in the studio."

Photography did, however, have various effects on the craft of illustration, some good, others bad. Periodicals such as *The London Illustrated News*, the Paris *L'Illustration,* and *Die Leipziger Illustrierte Zeitung*

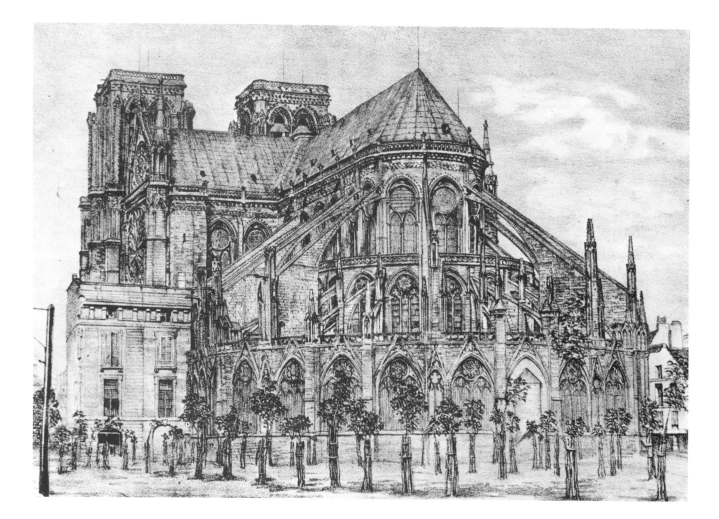

10. L. Marquier. *Notre Dame de Paris*. 1839.
Lithograph, 5¾ x 8⅛ inches.
George Eastman House, Rochester, N.Y.

became popular in the decade following the introduction of photography. Many of the pictures reproduced in these magazines were drawn from photographs, which provided jobs for numerous craftsmen. On the other hand, illustrators depended less and less on direct observation and tailored their drawings to photographs, thus diminishing the importance of individual styles.

One of the earliest examples of daguerreotypes used by an artist is found in the drawings of L. Marquier who depended on pictures taken by Daguerre's process for lithographs he made of Paris in 1839. The details in these prints were rendered so precisely and so objectively that they have the appearance of daguerreotypes. Such items as advertisements were copied faithfully. And in a view such as *Notre Dame de Paris*, perspective was drawn in a foreshortened fashion that stemmed from lens vision, not eye vision. (10)

It was felt by many that photographs would serve fine artists as well as illustrators as adjuncts to direct study. For instance the celebrated French academician Paul Delaroche was so impressed with the potential of the new invention as an aid for painters that he said, "Daguerre's process completely satisfies all the demands of art, carrying certain essential principles of art to such perfection that it must become a subject of observation and study even to the most accomplished painters."

In the United States the painter-inventor Samuel F. B. Morse subscribed to this view and made daguerreotypes "to accumulate for my studio models for my canvas." In 1840 Morse, recognizing that the new process would certainly affect painting, delivered a lecture to the members of the National Academy of Design on "The Probable Effects to Be Produced by the Discovery of Daguerre on the Arts of Design," in which he pointed out:

It will ease the artist's task by providing him with facsimile sketches of nature, buildings, landscapes, groups of figures . . . scenes selected in accordance with the peculiarities of his own taste . . . not copies of na-ture, but portions of nature itself . . . the public would become acquainted through photography with correctness of perspective and proportion, and thus be better qualified to see the difference between professional and less well-trained work.

Except for a few dissenters, who felt that the camera might prove to be a Pandora's box, the general reaction to the daguerreotype was most favorable. Edgar Allan Poe wrote in 1840:

In truth the daguerreotype plate is infinitely more accurate in its representation than any painting by human hands. If we examine a work of ordinary art, by means of a powerful microscope, all traces of resemblance to nature will disappear—but the closest scrutiny of the photographic drawing discloses only a more absolute truth, more perfect identity of aspect with the thing represented.

This exemplifies the view fostered in the first half of the nineteenth century by the invention of photography that accuracy has an inherent artistic value. For instance the artist Horatio Greenough, in his essay on "Art in America," stated flatly, "imagination is the language of art." One of the more important artists who took exception to the general feeling of excitement about the possibilities of Daguerre's process was the prominent American landscapist Thomas Cole. Writing to a friend, Cole said:

I suppose you have read a great deal about the daguerreotype. If you believe everything the newspapers say—which, by-the-by, would require an enormous bump of marvelousness—you would be led to suppose that the poor craft of painting was knocked in the head by this new machinery for making Nature take her own likeness, and we have nothing to do but give up the ghost. . . . This is the conclusion: that the art of painting is creative, as well as an imitative art, and is in no danger of being superseded by any mechanical contrivance.

Nor did Eugène Delacroix think that photography would supersede painting, but he did applaud its invention. He was the first French painter of quality to

 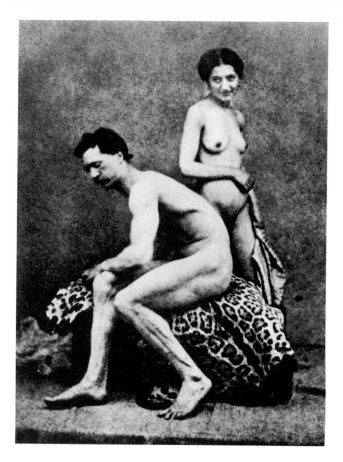

11.

12.

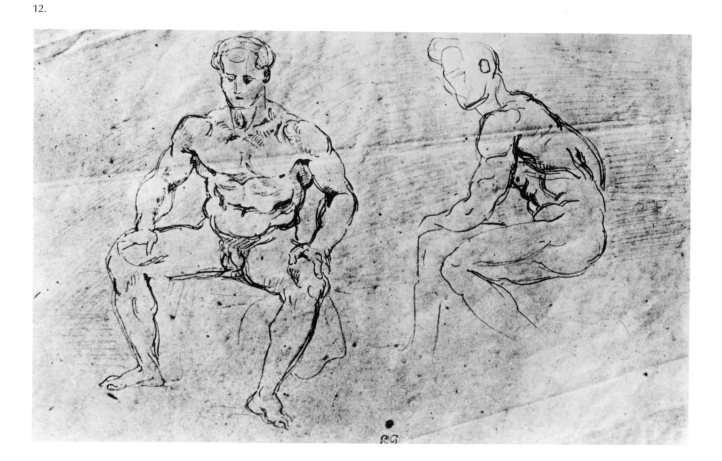

11. Eugène Durieu. *Studies.* 1854. Photographs (pair).
Musée Bonnat, Bayonne, France.

12. Eugène Delacroix. *Studies.* 1855. Pen and ink drawing,
9½ x 13¾ inches. Musée Bonnat, Bayonne, France.

espouse openly the idea that photographs were a proper aid for artists. He drew and painted from both daguerreotypes and paper prints. In his *Journal,* on May 21, 1853, he wrote, "let a man of genius make use of the daguerreotype as it should be used, and he will raise himself to a height that we do not know."

Delacroix also made reference to borrowing daguerreotypes of male nudes made by Ingres' student Jules-Claude Ziégler. In Paris during 1853 and 1854, Delacroix posed models and had his friend Eugène Durieu photograph them by the wet-plate process for future study. Delacroix wrote of the resulting prints: "I look enthusiastically and without tiring at these photographs of nude men—this human body, this admirable poem, from which I am learning to read—and I learn far more by looking than the inventions of any scribbler could ever teach me." (11-12)

The photographs of male and female nudes made for Delacroix are the earliest nudes directly connected with a group of drawings or paintings. (13-16) Delacroix also found photographs useful when traveling away from Paris. In 1854 during a stay in Dieppe he referred in his *Journal* to his practice of drawing from photographs he had brought with him to study. The art historian F. A. Trapp feels that Delacroix refreshed his vision with photographs. They challenged his eye, which was trained to see within the bounds of rather strict artistic conventions. Trapp has discerningly commented that:

the attraction of the photograph as an object of study was more than one of simple convenience; it served, as it were, as a foil to his [Delacroix's] own perception experience, and, in some measure, as an objective verification of his exceptional awareness of the selective reference to visual "fact."

In an essay addressed to students, Delacroix touched on the important difference between the particularity of camera vision and the weakness of human vision when he noted:

The daguerreotype is more than a tracing, it is the mirror of the object. Certain details almost always overlooked in drawing from nature here take on characteristic importance and thus introduce the artist to complete knowledge of construction as light and shade are found in their true character.

The Flemish painter Constant Dutilleux, as noted in Raymond Escholier's book on Delacroix, also referred to the part the "master" played in posing models to be photographed:

Delacroix did not simply admire photographs in theory . . . he drew a great deal from photographic plaques [daguerreotypes] and from proofs on paper. I own an album made up of poses of models, both men and women, which were prescribed by him and caught by the lens before his very eyes. . . . Incredible phenomenon! The choice of nature, the posture of distribution of the light, the twist of the limbs are so singular that one could say of many of these proofs that they were taken after the master's own original works. The artist was somehow the sovereign master of machine and material. The radiance of the ideal that he bore within himself transformed models hired at three francs a session into vanquished heroes and dreamers, and nervous, palpitating nymphs.

Further evidence of Delacroix's involvement with photography is indicated in a letter he wrote to his friend Dutilleux on March 7, 1854.

How I regret that such a wonderful invention arrived so late, I mean as far as I am concerned! The possibility of studying such results would have had an influence on me which I can only imagine by the usefulness which they still have for me, even with the little time that I can give to serious study. They are palpable demonstrations of the free design of nature, of which we have hitherto had only very imperfect ideas.

By the time the above letter was written in 1854, photography had spread all over Europe, and to the Orient and the Americas. A veritable flood of landscapes, genre pictures, and portraits were being made by amateurs and professionals; and artists were making extensive use of photographs in all these categories. Critics were also publishing comments on the influence

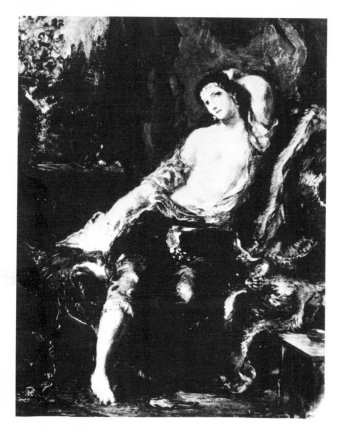

15.

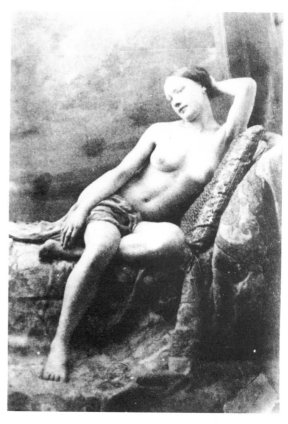

16.

13.

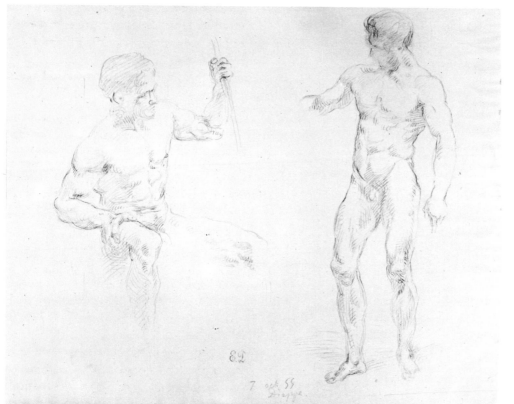

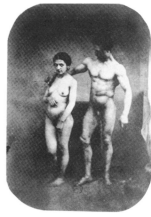

14.

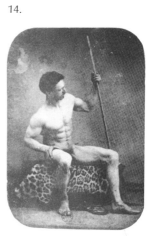

10

13. Eugène Delacroix. *Studies*. 1855. Pencil drawings, 7¼ x 9⅜ inches. Collection F. A. Trapp, Amherst, Mass.

14. Eugène Durieu. *Nude man* and *Nude man and woman*. c1854. Photographs (pair). Bibliothèque Nationale, Paris.

15. Eugène Delacroix. *Odalisque*. 1857. Oil, 14 x 12 inches. Niarchos Collection.
Photograph, courtesy Aaron Scharf, London.

16. Photographer unknown. *Seated nude*. c1855. Photograph. Bibliothèque Nationale, Paris.

of the camera on painters. In 1853 Robert Hunt wrote in *The Art Journal*, "In the last exhibition of the Royal Academy, pictures and bits of pictures could be detected in which the aid of the camera was apparent."

That the use of photographs by artists was thought to be an acceptable practice a hundred years ago is indicated by the following comments published in 1855 in *The Crayon*. "As an auxiliary to Art, Photography comes opportunely to the aid of the artist in those preparatory studies always necessary in the production of a work of Art. . . . These results are attained with the utmost accuracy of form and correctness of effect, such as the most accomplished artist could have attained only at an enormous expenditure of time and labor."

Three years later, in 1856, M. A. Dwight in her book, *Introduction to the Study of Art*, commented:

It has often been remarked how much assistance the young artist may derive from the photographic art. Yes, just the same that a student of language derives from a translation. Give to a young artist thorough instruction in the principles as well as the practice of form, and light and shade, and he needs no aid from the photographic art, or any other form of mechanism. In resorting to the use of them he acknowleges [sic] his own deficiencies and weakness, and so long as he depends upon the aid they give, he is but a feeble copyist, entirely destitute of artistic knowledge and skill, incapable of producing works of ordinary merit, much less those bearing the stamp of ideal beauty in any form of imitation. In this point of view, photography, instead of being a great aid to artists, or in any way promoting the progress of art, contributes materially to its degeneracy. It is one thing to copy nature, and quite another to compose a picture according to the rules of imitative art founded upon the laws of nature.

Charles Baudelaire in his review of the Paris Salon of 1859 paid a good deal of attention to the effect of photography on artists and on the taste of the public. He wrote:

It is an incontestable, an irresistible law that the artist should act upon the public, and that the public should react upon the artist; and besides, those terrible witnesses, the facts, are easy to study; the disaster is verifiable. Each day art further diminishes its self-respect by bowing down before external reality; each day the painter becomes more and more given to painting not what he dreams but what he sees. Could you find an honest observer to declare that the invasion of photography . . . has no part at all in this deplorable result? Are we to suppose that a people whose eyes are growing used to considering the results of a material science [photography] as though they were the products of the beautiful, will not in the course of time have singularly diminished its faculties of judging and of feeling what are among the most ethereal and immortal aspects of creation?

Baudelaire further said that the photographic industry "was the refuge of every would-be painter, every painter too ill-endowed or too lazy to complete his studies." And he continued, "I am convinced that the ill-applied developments of photography, like all other purely material developments of progress, have contributed much to the impoverishment of the French artistic genius, which is already so scarce."

Baudelaire felt that many Frenchmen would reason as follows:

I believe in nature, and I believe only in nature. I believe that Art is, and cannot be other than, the exact reproduction of nature (a timid and dissident sect would wish to exclude the more repellent objects of nature, such as skeletons and chamber pots). Thus an industry [photography] that gives us a result identical to nature would be the absolute art.

Baudelaire concluded:

A revengeful God has given ear to the prayers of this multitude. Daguerre was his Messiah. And now the faithful says to himself: "since Photography gives us every guarantee of exactitude that we could desire (they really believe that, the mad fools), then Photography and Art are the same thing."

Although Baudelaire was very much opposed to the encroachment of photographic imagery on art, he was not consistent in his views. Speaking enthusiastically of an etching of San Francisco drawn from five da-

guerreotypes, Baudelaire said, "the great printmaker [Méryon] has a good right to call [the San Francisco etching] his veritable masterpiece. The owner of the plate, M. Niel, would be performing a real act of charity if from time to time he had a few impressions printed from it."

Baudelaire nevertheless sternly warned those who were obedient to the siren's call of machine-made pictures, "If photography is allowed to supplement art in some of its functions, it will soon have supplanted or corrupted it altogether . . . if it be allowed to encroach upon the domain of the impalpable and the imaginary, upon anything whose value depends solely upon the addition of something of a man's soul, then it will be so much the worse for us!"

Baudelaire was a true prophet, for painting external reality became more and more the aim of artists, and painting from daguerreotypes and paper prints was an easy way to achieve accuracy in paintings, etchings, and lithographs.

In this regard Théophile Gautier observed in reviewing the Paris Salon of 1861, "the daguerreotype, which has neither been given credit nor medal, has nevertheless worked hard at this exhibition. It has yielded much information, spared much posing of the model, furnished many accessories, background and drapery which has only to be copied and colored."

In his preface to the publication of the *Société des Aquafortistes* in 1863, Gautier called attention to another facet of the relationship between pictures made with the camera and those executed by more traditional means: "In these times, when photography fascinates the vulgar by the mechanical fidelity of the reproductions, it is needful to assert an artistic tendency of free fancy and picturesque mood. The necessity of reacting against the positivism of the mirror-like apparatus has made many a painter take up the etcher's needle."

Admiration for photography was, however, widespread among many painters. William Rothenstein noted, "Turner believed that photography would revolutionize painting—that it would help painters to a new knowledge of light."

In France, J. F. Millet, the Barbizon painter of peasants, saw value for artists in photographs. He would, however, view them with caution and use them only for information or in teaching. "Photographs are like casts from nature, which never can be as good as a good statue. No mechanism can be substituted for genius. But photography, used as we use casts, may be of great service!"

Although there has not as yet come to light a one-to-one link between the work of Jean A. D. Ingres and specific photographs, he does seem to have used photographs as an aid when painting some of his pictures. Certainly his later nudes clearly resemble daguerreotypes in their hard outline, smooth finish, and lack of color. The photography historian Helmut Gernsheim has expressed the opinion that one of Ingres' late works, *La Source*, is directly related to Nadar's 1856 photograph of Christine Roux. It is known that Ingres admired photographs, for he said of them, "This is the exactitude that I would like to achieve." At another time he was more cautious and expressed reservations, "It [a photograph] is admirable but one must not admit it." To his pupils Hippolyte Flandrin and E. Pineux Amaury-Duval he said, referring to a photograph, "Look at this, gentlemen! Which of you would be capable of such fidelity, such firmness of line, such delicacy of modelling?"

It is not surprising to find that the mid-nineteenth-century champion of realism Gustave Courbet also turned to the camera for studies of nudes. Aaron Scharf has indicated that the central figure in Courbet's giant canvas, *L'Atelier du Peintre: Allégorie Réelle*, was taken from photographs. Before he began to work on this picture Courbet wrote to his friend and patron Alfred Bruyas asking for a photograph to serve as a model for a figure he planned to include in this painting. Courbet requested "that photograph of the nude woman I spoke to you about. She will stand behind my

17. 18.

17. Gustave Courbet. *Femme avec Bouteilles du Vin.* c1867. Lithograph. Reproduced from *Le Camp des Bourgeois.*

18. Gustave Courbet. *"Messieurs, je suis pharmacien dans un quartier populeux."* c1867. Lithograph. Reproduced from *Le Camp des Bourgeois.*

19. Charles Reutlinger. *Pierre-Joseph Proudhon.* c1855. Photograph. George Eastman House, Rochester, N.Y.

20. Gustave Courbet. *Proudhon and His Children* (detail). 1865. Oil, 58 x 78 inches. Musée du Petit Palais, Paris.

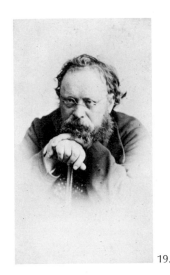

19.

chair in the middle of the picture." Although no evidence has yet been discovered that some of Courbet's other nudes were painted from photographs, they have the flavor of the lens and probably were derived from camera-made studies.

Étienne Baudry arranged for Courbet to illustrate his *Le Camp des Bourgeois,* a book published in 1867, that deals with various bourgeois types. To capture as convincingly as possible the faces and actions of Baudry's characters, Courbet took his illustrations from photographs by the famous Parisian cameraman Étienne Carjat. (17-18) Baudry wrote, "Carjat placed at my disposal a drawer full of photographic proofs left for payment. From the pile I made a choice and Courbet, to whom I took them, chose ones which pleased him." Further, part of the 1865 portrait of Courbet's friend, the socialist Pierre-Joseph Proudhon, was also derived from a photograph. (19-20) Courbet wrote to Jules-Antoine Castagnary on January 20, 1865: "Send me what photographs my friend Carjat has taken. Ask him . . . to ask Reutlinger . . . for the large photograph he [Reutlinger] took of the philosopher in the pose I suggested. Send me all this as soon as possible. . . . I want to represent him . . . with his wife and children. . . . I am giving up everything else for the present." As late as 1874, while exiled in Switzerland, Courbet painted a view of *Le Château de Chillon* from a photograph made by the distinguished French photographer Adolphe Braun.

The next generation of avant-garde painters, the Impressionists, were influenced by the unstudied poses caught by the camera and by the way light was recorded. In *Renoir, My Father,* Jean Renoir wrote:

The Impressionists attached considerable importance to the latest development in photography. Renoir regarded photography as both a great good and a great evil. He gave credit to Niépce and Daguerre for having, "freed painting from a lot of tiresome chores, starting with family portraits. Now the shopkeeper

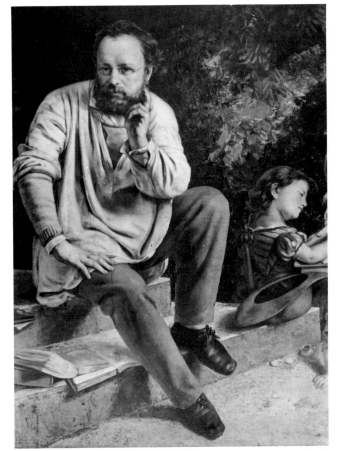

20.

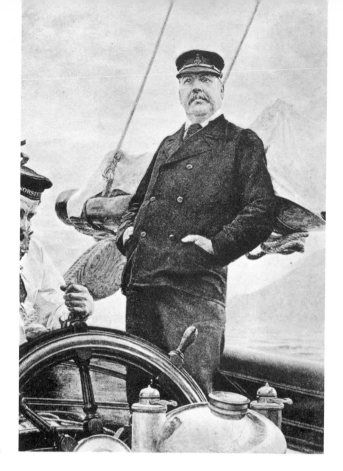

21. Edward Gregory. *S. R. Platt Esq.* 1891.
Courtesy Royal Academy of Arts, London.

22. William Bartlett. *Now We Go Round and Round.* 1894.
Courtesy Royal Academy of Arts, London.

21.

22.

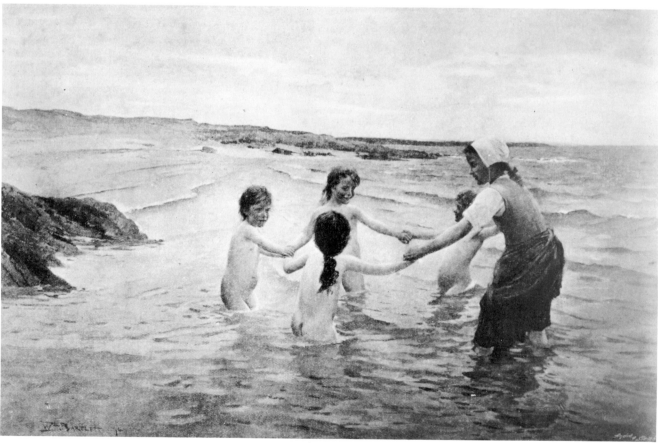

who wants his portrait has only to go to the photographer. So much the worse for us, but so much better for the art of painting."

The American critic Sadakichi Hartmann wrote extensively about the relationship between the tonal school of painting and photography, concluding that the vision of the camera was a definite factor in the evolution of Impressionism:

It is a singular coincidence, indeed, that while the men of the lens busy themselves with imitating the art of several centuries ago, those of the brush are seeking . . . the accuracy of the camera plus technical individuality.

The impressionist painters adhere to a style of composition that apparently ignores all previous laws. They depict life in scraps and pigments, as it appears haphazard in the finder or on the ground glass of the camera. The mechanism of the camera is essentially the one medium which renders every interpretation impressionistic, and every photographic print, whether sharp or blurred, is really an impression.

How did the impressionistic painters arrive at this new style of composition? Permit me two questions. When was impressionism introduced into painting? In the sixties. When did photography come into practice? In the early forties. Do you see what I am driving at? Photography in the sixties was still a comparative novelty, and consequently excited the interest of pictorial reformers more than it does today. Its influence must have been very strongly felt, and the more I have thought of the nature of this influence the stronger has become the conviction in me that the impressionistic style of composition is largely of photographic origin.

Impressionistic composition is unthinkable without the application of focus. The lens of the camera taught the painter the importance of a single object in space to realize that all subjects cannot be seen with equal clearness, and that it is necessary to concentrate the point of interest according to the visual abilities of the eye. There is no lens, as everybody knows, which renders foreground and middle distance equally well. If three objects, for instance, a house, a tree and a pool of water, stand at different depths before the camera, the photographer can, at will, fix either the house, the tree or the pool of water, but whatever one of these three

objects it will be, the other two objects will appear less distinct. . . . The impressionist is satisfied with giving one full impression that stands by itself, and it was the broadcast appearance of the photographic images in the sixties that taught him to see and represent life in focal planes and divisions.

Near the end of the century, in 1894, George Moore included in his book *Modern Painting* a chapter entitled "The Camera in Art." Here he wrote:

I pass on to consider a matter of more practical interest, a growing habit among artists to avail themselves of the assistance of photography in their work. It is not to be questioned that many artists of repute do use photographs too well, to put it briefly, to save themselves trouble, expense, and in some cases, to supplant defective education. Mr. [Edward] Gregory is the most celebrated artist who is said to make habitual use of photography . . . his picture of a yachtsman in this year's Academy was a paltry, as "realistic" as may be. Professor [Sir Hubert von] Herkomer is another well known artist who is said to use photography. It is even said that he has his sitter photographed on to the canvas, and the photographic foundation he then covers up with those dreadful browns and ochres which seem to constitute his palette. Surely we must recognize all the cheap realism of the camera in Professor Herkomer's portraits. Mr. [William] Bartlett is another artist who, it is said, makes habitual use of photographs; and surely in some of his boys bathing the photographic effects are visible enough. (21-22)

In the nineteenth century the photograph was most frequently used as a crutch. Only a few artists expanded the potential of their work by using camera vision. In the twentieth century, due to the veritable tidal wave of photographs that appeared in magazines and family albums, the vision of the camera became unavoidable and was absorbed by artists and the public. This potent force became more and more recognized as a conceptual agency. To understand better what happens when the artist's eye is reinforced by the lens of a camera, the reader will be presented with specific examples of how painters have used photographs for all kinds of subjects.

1. PORTRAITS
NINETEENTH CENTURY

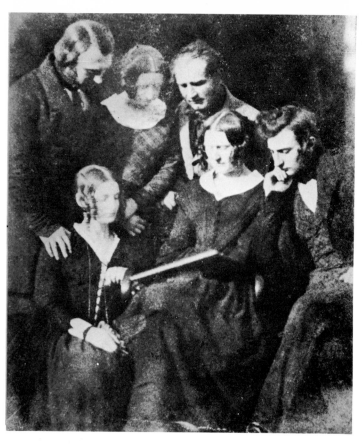

24.

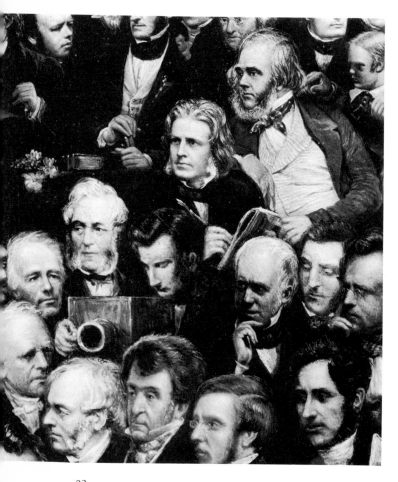

23.

Detail of painting at *left*.　　Detail of photograph *above*.

23. D. O. Hill. *The first general assembly of the Free Church of Scotland, signing the Act of Separation and Deed of Demission* (detail). 1844. Oil, 58 x 141 inches.
Courtesy Scottish National Portrait Gallery, Edinburgh.

24. D. O. Hill and Robert Adamson.
The Adamson Family (Robert on right). c1845. Calotype.
Courtesy Scottish National Portrait Gallery, Edinburgh.

25. *Engraving from a broadside of Brady's Daguerrean Gallery.*
1851. New-York Historical Society, New York.
Bella C. Landauer Collection.

1. PORTRAITS NINETEENTH CENTURY

25.

Landscapes and city scenes were the first photographs copied by artists, but it was the portrait painter who made the greatest use of the camera in the nineteenth century. Although Arago, in his report to the joint meeting of the French Academy of Sciences and Fine Arts on August 19, 1839 said, "In general there is little ground for believing that [Daguerre's process] will ever serve for portraiture . . ." likenesses were made in vast numbers by Daguerre's direct positive process as well as by Talbot's paper-negative process as early as 1841.

David Octavius Hill, a Scottish landscape painter, was one of the first artists to paint a large number of portraits from photographs. Because of a dispute over the right of members to select their ministers, Hill, a former member of the official Presbyterian church, had joined with some of his friends and a large group of clergymen in Edinburgh to establish a new church, independent of state support. He decided to paint a picture representing, in symbolic fashion, the signing of the Act of Separation and Deed of Demissions to commemorate the founding of the Free Church of Scotland. Portraits of 470 people sympathetic to this cause were included in his giant canvas, as well as a few genre elements.

Hill decided to depend on photographs for accurate likenesses of his subjects, because (1) being a landscape painter, he was unaccustomed to making portrait sketches; (2) the clerics he wished to paint were in Edinburgh for only a short time; and (3) the work on such a complex canvas would take years. He had been interested in photography even before he began to paint his great group portrait; it is, therefore, not surprising that he made this decision.

Hill chose Talbot's paper-negative process (calotype) for his studies because that photographic technique had been investigated and used by a number of university professors and amateur cameramen in Edinburgh. As early as 1840, Dr. John Adamson, professor of chemistry at the University of St. Andrews, had made the first calotype portrait in Scotland and, perhaps, even in the world. John Adamson's brother Robert, also a pioneering photographer, was chosen by Hill as a collaborator and technician.

A contemporary account of the success of Hill and Adamson has been preserved. The plan of the two men to photograph the participants in the protest against the Church of Scotland was the subject of a letter to Talbot written in July 1843 by Sir David Brewster, Principal of the University of St. Andrews, who said:

I got hold of the artist—showed him your calotype and the eminent advantage he might derive from it in getting likenesses of all the principal characters before they dispersed to their respective homes.

He was at first incredulous, but went to Mr. Adamson, and arranged with him the preliminaries for getting all the necessary Portraits. They have succeeded beyond their most sanguine expectations—They have taken, on a small scale, groups of 25 persons in the same picture all placed in attitudes which the painter desired, and very large pictures besides have been taken of each individual to assist the Painter in the completion of his picture. Mr. D. O. Hill, the painter, is in the act of entering into partnership with Mr. Adamson and proposes to apply the Calotype to many other general purposes of a very popular kind.

Hill posed his subjects out-of-doors because the paper negatives he and Adamson used were not sensitive enough to take pictures inside a studio. When posing the ministers and others for his studies, Hill seems to have had in mind some of the qualities found in well-known portraits by the famous Scottish painter Henry Raeburn. This is apparent from the way Hill handled the massing of forms and the light and shade relationships. Raeburn's custom of painting his subjects in a direct overhead light with a shadow cast down on the lower part of the face was followed by Hill in many calotypes. The full sunlight in which his subjects were posed for the camera caused dark areas which seem to have been muted by reflectors. Hill undoubtedly also directed the placement of highlights by means of concave mirrors. (23-24, 26-28)

26. D. O. Hill. *The first general assembly of the Free Church of Scotland, signing the Act of Separation and Deed of Demission* (detail). 1844. Oil, 58 x 141 inches. Courtesy Scottish National Portrait Gallery, Edinburgh.

27. D. O. Hill and Robert Adamson. *Rev Jabez Bunting*. c1845. Calotype. Courtesy Scottish National Portrait Gallery, Edinburgh.

28. D. O. Hill and Robert Adamson. *Rev Dr Abraham Capadoze*. c1845. Calotype. Courtesy Scottish National Portrait Gallery, Edinburgh.

29. William Etty. *Self Portrait*. 1843-47. Oil, 15½ x 12 inches. National Portrait Gallery, London.

30. D. O. Hill and Robert Adamson. *William Etty*. 1844. Calotype. Courtesy Scottish National Portrait Gallery, Edinburgh.

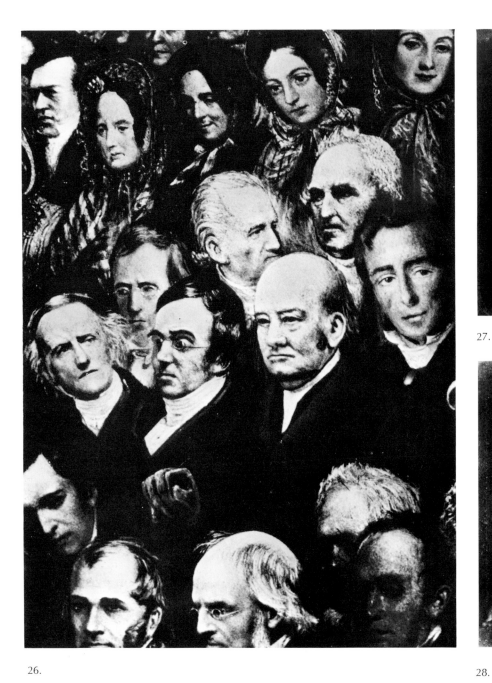

26.

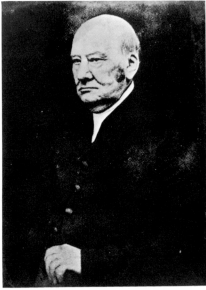

27.

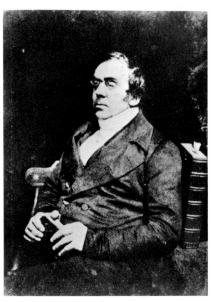

28.

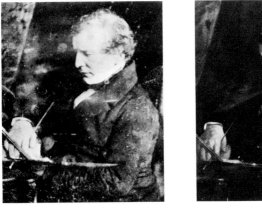

29. 30.

The exposures made by Adamson usually lasted over a minute and accounts for many of the poses with books and furniture used as props to steady the sitters. Such props served as appropriate settings for his subjects, but their use produced some static poses that were carried over into Hill's paintings. Limited as they were, the calotype portraits made by Hill and Adamson are still some of the most sensitive photographs ever made.

In October 1844 the prominent English portrait painter William Etty came to Edinburgh and was the guest of honor at a Royal Scottish Academy dinner. The occasion celebrated a new installation of a group of his paintings by the Academy. Etty also visited Hill and Adamson's studio on Calton Hill in Edinburgh where at least two seated likenesses were made of the portraitist. One of these later served rather directly as a preparatory study for a "self-portrait" by Etty. (29-30) Heinrich Schwarz, the first contemporary scholar to call attention to D. O. Hill's photographs, feels this picture may not have been done by Etty. Be that as it may, the painted portrait was based on the photograph made of Etty in Edinburgh.

Many other portrait painters in Europe and the United States used the eye of the camera as a guide in the 1840s. One artist's reaction to the introduction of the daguerreotype to America is found in a letter from Boston written by George Fuller to his father on April 11, 1840, a number of years before he became well known as a visionary painter. Fuller wrote:

You have heard much (through the newspapers) of the daguerreotype, or drawing produced by rays of light upon a plate chemically prepared. Augustus [Fuller's brother] and I went to see the specimens, and were much pleased. . . . Now this can be applied to taking miniatures or portraits on the same principle that it takes landscapes. M. Gouraud is now fitting up an apparatus for this purpose. . . . The plate (metallic) costs about $1.50, and it is easily prepared; but two minutes' time is required to leave a complete impression of a man's countenance, perfect as nature can make it. . . . This is a new invention, and consequently a great novelty, of which every one has heard, and has a curiosity to see. It is just what the people of this country like, namely, something new. I think anyone would give $7.00 for their perfect likeness.

The camera was bought by Fuller and his brother, who was an itinerant portrait painter. When George Fuller became a full-fledged portrait artist in the mid-1840s he frequently accepted commissions to make portraits in oil from daguerreotypes, for this was the most popular photographic process used by artists as a guide for portraits until the late 1850s. To meet the growing taste for daguerreotypes, artists tailored their style to fit the special characteristics of portraits made with the camera. Even so, one group of portrait painters, the miniaturists, lost out to the camera.

The *Home Journal* published a note regarding the effect of photography on those who painted portraits in oil, especially those who painted miniatures. "The Daguerreotype has killed miniature painting, and superseded portrait painting. The great majority of those who would otherwise be the patrons of portraiture are now content with likenesses that are truer, cheaper, and quicker done."

Another commentator wrote, "the miniaturist in the presence of the photograph was like a bird before a snake: it was fascinated—even to the fatal point of imitation—and then it was swallowed."

21

In 1867 Henry Tuckerman in his book on American painting also mentioned the effect of photography on miniature painters:

Photography has done and is doing much to banish mediocrity in portraiture, and it has, in a great measure, superseded miniature painting; when for a trifling expense, a literal though sometimes unsatisfactory likeness can be obtained by a mechanical and chemical process, the only delineators of the "Human Face Divine" whose services are likely to be called into frequent requisition are those whose superior ability or original genius make their work infinitely transcend the commonplace and the familiar; accordingly it seems a just inference from the economy and facility of the photographic art that the time will come when only the best class of portrait painters can find encouragement.

In New England daguerreotype portraits were sometimes sent to China where artists copied them with watercolors on ivory. The portrait of Polly Baker would seem to indicate that the Chinese artists merely added color to photographic likenesses, for the stiff pose assumed before the camera was faithfully retained. (31)

In moralistic America virtue was found in the fact that daguerreotypes did not often show sitters in an advantageous light. Nathaniel Hawthorne included a daguerreotypist in his famous novel *The House of the Seven Gables.* In this book, published in 1850, the author speaks through his cameraman, Holgrave:

While we give it credit only for depicting the merest surface, it [the daguerreotype] actually brings out the secret character with a truth that no painter would even venture upon, even if he could detect it. There is, at least, no flattery in my humble line of art.

Other commentators also looked with favor on the frankness with which the lens recorded people. The following remarks appeared in 1846 in *The Living Age:*

It [the daguerreotype] is slowly accomplishing a great revolution in the morals of portrait painting. The flattery of the countenance delineators is notorious. . . . Everyone who pays must look handsome, intellectual, or interesting at least—on canvas. These abuses of the brush the photographic art is happily designed to correct.

Ralph Waldo Emerson wrote in 1841, " 'Tis certain that the Daguerreotype is the true Republican style of painting. The artist stands aside and lets you paint yourself." Even though thousands and, later, millions of daguerreotype and ambrotype portraits were made, the demand for oil portraits continued, but more and more of them were painted from photographs.

An early example is a portrait of William Henry Harrison, the military hero of the War of 1812 who was elected President in 1840. (32-33) He served as President for only thirty days before dying of pneumonia in April 1841. A painting of Harrison by Albert Hoyt, in the collection of the Massachusetts Historical Society, although undated, has formerly been considered a work of 1839 or 1840 but should probably be dated 1841. Since the painting was taken from a daguerreotype made by Southworth and Hawes, a Boston firm, it is unlikely that the photograph could have been made before early 1841, the year when Albert Sand Southworth established his studio with Josiah Johnson Hawes. The unselective lens of their camera recorded Harrison's face and brow as wrinkled, as might be expected in the case of a former field general and sixty-eight-year-old Indian fighter. Hoyt's version of the Southworth and Hawes daguerreotype omitted these signs of age but otherwise followed quite specifically the photographed features and dress of the President.

The Whigs nominated Harrison as their candidate for the presidency in 1840. The outstanding leader of that party at the time was Henry Clay, the great Kentuckian who served the nation half a century as a Senator and Secretary of State. He was a popular subject in a number of portraits, many of which were painted from photographs. Hanging in the National Capitol is a half-length picture of Clay by Henry F. Darby, derived from a photograph made about 1849 in Mathew Brady's studio or copied by one of his operators from a daguerreotype made by an unknown

31. Unknown Chinese artist. *Polly Baker.* n.d.
Watercolor on ivory copied from an American daguerreotype,
3¼ x 2⅞ inches. Childs Gallery, Boston.

31.

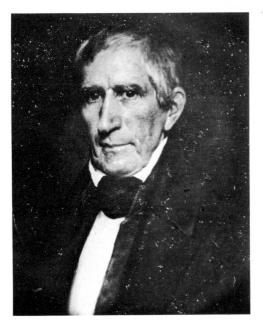

33.

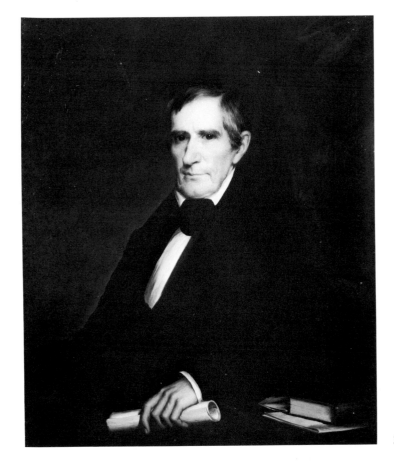

32.

32. Albert Hoyt. *William Henry Harrison.* c1840.
Oil, 35¾ x 28½ inches.
Massachusetts Historical Society, Boston.

33. Southworth and Hawes studio. *William Henry Harrison.*
c1840. Daguerreotype. Metropolitan Museum of Art, New York.
Gift of I. N. Phelps Stokes, Edward S. Hawes, Alice Mary Hawes,
Marion Augusta Hawes, 1937.

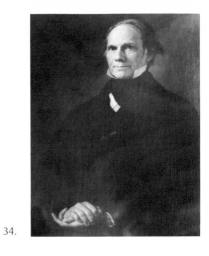

34.

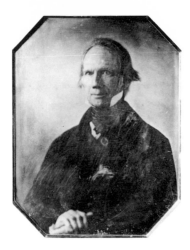

35.

36.

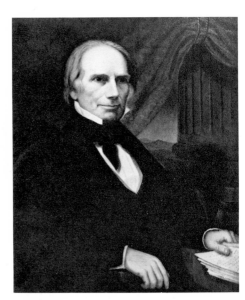

37.

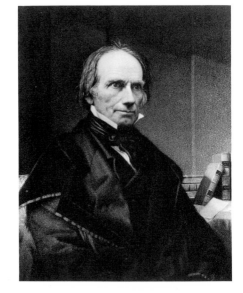

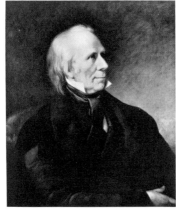

38.

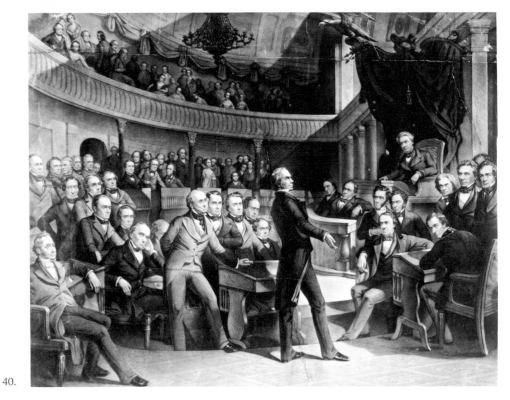

40.

24

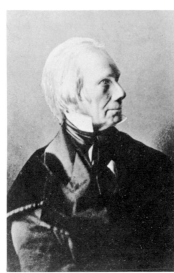

39.

34. Henry F. Darby. *Henry Clay.* c1850.
Oil, 49½ x 39¼ inches. National Capitol, Washington, D.C.

35. Mathew Brady studio (probably copied from an earlier daguerreotype).
Henry Clay. n.d. Daguerreotype (reproduced reversed).
George Eastman House, Rochester, N.Y.

36. A. H. Richie. *Henry Clay.* c1850. Engraving (after a daguerreotype by Paige and Beach), 11 x 9 inches. Prints and Photographs Division, Library of Congress, Washington, D.C.

37. Oliver Frazer. *Henry Clay.* c1850. Oil, 36 x 29 inches. Lafayette College, Allan Kirby Collection, Easton, Pa.

38. Chester Harding. *Henry Clay.* Oil. Whereabouts unknown.

39. Mathew Brady studio. *Henry Clay.* c1849. Photograph. Prints and Photographs Division, Library of Congress, Washington, D.C.

40. P. F. Rothermel. *Henry Clay Addresses the United States Senate, 1850.* Engraving, 27 x 34 inches. Prints and Photographs Division, Library of Congress, Washington, D.C.

photographer. (34-35) This was a common practice among photographers who collected portraits of famous Americans for sale to their many admirers. Darby represented Clay's hands in sharp relief rather than out of focus as they appeared in the photograph he copied. Dress, lighting, and the placement of Clay's features were transcribed without change, except that the pockmarks on the statesman's face were eliminated.

Henry Clay lived most of his life in Lexington, Kentucky. Oliver Frazer, a portrait painter who also lived in that city and was an acquaintance of Clay, relied on the tireless memory of the camera as his guide when painting one of his portraits of his famous fellow citizen. (36-37) Frazer's picture of Clay, like the staid photograph, is as stiff and smooth as a wax figure.

Chester Harding's portrait of Henry Clay was also from a photograph. The oil is quite grand and considerably more dramatic than the countenance and setting in the photograph on which Harding depended for a likeness. The light on Clay's right cheek and the creases around the mouth of "The Great Pacificator" were altered or played down. The same photograph served P. F. Rothermel when he composed his 1850 picture for the well-known engraving *Henry Clay Addresses the United States Senate.* (38-40) This print, in which Clay was portrayed discussing the admission of California to the Union, included over fifty portraits of senators. Many of these portraits can be matched with photographs so exactly as to indicate that the camera provided the artist with all or most of the likenesses he engraved.

For success, daguerreotypists needed large numbers of customers; and to attract clients they used famous personages as lures, implying that their studio had been selected by the famous because the pictures made there were superior.

Mathew Brady, America's best known mid-nineteenth-century photographer of well-known personages, opened his first daguerreotype gallery in New York in 1844 after being instructed in photography by

Samuel F. B. Morse. Brady had a gift for attracting prominent figures in politics, society, and the arts to his New York gallery and later to the gallery he established in Washington. This faculty proved of great benefit to many of his friends who were artists, for the portraits made by his cameramen or copied from pictures made by other photographers often served as models for paintings. William Page, George P. A. Healy, Charles Loring Elliott, John Neagle, Constant Mayer, Thomas Sully, George Henry Story, and Francis Carpenter were among the notable artists who were guided in their work by pictures made under Brady's direction or in his studios.

At times Brady was called on to make special photographs which substituted for life sketches. He also maintained a large stock collection of portraits made by his photographers or copied from work done elsewhere. These served as prototypes for likenesses of public figures who were too busy or not inclined to pose for painters.

Brady was very much aware of the service his photographs performed for artists. He once wrote Morse, "I endeavored to render it [photography] as far as possible an auxiliary to the artist."

John Neagle was probably the painter who had been working in a traditional fashion the longest before coming to rely on Brady's work for at least one of his portraits. He made extensive use of a Brady studio pose for a portrait of Daniel Webster painted about 1849. Neagle's oil was more flattering to the subject than the photograph, in that Webster's double chin was concealed in shadow and his loss of hair played down. The oil, however, lacks the sense of personality we experience when looking at the photograph. The obvious resemblances, both major and minor, between Brady's daguerreotype and Neagle's painting of Webster proved somewhat embarrassing to the photographer late in his life.

Brady kept Neagle's canvas in his possession for a number of years after it was painted. In 1881 he wished

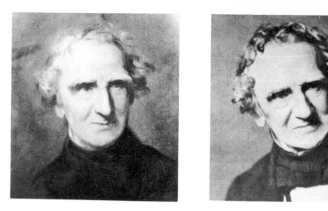

44.

45.

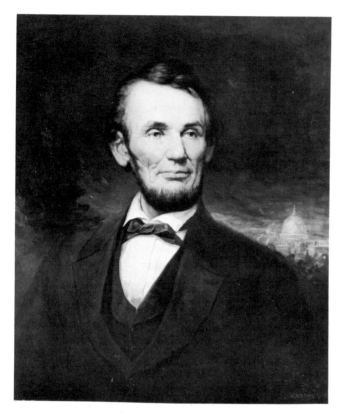

41.

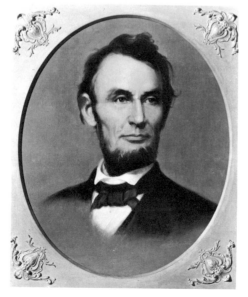

43.

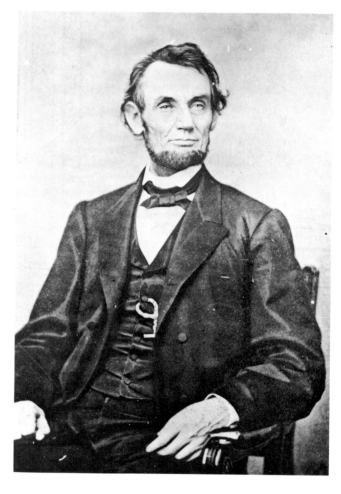

42.

41. George Henry Story. *Abraham Lincoln*. 1862-1916.
Oil, 30 x 25 inches. Courtesy National Collection of Fine Arts,
Smithsonian Institution, Washington, D.C.

42. Mathew Brady studio. *Abraham Lincoln*. 1864. Photograph.
Prints and Photographs Division, Library of Congress,
Washington, D.C.

43. Thomas Sully. *Abraham Lincoln*. 1869. Oil, 24 x 20 inches.
University of Southern California, Los Angeles.

44. Thomas Sully. *Self-portrait*. 1867. Oil, 14⅞ x 13½ inches.
Whereabouts unknown.

45. Photographer unknown. *Thomas Sully*. c1860. Photograph.
George Eastman House, Rochester, N.Y.

to sell the picture to the Federal government for $4,000. When asked if the work was from life, Brady said that Neagle had based his paintings solely on sketches of Webster made while Brady's "operators" were photographing the famous statesman. Charles Fairman wrote in his book *Arts and Artists of the Capitol*, "Those acquainted with the work of John Neagle . . . do not feel at all inclined to the belief that he was aided in his work by recourse to photography." This rather defensive statement is hard to understand when the photograph is compared with the painting. It is apparent that the painter consulted the Brady photograph— the resemblance is too striking to believe otherwise.

Although Fairman's comment is an example of the stigma attached to the practice of painting from photographs that has developed in our century, painters in the nineteenth century used photographs quite openly in lieu of or in addition to sittings by their subjects. Nevertheless, a widespread notion still exists that only from living models can the artist extract that intangible quality we call art. The very fact that most persons who hold this view cannot distinguish between a portrait made from life and one modeled from a photograph would seem to mitigate their stand.

In 1858 Brady opened his *Photographic Parlors*, a grand new gallery in Washington, D.C. A year later George Story, a young portrait painter, took a studio in the same building. The two men became friends, and in 1861 the painter was asked to aid in posing President Lincoln when he came to Brady's studio for his first official photographic likeness. In the following years, Lincoln was photographed in Brady's studio over a dozen times.

On February 9, 1864 four poses of the President— three seated and one standing—were taken by Brady's cameramen. All three of the seated poses were used by artists as models for painted portraits of Lincoln. George Story, Thomas Sully, John Peto, David Bustille Bowser, and others painted likenesses of Lincoln after one or another of these photographs. Bowser's portrait was bought by Lincoln soon after it was completed. Peto's pictures were painted after Lincoln was killed, as were the portraits by Sully and Story.

While true to Brady's photograph of Lincoln, George Story's painting is sentimental and Lincoln's face is overly fleshy. (41-42) Lacking is the gaunt look of Lincoln, a quality that strikes one immediately in the Brady photographs.

Thomas Sully, an English-born portrait painter who had been influenced by Sir Thomas Lawrence, was near the end of his career when he painted his portrait of Lincoln. (43) Working from photographs was not unusual for Sully. He had used camera studies when painting the portraits of others, as well as a self-portrait. The appearance of Brady's studio portrait of Lincoln was only partially altered by Sully when he transferred the likeness to canvas. He idealized the President's features, smoothed out his deep wrinkles, reduced the size of his mouth and elongated his face to give him an appearance of elegance alien to his true nature. There is, nevertheless, a feeling of freshness and vitality in the Sully oil portrait that is lacking in Story's version of the same Brady photograph.

Sully's self-portrait, like his picture of Lincoln, was painted when the artist was over seventy-five years old. Working from a photograph would have been less tiring than posing and painting at the same time in front of a mirror and may explain why he elected to use a photograph when painting his own likeness. The shadows and all the major passages match in the two pictures, with the exception of a slight softening of the edges in the oil portrait. Sully also turned the corners of his mouth up, but otherwise, he accepted the record made by the camera and followed it rather explicitly. (44-45)

Returning to Brady—we find that John Peto, a trompe l'oeil artist, copied one of Brady's seated poses of Lincoln taken on February 9, 1864 in a memorial painting in which the date of the President's birth and death and the name "Abe" were represented as if

46. John F. Peto. *Reminiscences of 1865*. c1890.
Oil, 30 x 20 inches. Minneapolis Institute of Art, Minn.

47. Mathew Brady studio. *Abraham Lincoln*. 1864. Photograph.
Prints and Photographs Division, Library of Congress,
Washington, D.C.

48. David Bowser. *Abraham Lincoln*. c1864. Oil, 28 x 22 inches.
Collection A. Frank Krause, Jr., Fairfax, Va.

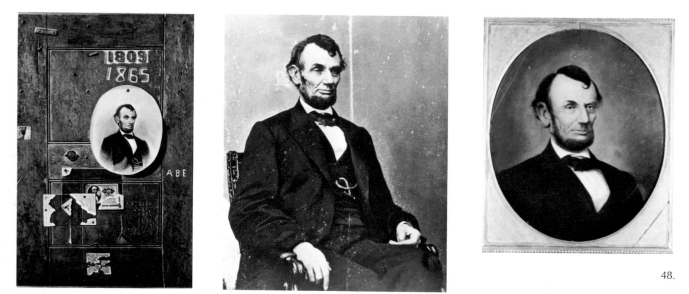

46.

47.

48.

carved into a door. (46-47) Incorporated in this composition was a credibly painted picture of the President that intentionally mimicked the Brady likeness.

David Bowser, a Negro artist from Baltimore, rather amateurishly exaggerated the lock of hair that fell over Lincoln's forehead, enlarged the size of his right ear, and gave the President a stern look at odds with the Brady photograph. (48) This portrait, however, does convey in a rudimentary fashion something of the sensitivity and determination of the subject.

A seated portrait also made on February 9, 1864 was used in a reversed version in Francis Carpenter's painting of Lincoln's family. (49) This picture was taken by A. Berger, one of Brady's associates and for a time the manager of his Washington studio. Carpenter made few alterations in adapting Berger's photograph of the President to suit the composition of the painting, which was painted in a servile manner from different photographs of the family.

Intended primarily as a study for an engraving, *The Lincoln Family in 1861* was executed in tones of gray

and depicted the President in a seated pose turning the pages of a large book while talking to his youngest son Thomas. (50) What many believe to be a clasped Bible was in fact a large photographic album used as a prop. Behind the table stood Lincoln's eldest son, Robert Todd Lincoln, who was later Secretary of War in the cabinets of President Garfield and President Arthur. (51) The almost literal translation of this portrait from the Brady photograph is striking.

No major changes or additions were made by Carpenter except in the treatment of Robert's right hand which was moved from the marble-topped table to the back of the chair. All other details, including the gloves in his hand, were repeated literally from the photograph. Carpenter's portrait of Mrs. Lincoln also stems from a picture made in Brady's studio in 1861. Although some alterations were made, that photograph served as the source for her face, costume, and jewelry. Also notable is the fact that the background of this family painting in its flatness recalls the backdrops commonly used by photographers. Young William Lin-

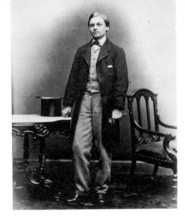

51.

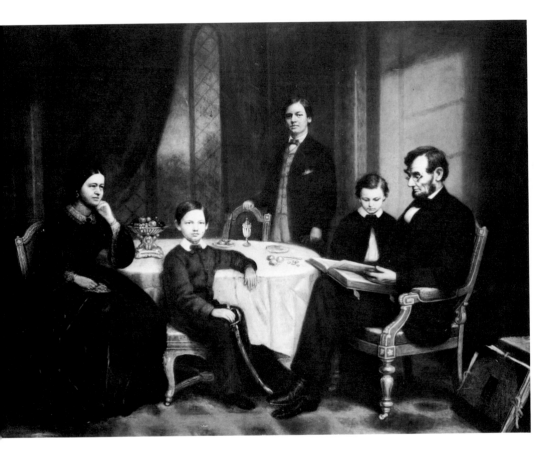

49.

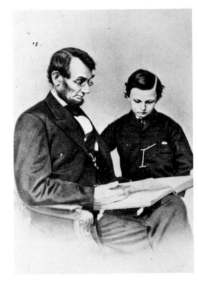

50.

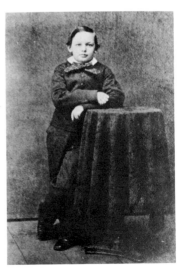

52.

49. Francis Carpenter. *The Lincoln Family in 1861.* c1865. Oil, 27 x 36¾ inches. New-York Historical Society, New York.

50. Mathew Brady studio. *Abraham Lincoln and son "Tad."* 1864. Photograph. Prints and Photographs Division, Library of Congress, Washington, D.C.

51. Mathew Brady studio. *Robert Todd Lincoln.* c1864. Photograph. Prints and Photographs Division, Library of Congress, Washington, D.C.

52. Mathew Brady studio. *William Lincoln.* c1861. Photograph. Prints and Photographs Division, Library of Congress, Washington, D.C.

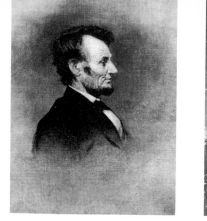
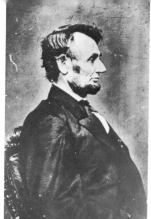

57.

58.

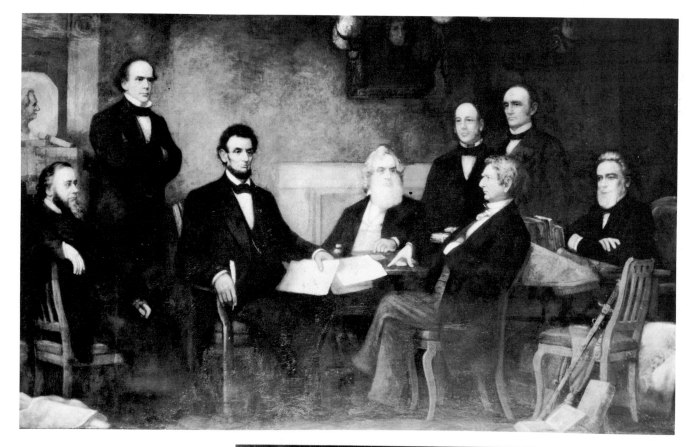

53.

54.

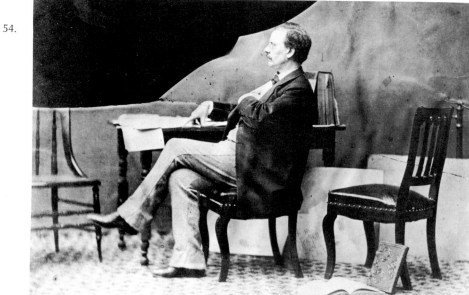

53. Francis Carpenter. *First Reading of the Emancipation Proclamation.* 1864. Oil, 108 x 174 inches. National Capitol, Washington, D.C.

54. Mathew Brady studio. *Francis B. Carpenter posed in position of William H. Seward, Secretary of State, for Carpenter's painting "Reading of the Emancipation Proclamation."* c1864. Photograph. Reproduced from Stefan Lorant's *Lincoln, a Picture Story of His Life,* W. W. Norton & Co.

55. Francis Carpenter. *Horace Greeley.* 1874. Oil, 43¼ x 35½ inches. New-York Historical Society, New York.

56. Bogardus and Bendann Brothers. *Horace Greeley.* Photograph. Prints and Photographs Division, Library of Congress, Washington, D.C.

57. J. O. Eaton. *Abraham Lincoln.* c1864. Oil, 24½ x 9½ inches. Collection Mrs. Charles Hickox, Cleveland.

58. Mathew Brady studio. *Abraham Lincoln.* 1864. Photograph. Prints and Photographs Division, Library of Congress, Washington, D.C.

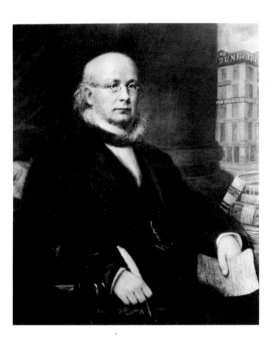

55.

56.

coln, who appears seated in the middle of the composition, died three years before Carpenter painted the group. It is therefore not surprising to find that his likeness was also taken from a photograph. (52)

Lincoln, as recorded by Brady's camera, was included in another group portrait by Carpenter. In his large canvas *The First Reading of the Emancipation Proclamation,* several Brady studio photographs were used as models. (53-54) Brady's cameramen made a number of stereoscopic views of the President's office in the White House as studies for Carpenter. Some exposures were also made of aides posed in the place of the statesmen present at that historic occasion. The picture, which now hangs in the east staircase of the House wing of the Capitol, includes individual portraits of Lincoln's cabinet. Carpenter called on Brady for portraits of Salmon P. Chase, Secretary of the Treasury; Gideon Wells, Secretary of the Navy; and Edwin Stanton, Secretary of War, as well as other prominent men included in his composition.

Not only did photographs play a very considerable role in Carpenter's pictures of Lincoln but a similar procedure was followed when he painted a portrait of Horace Greeley. (55-56) In this case Carpenter depended on an informal photograph made in the famous newspaper editor's office. To indicate the achievements of his subject, the artist merely added symbolic elements such as an opening to the right of the editor's office that reveals a view of the Tribune Building. Four books written by Greeley are stacked beside him: *Recollections of a Busy Life, The American Conflict, What I Know about Farming,* and *Political Economy.* Likeness and dress and, to a large extent, pose were transferred directly from the photograph onto the canvas. One of Greeley's hands, however, was altered. Like most of Carpenter's work, his portrait of Greeley was deficient in artistic qualities and conveyed little beyond the surface appearance of his subject.

Joseph O. Eaton's profile of Lincoln's head and right shoulder was not much more successful. (57-58) Al-

59. Marsden Hartley. *Great Good Man.* 1942.
Oil, 40 x 30 inches.
Collection William H. Lane, Leominster, Mass.

60. Mathew Brady studio. *Abraham Lincoln.* 1862. Photograph.
Prints and Photographs Division, Library of Congress,
Washington, D.C.

61. Marsden Hartley. *Young Worshipper of the Truth.* 1938-39.
Oil, 18 x 22 inches. University of Minnesota Art Gallery,
Collection Ione and Hudson Walker, Minneapolis.

62. J. F. P. von Schneidau. *Abraham Lincoln.* 1858.
Daguerreotype. Courtesy Lloyd Ostendorf, Dayton, Ohio.

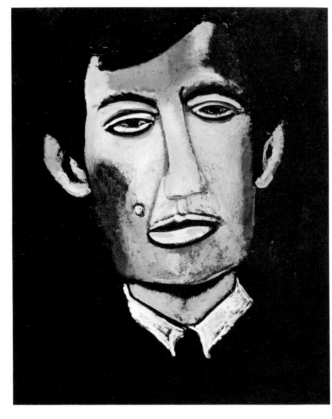

61.

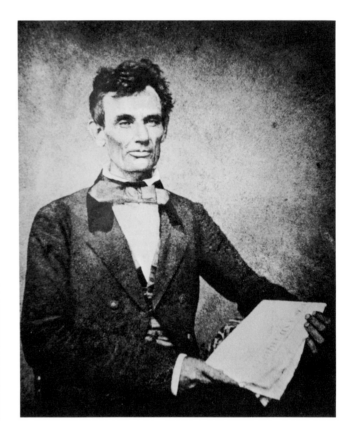

62.

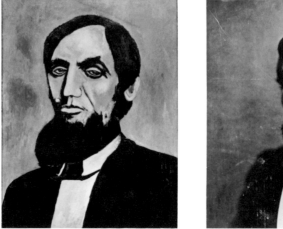

59.

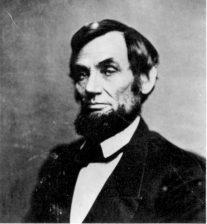

60.

though this stern-looking oil portrait was condensed and edited from a Brady photograph, it was out of tune with its source and more like an impersonation of Lincoln's appearance than a disclosure of his true characteristics.

James R. Lambdin also used a photograph for his Lincoln portrait. His three-quarter, seated portrait was primarily painted from a likeness taken at the Washington studio of Brady's former assistant, Alexander Gardner. While Lambdin exaggerated the light and shade relationships in his version of the photograph to add a certain degree of drama, the pose and many details show that he adhered to the sitting made for the camera.

None of these paintings of the President convey Lincoln's characteristics as well as the photographs do. The photographs show untidy hair, a lined face, and the large mole on his cheek; yet these facial details all added up to much more. Quite simply the photographs show the man as he was, without concealment or apology, and convey an extraordinarily full sense of a personality with particular and strikingly distinct characteristics. Lincoln was a man whose face reflected much of his personality. Brady's lens captured that face so authentically as to convey both a sense of Lincoln's obstinacy and his profound humanism.

In 1942 in homage to Lincoln, Marsden Hartley painted a portrait from one of Brady's famous likenesses. (59-60) Hartley boldly emphasized the sharp outline of his hero's face and the angular leanness of the facial construction, thereby creating a picture that says, with rough-hewn vigor, we are looking at an iconic representation of a "special" man. This is a good example of how an artist may at times distill from a photograph qualities only hinted at in the single moment caught by the camera.

Marsden Hartley's *Young Worshipper of the Truth* is also from a photograph of Lincoln. (61-62) Unless carefully analyzed, this cannot be easily detected. The photograph Hartley used was made early in Lincoln's life before he had a beard, but the prominent mole on his cheek, the distinct forelock, and his unusually large ears are the elements that tie this painting to a particular photograph. The way in which Hartley painted the lips and the half-closed eyes of his subject shows how carefully he observed and then followed the photograph. Lincoln's nose was treated in a schematic fashion to flatten the face in the painting. The President's left ear, only partially seen in the photographic source, was given prominence to balance the blocky shape of the face. Despite these changes made by Hartley for expressive purposes, it was the camera-made likeness that provided the image on which the painter based his interpretation. This paraphrase and his other painting of Lincoln stand out as examples of the fruitful results that can come from an artist's use of photographs.

One of the most popular and professionally esteemed nineteenth-century American portraitists was George P. A. Healy. He painted famous personages of his day in Europe, New York, Washington, Chicago, and in less populous cities of the United States. In a number of instances he used Brady photographs as models for his portraits in oil. An example of this may be found in *The Peacemakers* painted in 1869. In the winter of 1867-68 Healy conceived the idea of commemorating the historic James River meeting which brought together President Lincoln, General Ulysses S. Grant, General William T. Sherman, and Admiral David Porter. This group met to discuss war strategy aboard the steamer *River Queen* on March 27, 1865, less than two weeks before General Robert E. Lee surrendered at Appomattox Courthouse on April 9.

For this canvas Healy used studies of President Lincoln that he had made from life in 1862. These notations were brought up to date with the aid of studio portraits made in Brady's gallery in 1864. A bust of Porter, also made in Brady's studio, served Healy as a guide for his portrait of the Admiral. His dress epaulettes were removed and a less elaborate uniform substituted, but the features captured by the camera were

64.

63. George P. A. Healy. *The Peacemakers.* 1868.
Oil, 47¾ x 66 inches.
The White House Collection, Washington, D.C.

64. Mathew Brady studio. *U. S. Grant.* 1864. Photograph.
Prints and Photographs Division, Library of Congress,
Washington, D.C.

65. Constant Mayer. *U. S. Grant.* 1866. Oil, 36 x 29 inches.
Schweitzer Gallery, New York.

66. Mathew Brady studio. *U. S. Grant.* c1865. Photograph.
Coke Collection, Rochester, N.Y.

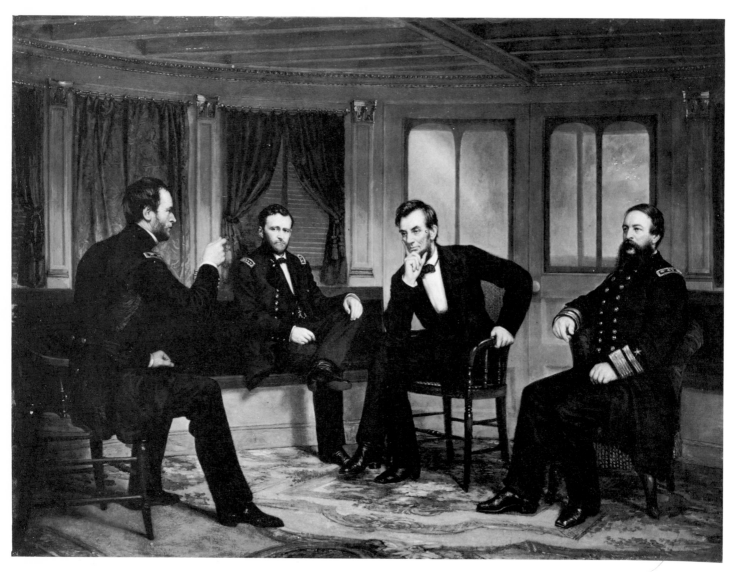

63.

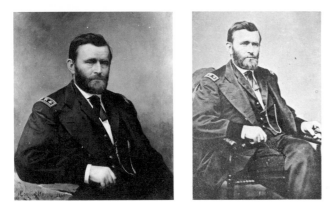

65. 66.

closely followed by the painter. General Grant was painted directly from a Brady photograph taken in 1864 when Grant came to Washington from the Western campaigns to take command of all Federal forces. Healy made very few changes when translating the photograph into paint. (63-64) General Grant was merely moved from the straight-backed studio chair to the built-in upholstered ship's seat. The pose assumed in Brady's studio was used by Healy so that Grant's camera-fixed gaze and posture would fit into the overall arrangement of the painting.

Another Grant portrait, painted by Constant Mayer in 1866, was copied in a straightforward manner from one of the Brady photographs made in May 1864. Grant's rugged quality was caught by the lens and with minimal changes was transferred to Mayer's canvas. (65-66) The painter did not attempt to improve on or idealize the likeness recorded by Brady's camera. The oil is also deficient in the humanistic qualities found in the photograph.

G. P. A. Healy used photographs as a basic source for at least one other portrait. In a picture of Henry Wadsworth Longfellow and his daughter Edith, posed under the Arch of Titus in Rome, Healy collaborated with Frederic Church and Church's pupil Jervis McEntee. A likeness of the poet and his daughter, made in a photographer's studio in Rome, was merely squared off by Healy and enlarged to suit the composition of the painting. (67-68) In addition the arch portion of the picture, as well as the part that included the three artists, was probably taken from photographs. Further, when Healy painted his three-quarter, seated pose of Robert E. Lee in profile, he obediently imitated a photograph made under Brady's direction. (69-70) This photograph was one of a series taken in Lee's Richmond home immediately after the surrender at Appomattox. Photographer Michael Miley of Lexington, Virginia, provided Healy with a head-and-shoulders pose for another portrait of the General, which showed him as an elderly man. (71-72) Although Healy eliminated some

of Lee's bushy hair, he copied very carefully the rest of what Miley had labeled the "Last Photograph of General Robert E. Lee."

In 1869 Lee, then President of Washington College in Lexington, Virginia, made his last visit to the capital of the country he had fought so hard to divide. He paid his respects to his wartime opponent General Grant, then President of the United States, and also made a stop at the gallery of Mathew Brady. Here at least three photographic portraits were made, one in a seated pose and two in limited half-length poses. One of these served as the basis for a likeness painted by John Adams Elder, an active portraitist in the South during the last half of the nineteenth century. (73-74) In Elder's idealized portrait of the Confederate military leader, the uniform was that worn by Lee during the conflict, but the leonine head was borrowed from the post-war picture made by Brady's studio. It seems reasonable to assume that Elder felt that the full head of white hair and the lined face of the older Lee were more suitable than the wartime photograph to symbolize the spirit of a great vanquished warrior. Elder also painted a three-quarter pose of Lee from a photograph made late in the General's life by the studio of Boude and Miley of Lexington, Virginia.

General Lee in uniform was the subject of a romantic portrait by W. B. Cox, who like many routine painters found it difficult to evolve a pictorial composition unaided by photographs. (75-76) His Lee was painted in Richmond in 1865 from two photographs by Julian Vannerson. A shot of Lee looking to the left of the camera served Cox for the head in his canvas. For this portrait the artist changed the direction of Lee's sword, altered the top of his uniform, and added a horse, tent, and symbolic landscape background, but the painting was essentially an enlargement of Vannerson's photograph.

William Page, a painter of note and frequently spoken of as "the American Titian," also patiently executed a number of paintings from photographs. He

67. G. P. A. Healy, Frederic Church, and Jervis McEntee.
The Arch of Titus. c1870. Oil, 73½ x 47 inches.
Newark Museum, N.J.

68. Photographer unknown. *Henry Wadsworth Longfellow
and his daughter* (in Rome). 1868-69.
Photograph. Archives of American Art, New York.

69. G. P. A. Healy (?). *Robert E. Lee.* n.d. Oil, 48 x 36 inches.
Thomas Gilcrease Institute of American History and Art, Tulsa.

70. Mathew Brady studio. *General Robert E. Lee.* 1865.
Photograph. Prints and Photographs Division, Library of
Congress, Washington, D.C.

71. G. P. A. Healy. *Robert E. Lee.* 1876. Oil, 29½ x 24¾ inches.
Collection F. D. Gottwald, Richmond, Va.

72. Michael Miley. *Robert E. Lee.* 1870. Photograph.
Prints and Photographs Division, Library of Congress,
Washington, D.C.

69. 70.

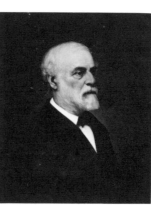

71. 72.

73. John Elder. *General Robert E. Lee.* n.d.
Oil, 54½ x 40¾ inches.
Corcoran Gallery of Art, Washington, D.C.

74. Mathew Brady studio. *Robert E. Lee.* 1869. Photograph.
Prints and Photographs Division, Library of Congress,
Washington, D.C.

75. W. B. Cox. *Robert E. Lee.* 1865. Oil, 24½ x 21 inches.
Courtesy Jay P. Altmayer, Mobile, Ala.

76. J. Vannerson. *Robert E. Lee.* 1864. Photograph.
Prints and Photographs Division, Library of Congress,
Washington, D.C.

67. 68.

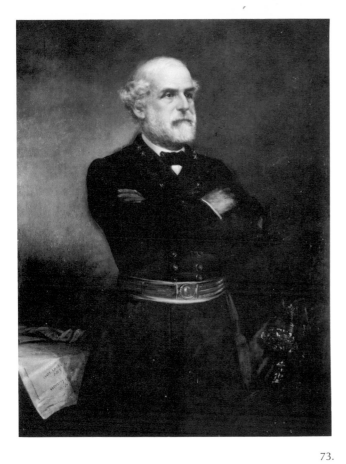

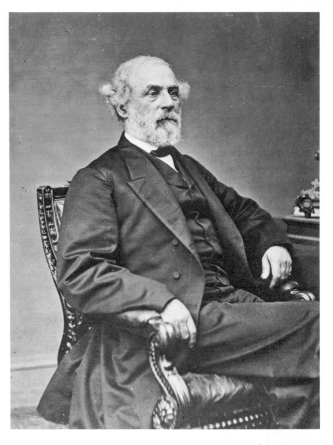

73.

75.

76.

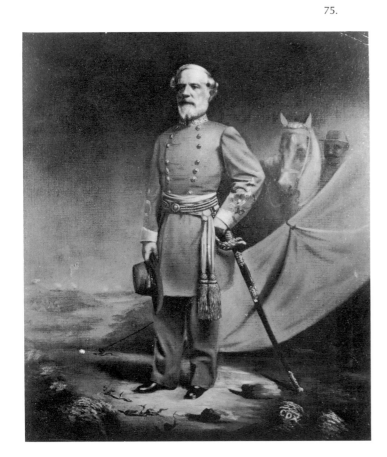

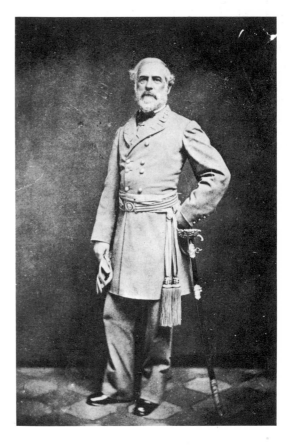

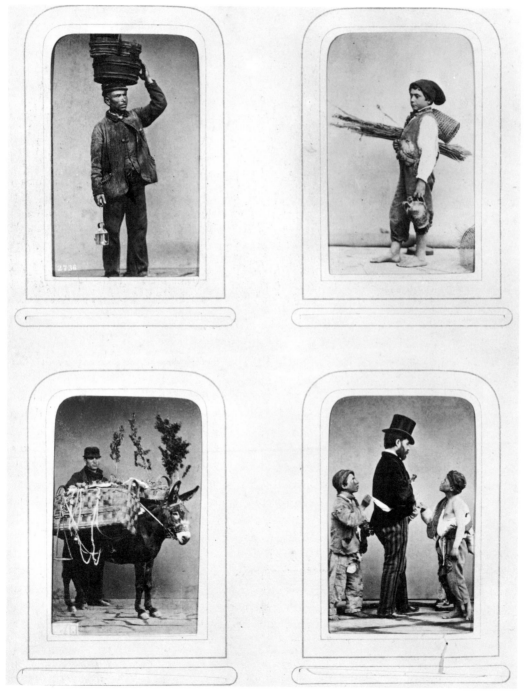

77. George Sommer studio. *Posed Italian types.* c1865-70.
Hand-colored *carte de visite* photographs.
Art Institute of Chicago.

78. William Page. *Charles Eliot* (detail). 1875.
Oil, 52½ x 35 inches.
Reproduced from Alan Burroughs, *Limners and Likenesses,*
Harvard University Press, Cambridge, Mass.

79. Photographer unknown. *Charles Eliot.* n.d. Photograph.
Courtesy Joshua C. Taylor, Washington, D.C.

78. 79.

lived in Rome in the 1850s. If in Italy an artist did not wish to paint from a model or could not afford one he would often use studies of nudes or peasants in costume specially posed for this purpose by photographers such as George Sommer, Robert Macpherson, and Frederico Faruffine. (77) Macpherson, an Englishman, was an active photographer in Rome in the last half of the nineteenth centuy. Sommer's studio was in Naples. Faruffine, unsuccessful as a painter, became a photographer and made available to artists a great variety of camera studies that were completely composed and ready to be squared off and transferred to canvas.

When Page returned to the United States, he continued the practice he had followed in Rome. A representation of Admiral Farragut's face was borrowed from a likeness on a *carte de visite.* The same procedure was used by the artist in 1875 when he was painting a portrait of Charles Eliot, the President of Harvard University. (78-79) He merely squared off a photo-

graph of Eliot and with this as a guide copied the likeness caught by the camera.

Page's biographer, Joshua Taylor, feels that working from photographs usually destroys all sense of design and unity of color in a painting but in the case of Page this did not seem to happen. Taylor speculated that Page felt the reduction made by the camera served much the same purpose of presenting to the eye a single unified form like his small preliminary figure drawings.

Page's portraits of Robert Gould Shaw and General Winfield Scott were also painted from photographs. No secret was made of his dependence on the camera. It was his view that nature must be copied by the artist without deviation or additions. In justification of this practice Page wrote:

We have arrived at a time when by the advance of science tools are put into our hands, the work of mechanical means by the use of which results are obtained that shame all but the best endeavors of what had been

80. Chester Harding. *Daniel Webster.* 1865. Oil, 27 x 22 inches. Cincinnati Art Museum, Ohio.

81. Howard H. H. Langill. *Daniel Webster.* c1852. Daguerreotype, 8 x 6 inches. Dartmouth College, Hanover, N.H.

82. Emery Seaman. *Daniel Webster.* 1852. Oil, 56 x 46 inches. Courtesy Berry-Hill Galleries, New York.

83. Mathew Brady studio. *Daniel Webster.* Photograph. Prints and Photographs Division, Library of Congress, Washington, D.C.

80.

81.

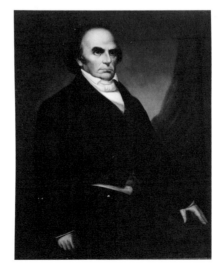

82. 83.

84. Henry F. Darby. *Washington Irving.* c1852.
Oil, 50 x 40 inches. Sleepy Hollow Restorations, Tarrytown, N.Y.

85. John Plumbe (later copies by Mathew Brady's studio in 1861). *Washington Irving.* 1852. Photograph.
Prints and Photographs Division, Library of Congress, Washington, D.C.

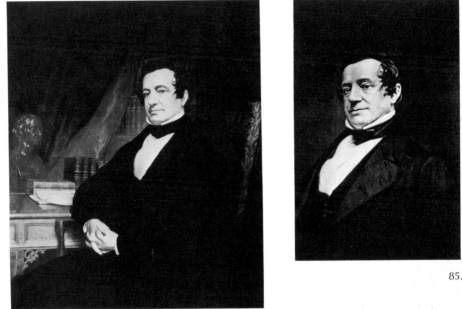

84.

85.

for ages art; we mean the drawing and grouping of objects together which is given us by photography, with all the accidental aptness and completeness that much study in this branch of art gave us but feebly and imperfectly before. . . .

Daniel Webster was a popular subject for portraits. Chester Harding, Emery Seaman, and William Willard derived their likenesses of this powerful political leader from photographs, although each painter used a different photograph as his model. The Harding portrait was from a small daguerreotype in which the statesman's features were seen in profile. Not a trace of humor brightened his dour, impassive face. (80-81) This look and other characteristics of Webster's face found in all photographs of Webster were carried over into the Seaman as well as the Harding canvases. (82-83) Although Willard painted a stylized and less severe likeness than that recorded by Brady's camera, the debt to photography is still quite evident despite the artist's attempt to give Webster the appearance of a younger man.

Henry Darby, who had also painted Webster from a photograph, also painted a portrait of Washington Irving from a photograph made by one of John Plumbe's operators. Plumbe was the first photographer to establish a chain of studios in various parts of the country. While it is Brady's copy of the Plumbe portrait that has survived, Darby may have used the original daguerreotype for his painting of Irving. The canvas has been dated approximately 1852, which places it in the daguerreotype period rather than in the later period when the wet-plate collodion process was used.

Darby's picture, in the collection of Sleepy Hollow Restorations, shows Irving seated in a chair beside a table on which rests a bust of George Washington and some volumes of Irving's life of Washington finished in the early 1850s. (84-85) The author was represented in a more upright position in the painting than in the photograph. And Irving's face was given such a youth-restored treatment by Darby that it drains his features of life and certainly does not indicate that Irving was

41

87.

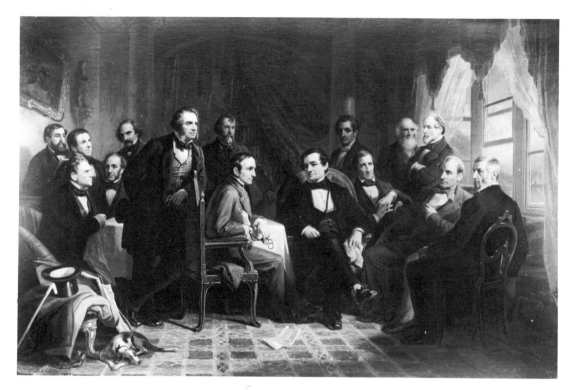

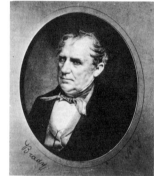

88.

86.

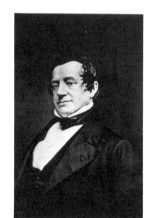

85.

86. Christian Schussele. *Washington Irving and His Literary Friends at Sunnyside.* 1863. Oil, 72 x 96 inches. Sleepy Hollow Restorations, Tarrytown, N.Y.

87. Mathew Brady studio. *Nathaniel Hawthorne.* c1860. Photograph. Prints and Photographs Division, Library of Congress, Washington, D.C.

88. Mathew Brady studio. *James Fenimore Cooper.* n.d. Photograph. Prints and Photographs Division, Library of Congress, Washington, D.C.

89. Henry F. Darby. *John C. Calhoun.* c1850. Oil, 49½ x 35½ inches. National Capitol, Washington, D.C.

90. Mathew Brady studio. *John C. Calhoun.* c1849. Photograph. Prints and Photographs Division, Library of Congress, Washington, D.C.

89.

90.

sixty-nine years of age when the canvas was painted.

Christian Schussele, who preceded Thomas Eakins as the major teacher of painting at the Pennsylvania Academy of Art, was commissioned to paint a group portrait of men prominent in American letters. (86-88) The scene was Washington Irving's library at Sunnyside. Although considerable license was taken with the space available in that room—it could never have accommodated such a large crowd—the faces of the group were only superficially modified from those in the photographs that Schussele used as guides. The distinguished authors such as James Fenimore Cooper, Nathaniel Hawthorne, and Washington Irving had to be painted looking in whatever direction the camera had caught them. This left little leeway for the artist and created an awkward and unnatural situation.

A comparison between paintings of eminent Americans and the photographs from which they stem indicates how rarely the artists improved on their models and how often the paintings were superficial imitations of what the camera recorded. At firsthand, a painter

could study a person and evoke the intrinsic nature of his personality. But unless he knew the subject intimately, the painter found it difficult to penetrate the surface characteristics documented by the lens. Rarely were the innate qualities of a subject captured by a painter from a photograph; too often the painter merely transcribed the superficial look of a moment in time as recorded by the camera.

Henry Darby, a routine face-painter of mediocre artistic distinction, represents the average artist who painted a great number of portraits of prominent people in the United States during the Civil War and for a decade or two afterward. A comparison between Darby's portrait of John C. Calhoun, the great Southern leader, and Brady's portrait of him, points up the nature of the aesthetic failure of many artists who depended on photographs. (89-90)

The Brady studio portrait of Calhoun instantly makes its impression; Calhoun's personality is enunciated in a very persuasive fashion. On the other hand, as was the case with most portraits painted from photographs,

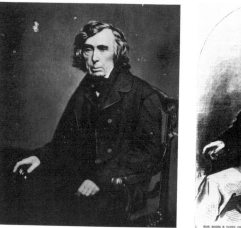

91.

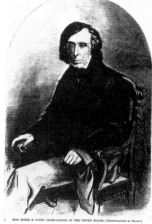

92.

95.

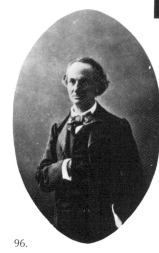

96.

93.

91. Mathew Brady studio. *Chief Justice Roger B. Taney.* c1860. Photograph. Prints and Photographs Division, Library of Congress, Washington, D.C.

92. Winslow Homer. *Hon. Roger B. Taney, Chief Justice of the United States.* 1860. Woodcut after a photograph, 9 x 5¾ inches. Reproduced from *Harper's Weekly.* Courtesy George Eastman House, Rochester, N.Y.

93. Thomas Eakins. *Frank Hamilton Cushing.* 1895. Photograph. Collection Joseph H. Hirshhorn, New York.

94. Thomas Eakins. *Frank Hamilton Cushing.* 1895. Oil, 90 x 60 inches. Thomas Gilcrease Institute of American History and Art, Tulsa, Okla.

95. Édouard Manet. *Charles Baudelaire.* 1862. Etching, 3¾ x 3 inches. Bibliothèque Nationale, Paris.

96. Nadar. *Charles Baudelaire.* 1862. Photograph. Bibliothèque Nationale, Paris.

44

94.

97.

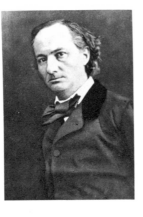

98.

97. Alexander Lafond, *Charles Baudelaire*, 1860. Oil, 19 inches in diameter. Collection H. Matarasso, Nice, France. (Reproduction prohibited.)

98. Nadar. *Charles Baudelaire*. 1860. Photograph. Bibliothèque Nationale, Paris.

Darby's picture much less successfully represents the distinct visual qualities and personal traits of the man. There is a lack of credence and a marked shallowness about Darby's portrait that is hard to explain when we realize that the painted portrait rests on a very firm foundation. The painter was caught up in the idea that a portrait should improve on nature by eliminating surface blemishes and tidying up the hair. That the subject should be idealized was the common credo among most portraitists. With this in mind Darby drained Calhoun's powerful face of its inherent strength and individuality, qualities that are conveyed in Brady's photograph.

For Darby, who had a modest reputation as a portraitist before the invention of photography, photography never became the inspiration it did for many of his contemporaries. The researcher Inge Hacker has said of Darby, "The camera led him only to a precise, literal translation of his sitters. His freshness and unconventionality disappeared. Probably sensing this and not finding the necessary recognition, he followed early religious inclinations and became an Episcopal minister."

Winslow Homer, in his early work as an illustrator for *Ballou's Weekly* in Boston and for *Harper's Weekly* in New York, frequently used photographs to draw portraits reproduced in these magazines. In some instances this was done because the subject had died, but more often it was because the editors wanted their leading artist to use the most up-to-date method of capturing a likeness. In most cases, Homer's drawings from photographs for these publications were engraved on wood by artisans. In a few instances Homer copied a photograph on a white-painted block of wood and then engraved the picture himself. Examples of Homer's drawings from photographs are numerous. His portrait of Rembrandt Peale was taken from a photograph made during the veteran painter's visit to Boston. The three-quarter-length likeness of Chief Justice Taney was also drawn by Homer from a Brady photo-

graph. (91-92) Homer could have made sketches of both of these men from life, yet he elected or was directed to draw their portraits from photographs.

Before turning to the portraits painted from photographs by European artists it should be noted that another of America's great realist painters, Thomas Eakins, altered only minimally his snapshot of Frank Hamilton Cushing, when painting his portrait. (93-94) Eakins wanted to paint the prominent archaeologist standing, so as to show to full advantage the magnificent Western dress worn by his subject. But Cushing had been seriously ill and could not stand in one pose for long periods of time, which may explain in part why Eakins used the photograph as a convenience when painting Cushing. The Western regalia was intricate, and by following the photograph Eakins undoubtedly found it easier to reproduce the effect of light on the garment's many details and folds.

In France, as in the United States during the last half of the nineteenth century, it was the practice of well-known photographers to seek out prominent and popular persons for sittings in their studios. Painters often made use of such photographs. Portraits of Charles Baudelaire serve as good examples of how often this took place. While he may well have been photographed by amateurs, it was the work of well-known cameramen, Nadar and Étienne Carjat, that was used by a number of artists. Henri Fantin-Latour, who knew how to operate a camera as well as a brush and pencil, both drew and painted portraits of Baudelaire from pictures provided by these popular Parisian photographers.

Nadar, at one sitting in 1862, took four quarter-plate portraits of the famous French poet. These photographs of Baudelaire were used in a readily discernible fashion not only by Fantin-Latour but also by Édouard Manet, Félix Bracquemond, and a number of lesser nineteenth-century artists such as Alexander Lafond. (95-96) The Lafond painting of Baudelaire followed Nadar's photograph with few diversions. (97-98) When the Nadar likeness of Baudelaire is reversed, Bracquemond can be

45

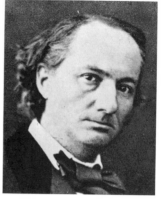

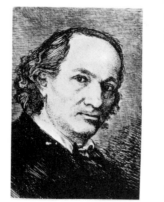

99. Félix Bracquemond. *Charles Baudelaire.* c1861.
Etching, 4¼ x 3 inches. Coke Collection, Rochester, N.Y.

100. Nadar. *Charles Baudelaire* (reproduced in reverse). 1860.
Photograph. Bibliothèque Nationale, Paris.

99.

100.

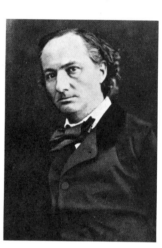

101. Henri Fantin-Latour. *Homage to Delacroix* (detail of
Baudelaire). 1864. Oil. The Louvre, Paris.

102. Nadar. *Charles Baudelaire.* 1860. Photograph.
Bibliothèque Nationale, Paris.

103. Henri Fantin-Latour. *Charles Baudelaire.* c1863.
Pencil drawing. Whereabouts unknown.

104. Félix Vallotton. *Charles Baudeliare.* 1892.
Woodcut, 7¾ x 9¼ inches. Coke Collection, Rochester, N.Y.

105. Raymond Duchamp-Villon. *Baudelaire.* 1911.
Bronze sculpture, 15¾ inches high.
Collection Museum of Modern Art, New York.

106. Étienne Carjat. *Charles Baudelaire.* c1861. Photograph.
Coke Collection, Rochester, N.Y.

101.

102.

103.

A BAUDELAIRE

FV

104.

105.

106.

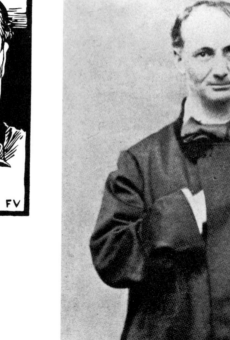

46

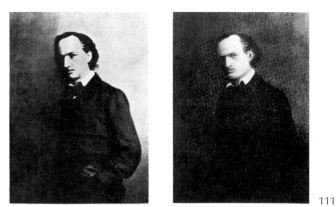

110. 111.

107. Henri Matisse. *Baudelaire*. 1944. Drawing, 20 x 16 inches. Whereabouts unknown.

108. Georges Rouault. *Baudelaire*. 1927. Lithograph, 8⅜ x 6¾ inches. Coke Collection, Rochester, N.Y.

109. Étienne Carjat. *Charles Baudelaire*. 1861-62. Photograph. George Eastman House, Rochester, N.Y.

110. Henri De Groux. *Charles Baudelaire*. n.d. Lithograph, 9¾ x 6¾ inches. Cabinet des Estampes, Bibliothèque Royale de Belgique, Bruxelles.

111. Photographer unknown. *Charles Baudelaire*. c1854. Photograph. Whereabouts unknown.

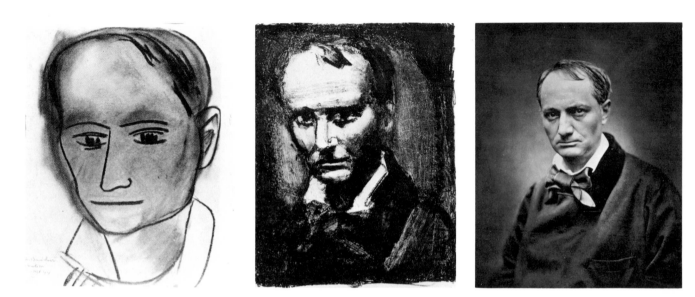

107. 108. 109.

seen to have made a rather direct transcription from it except that the etcher reduced the size of the poet's mouth. (99-100) In the case of the head of Baudelaire in Fantin-Latour's group portrait *Homage to Delacroix*, the link is a little less easily recognized. The primary clues reside in the way Fantin-Latour discreetly carried over into his paraphrase of the photograph the angle of Baudelaire's head, the contour of his face on the left side, and the way in which his eyes were recorded by the camera. (101-102)

A Carjat likeness of Baudelaire also aided Alfred Stevens in a portrait, Fantin-Latour in a drawing, Félix Vallotton in a woodcut, and Duchamp-Villon in a piece of sculpture. They all used the same three-quarter standing, full-face photograph. Another Carjat photograph served as a model for portraits of Baudelaire by Henri Matisse and Georges Rouault. (103-109)

The lock of hair which fell over Baudelaire's forehead, the contour of his face, and his straight tight-lipped mouth shown in the photographs were incorporated in one form or another in all the likenesses made by these artists. Another portrait of the poet, a lithograph, was drawn by Henri de Groux from a picture by an unknown photographer. (110-111)

These pictures tend to confirm the idea that painting from photographs was a common practice in France. The fact that Baudelaire was alive when most of these pictures were made and that many of these artists were his close friends would seem to indicate that copying photographs was a generally accepted procedure among some first-rank French artists as well as a practice followed by limners and illustrators.

Although artists, printmakers, and sculptors in Europe and America readily accepted the aid of photographs or used them as the primary guide for portraits, they usually made alterations which were considered to be improvements on camera-made likenesses. Intensity and direction of illumination were often shifted to add drama to a portrait or to smooth out wrinkles on an old face. Even so, distinct vestiges of

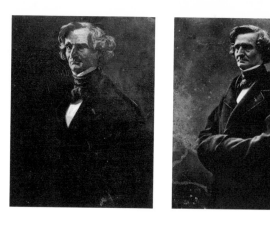

112. André Gill. *Hector Berlioz.* c1860. Oil.
Musée de Versailles, France.

113. Nadar. *Hector Berlioz.* c1860. Photograph.
Bibliothèque Nationale, Paris.

112.

113.

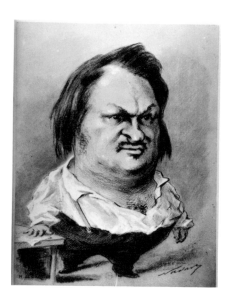

116.

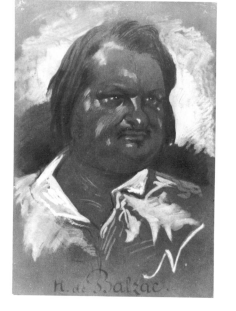

117.

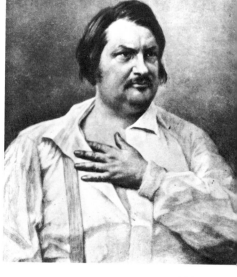

118.

114. Edouard Manet. *Edgar Allan Poe.* 1856.
Etching, 7½ x 5⅞ inches. Coke Collection, Rochester, N.Y.

115. S. W. Hartshorn (attributed to). *Edgar Allan Poe.* 1848.
Daguerreotype. Reproduced from the original at
Brown University, Providence.

116. Nadar. *Balzac.* 1854. Drawing on brown paper,
9¼ x 6½ inches. Bibliothèque Nationale, Paris.

117. Nadar. *Balzac.* 1854. Drawing on brown-gray paper,
10¼ x 6½ inches. Bibliothèque Nationale, Paris.

118. Nadar (?). *Balzac.* c1842. Facsimile of a daguerreotype.
Bibliothèque Nationale, Cabinet des Estampes, Paris.
Musée de la Maison de Balzac, Paris.

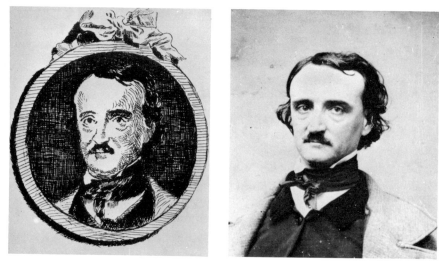

114.

115.

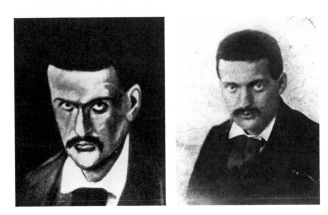

119. 120.

119. Paul Cézanne. *Self-Portrait*. 1861. Oil. Reproduced from John Rewald, *Paul Cézanne*, Schocken Books, Inc., New York.

120. Photographer unknown. *Paul Cézanne*. 1861. Photograph. Reproduced from John Rewald, *Paul Cézanne*, Schocken Books, Inc., New York.

the appearance on film of a sitter's face were retained in oil portraits taken from photographs. This was the case because painters usually found it convenient to follow more or less specifically the facial contours and details of clothing registered by the lens; and frequently the way in which the camera caught the hair, the ears, or the placement of buttonholes and folds in a subject's coat was slavishly copied. Because it was easy to do so, painters almost always represented their subject facing in the same direction found in the photograph they used and carried over the outline of the sitter's head and shoulders.

This is the case in two portraits from photographs thought for some time to be the work of Honoré Daumier. These are of Jules Michelet and Hector Berlioz. The art historian Heinrich Schwarz has convincingly shown that Daumier painted neither portrait and has linked the Berlioz picture to Daumier's friend, the cartoonist André Gill. In addition, Schwarz correctly pointed out that Nadar's camera provided the artist with his likeness of the famous composer. (112-113) In the *Gazette des Beaux-Arts* Schwarz wrote, "A comparison between the photograph and the painting shows how the painter in every detail has remained dependent on his model, but also how every detail has become coarser and cruder in the painting, thus impairing the graphic and spiritual finesse of the photographic original."

Manet's small etching of Edgar Allan Poe is an example of the tendency of a picture made from a photograph to lose "the graphic and spiritual finesse of the . . . original." This etching is linked directly to a well-known American daguerreotype attributed to S. Hartshorn and dated about 1848. (114-115) As mentioned previously there is a similar relationship between Manet's etching of Baudelaire and a Nadar photograph.

John Richardson has expressed the opinion that the

camera played an important role in determining the style of Manet's portraits. The critic calls attention to the prevalence of frozen poses and deadpan expressions in a number of likenesses by Manet and asks, "What are these models staring at so intently, yet so vacantly? Not the artist, one feels, but Nadar's 'magic box.'"

It is not surprising to find that Nadar, a cartoonist as well as a prominent professional photographer, began many of his lampoons from photographs. His caricature of Balzac is a good example of how Nadar starting from a photograph exaggerated various aspects of his subject's anatomy. (116-118)

According to Émile Bernard, Cézanne "did not object to a painter's use of photography, but he must interpret this exact reproduction as one interprets nature." At least three Paul Cézanne self-portraits, his portraits of Victor Chocquet, and a drawing of Delacroix were derived from photographs.

Cézanne's very early self-portrait was painted from a photograph in 1861 in a rather literal fashion. (119-120) He did, however, make his face appear to be somewhat longer than it was recorded by the camera. The relatively soft light used in the photography studio was replaced by strong highlights running downward across his face.

In the case of the portraits of Victor Chocquet, the derivative nature of the pictures can be determined rather easily. (121-124) Nevertheless, Cézanne's vision shaped the portrait. He went to the photograph merely for a general description of his friend's face. No narrow compliance with the camera's record was involved as Cézanne summarized Chocquet's features. The photographs helped Cézanne get rid of the visual dross, then he concisely reduced the pattern in Chocquet's cravat and gave solidity to his head by changing the irregular form of his hair into a distinct oval shape.

In England Sir John Everett Millais in quite a differ-

121. Paul Cézanne. *Victor Chocquet.* c1875. Pencil. Formerly collection Sir Kenneth Clark, present location unknown. Courtesy Wayne Andersen, Cambridge, Mass.

122. Paul Cézanne. *Portrait of Victor Chocquet.* c1885. Oil. Whereabouts unknown.

123. Paul Cézanne. *Portrait of Victor Chocquet.* n.d. Oil. Private collection, Paris.

124. Photographer unknown. *Victor Chocquet.* n.d. Photograph.

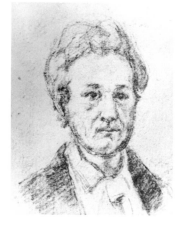

121.

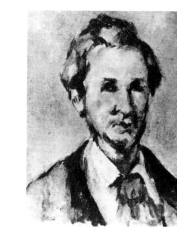

122.

123.

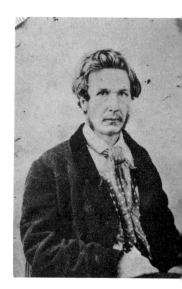

124.

ent fashion used photographs as *aides-mémoire.* He was not by any means alone, but his work serves as an example of what took place when an artist who tended to paint minute details used photographs. Millais' pictures of *Princess Marie* and *Lady Perry Primrose* and his portrait of Gladstone and the drummer boy in *An Idyll* are from photographs. Princess Marie was an attractive child with long hair and large eyes, but the shadows in the photograph tend to divert our attention from this fact. Millais, in painting the Princess, subtly exaggerated the size of her eyes and eliminated the strong light and shade patterns beside her nose and mouth. (125-126) He somewhat overstated the beauty of the girl and conveyed an impression that recalls an angel by Raphael, whereas in the photograph she seems quite capable of mischief.

While Millais did not depend on the photograph completely, he did use it nominally when painting the face, dress, and arms of the Princess. He changed the position of the fingers of her left hand to get a more pleasing relationship of forms, but he followed the shape of the outline and the effect of light along her arms as revealed by the camera. Some details of her beautiful lace dress were also taken from the photograph but not the position of the object she was knitting nor the way the yarn fell as it ran to her needles from the ball on the table.

Working from photographs was a practice followed in Germany as much as it was in France, England, and the United States. In Germany the well-known painter Franz von Lenbach employed photographs in a very direct fashion. He traced onto his canvases photographs made by himself and others. Among such pictures is his seated portrait of Bismarck done in 1896, which is little more than an enlarged and colored variation of a camera study. (127-128)

Hubert von Herkomer wrote in 1905 of Lenbach's procedure, "He first took a number of photographs of

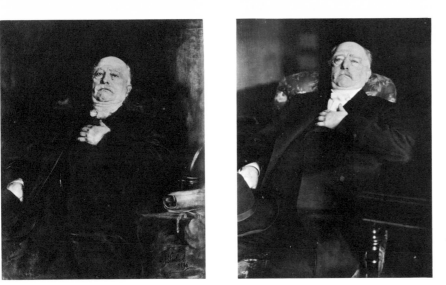

127. 128.

125. Sir John E. Millais. *Princess Marie*. 1882.
Oil, 35½ x 24½ inches.
Royal Collection, Windsor, England (Copyright Reserved).

126. Armond Richard (?). *Princess Marie*. c1880. Photograph.
Courtesy Sir Ralph Millais, Hawkhurst, Kent, England.

127. Franz von Lenbach. *Portrait of Bismarck*. 1896.
Oil, 49 x 41 inches. Courtesy *Photo Magazine*, Munich.

128. Photographer unknown. *Otto von Bismarck*. c1896.
Photograph. Courtesy *Photo Magazine*, Munich.

125. 126.

129. Franz von Lenbach.
Self-Portrait with Wife and Daughters. 1903.
Oil, 36 x 48 inches. Stadt, Galerie, Munich.

130. Franz von Lenbach. *Study for family painting.* 1903.
Photograph. Stadt, Galerie, Munich.

131. Wyatt Eaton. *Corot at Work.* c1888. Ink drawing.
Reproduced from *Century Magazine.*

132. Charles Desavary. *Corot at Arras.* 1871.
Photograph. George Eastman House, Rochester, N.Y.

129.

130.

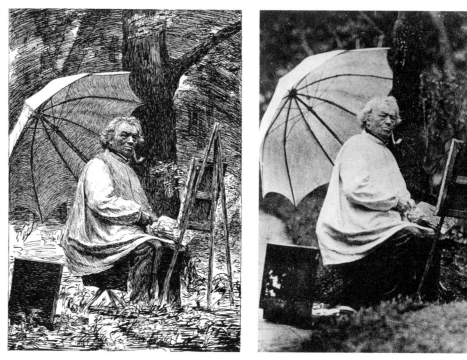

131. 132.

a sitter in all sorts of poses. From these he chose the one or two that offered him his best chances for his type of work. Then from an enlargement of such a photograph he made a pen outline on the canvas which remained visible to the last. After this he 'constructed' his picture in tone and colour, and when the sitter came for the first sitting the portrait was half done. For such a master, working in so strongly marked a groove, the method is eminently practicable, saves time, and the irritation of the invariably bad sitting at the start; and, in his case, it showed how the modern appliances can be used without disturbing the aspect of an old convention."

Herkomer, who also worked from photographs, added, "I see clearly in his art the side that has been fostered by photography. I see it in poses, but most clearly in his treatment of eyes. The glassy glitter of the Lenbach eye—so often mistaken for intellectuality of look—is the eye that has stared into a camera for several seconds, fixedly. The defects and inequalities of eyes, their wateriness, which causes so much of that glistening effect, are all exaggerated in the photograph. They are easy to copy; and, if the artist only dares to put it all in his pictures, it secures for him a type of work that may be taken for originality."

Herkomer concluded, "I deny that the expression of an eye that has stared into a camera gives a true reflection of the mind of the sitter. How differently the eye appears when looking at the painter during conversation. But photography, used in the way Lenbach applied it, is so comfortable and convenient and worry-saving, that it weans the artist imperceptibly from the greater effort of knowing his sitter well, from personal knowledge before he allows photography to mislead him." Herkomer favored the use of photography if the artist has an intimate knowledge of his subject. He felt that to successfully use photographs a painter must be able to see "through" the photograph and not be limited by the single moment caught by a lens.

Not only did Lenbach follow this procedure when painting commissioned portraits of prominent personalities such as Bismarck and Pope Leo XIII but also when painting himself and his family. (129-130) A bedsheet served as a background in the photograph the painter took of his family. This mundane prop was enlarged and given an ambiguous connotation in the painting. The artist also painted the blond locks of his daughter's hair as if they were even longer than was in fact the case. Shadows were relocated to tie light areas together. Other than these changes and the addition of color, the arrangement and poses in the photograph were imitated by the famous Munich portraitist.

Franz von Stuck was another famous German academic artist who relied on photographs when painting portraits and genre compositions. In his picture of himself with his wife standing in his studio before a fresh canvas, he used a photograph. In a similar fashion he used photographs of himself and his daughter in his painting of her as a Spanish infanta.

Illustrators more frequently even than fine artists set to work with a photograph as a guide. In 1871 Charles Desavary, a native of Arras, France, photographed Corot seated in the forest before his easel. From this, Wyatt Eaton, the prominent American illustrator, made a drawing of Corot. (131-132) The results were published in *Century Magazine* in connection with an article about the famous French painter. When Eaton's drawing was published, no mention was made that the likeness of Corot was from a photograph. It can be seen, however, that the draftsman was indebted to the photograph to a very large extent. All that Eaton added was a tree limb above Corot's easel and some shorthand strokes to represent the forest floor, which had to have been invented by the illustrator since this portion of the Desavary photograph was so out of focus that it lacked an indication of the true nature of the ground cover.

The momentary effects of light were caught by the camera which relates Impressionism to photography in many ways. However, no portrait by an Impressionist

133.

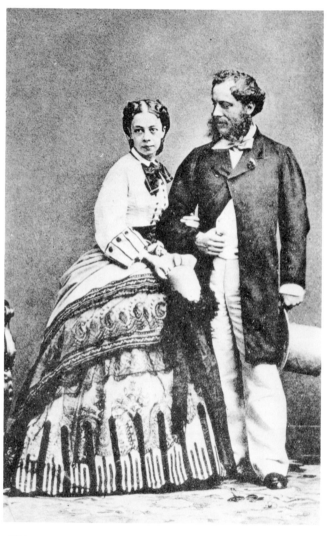

134.

133. Edgar Degas. *Princess Metternich*. c1875.
Oil, 16 x 11 inches. Tate Gallery, London.

134. Adolphe-Eugène Disdéri. *Prince & Princess Metternich*.
c1860. *Carte de visite* photograph. Whereabouts unknown.

135. 136.

135. Photographer unknown. *James Ensor.* c1887. Photograph.
Musées Royaux des Beaux-Arts de Belgique, Archives
de l'Art Contemporain, Bruxelles.

136. James Ensor. *Self-Portrait (State 1), My Portrait
Skeletonized (State 3)* (pair). 1889.
Etchings, each 4¾ x 3¼ inches. Musées Royaux des
Beaux-Arts de Belgique, Cabinet des Estampes, Bruxelles.

in his mature style is known which can be said with
certainty to have been painted from a photograph.
Some of Degas' early work had the flavor of photo-
graphs but this was before he became an Impressionist.
The art historian Jean Boggs has noted that *Head of
Woman,* 1860-62, in the Walters Art Gallery may
have been done from a photograph, and she feels that
The Belleli Sisters, 1862-64, in the Los Angeles County
Museum was daguerreotype-inspired.

There is in the Tate Gallery a portrait of Princess
Metternich that was copied by Degas from a *carte de
visite* photograph by Adolphe-Eugène Disdéri. (133-
134) While not an outstanding example of the artist's
dynamic style, it does add further evidence that major
artists felt that using photographs was permissible
when painting portraits. This curious portrait poses
some problems. Because the left arm of the Princess
was tucked under her husband's arm in the photograph,
Degas was forced to invent a solution for its placement.
Despite the fact that Degas was a skilled draftsman and
a knowledgeable anatomist, without a photograph of
the arm to serve as a guide, he handled the problem
inconclusively and awkwardly by eliminating the arm.

It was as if he were at a loss as to how to treat this
portion of his painting where the photograph was
inexplicit.

While French Impressionists do not seem to have
used photographs directly for portraits, artists of the
next generation sought the guidance of the lens in a
number of instances. The late ninteenth-century Flem-
ish Expressionist James Ensor used a snapshot as a
guide for a most unusual etched self-portrait. (135-
136) In the first state of this print he drew a rather ob-
jective reflection of the photograph, then from that
image, he drew a curious skeletonized likeness of
himself.

Libby Tannenbaum, the Ensor scholar, has noted,
"Ensor would seem to have used photographs notably
in relation to portraits, viz, *Old Woman with Masks.*
Many of the self-portraits were made from photo-
graphs. The small figure with the flute on the chimney
in the upper right of *The Game of Love* painting is
from a photo." She added, "among his drawings there
is a sketch of Tolstoy made from a photograph."

Another lowlander, Vincent van Gogh, while living
in Antwerp, intended "to make his living by working

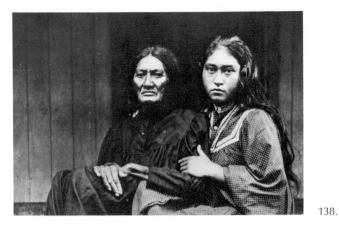

138.

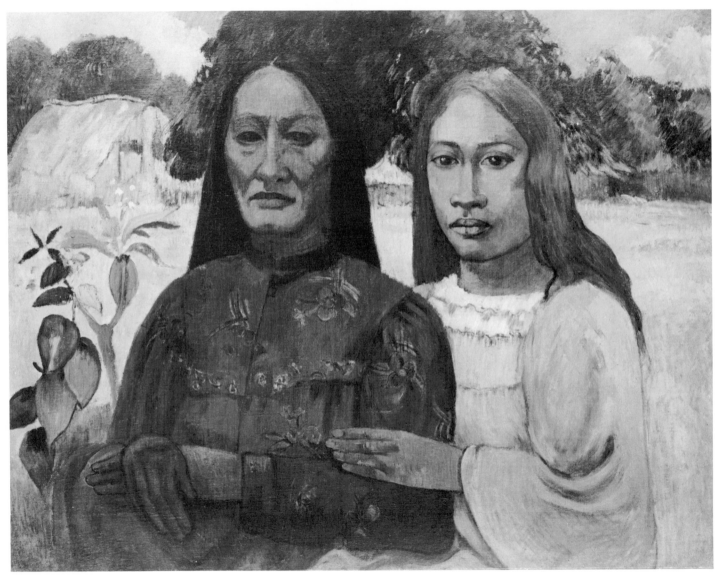

137.

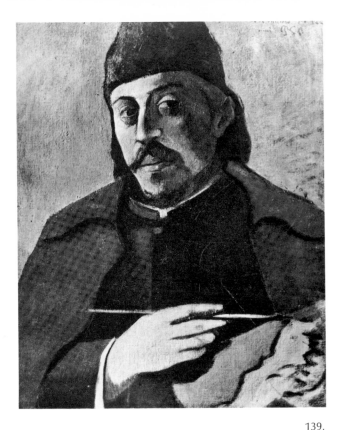

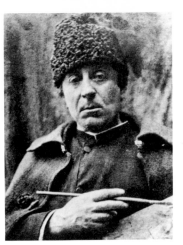

140.

137. Paul Gauguin. *Mother and Daughter*. 1890.
Oil, 28¾ x 36 inches.
Collection Mr. and Mrs. Walter Annenberg, Philadelphia.

138. Henry Lemasson. *Two women* (detail). c1897. Photograph.
Courtesy Bengt Danielsson, Stockholm.

139. Paul Gauguin. *Portrait of the Artist with a Palette*. 1893.
Oil, 36½ x 28¼ inches. Collection Norton Simon, Los Angeles.

140. Photographer unknown. *Paul Gauguin*. c1893.
Photograph. Coke Collection, Rochester, N.Y.

139.

for a photographer who was to give him portraits to paint." While no such van Gogh portraits from his early period have been discovered, we know that in 1888 in Arles he painted a portrait of his mother from a photograph.

Paul Gauguin also painted a portrait of his mother from a photograph. This might be expected, for he borrowed many of his ideas from already existing pictures. Counterparts of photographs are *Mother and Daughter* and *Portrait of the Artist with a Palette*. The first was probably painted in Papeete, Tahiti, but may have been executed in Paris during the artist's trip to France in 1893-94. The pose in the photograph taken in Tahiti by the postmaster, Henry Lemasson, was retained by Gauguin for *Mother and Daughter*, but the forms in the painting were flattened and simplified compared to those in the scene registered by the camera. (137-138) Gauguin gave the faces of his subjects a more monumental character by exaggerating the size of the girl's mouth and nose and by placing the women in an environment that was much more exotic. He altered the position of the girl's thumb to carry one's eye across the bottom of the composition and used a lighter tone for

her dress, which made a more exciting pattern of dark and light than in the photograph and eliminated the problem of dealing with the assertive linear decorations around her neck and the polka dots in her robe. Gauguin also gave the figures a greater feeling of importance by creating a light-toned background, thus enveloping the silhouettes of the two women with a sense of atmosphere.

In *Portrait of the Artist with a Palette*, a self-portrait from a photograph, Gauguin reshaped his face, altered the kind and form of the hat he was wearing, and greatly exaggerated the size of his moustache. (139-140) The position of his hand holding the brush and the way he painted his heavy jacket and shirt closely resemble these parts of the photograph.

Rarely did innovative artists in the last half of the nineteenth century fully utilize photographs. But photographs did provide many elements for a substantial number of portraits. Scattered as the examples cited are, they represent a practice that has generally gone unrecognized but foretells many future discoveries of the nineteenth-century artist's reliance on photographs.

57

The Painter and the Photograph 2. PORTRAITS
TWENTIETH CENTURY

141. Back of *carte-de-visite*. c1880.
Coke Collection, Rochester, N.Y.

Below. Wayne Wollingworth. *View of Chuck Close's studio
in New York*. 1970. Courtesy Bykert Gallery, New York.

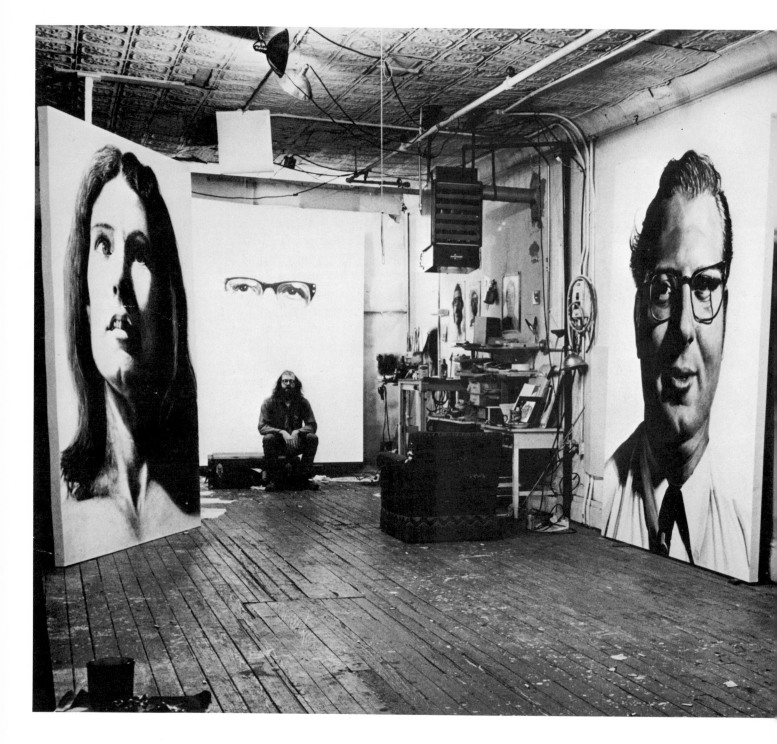

2. PORTRAITS TWENTIETH CENTURY

141.

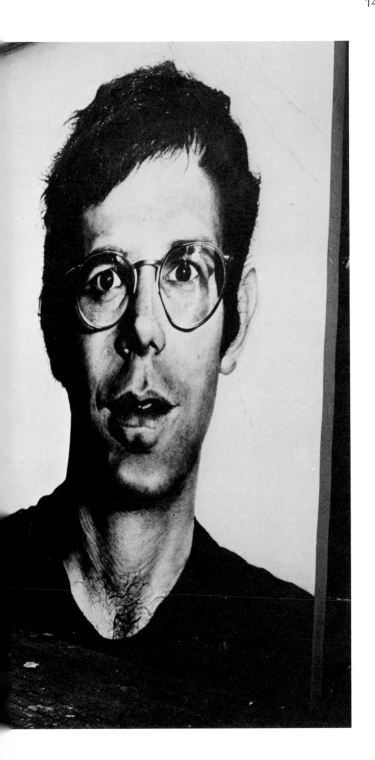

Drawing from photographs was a practice in no way frowned on by many artists at the turn of the century, as the work of the well-known illustrator George T. Tobin indicates. When signing his drawings, he often included the statement, "after a photograph by ———." Tobin, in his drawing of King Edward VIII, published in 1902 in *The Century Illustrated Monthly Magazine*, verified his source of imagery as a photograph made in the studio of W. and D. Downey, prominent London cameramen. (142) Tobin vignetted this portrait, thereby calling special attention to the King's decorations and the details of his face. The questions might be asked: What was the purpose in copying a photograph so explicitly? Why not just reproduce the photograph? Special treatment of parts of a picture would have been difficult for a photographer since the demanding eye of the camera, incapable of selecting details for emphasis, records without discrimination all that is sharply focused before it. Further, drawings had more prestige as illustrations than photographs until recent years.

By the end of the nineteenth century it was rare to find a portrait or a figure painter who did not rely to some extent on photographs, and many were competent in the darkroom as well as with the camera. This was true of the famous Czech *fin de siècle* illustrator and poster designer Alfonse Mucha who used the camera extensively. His son Jiri Mucha noted:

When, in the early nineties, my father acquired his first camera, photography seemed to have become the vogue among artists. Not however for the pleasure of taking pictures. Most [photographs] show either models posing for his posters, or less frequently, landscapes serving as background for his illustrations. . . . My father told me often of a friend of his—whose name he mercifully omitted—who painted portraits with the help of a concealed camera. The client was seated on the rostrum, the artist put up his canvas, busied himself with the paint, disappeared behind a screen, took a photograph, came out, drew, disappeared again, came out, mixed the colours, sharpened the charcoal, till the model lost track of his activities. When the client was

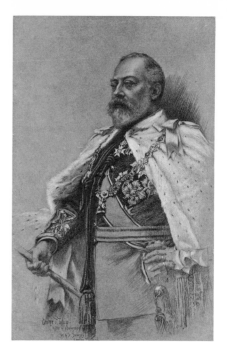

142.

142. George Tobin. *King Edward VII* (after a photograph by W. and D. Downey, London). c1900. Pastel. Reproduced from *The Century Illustrated Monthly Magazine,* 1902.

143. Carlos Baca-Flor. *J. Pierpont Morgan.* 1903. Oil, 45 x 40 inches. Metropolitan Museum of Art, New York. Gift of J. Pierpont Morgan.

144. Edward Steichen. *J. Pierpont Morgan.* 1903. Photograph. Collection Capt. and Mrs. Edward Steichen, West Redding, Conn.

145. Pablo Picasso. *Renoir.* 1917. Drawing, 24 x 19 inches. Courtesy Christian Zervos, Paris.

146. Photographer unknown. *Auguste Renoir.* n.d. Photograph. New York Public Library.

143.

144.

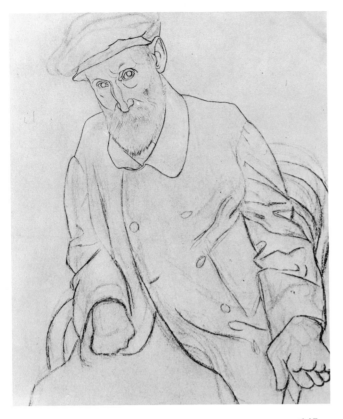

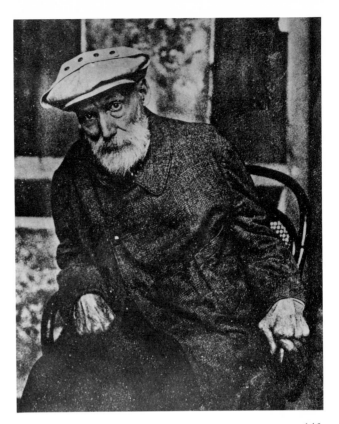

145.

146.

gone, the plate was developed, copied onto another plate [transparent] and the enlarged picture projected on the canvas. All the painter had to do was copy carefully the projection.

In New York the Peruvian artist Carlos Baca-Flor did not use a projected image to help him paint a portrait of J. P. Morgan, Sr., in 1903, but he did request photographs to guide him. Edward Steichen, then a young photographer, was called in to photograph Morgan in Baca-Flor's studio. According to Carl Sandburg, Steichen's brother-in-law, Morgan stipulated that the photographer could have only a few minutes to work. Steichen rehearsed the sitting by trying out a pose and lighting on the building janitor in a different part of the studio and was ready to shoot when Morgan sat before the camera. Steichen asked Morgan to turn his head from side to side to loosen the muscles of his neck. At the moment Steichen saw what he wanted he asked Morgan to hold the pose and clicked his shutter. Two similar exposures were made, one of which was obviously the model for the painted portrait of Morgan. (143-144) Even with the Steichen before him, Baca-Flor could not get a sense of life into Morgan's face.

Stale and static, the painting lacks conviction. Morgan's powerful head does not give an impression of

having volume in the painting, nor is the flesh shown folded under Morgan's eyes and chin in a natural fashion. By omitting these signs of age, Baca-Flor produced an artificial and unconvincing picture without any redeeming artistic qualities. Steichen retouched Morgan's overly large nose to reduce its prominence and puffy appearance, yet this change did not affect the power of the photographic likeness as did the changes made by Baca-Flor. It should be noted that the photograph is today the most famous likeness of Morgan, whereas the painting is rarely seen.

Pablo Picasso in a series of drawings made between 1917 and 1919 not only worked from photographs but traced over photographs when making some of his drawings. One of the most interesting of these is a portrait of Renoir after he had become an elderly and arthritically crippled man. (145-146) The contours of the famous Impressionist's form were copied or traced from a photograph. Picasso eliminated the emphatic overcoat pattern in his transcription in order to increase the legibility of the principal forms. In this instance the artist seems to have been overly willing to follow the dictates of the camera. Apparently he found it difficult, when the source of his imagery was without three-dimensional characteristics, to disengage from the flat-

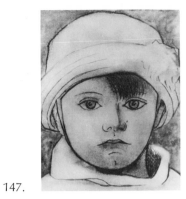

147.

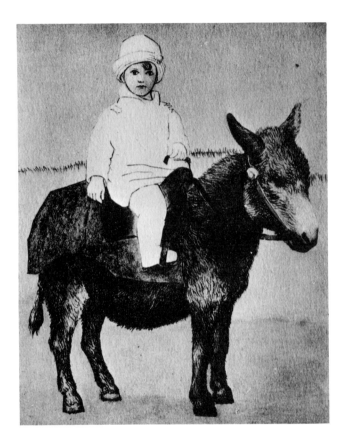

148.

149.

150.

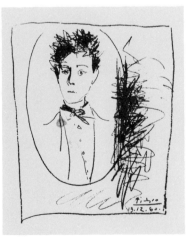

151.

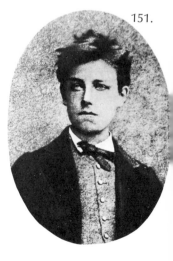

147. Pablo Picasso. *Portrait of the Artist's Son Paul*. 1923. Oil, 10¾ x 8¾ inches. Collection Pablo Picasso, Grasse, France. Permission SPADEM, 1971, by French Reproduction Rights, Inc.

148. Pablo Picasso. *Paul, Son of the Artist*. 1923. Gouache, 40 x 32 inches. Collection Pablo Picasso, Grasse, France. Permission SPADEM, 1971, by French Reproduction Rights, Inc.

149. Photographer unknown. *Picasso's son Paul on a donkey*. c1923. Photograph. Collection Pablo Picasso.

150. Pablo Picasso. *Portrait of Rimbaud*. 1960. Lithograph, 13 x 10 inches. Courtesy Ferdinand Roten Galleries, Baltimore.

151. Étienne Carjat. *Rimbaud*. 1871. Photograph. New York Public Library.

152. 153. 154. 155.

152. Diego Rivera.
Trinity of Architect, Sculptor and Painter (detail). 1923-28.
Fresco. Secretaría de Educación Pública, Mexico, D.F.

153. Edward Weston. *Diego Rivera* (detail). 1924. Photograph.
Reproduced by permission of Cole Weston, Carmel, Calif.

154. Georges Rouault. *Field Marshal von Hindenburg.* c1927.
Lithograph, 18 x 13 inches.
Courtesy Ferdinand Roten Galleries, Baltimore.

155. Photographer unknown. *Field Marshal von Hindenburg.*
n.d. Photograph. Prints and Photographs Division,
Library of Congress, Washington, D.C.

ness of the photograph and reconstitute through line alone a sense of life and substance.

Picasso was more successful when painting two pictures of his son Paul, both from a single photograph. One of these paintings shows Paul seated on a burro, the other is of the boy's head. (147-149) The cluttered background of the photograph was left out of the painted version, and young Paul was pictured larger in proportion to his mount than was the case in the snapshot. Other aspects of the camera-caught situation were carried over directly by Picasso. Imparted to the painting of the boy on the burro was the casual feeling we associate with the candid and unstudied imagery of a snapshot. In the painting of the boy's head, Picasso took over the perplexed look recorded by the camera, but enlarged the boy's eyes and focused them beyond us to give the little portrait a sense of introspection quite different in feeling from the situation recorded in the routine photograph.

Picasso also used a photograph for his 1960 lithograph of the French poet Arthur Rimbaud. (150-151) Summarized though the forms may be, details of dress and pose still can be seen to have been directly taken from the photograph.

In the early 1920s Picasso's friend Diego Rivera became acquainted with Edward Weston, the photographer, while he was living in Mexico City. Weston joined the circle that orbited around Rivera; and as a result, a portion of a Weston portrait of the famous Mexican muralist was quoted by the painter in one of his large fresco murals. This Rivera self-portrait is located on the wall at the head of a stairway in the Edu-

cation Building in Mexico City. (152-153) The artist painted himself in this instance as the architect of the master plan of the new order being wrought in his country. Strangely, Rivera's face is drained of any personality and lacks the introspective mien captured by Weston's camera. One reason for this was that Rivera did not preserve from the photograph the strong shadow across his face. Thus a form that conveyed a sense of volume was eliminated and with it the fullness of personality apparent in the Weston photograph.

In his lithograph of Charles Baudelaire, mentioned earlier, Georges Rouault escaped this trap. Less successful, unless one can consider his treatment to have been intended as a symbol, was his portrait of Field Marshal von Hindenburg. (154-155) Here is found a stilted likeness which lacked both a sense of volume and life. If this print had been intended to satirize the German leader, Rouault could not have found a better way to do so than to follow closely the stiff, impersonal, and considerably retouched camera portrait he selected to serve as a model for this likeness of the Field Marshal. The representation Rouault drew for this print was even more stilted and two dimensional than the photograph he used as a guide.

Jacques Villon, another of France's great printmakers, made two etchings in 1926 that were inspired by nineteenth-century family daguerreotype portraits. Six years later Morris Kantor painted *The Daguerreotype*. Both artists incorporated in their work many of the qualities we associate with early camera portraits. Sharp focus, static poses, and staring eyes neutralized any feeling of vitality in the figures. The use of head

65

156. Jacques Villon. *Daguerreotype No. 1.* 1927.
Etching, 6¼ x 8¼ inches.
Coke Collection, Rochester, N.Y.

157. Adolphe Braun. *Elderly man and woman.* c1860.
Photograph. Courtesy Adolphe Braun et Cie., Mulhouse, France.

158. Adolphe Braun. *Man and woman.* c1860. Photograph.
Courtesy Adolphe Braun et Cie., Mulhouse, France.

159. Morris Kantor. *The Daguerreotype.* 1931.
Oil, 26 x 30 inches. Collection Morris Kantor, New York.

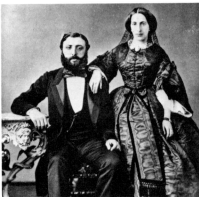

158.

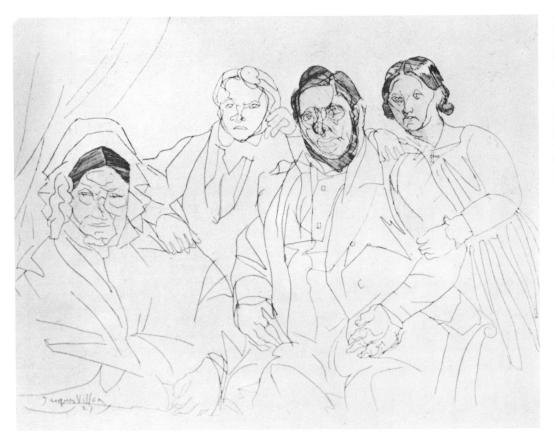

156.

157.

159.

clamps, to assure immobility, explains the rigid stance assumed by the subjects a hundred years ago as they were forced to remain still for the long exposures required by the insensitive daguerreotype plates.

Villon's subjects in his compositions were his wife's relatives, including, in *Daguerreotype No. 1*, his maternal grandfather, the prominent etcher Émile Frederic Nicolle. As can be seen when comparing Villon's prints with pictures in most family albums of the 1850s, standard studio poses were assumed by the individuals in the group. (156-158) Villon imposed his personalized and quite modified version of Cubism on the photographic imagery. He did not linger over details but retained only the essential outline of the figures. He partially fractured the contours and reassembled them to give emphasis to geometric forms. In *Daguerreotype No. 1*, more than in *Daguerreotype No. 2*, Villon outlined and linked his figures in a way that, while related to Cubism, reminds one of the artist's impressive early art nouveau prints. Despite the departure from his sources, there remains in these etchings a distinct flavor of mid-nineteenth-century daguerreotype portraits of family groups.

Morris Kantor's painting from a daguerreotype was executed in an intentionally artificial manner, with close attention given to simulating the silvery-gray tones of his source. (159) The artist was interested in transforming a family memento into an Americana period piece. With his sharp eye for specific details he painted a capsule history of an individual and caught the spirit of the past century. Kantor confirmed that this rather romantic notion had been his aim:

I was fascinated with the woman in the portrait. She appears so rigidly composed yet so well relaxed in the chair. Her tightly drawn hair, which was especially groomed for the occasion, seemed to fit her simplicity. This and her checkered dress fading together in the aging camera study gave me the idea for the painting. I used the living room of our old house for the interior setting because I thought she belonged there.

The camera tends to alter the physical arrangement of forms compared to the way we would observe them directly. In Kantor's picture the tilted floor and the exaggerated perspective of the fireplace are both characteristic of the kind of camera vision that a wide-angle lens produces. Without losing the sense of reminiscence so important to the painting, Kantor made use of this interesting pictorial scheme to add visual excitement to his otherwise rather sentimental subject. By painting

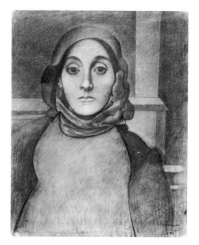

161.

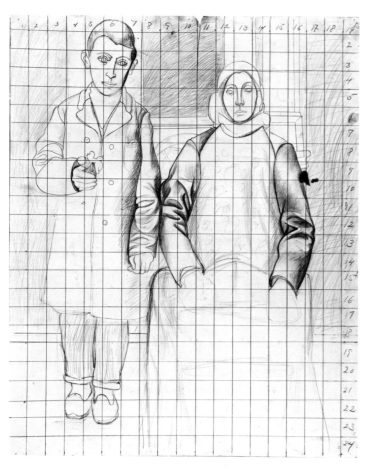

160.

162.

160. Arshile Gorky. *The Artist and His Mother.* c1936.
Pencil, 24 x 19 inches. Estate of Arshile Gorky.

161. Arshile Gorky. *The Artist's Mother.* 1936.
Charcoal, 25 x 18 inches.
Art Institute of Chicago. Worcester Sketch Fund.

162. Photographer unknown. *Arshile Gorky and his mother.*
n.d. Photograph. Courtesy Sarkis Avedisian.

164.

163. Elaine de Kooning. *Portrait of Caryl Chessman*. c1963.
Gouache and charcoal, 106 x 48 inches.
Graham Gallery, New York.

164. Photographer unknown. *Caryl Chessman*. n.d. Photograph.
Courtesy Elaine de Kooning, New York.

163.

in grisaille the portion of this picture stemming from the silver-gray tones in the daguerreotype and by painting the remainder in natural hues, Kantor used color or the lack thereof as an added indication of his source of inspiration.

From 1926 to 1936 Arshile Gorky painted two versions of his well-known composition *The Artist and His Mother*. A faded photograph, made in 1912 when the artist was eight and still living in Armenia, provided the basic ingredients for these portraits. (160-162) Although the photograph established for his paintings and drawings the general placement of the elements and provided a psychological link with the rigid attitudes caught by the camera, he reduced or eliminated in the paintings the elaborate floral pattern of his mother's dress, the buttons on his coat, the handkerchief in his breast pocket, and parts of the bouquet of flowers in his right hand. Eyes, mouth, and nose were isolated against the flat faces by the harsh light that characterizes many photographs made by street or fairground cameramen.

In the drawing for the paintings, Gorky further stylized his own and his mother's features and hands and enlarged his head, giving emphasis to bold generalized shapes. Out of the rather primitive photographic document was condensed something of a man's feeling of loneliness and isolation in a foreign land. With his gift for interpretation, the unsophisticated camera likeness was translated by Gorky into a monumental sym-

bol that deals with tender emotions without becoming mawkish.

Gorky's highly finished charcoal drawing of his mother has a quality of reverie about it that stems from the inward look given her eyes. Although derived from the same photograph as is the squared-off drawing for the mother and son paintings, Gorky gave this work a special feeling of melancholy by softening his mother's face and greatly simplifying her clothes and headdress so as to concentrate attention on her soft symmetrical features. Gorky retained the architectural elements from the painted backdrop before which he and his mother had stood to be photographed in Armenia. To retain the linear geometric elements in the backdrop and to avoid detracting from his mother's face, he moved the simulated column behind her head to a position slightly to the right. The fact that this poignant and uncanny likeness was based on a very mediocre photograph supports the view that a first-rank artist can convert almost any source of imagery into a work of art.

In the 1950s few portraits were made that can be associated in style with Abstract Expressionism, the dominant mode of that period. Elaine de Kooning's portraits were an exception. In one of the best examples she successfully utilized a photograph to paint a symbolic picture of Caryl Chessman. (163-164) Her gouache of Chessman was based on a magazine photograph taken in a California prison after he had been sentenced to the

165.

166.

165. Larry Rivers. *Europe II.* 1958. Oil, 54 x 48 inches.
Collection Mr. and Mrs. Donald M. Weisberger, New York.

166. Photographer unknown. *Larry River's great uncle and
cousins photographed in Poland.* c1928. Photograph.
Courtesy Larry Rivers, Southampton, Long Island, N.Y.

gas chamber. The artist's deeply felt indignation at what she considered to be an unjust sentence was powerfully communicated in her painting. For her the image made with a camera was a starting place. It is only barely recognizable in the heavily worked forms and the punished surface of her expressive painting. On close examination the way in which she painted Chessman, however, can be seen to have been derived from characteristics found in the newsphoto.

In the photograph Chessman was shown looking down at his hands, a pose that provided the basis for Mrs. de Kooning's concept of her subject, as well as a formal solution to the problem of how best to represent him. She summed up her response to the impending execution by almost obliterating Chessman's face and only sketchily representing his jacket. The highlights on his hands and on the back of his jacket collar were particularized. If her picture had been painted from life, it is unlikely that she would have represented Chessman's hands as she did, for they would have attracted less attention in life than in the photograph, which shows them reflecting the strong overhead lights in the prison. The use of the photograph did not in the least diminish the impact of the painting and probably contributed to a fruitful psychological state in which the artist could work so successfully.

Mrs. de Kooning has written of the powerful effect this photograph had on her.

I had seen a great many photographs of Caryl Chessman through the years from 1954 when I read his first book, "Death Row" to May 1960 when he was executed. I had, during this period, become very much involved in Chessman's fight for his life. I felt he was a tremendous force in the crusade against capital punishment—a symbol of the rage to live.

I came across the picture I used in a magazine just before his execution. I was immediately struck by the curiously submissive expression of the face, the hands, in fact, the entire pose which belied the superhuman efforts of his twelve year battle against extermination. The image somehow seemed to exemplify the man's great dignity, courage and resourcefulness in the face of monstrously unfair circumstances.

After his execution, the photograph became something else—an image of despair. I found myself, then, compulsively working for weeks on a series of black and blacker ink and charcoal renderings in an attempt to exorcise this fierce grief.

A generation after Gorky painted his mother and himself from a European photograph, Larry Rivers painted a similar portrait of his Polish relatives from a family photograph, which conveyed a poignant echo of his European heritage. Although the individuals were photographed in a clear and straightforward fashion they were blurred in the painting, which Rivers executed in his modified Abstract Expressionist style. The painting provides only enough evidence to make a few recognizable likenesses of his family. Other faces were understated or given a sketchy treatment. Rivers skillfully composed his picture so as to guide our eye over the surface from one face to another by selectively editing his source of imagery.

The effect is somewhat like a multi-screen film presentation. (165-166) The suggested or half-finished parts and the multiple representations of the head of the boy in the center and the young man on the right introduce a sense of movement that may stand for time. Rivers, while perhaps emotionally involved with the individuals in the photograph, was above all a painter using this particular motif to demonstrate his considerable abilities as a draftsman and his facility with a brush. In some instances it seems almost as if Rivers intended his spontaneous brush strokes to compete technically with the clarity of the photograph. Rivers probably wanted this particular picture to be a kind of talisman in which he was forced to invent an artistic context that would convey his allegiance to the people photographed and at the same time create a symbolic language that would express in pictorial terms his involvement with the problems of picture making.

Andy Warhol was probably the first major artist to

167. Andy Warhol. *Marilyn Monroe*. 1962.
Silk-screened photograph, 81 x 66¾ inches.
Collection Vernon Nikkel, Clovis, N.M.

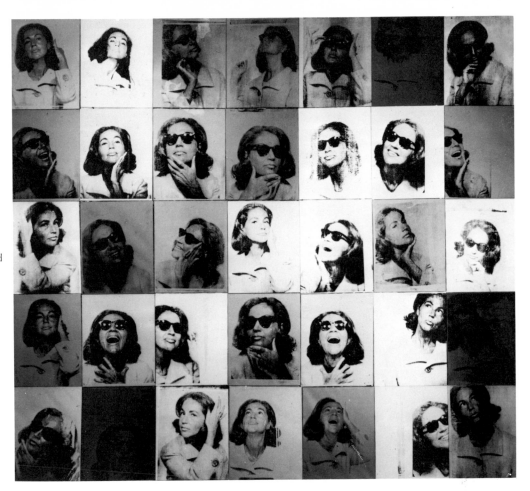

168. Andy Warhol. *Ethel Scull, 35 Times*. Silk-screened photographs, 100 x 112 inches. Collection Mr. and Mrs. Robert Scull, New York. Photograph, courtesy Leo Castelli Gallery, New York.

create significant portraits not by facile brush strokes but by mechanical silk-screen reproductions of photographs. Notable are those of three glamour heroines: Marilyn Monroe, Elizabeth Taylor, and Jackie Kennedy. (167)

Warhol's silk-screened photographs of Marilyn Monroe combine factual elements with slightly varied passages that appear clotted due to the stenciling process he uses. The actress' darker side is somehow implied in these unrefined and sharply colored candid portraits. Although each viewer sees the screen beauty in a different light, one is ever mindful of her tragic life. Warhol's multiple likenesses convey a measure of her ebullience but also hint at a kind of gaiety that was repressed because of her never-ending conflict with a bizarre personal history. The disturbing actuality of her face, repeated larger than life, is certainly related to Warhol's films in which one's attention is fixed on a single unchanging image for an almost unendurable length of time. This intensifies one's awareness of forms but also traps the viewer into a heightened experience as the dotted screen representation of a photograph is transformed into an icon. This is especially appropriate in the case of Marilyn Monroe whose inti-

mate presence was known to most people only through the grainy image projected on a screen.

One of Warhol's most effective examples of transferring a photograph to canvas, however, is his multiview portrait of Ethel Scull, the wife of a major New York collector of Pop art. (168) Ethel Scull's portrait began when she sat for a series of pictures in a Photo-Matic booth in a pinball arcade at 52nd Street and Broadway. As she fed coins into a slot in the machine, a light flashed on; and while she looked with apparent pleasure and approval at her likeness in the mirror before her, she was recorded by the automatic camera. For each exposure, she turned her head from side to side and changed her expression. The small direct positive prints made in this fashion were then enlarged by technicians and screened for Warhol to print on canvas. As in his other pictures, Warhol used the machine and mass-reproduction techniques to express something of his feelings about the role that technology plays in our society and to comment on television and films, the source of many of our visual ideas. The varied cinemalike repetition of frame-after-frame imagery in Warhol's work seems very suitable for his purpose.

Chuck Close, a generation younger than Warhol,

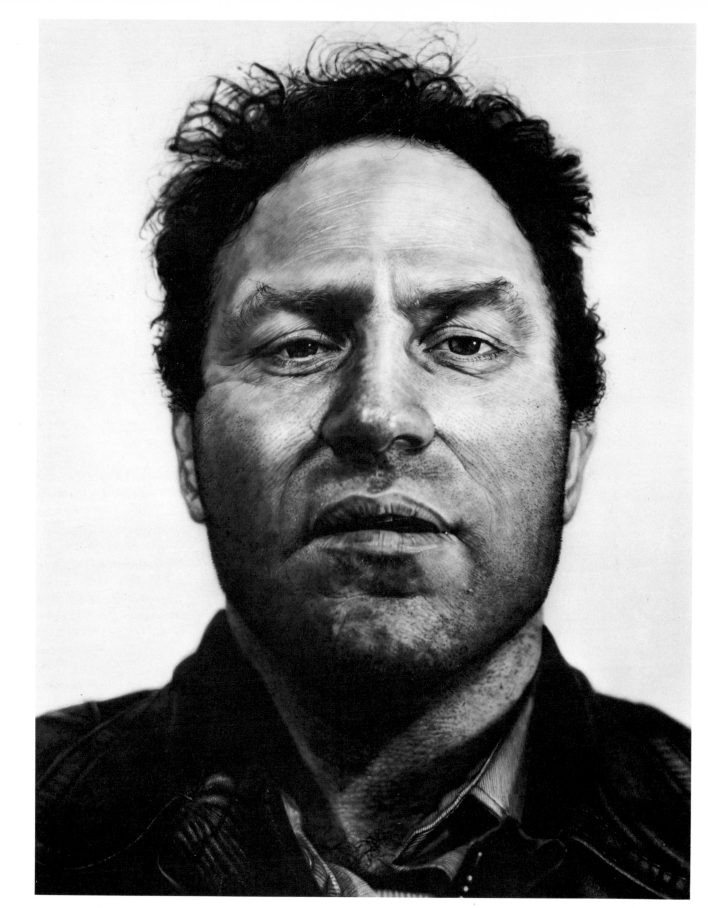

169. Chuck Close. *Richard*. 1969. Acrylic, 108 x 84 inches.
Collection Dr. Peter and Irene Ludwig, Aachen, Germany.

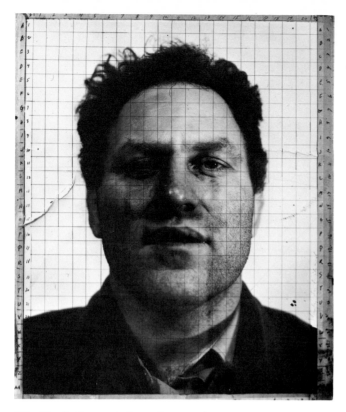

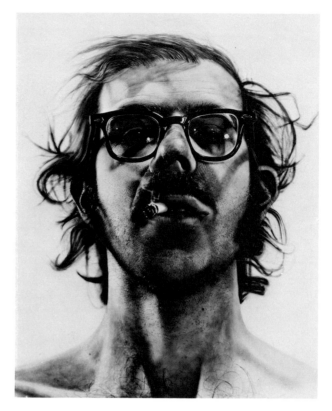

170. Chuck Close. *Working photograph for Richard.* 1969. Photograph. Bykert Gallery, New York.

171. Chuck Close. *Self-Portrait.* 1968. Acrylic, 107½ x 83½ inches. Walker Art Center, Minneapolis.

bases seven-by-nine-foot paintings of heads on eight-by-ten-inch photographs. (169-171) He is interested in the way a camera sees as opposed to the way the eye sees. It is his intention in such pictures as *Richard* to translate photographic data into information given life by his special skills and the materials available to him as a painter. His technique is to use an airbrush and to etch details in dark areas with a razor blade so as to best simulate a photograph.

Close has said, "The camera is objective. When it records a face it can't make any hierarchical decisions about a nose being more important than a cheek. The camera is not aware of what it is looking at. It just gets it all down. I want to deal with the image it has recorded which is black and white, two-dimensional, and loaded with surface detail."

Close makes strict copies of photographs, but by enlarging them to gigantic proportions he forces one to see the various parts of a face as independent shapes. He likes a lot of hair on a subject's head and face and selects photographs that show every pore and blemish, very much like Richard Avedon's closely cropped photographs of heads of famous stage and political personalities, in which every hair follicle and skin indentation are exaggerated. While the eye adjusts and can refocus when switching from one thing to another, a camera cannot. This aspect of camera vision

appeals to Close, and the out-of-focus characteristics of a head in a photograph such as the hair behind the brow or ears are painted by him as they were recorded by the camera, that is, indistinct or fuzzy. Close likes the idea that the blurred areas he copies from the limited vision of the camera cannot be ignored when he paints a head over seven feet high. Recapitulating this phenomenon peculiar to camera vision stimulates him, both physically and psychologically.

In summary because likeness was one of the major aims of portraiture it was inevitable that artists should have turned early in the history of photography to the camera as a legitimate aid. People move when posing for a painter even when instructed not to do so. As a consequence it is difficult for a portraitist to catch the individual quality of a sitter's eyes or mouth or natural posture. In a photograph all is still, and details can be studied and forms analyzed. While a moment preserved on film may not truly convey a sitter's personality it is sufficiently accurate when translated into a painting to satisfy most subjects and their friends.

Some portraits have always been painted which were intended to be much more than a means of recalling the appearance of a person. In these instances photographs became a flexible model and an inexhaustible source to which a painter could refer for information or which could serve him as a springboard for imaginative leaps.

3. GENRE

NINETEENTH CENTURY

172. *Painting Offering to Photography a Place at the Exposition of Fine Arts.* 1859. Wood engraving after Nadar.

173. John Le Conte. *Rev Thomas Chalmers and his grandson Thomas Chalmers Hann.* c1850.
Lithograph after D. O. Hill's painting.
Scottish National Portrait Gallery, Edinburgh.

174. D. O. Hill and Robert Adamson. *Rev Thomas Chalmers and his grandson Thomas Chalmers Hann.* c1845. Calotype.
Courtesy Scottish National Portrait Gallery, Edinburgh.

175. William Frith. *Derby Day.* 1858.
Oil, 30 x 99½ inches. Tate Gallery, London.

173.

174.

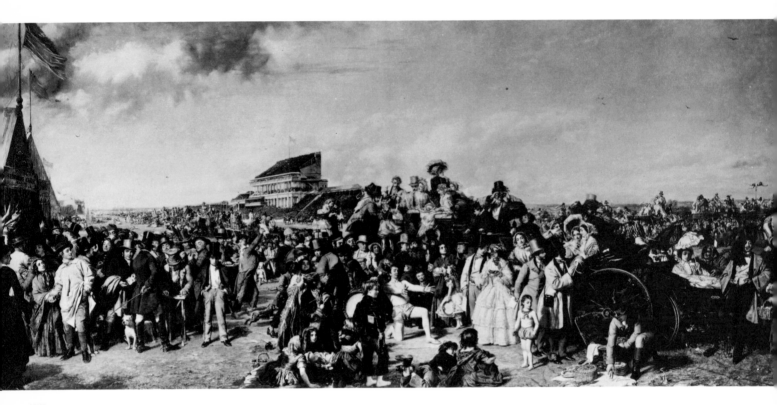

175.

176. 177.

176-177. William Frith. *Derby Day* (details).

178. Robert Howlett. *Grandstand and people on Derby Day.*
1856. Photograph.
Gernsheim Collection, University of Texas, Austin.

178.

78

3. GENRE NINETEENTH CENTURY

172.

Considerable visual and literary evidence indicates that artists were using photographs to assist them with their genre compositions in the early 1850s. It was during this period that D. O. Hill probably painted his charming picture of two generations, *Reverend Thomas Chalmers and his grandson Thomas Chalmers Hann.* Today we have only a lithograph of Hill's picture by the watercolorist and printmaker John Le Conte, but this indicates that Hill followed quite closely the pose he had arranged for Robert Adamson, his collaborator, to photograph. (173-174) The painter added a frame of trees and sharpened the face of young Hann, for the boy had moved during the long exposure in front of the camera. Except for these slight changes, Hill was content to translate the calotype directly into paint.

Another artist who like Hill turned from painting to photography was Oscar Rejlander. In the mid-fifties he developed to a high degree of proficiency a technique whereby many negatives of groups and single figures were combined into a single composite picture. Initially Rejlander created his manipulated compositions "with the idea of making photographic studies of his sitters and of draperies as an aid to painting." In 1857 his most complex and painterly effort, *The Two Ways of Life,* brought him fame when Queen Victoria acquired a print of his 16 by 31 inch photograph, which was produced in a very limited edition. Rejlander stated that one of his purposes in executing this *tour de force,* in which over thirty negatives were combined, was "to show to artists how useful photography might be as an aid to their art, not only in details, but in preparing what may be regarded as a most perfect sketch of their composition."

Pictures of large crowds painted in great detail were popular in England a hundred years ago. The public was entranced by the skill necessary to present convincingly the many people included in such scenes. To assist them in painting such pictures, many artists turned to photographs. In 1863 the English author T. Sutton wrote, "On Some of the Uses and Abuses of Photography," using the work of William Frith as an example: "Mr. Frith used photographs largely in obtaining studies for parts of his pictures. Thus, on Derby Day, Mr. Frith employed his kind friend, Mr. Howlett to photograph for him from the roof of a cab as many queer groups of figures as he could and in this way the painter of that celebrated picture, the *Derby Day,* got many useful studies."

Apparently only one of Howlett's camera studies for *Derby Day* has survived. Gernsheim reproduced the general view of the grandstand and the people seated or milling about on the edge of the racecourse and compared it to Frith's painting. Further study of the photograph indicates that it was used not only as a guide for the artist's view of the grandstand but also for details of the people. The photograph was altered, probably on the surface of the print rather than in the negative, to sharpen for the painter the appearance of the roof over the spectators to the right and left of the picture, as well as at the edges of the grandstand. (175-178) In addition, it can be seen that the two women dressed in light-colored frocks photographed sitting on the turf in the foreground were copied by Frith in *Derby Day* as part of a group of people in the middle ground, to the left of the grandstand. The painter also borrowed the figure of a man walking on the trestle-supported stands and possibly other figures for his representation of masses of people.

In his autobiography William Frith ignored the help he had received from the camera work done by "his kind friend" Robert Howlett. Strangely enough Frith was not reluctant to admit he had sought the assistance of the camera for one of his important portraits. He noted, "As I have heard that portrait painters had often derived advantages from photography, I asked Dickens to give a meeting at Mr. Watkin's who was thought to be one of the best photographers of the day."

Following the great success of *Derby Day,* Frith painted *Paddington Station* and again had a photographer, in this case Samuel Fry, make pictures of de-

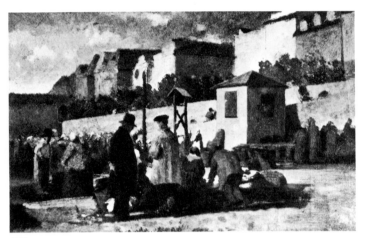

179.

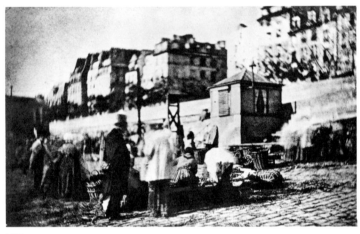

180.

181.

179. Charles Nègre. *Scene in a Market.* 1852.
Oil, 6 x 7¾ inches. Collection Joseph Nègre, Paris.
Photograph, courtesy André Jammes, Paris.

180. Charles Nègre. *Market scene on a quai in Paris.* 1852.
Calotype. Collection Joseph Nègre, Paris.
Photograph, courtesy André Jammes, Paris.

181. Edgar Degas. *Carriage at the Races.* c1873.
Oil, 13¾ x 21⅜ inches. Museum of Fine Arts, Boston.
Arthur Gordon Tompkin's Residuary Fund.

tails of railroad equipment and groups of people for him to follow in his studio.

A contemporary of Frith was the Pre-Raphaelite artist Dante Gabriel Rossetti. Rossetti posed his friend Mrs. William Morris for the camera and used photographs of her in his paintings. It seems quite likely that one of these surviving photographs was used as a basis for at least the head and upper portion of the figure in *The Salutation of Beatrice.* The use of photographs was probably a common practice with Rossetti, for in 1863 he wrote his mother, "if there are any stereoscopic pictures, either in the instrument or elsewhere, which represent general views of cities, would you send them, or anything of a fleet of ships. I want to use them in painting Troy at the back of my *Helen.*"

In France many artists also used photographs in one way or another. Charles Nègre, one of these, was both a painter and a photographer. He used his work with the camera to provide "memoranda" for impressionistic oils such as *Scene in a Market.* (179-180) The dappled spots of light on the buildings and the moving crowd in this Parisian riverside scene would have been difficult to paint on the spot. Nègre, therefore, took advantage of his knowledge of photography and caught with his camera the moment he wished to portray. Since the size of the painting and the photograph of this scene are almost identical, Nègre may have painted his picture directly on a print of his photograph.

The subjects moved during the exposure, and therefore we experience quite a different feeling when viewing the two matching pictures. There is a certain liveliness to the oil, due to Nègre's application of paint in rather broad strokes that de-emphasize details, and yet his painted version seems static compared to the somewhat blurred group of people recorded by the camera. Their activity evokes a sense of the hustle and bustle of a market, whereas the painting is too abstract to convey this feeling. As is often the case when a painter works from (or even over) photographs, broad areas in Nègre's paintings were followed closely, but specifics were simplified or omitted.

Much better known than Nègre is Édouard Manet who, although he was an amateur photographer, does not seem to have worked from his own photographs. He did, however, utilize pictures made by other cameramen. One of his versions of *The Execution of the Emperor Maximilian* was derived in part from photographs. While photographs certainly were involved in the evolution of this painting, none have been found that can be connected in a one-to-one relationship to the painting. Nevertheless, photographs served as references, even though Manet did not feel bound to copy them directly.

During the 1860s the instantaneous action of the shutter and the short focal-length lenses of the stereo camera frequently caught people and horses in casual attitudes barely glimpsed by the human eye. Figures were often frozen in awkward positions and cut off by the edge of the picture, charging the images with the flavor of life.

By studying these little photographs, Edgar Degas was encouraged to break away from esthetic concepts that dictated the placement of figures in idealized poses or arrangements and to compose his canvases in a new way. Degas saw a means of heightening the immediacy of his scenes and bringing into play unconventional compositional arrangements by following the photographs made by the unsophisticated eye of stereo cameramen. We know that his *Carriage at the Races* was inspired by photographs. (181) The abrupt cutting off of the carriages in the foreground and on the left edge of the composition not only enhances the feeling of action but also implies that the composition is only a fragment. The artist thus invites the viewer to supply the missing parts and creates a feeling of involvement seldom engendered by academic paintings.

Degas probably also used photographs for some of his pictures of women ironing. Photographs of this motif were found in his studio after his death, and some were shown in the large Degas exhibition held in

186.

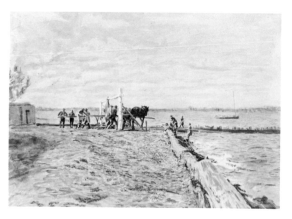

182

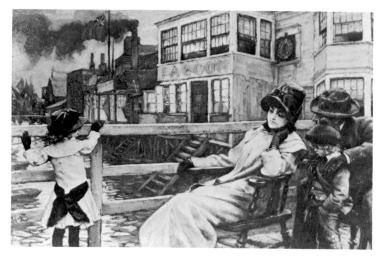

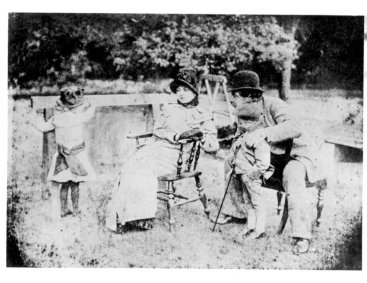

182.

183.

184.

185

182. James Jacques Joseph Tissot. *Waiting for the Ferry*. n.d. Oil, 12 x 14 inches. Collection Viva King, London.

183. Photographer unknown. *Mrs. Newton, her children and Tissot*. c1875. Photograph. Courtesy Marita Ross, London.

184. Paul Cézanne. *The Bather*. 1885-90. Oil, 50 x 38⅛ inches. Museum of Modern Art, New York. Collection Lillie P. Bliss.

185. Photographer unknown. *Standing male model*. n.d. Photograph.
Museum of Modern Art, New York. Gift of Curt Valentin.

186. Thomas Eakins. *Hauling the Seine*. 1882. Oil, 12½ x 18 inches. Cincinnati Art Museum.

187. Thomas Eakins. *Drawing the Seine*. 1882. Watercolor, 8 x 11 inches. Courtesy John G. Johnson Collection, Philadelphia.

1932 in Philadelphia. In addition, Pierre Cabanne has indicated that Degas' picture of Madame Hertel in *Woman with Chrysanthemums* was based on a photograph. Cabanne also stated that photographs exist of Madame Arthur Fontaine, Monsieur Porjaud, and the artist himself, which served as studies for Degas' *Pouting*.

Degas' friend James Tissot also found the camera a useful ally. Tissot relied on photographs of his mistress, Kathleen Newton, for accuracy, when working on a number of prints made from 1877 to 1882. The figures in *Waiting for the Ferry*, as the art historian Henry Zerner has pointed out, were painted from a photograph, although Tissot made a number of changes and added a totally different background. (182-183)

In the snapshot the woman was keeping an eye on the little girl beside the fence. The girl was changed only slightly in Tissot's painting, but the woman's concern appears to be more internal and more pensive in the canvas than in the photograph. This also applies to the man. In the photograph he looked toward the little girl. In the painting he seems to be talking to the woman, which entirely alters the meaning of the picture. Tissot did not very successfully integrate the pre-existing figures from the photograph with the new setting of the painting. The background in the painting was lighted in a different fashion from the figures; as a consequence, the composition lacks conviction.

Paul Cézanne used photographs for various reasons. For one, he felt uneasy in the presence of most people and often found working from a photograph preferable to using a live model. A prime example of this way of working that has survived is the full-length studio picture of a man, nude except for a pair of short trunks. From this photograph Cézanne painted his standing male bather. Cézanne was a very slow painter and would have found it difficult to find a model who could hold a pose of this kind day after day. The frozen camera-made study was therefore doubly useful since it provided the painter with a "still" model with whom

he did not have to become involved personally. While many aspects of the photograph were incorporated in Cézanne's painting it should be noted that the effect of the figure in the painting is quite different from the effect conveyed by the man documented by the camera. (184-185) The photograph shows a static figure in an interior. Cézanne's figure, which he placed in a landscape, moves out toward us in a convincing fashion. The effect of movement was achieved, in part, by changing in the painting the position of the man's right kneecap and placing the model's feet closer together.

Cézanne generated an additional sense of dynamism by shortening the length of the figure's torso in comparison to the proportions of the model in the photograph. To keep the eye from dwelling too long on the head of his motif, Cézanne omitted the man's moustache. Further, we see that the edges of the model's body were recorded somewhat indistinctly in the photograph. Cézanne, on the other hand, painted the contours that defined the model's legs as a partially interrupted line which gave these elements tangible solidity and separated them from the background, characteristics at odds with the photograph.

Thomas Eakins, an American contemporary of Cézanne, used his own photographs in the place of detailed sketches when painting the effect of light and depicting people and animals in motion. This was to be expected of an artist who considered himself a "scientific realist." Recording the physical properties of his subjects was one of his primary aims. To achieve this goal, he often relied on camera vision. His oil, *Hauling the Seine*, of 1882, depended on many passages found in his photograph of the same subject. While he changed a number of elements, to a large extent he based his picture of fishermen seining for shad in the Delaware River on his photograph. (186)

In a watercolor painted the same year, *Drawing the Seine*, there is an almost one-to-one relationship throughout the composition between Eakins' photograph and his painting. (187) He photographed the

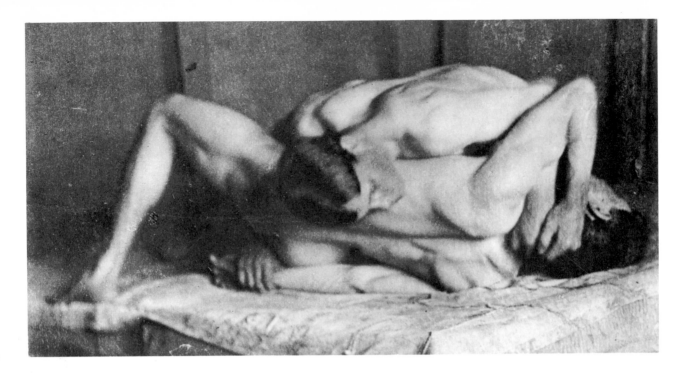

188.

189.

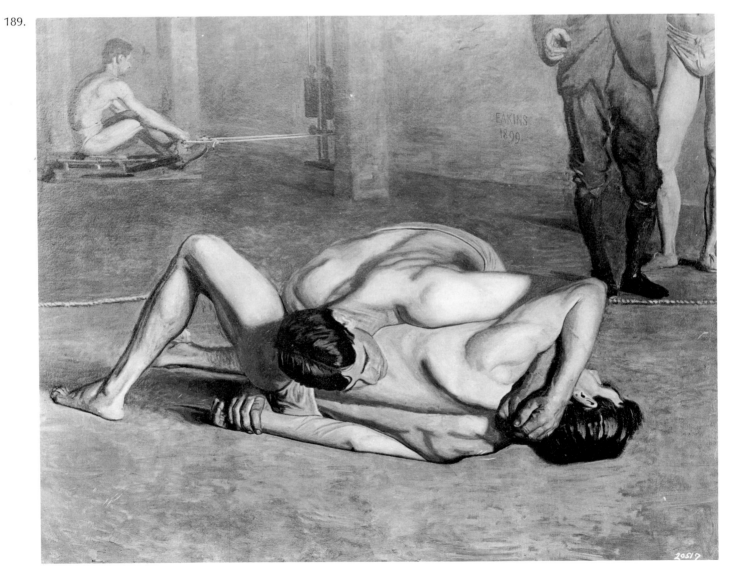

84

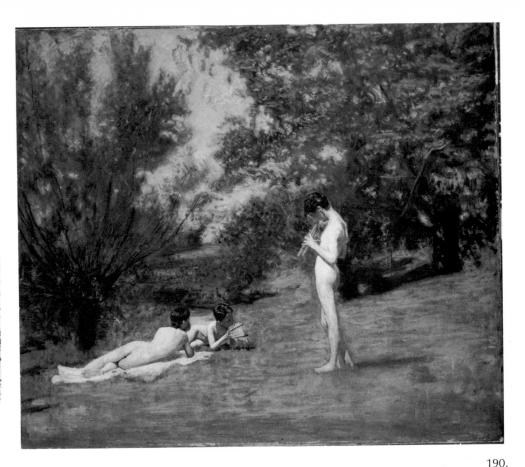

191.

190.

188. Thomas Eakins. *The Wrestlers.* 1899
Oil, 48 x 60 inches.
National Academy of Design Collection, New York.

189. Thomas Eakins. *Wrestlers.* c1889. Photograph.
Collection Joseph H. Hirshhorn, New York.

190. Thomas Eakins. *Arcadia.* 1900. Oil, 82 x 42 inches.
Metropolitan Museum of Art, New York.
Bequest of Miss Adelaide Milton de Groot (1876-1967), 1967.

191. Thomas Eakins. *Boy playing pipes.* c1900. Photograph.
Collection Joseph H. Hirshhorn, New York.

fishermen using a horse-powered device to pull in the nets cast in the Timber Creek estuary. The picture that resulted was transcribed, detail for detail, to watercolor paper.

One of Eakins' less successful paintings is *The Wrestlers.* (188-189) It is difficult to understand why this oil was submitted to the National Academy in 1899 as the artist's diploma picture. It is from a photograph, but he seemed in this canvas less able to transcend the limitations of the single view documented by his camera. Photographs were useful as a guide when painting a scene spread over considerable distances, such as the two pictures of fishermen, or to capture with accuracy the position of a fast-moving horse's legs. But Eakins was betrayed by his camera's limitation when he painted the two men wrestling. The convincing draftsmanship associated with Eakins' pictures of men in action is lacking. His painting of the wrestlers also lacks the high level of lifelike tangibility we associate with Eakins' work. The foreshortening of the

back of the man on top seems to have been copied blindly by Eakins without his realizing how one-dimensional is the record made with a camera's lens. He was apparently unable to rework his static photograph so as to convey the pulse of life in this painting.

A painting somewhat out of keeping with Eakins' usual subject matter is *Arcadia.* (190-191) For this picture Eakins posed his models to conform to the idea that he had in mind for the painting, then he photographed them instead of making detailed sketches. But his models seem uneasy in the poses Eakins had them take. His photograph of the boy lying on the ground playing pipes is especially stiff and artificial. The general theme of the canvas, while an homage to antiquity, was in truth an excuse for Eakins to paint the nude figure but it is overly contrived. This is due in part to the inconsistent treatment of the figures copied from photographs and the trees painted from life or imagination, as well as the stilted poses of the models.

The imprint of photography on Eakins was greater

192. 193.

194.

195.

192. Theodore Robinson. *Gathering Plums.* 1891.
Oil, 22 x 18 inches. Georgia Museum of Art,
University of Georgia, Athens. Holbrook Collection.

193. Theodore Robinson. *Woman picking fruit.* c1891.
Photograph.

194. Theodore Robinson. *Two in a Boat.*
Oil, 9¾ x 14 inches.
Phillips Collection, Washington, D.C.

195. Theodore Robinson. *Two in a boat.* c1891. Photograph.

than has generally been thought. Even so, it is clear that he considered the camera to be merely a working tool. He could successfully interweave what he knew about the human figure from his extensive study of anatomy with what he found in photographs. Usually Eakins subtly refined away the surface reality of his subjects. This was not the case in a staged event like *Arcadia*, but in *Drawing the Seine* he made very effective use of the light and movement recorded by his camera and produced a freshly realized genre scene.

America's leading Impressionist, Theodore Robinson, depended in a more sophisticated way on the sure eye of the camera to summon up recollections of his models. This fact was revealed a few years ago when a group of his photographs turned up in a small hotel in Giverny, France, where he painted over seventy-five years ago. He apparently used photographs for many of

his genre oils as well as for watercolors. (192-193) In explanation of this he wrote home from Paris in the early 1880s, "Painting directly from nature is difficult as things do not remain the same, the camera helps to retain the picture in your mind."

Economy may have been one reason for Robinson's reliance on photographs, although he was also following a practice that was accepted as legitimate by his contemporaries. He wrote in his diary in 1893 rather apologetically, "I don't know just why I do this [use photographs] . . . partly I fear because I am where other men are doing this—it is in the air."

The natural quality of the poses assumed by Robinson's models was retained in his painting. He also benefited from the light and shade patterns captured on film. Some of his work, however, has a tentative quality when the photographs he referred to were not clear

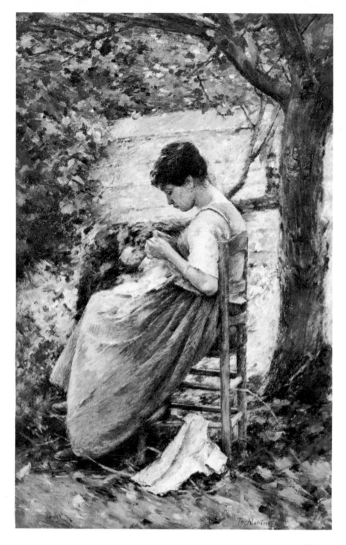

196.

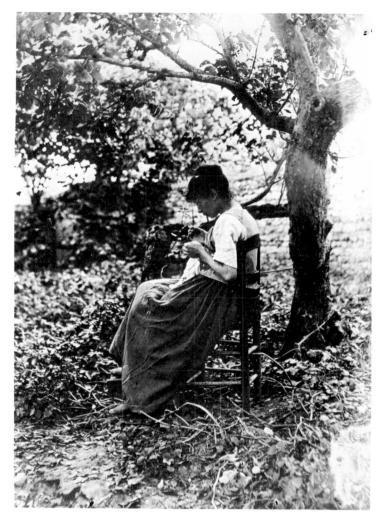

197.

196. Theodore Robinson. *The Layette.* 1892.
Oil, 58 x 36½ inches. Corcoran Gallery of Art, Washington, D.C.

197. Theodore Robinson. *Young woman knitting.* c1892.
Photograph.

in specific details. It is interesting to note that when a blur occurred in his photographs this quality was carried over into his paintings. Robinson, like most artists who depended on camera vision, simplified the arrangement of forms he found in his photographs and eliminated this or that detail which he felt was not suitable for his purposes. In his canvas *Two in a Boat* he eliminated one of the boats that appears in the study photograph used. (194-195) Except for this omission, the squared-off photograph was transferred to canvas almost intact.

Robinson's photograph of the woman on the ladder, which he used as a study for *Gathering Plums*, included only one person. He added a second figure on the left side of his composition but followed exactly the camera record of the major figure's head and left arm. The woman's head and arm were apparently moving when

the picture was taken and consequently appear somewhat blurred in the photograph. Because the leaves of the plant in the lower right-hand corner of the photograph were out of focus and therefore registered indistinctly, Robinson carried this characteristic over into his painting.

In his painting *The Layette*, Robinson muted details and added the piece of paper caught against the chair rung. (196-197) He ignored the fact that the trees in the background were out of focus, whereas the young lady and the twisted limb in the center of the composition were sharp. He treated the setting as if it were all slightly out of focus.

In considering the effect of using photographs, Robinson noted in his diary, "I must beware of the photo, get what I can out of it and then go. . . ." And later, "In the past too many things began well enough, but

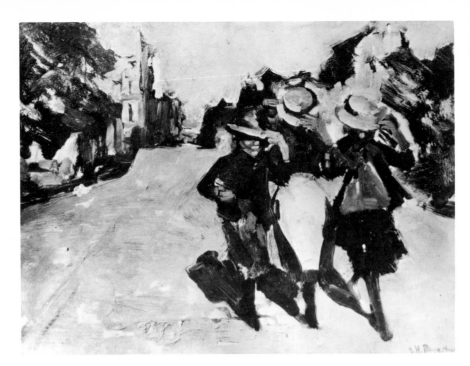

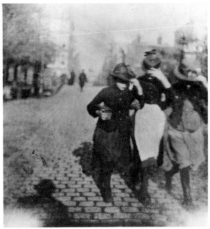

201.

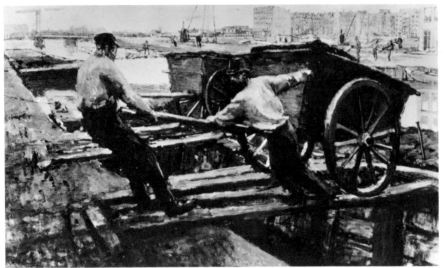

199.

200.

198.

198. Georg-Hendrik Breitner. *Kruiers.* c1895.
Oil, 31¼ x 52 inches.
Courtesy Lemniscaat, Rotterdam.

199. Georg-Hendrik Breitner. *Wheelbarrow men.* c1895.
Photograph.
Courtesy Lemniscaat, Rotterdam.

200. Georg-Hendrik Breitner. *Drie Meisjes.* c1895.
Oil, 26 x 38 inches.
Courtesy Lemniscaat, Rotterdam.

201. Georg-Hendrik Breitner. *Three young girls.* c1895.
Photograph.
Courtesy Lemniscaat, Rotterdam.

202. Fernand Khnopff. *Memories.* 1889.
Pastel, 50 x 78¾ inches.
Musées Royaux des Beaux-Arts de Belgique, Bruxelles.

203. Photographer unknown. *Woman with tennis racket,*
study for *Memories.* c1889. Photograph.
Musées Royaux des Beaux-Arts de Belgique,
Archives de L'Art Contemporain, Bruxelles.

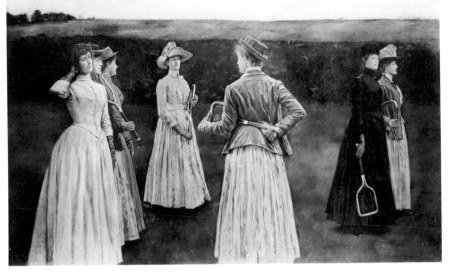

202.

203.

too many photos, too little model, time, etc." These thoughts seem to indicate that dependence on the camera bothered Robinson, and he blamed some of his problems as a painter on the fact that he worked from photographs. Despite his misgivings, Robinson throughout his Impressionist period relied on the camera to provide him with the major elements of his compositions.

Another Impressionist, the Dutch artist Georg-Hendrik Breitner, used his own photographs as a basis for many of his spirited paintings. He utilized the indistinct quality found in his snapshots of street scenes to evoke a sense of movement and candor. (198-199) His compositions were casual and convincing because he was able to incorporate in his paintings a realistic quality that came from the snapshots he took with a small folding Kodak camera. (200-201) He caught with the camera the ever-changing play of light on his subjects as they went about their everyday business; later, he studied the results at his leisure in the studio.

A Belgian contemporary of Breitner, Fernand Khnopff, was another painter who found casual photographs useful as a means of capturing details of costumes and unusual but true-to-nature poses of people for his figure paintings.

In his painting *Memories,* Khnopff used a snapshot as a sure point of origin. This is clearly seen in the unusual way in which the young lady with her back toward us holds her tennis racket and in the way the folds of her jacket are so realistically represented. (202-203) It appears that the photograph was deliberately posed to serve as a study rather than selected out of an album of random personal snapshots. The figure was transferred to the canvas intact except for the background which was painted to suit the scene and excluded the bushes recorded by the camera. The title *Memories* and the fact that Khnopff was associated with the Belgian Expressionist movement would seem to indicate that this scene was intended to be viewed as more than just a casual genre situation. It was more

204. Paul Gauguin. *Pape Moe (The Mysterious Water).* 1893.
Oil, 39 x 29½ inches.
Collection H. Anda-Buhrle, Zurich.

205. Charles Spitz. *Tahitian Youngster Drinking from a Waterfall.* c1883. Photograph.
Courtesy Bengt Danielsson, Stockholm.

206. Henri de Toulouse-Lautrec. *À La Mie.* 1891
Oil, 19¾ x 27½ inches.
Courtesy Museum of Fine Arts, Boston.
S. A. Denio Fund and General Income for 1940.

207. Paul Sescau. *Man and woman in cafe.* c1890. Photograph.

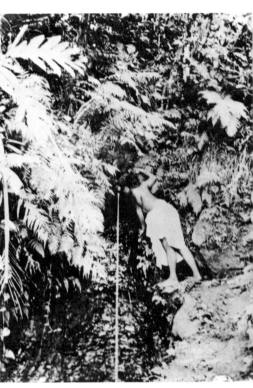

205.

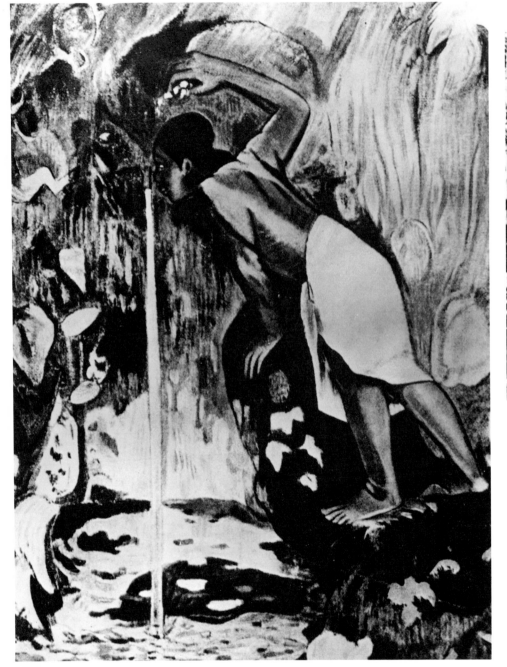

204.

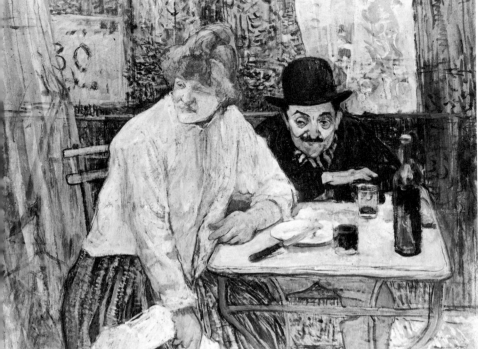

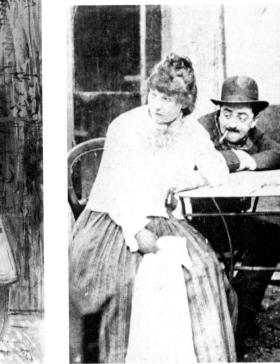

206.

207.

than likely intended as an excursion into nostalgia with connotations that are somehow strange in the same way that ordinary scenes by Munch or Ensor are "strange."

In a similar way Gauguin used a photograph by Charles Spitz as a guide when painting a picture of a Tahitian youngster drinking from a waterfall. (204-205) In the painting the water flows into a pool at the feet of the Tahitian rather than dropping out of the picture as it does in the photograph. This change provided Gauguin with a motif in which he could include the flowing forms he loved so much to paint. Gauguin also greatly simplified the appearance of the vegetation, especially the delicate fern leaves. In the place of lace-like fronds in the photograph, he created flat shapes with undulating outlines to represent the lush tropical growth. These shapes help to convey a feeling of mystery consistent with the title of the painting *Pape Moe (The Mysterious Water).*

Henri de Toulouse-Lautrec was the best-known turn-of-the-century artist to use photographs. His frequent companion was the professional photographer Paul Sescau, for whom he made a large lithographic advertising poster. In 1891, under Lautrec's direction, Sescau photographed Maurice Guilbert and a model seated at a cafe table. From this picture the essential elements for Lautrec's painting *À La Mie* were taken. Many of the details of the girl's dress and pose were suggested by Sescau's photograph. (206-207) A camera, when used at a reduced elevation, will record with exaggerated prominence foreground objects that are close to the photographer. This choked-up perspective was first used by Degas and appeared a number of times in Lautrec's work. His painting *Fernando Circus: The Ring Master* is a prime example of foreground exaggeration, as the horse's rump is out of all proportion to the way we would see it firsthand. This type of imagery is derived from photographic distortions.

Lautrec, late in his brief career, again looked to the camera for assistance. In 1900 he wrote to Maurice Joyant, one of his closest friends, "Have you any photographs, good or bad, of *Messaline* by de Lara? I am enthralled by this opera, but the more documentation I have, the better I shall be able to work."

4. GENRE

TWENTIETH CENTURY

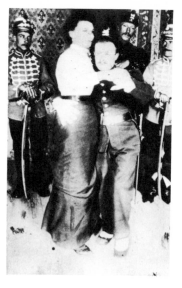

210.

209. André Derain. *At the Suresnes Ball.* 1903.
Oil, 70⅞ x 47-1/16 inches.
City Art Museum, St. Louis, Mo.

210. Photographer unknown. *Soldiers off duty.* 1903.
Photograph. Courtesy *Paris Match.*

211. Edvard Munch. *Young Girl in Front of Bed.* 1907.
Oil, 57 x 58 inches. Munch-Museet, Oslo.

212. Edvard Munch. *Young Girl in Front of Bed.* c1906.
Photograph. (A double exposure made by the painter in
Berlin.) Munch-Museet, Oslo.

209.

211.

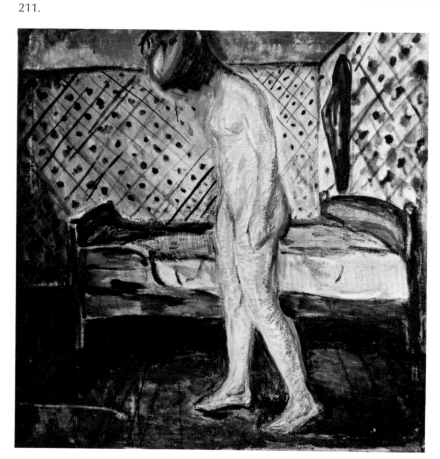

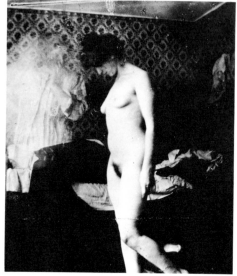

212.

208. Will Barnet. *Portrait of Djorje Milicevic.* 1967.
Oil, 37½ x 21½ inches.
Collection Art Students League, New York.

4. GENRE
TWENTIETH CENTURY

In the early years of the twentieth century there were produced some interesting paintings related to photographs. André Derain, working in his early style, painted *At the Suresnes Ball* from a photograph. It is a quotation from a snapshot of soldiers off duty in a dance hall and was painted as a reminder of the artist's service in the French army. (209-210) In addition to recalling the past there probably were pictorial considerations that attracted Derain to this snapshot. Perhaps he recognized that this picture, small in scale, casually conceived, and lacking color could give him a different viewpoint from a studio setting and posed models. The imprecise illusion of mass and space in the snapshot may have also attracted Derain.

One of the differences between painting from direct experience and painting from a photograph may be explained in part by the way a lens casts a scene on film. The camera works with a single eye that sees in a more or less flat pattern; and as a consequence, photographs lack the atmospheric separation and tangible corporeal qualities we experience with our eyes. If a lens is of simple construction, as is generally the case with inexpensive cameras, the pictures made with it tend to lack definition. When sharpness is decreased, either through focus, camera movement, or type of lens used, a broadening or spreading of the image occurs that results in photographic prints without plastic values.

The rather stilted, playing-card appearance of the figures in Derain's painting was caused by lack of the three-dimensional quality in the snapshot that served as his model. This was particularly noticeable in the blouse and face of the woman dancer and in the white glove pressed against her hip by her soldier partner. The photograph not only served as a reminder of many details and gave the artist a ready-made composition, but also dictated to a large extent the handling of the material, in that the painting retained the somewhat crude qualities of the snapshot.

In 1905, only a few years after Derain painted *At the Suresnes Ball*, he turned his back on photographs and became one of the artists who shocked the Paris art world with an exhibition of highly colored dissonant paintings at the Autumn Salon. Called "Fauves" by a critic, Derain and the painters who worked in this fashion were seeking to use bright and exuberant colors as a means of charging their work with a sense of great vitality. Derain felt they were using bright colors applied with gusto to disassociate themselves from the influence of the camera. He wrote of this period, "It was the era of photography. This may have influenced us, and played a part in our reaction against anything resembling a snapshot of life." This may indicate that the reaction against photography was a much more important factor in shaping the history of art than has been considered.

André Derain often took the nude as his subject in the twenties when his work began to have neo-classic overtones. It was during this period that he again found photographs useful. Man Ray in his autobiography tells about a visit he paid to Derain in the early twenties. "When I came to his studio he said he was very much interested in photography and thought it could be a great help to painters. He then produced some photographs of nudes saying he studied them before starting a painting. He did not want anything artistic, he said, just a documentary which could guide him." None of the camera studies Derain used are available for comparison, but it is not difficult to see photographic characteristics in his post-World War I nudes.

It is rather surprising to find that a few years earlier Edvard Munch also used a photograph of a nude model as a guide for at least one of his paintings. The somber canvas *Young Girl in Front of Bed* (1907) and a related lithograph were derived to a large extent from a photograph made by Munch in Berlin. (211-212) The photograph, with the ghostlike figure at the foot of the bed and the detailed recording of rumpled bedsheets, is a more provocative image than Munch's heavy-handed picture. With such a strong photograph before him, it is interesting to note that he omitted the semi-transparent

213. Henri Rousseau. *Artillerymen.* c1895.
Oil, 31¾ x 39½ inches.
Solomon R. Guggenheim Museum, New York.

214. Henri Rousseau. *Negro Attacked by a Jaguar.* 1907.
Oil, 44⅛ x 66 inches. Kunstmuseum, Basel.

215. Photographer unknown. Page from a picture book of
wild animals that belonged to Rousseau.

216. 217.

216. Heinrich Zille. *Even the Littlest One May Also Watch.*
1908. Drawing. Reproduced from *Mein Photo-Milljoh.*
Courtesy Fackelträger-Verlag Schmidt-Kuster, Hannover, Germany.

217. Henrich Zille. *Even the littlest one may also watch.* 1908.
Photograph. Reproduced from *Mein Photo-Milljoh.*
Courtesy Fackelträger-Verlag Schmidt-Kuster, Hannover,
Germany.

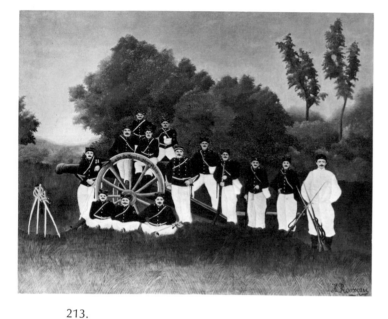

213.

214.

215.

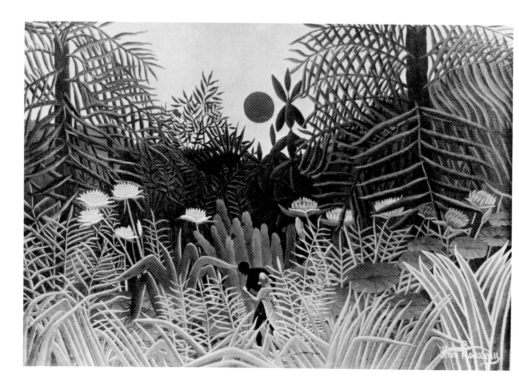

96

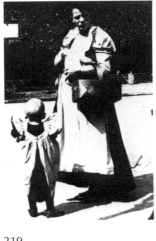

219.

218.

218. Heinrich Zille. *On the Way to Market.* c1900. Drawing. Reproduced from *Mein Photo-Milljoh.* Courtesy Fackelträger-Verlag Schmidt-Kuster, Hannover, Germany.

219. Heinrich Zille. *On the way to market.* c1900. Photograph. Reproduced from *Mein Photo-Milljoh.* Courtesy Fackelträger-Verlag Schmidt-Kuster, Hannover, Germany.

220. Walter Sickert. *The Raising of Lazarus.* 1928-29. Oil, 96 x 36 inches. National Gallery of Victoria, Melbourne.

221. Walter Sickert(?). *Posed models for "The Raising of Lazarus."* c1927. Photograph.

220. 221.

male figure, pubic hair, and his model's full breasts.

Henri Rousseau, the French primitive painter, was often inspired by snapshots and borrowed a number of his compositions or parts of them from photographs. A rather crude half-length ink drawing of the artist was created in this way. Further, *The Cart of Père Juniet* was also based to a large extent on a photograph. Poses of the participants in *Artillerymen* (213) and *Country Wedding* indicate that these paintings were copied from standard group photographs.

A more interesting and certainly more imaginative use of a photograph can be seen in Rousseau's *Negro Attacked by a Jaguar.* (214-215) The man in the photograph was changed in the painting from a zoo attendant to a black jungle native, and the front paw of the "attacking" jaguar was placed in a different position. Most details of the man being mauled were suppressed to gain a more realistic feeling of an African landscape. Nevertheless, the camera supplied the painter with the idea and the basic form for this part of his romantic composition.

The very popular Berlin illustrator and genre artist Heinrich Zille was a prolific photographer. He used a hand camera to take pictures of all kinds of street life, as well as studio interiors complete with models, as the

basis for many of his published drawings. (216-217) The camera provided him with documentation of people hurrying to market, hanging up the wash, or pushing a baby carriage full of firewood. His photographs also served as records of store fronts and buildings, which he copied as backgrounds for his semi-caricature genre sketches of simple everyday scenes. The camera studies enabled him to bring to his drawings a sense of genuineness without the necessity of making detailed drawings of unfamiliar scenes. He could go through a file of his photographs at leisure and pick out suitable details of a locale he wished to draw without having to revisit it. (218-219)

In England Walter Sickert, who represents a late link between Victorian genre painting and Impressionism, was attracted to photography both as an inexpensive means of obtaining models and as a way of freeing himself from academic conventions. His close friendship with Degas may have encouraged this practice. Sickert superimposed his own charming impressionistic style of applying paint on unconventional compositions made with a camera. While many of the themes of his pictures—particularly in the 1920s and 1930s—were borrowed from photographs, the subjects were often drawn from biblical literature. His canvas

222.

223.

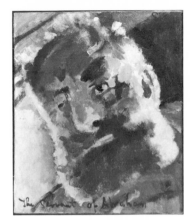

226.

227.

222. Walter Sickert. *Portrait of Edward VIII*. c1935.
Oil, 72 x 36 inches. Whereabouts unknown.

223. Photographer unknown. *King Edward VIII*. c1935.
Photograph.

224. Walter Sickert. *Self-Portrait with Blind Fiddler*, 1928 or
1929. Oil, 26 x 16 inches.
Collection G. Welsh, London.

225. Walter Sickert(?). *Posed models for "Self-Portrait with
Blind Fiddler."* Photograph.

225.

224.

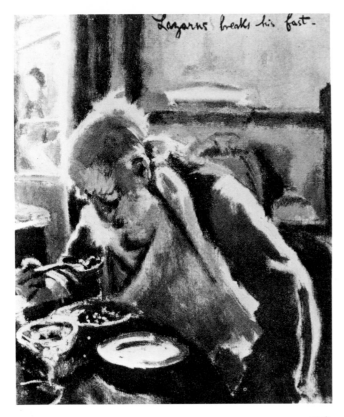

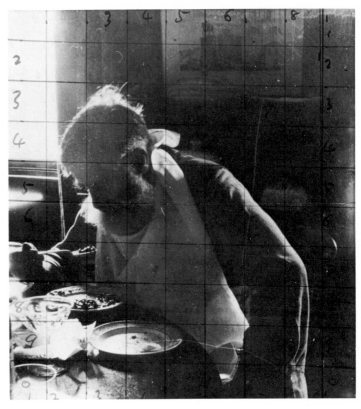

228.

229.

226. Walter Sickert. *The Servant of Abraham.* 1929.
Oil, 24 x 20 inches. Tate Gallery, London.

227. Walter Sickert. *Study for "The Servant of Abraham."*
c1929. Photograph.
Courtesy Courtauld Institute of Art, London.

228. Walter Sickert. *Lazarus Breaks His Fast.* 1927.
Oil, 30 x 25 inches.
Collection Eric Estorick, London.

229. Walter Sickert. *Man with beard.* c1927. Photograph.
Courtesy Courtauld Institute of Art, London.

The Raising of Lazarus was based directly on a photograph for which he and a friend posed with a lay figure. (220-221) In this photograph the figures are centered in the picture space. Sickert created a dynamic composition by placing the action on the extreme left edge of his canvas, even to the extent of cutting off parts of the figures. He also considerably lightened the degree of illumination on the face at the top of the painting but treated the center part quite as he found it in the photograph. It was Sickert's practice to create visual tensions by offsetting his figures. *The Raising of Lazarus, Self-Portrait with a Blind Fiddler,* and *Portrait of Edward VIII* illustrate this tendency.

Noting Sickert's use of photos, his biographer, Lillian Browse, noted, "They [photographs] certainly saved him from having to plan his compositions, and although he drew over them and squared them up, the spade work had already been done." (222-225)

A photograph of the artist and a rather poor snapshot, both of which were squared off for enlargement, provided Sickert with the essential data for *The Servant*

of Abraham and *Lazarus Breaks His Fast.* (226-229) In the photographs used as models for these paintings, strong lighting comes from the side and rear. The camera cannot adjust to and record with clarity those portions of a scene which include extremes of dark and light as can the human eye. As a consequence sharp tonal contrasts are often the result in photographic prints. Sickert exploited this effect in both of these paintings.

Sickert felt that any source was a legitimate point of departure, and R. N. Wilenski commented on this as follows:

His habit was to paint from drawings or photographs or prints. In some cases he used other people's photographs, in others he took the photographs himself or had them taken for his purpose. In his later years he used photographs especially for his portraits and genre pictures and advertised this by letters to the London papers and by inscribing on his double portrait *King George V Talking to Major Fetherstonhaugh at the Grand National 1927* "By courtesy of Topical Press" [copyright owners of photographs used]. (230-231)

99

230.

231.

Photographs not only provided a convenient way to work but gave Sickert viewpoints not found in direct experience. In his old age he came to rely almost exclusively on the camera for pictorial ideas. If we view his procedure in historic terms, perhaps we could say that he returned to the Renaissance practice of working from cartoons—cartoons meaning in this case photographs.

In the United States many painters of the West used photographs to ensure accuracy of dress and realistic poses when they took Indians of the region as their subject. Irving Couse, a well-known painter of Indians, photographed a Hopi dance before taking pictures of such ceremonies was forbidden by the Indians. In 1903 he decided to square off and enlarge a scene he had photographed of a Hopi flute dance. (232-233) He was hampered, however, by the candor of his model, which did not reflect his idea of how the theme of the dance—the creation myth—should be portrayed. Since he had

composed the snapshot in his camera viewfinder it had a semblance of artistic value. He was willing to accept the general placement of many of the elements as recorded on film, but he felt that changes in composition and emphasis had to be made. Accordingly, he tried to point up the action by stripping away superfluous elements, but made use of his model to ensure accuracy in details of dress and gesture. Left out of the canvas are certain details of the building and two burros in the middleground that did not suit the artist's sense of order—as well as the child in the foreground.

Couse's painting shows the medicine man funneling corn meal from his cupped right hand to create on the ground a symbolic design of clouds and rain; yet, due to the child in the foreground, this is scarcely visible in the photograph. To compensate for these shortcomings in his photograph, Couse relied either on memory or on some other snapshot now lost when he painted this very important aspect of the ceremony. There is little

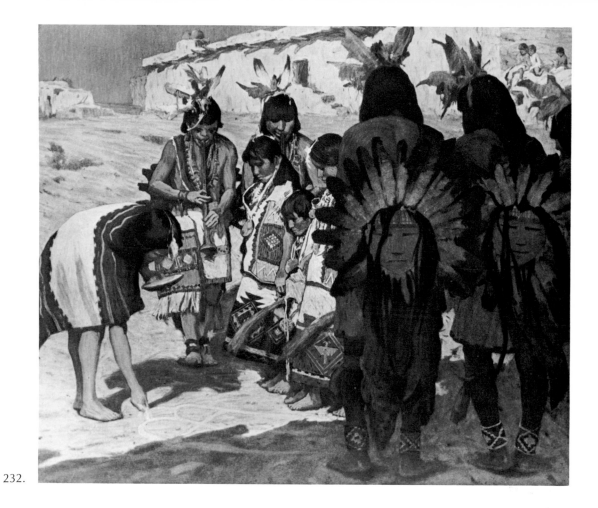

232.

233.

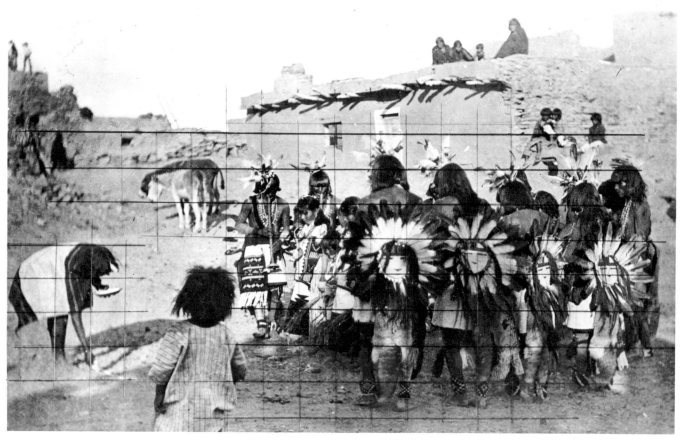

234.

235.

doubt that his changes added order and clarity to the scene.

It would, however, be a mistake to attribute much esthetic significance to the original photograph, for it was only an objective report of what was going on at the moment the shutter was released. Couse's real concern was to produce a work of art which possessed traditional artistic values, without sacrificing the naturalistic quality of the snapshot. Here, as in all his Indian paintings, it is the spirit of the ceremony, not the event alone, that he was after; and the photograph served as a bridge between the actual event and his somewhat idealized vision of the ceremony.

Couse believed that his Kodak provided more accurate details than preliminary sketches could; and this was justification enough, both for him and for many other painters. It is curious that few of the photographs they used have survived, perhaps because there was a stigma attached to using them as reference material.

Nicolai Fechin, like Couse a longtime resident of Taos, New Mexico, often used his own commonplace snapshots as preliminary sketches for some of his freely brushed canvases of picturesque subjects and for his skillfully drawn portraits. The photographs provided him with natural light and shade patterns and with spontaneous facial expressions.

Those photographic elements that he considered distracting were eliminated. (234-235) He often concentrated on a subject's smile, an expression too difficult to hold long enough to permit detailed drawings from

life. (236-237) In his paintings Fechin followed the general format of his snapshots, but his heavy impasto masked this fact, unless the photograph is carefully compared with the painting.

Oscar Berninghaus was another New Mexico artist who included details traceable to photographs. If all the facts were known, it is probable that the majority of Western painters used photographs for their canvases of Indians and Pueblo life. The house in the background of Berninghaus' painting *Tesuque Pueblo* can be traced to a set of photographic prints of Pueblo Indians and their environment made about 1890 by D. B. Chase of Santa Fe. The photograph Berninghaus selected showed the Governor's residence in the Pueblo of Tesuque. By including an exact copy of this building as a background for the Indian striding toward us, Berninghaus evoked a feeling of authenticity. (238-239) The placing of the central figure is reminiscent of a snapshot in that the head of the Indian is slightly merged with the building and does not stand out emphatically. Berninghaus, more often than most of the Taos artists, usually portrayed actual events of everyday life in the pueblos, rather than idealized situations. For this reason we must suspect that the camera provided him with many details and compositional suggestions.

Many well-known Western painters used snapshots to authenticate the features of cowboys and horses at rest or in motion. The Gilcrease Institute in Tulsa has an extensive file of photographs taken by W. R. Leigh who concentrated on genre scenes of the West, giving

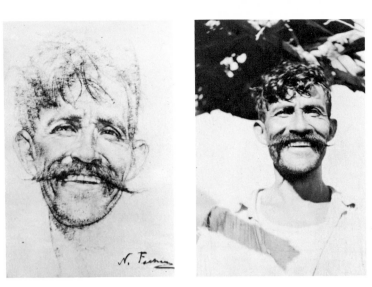

236. 237.

234. Nicolai Fechin. *Indian Grandfather* (actually a woman).
n.d. Oil, 20 x 24 inches.
Collection Douglas W. Cotton, Tulsa, Okla.

235. Nicolai Fechin. *Old Mexican woman.* n.d. Photograph.
Courtesy Eya Branham, Albuquerque, N.M.

236. Nicolai Fechin. *Smiling Man with Mustache.* n.d.
Drawing, 17 x 13¼ inches.
Courtesy Eya Branham, Albuquerque, N.M.

237. Nicholai Fechin. *Laughing man.* n.d. Photograph.
Courtesy Eya Branham, Albuquerque, N.M.

239.

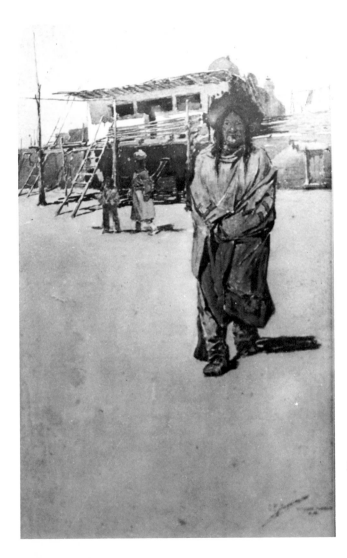

238. Oscar Berninghaus. *Tesuque Pueblo.* c1925.
Watercolor, 16 x 10 inches.
Collection Dr. and Mrs. Philip Shultz, Tesuque, N.M.

239. D. B. Chase. *Governor's residence in ancient pueblo of
Tesuque.* c1890. Photograph.
Collection Dr. and Mrs. Philip Shultz, Tesuque, N.M.

238.

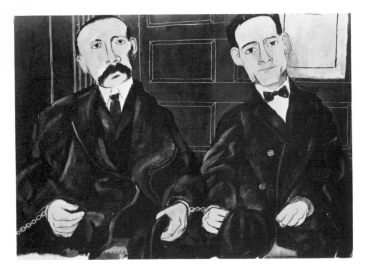

240.

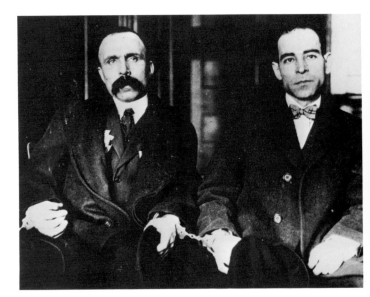

241.

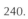

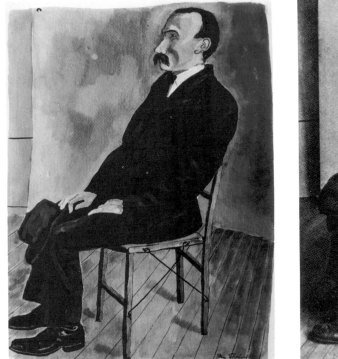

242.

243.

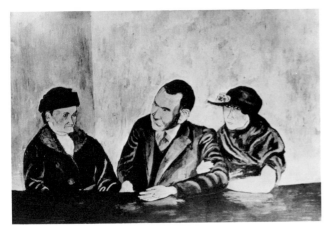

244.

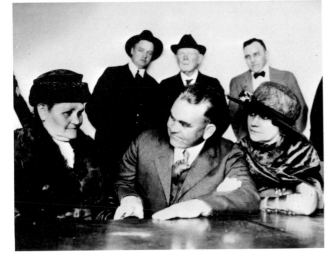

245.

240. Ben Shahn. *Bartolomeo Vanzetti and Nicola Sacco.*
1931-32. Tempera on paper, 10½ x 14½ inches.
Museum of Modern Art, New York.
Gift of Mrs. John D. Rockefeller, Jr.

241. Photographer unknown. *Bartolomeo Vanzetti and Nicola Sacco in the prisoner's dock.* 1921. Photograph.
United Press International.

242. Ben Shahn. *Bartolomeo Vanzetti.* 1931-32.
Gouache, 14½ x 11½ inches.
Collection, late Edith Halpert, New York.

243. Photographer unknown. *Bartolomeo Vanzetti before the Dedham trial.* 1921. Photograph.
Courtesy Viking Press, New York.

244. Ben Shahn. *Tom's Mother, Tom, Tom's Wife.* 1932.
Gouache, 16 x 23¾ inches.
Herbert A. Goldstone Collection of American Art, New York.

245. Photographer unknown. *Tom Mooney, his wife and mother.* 1930. Photograph.
Courtesy San Francisco Public Library.

special attention to accuracy of details. An examination of Leigh's paintings indicates how often he used photographs in developing his finished canvases.

In ways not often considered, Leigh's paintings are related to those of the Easterner, Ben Shahn. Both men used photographs as a guide, but Shahn's purpose was to use art as an instrument for social change. In 1927 two Italian immigrants, one a shoemaker, the other a fish peddler, were executed for murder in Massachusetts. The trial of the men was of international importance because the verdict seemed to be based on testimony that they were members of an anarchist movement rather than on conclusive evidence of murder. Many people close to the case were of the opinion that the men had had nothing to do with the crime, and consequently Nicola Sacco and Bartolomeo Vanzetti became symbolic martyrs representing all oppressed people.

In 1927 after the Italians had been executed, Ben Shahn went to Paris and while there witnessed demonstrations by French labor unions protesting the death of Sacco and Vanzetti. The experience of seeing how their unjust treatment and death had become the focus for worldwide objections made a lasting impression on Shahn. In 1930 he began a series of gouaches titled *The Passion of Sacco and Vanzetti*, based to a large extent on press photographs, for the artist had never actually seen the two men. (240-243) This group of pictures brought Shahn considerable recognition and identified him with left-wing causes.

In 1932 he painted a second series of pictures dealing with political martyrdom, social injustice, and political chicanery. These were of Tom Mooney and memorialized his unjust imprisonment. Mooney was accused of planting a bomb that injured and killed a number of people in San Francisco during the Preparations Day Parade in 1916. Like Sacco and Vanzetti, he was considered an anarchist and, with no concrete evidence against him, condemned to death. Later the Governor of California commuted this sentence, and after

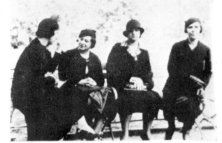

250.

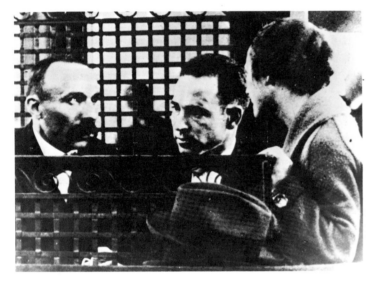

246.

247.

246. Photographer unknown. *Bartolomeo Vanzetti and Nicola Sacco.* 1921. Photograph.
Art Museum, Princeton University, N.J.

247. Ben Shahn. *In the Courtroom Cage.* 1931-32.
Gouache, 11½ x 14½ inches.
Art Museum, Princeton University, N.J.

248. Ben Shahn. *Study for "Nearly Everybody Reads the Bulletin."* c1945. Photograph.

249. Ben Shahn. *Study for "Nearly Everybody Reads the Bulletin."* c1945. Photograph.

250. Ben Shahn. *Nearly Everybody Reads the Bulletin.* 1946.
Gouache and ink, 22 x 29⅞ inches.
Philadelphia Museum of Art, Philadelphia.
The Louis E. Stern Collection, '63-181-67.

251. Ben Shahn. *Willis Avenue Bridge.* 1940.
Tempera on paper over composition board, 23 x 31⅜ inches.
Collection Museum of Modern Art, New York.
Gift of Lincoln Kirstein.

252. Ben Shahn. *Studies for "Willis Avenue Bridge."*
Photographs (pair).

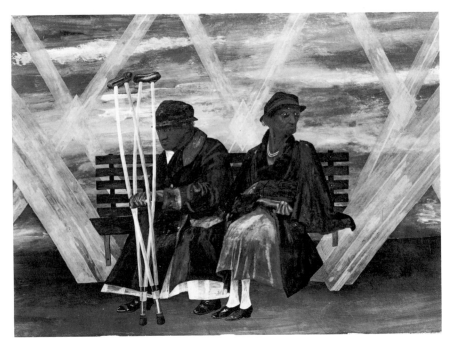

251.

252.

several appeals Mooney was pardoned in 1939. In these pictures of Sacco and Vanzetti and of Mooney, Shahn had difficulty distinguishing between caricature and candor.

Painting in an incisive graphic style Shahn sought to focus public attention on these events of national and international political importance. He used photographic source material to lend authenticity to his abridged versions of the subjects. His paintings were intended to enlist sympathy for the liberal causes he espoused but too often his interpretations of the people involved were stiff, contrived, and, to some extent even falsified for emphasis.

In the photograph it may be noted that Mooney and his mother both have faint smiles on their faces. (244-245) Shahn, however, inverted the smiles into solemn expressions and eliminated the onlookers who gave the scene a sense of reality. In the painting of Sacco seated behind a courtroom cage, Shahn carried over the hat in the foreground from the photograph he used as a guide. The hat as Shahn painted it floats in space without support. Study of his source photograph indicates that the canted hat, in fact, rests on another hat. Shahn's treatment of many details in the Sacco paintings could be compared to the effect of looking at a bad foreign film with stilted subtitles. (246-247) He superimposed his pseudo-documentary style of drawing on the straightforward record made by the lens. This often brought Shahn close to artistic failure, as he attempted to excerpt from and add meaning to his sources, which in

their raw state were more convincing than his paintings when it came to communicating the essential ideas with which he was concerned.

In the early thirties Shahn shared an apartment in New York with the well-known photographer Walker Evans, who taught him how to use a camera. During the Depression years Shahn became a member of the Farm Security Administration team of photographers and made some notable pictures with his Leica. Many of the photographs taken under these circumstances later became sources for bits and pieces of imagery that appeared in his paintings made in the years immediately preceding World War II. The extent to which Shahn's camera assisted him and in some instances substituted for his vision may be seen by comparing his paintings—*East Twelfth Street, The Blind Accordion Player*, and *Nearly Everybody Reads the Bulletin* —with his photographs. (248-250) Shahn photographed the accordion player in New York during the mourning procession that followed Roosevelt's death in 1945. The blind musician's grief is symbolized by felled trees in the background. Elements of *Willis Avenue Bridge* (251-252) were taken from two of Shahn's photographs. In his Social Security Building mural the basketball players were based in part on photographs that Shahn contributed to *Cecil Beaton's New York*.

Echoing Delacroix's early statements Shahn once said, "Photographs give those details of forms that you think you'll remember but don't—details that I like to put in my paintings." In describing a specific instance

255.

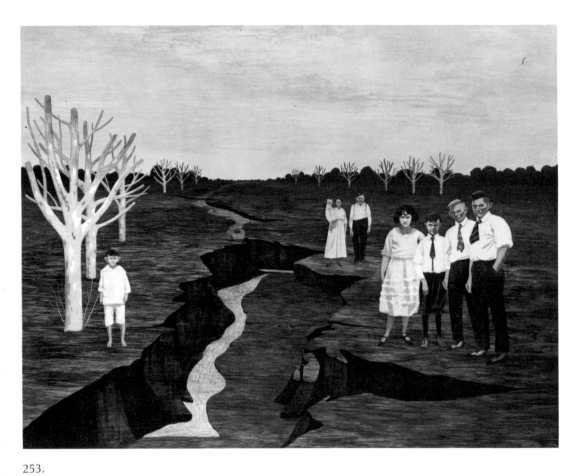

257.

253.

256.

254.

253. Carroll Cloar. *Alien Child.* 1955. Gouache, 25 x 32 inches.
Collection Joseph H. Hirshhorn, New York.

254-257. Photographer unknown. *Family Snapshots.*
1919 and 1921. Photographs.
Courtesy Carroll Cloar, Memphis, Tenn.

of his use of photography, Shahn noted, "The composition called for some kind of accent in the middle and I knew there'd be an election poster on that fence, so I looked through my photograph files to find one. I've got about three thousand. I picked out this particular one and copied it just as it was." This hybrid vision, part through the eyes and part through the lens, shaped Shahn's style to a large extent. From photographs he took gestures, details, and situations which sometimes retain the visual energy of the prototype but more often mock the factuality of the camera.

The paintings of Carroll Cloar are social comments as much as Shahn's pictures but in different terms. His recent work chronicles the history of the hermetic world peculiar to rural Arkansas, Tennessee, and the bayou country of the Mississippi Valley. Although the camera documents with extreme objectivity, Cloar has produced some very subjective paintings from the imagery registered on film.

For the most part Cloar's pictures are autobiographical and his kinship with the people and places he portrays imbues his pictures with the pulse of life. His characters ring true and their frozen expressions reflect the masks and poses people assume as they wait self-consciously to hear the shutter click. Yet factual as they appear on the surface, his paintings have eerie nuances and suggest an enigmatic mood that is at odds with the prosaic appearance of his subjects. His characters stem from snapshots, but a mood of fantasy is conveyed by Cloar's shifting and rearranging of these ordinary people in a variety of imaginative settings. (253-257) He combines a battery of mementos from a family album into a scenario that is rich in iconography, an iconography that is peculiarly in tune with life in the South. His pictures of the proud people of his region hint at tragedy and human weakness, in the same way as do the word pictures of William Faulkner.

News magazines and newspapers also provided a new source of imagery for artists of the 1930s, for more and more the mass media included newsphotos. Initial-ly, only a relatively few artists took advantage of this means of expanding their visual experience, although illustrators and commercial artists were making wide use of the camera in their work. It was not until the late fifties and early sixties that painters realized the pictorial possibilities inherent in news photography. The appeal then was hydra-headed but can be directly related to the vogue for "found objects" and the wish of some painters to return to realistic subject matter after experimenting with various styles of abstraction. Such artists used photographs in a variety of ways. Some searched for unusual relationships in the reduced vision peculiar to photographs, others realized that there is an independent expressive potential in camera imagery; still others were strongly influenced by their empathetic response to the subject matter in newsphotos.

In April 1945 the British Second Army arrived at Belsen, Germany, where the Nazis maintained one of their extermination camps. The wasted bodies of starved and murdered men and women had been cast into an open pit since inmates of the horror camp were dying faster than they could be buried. A British photographer recorded this communal death pit, and the picture was widely published. Picasso must have seen it for there are a number of elements in his *Charnel House* that seem to have been inspired by parts of this photograph. (258-260)

While Picasso cast his painting in a mold reminiscent of *Guernica* and used the freedom he had developed in his synthetic Cubist days, the two heads in the foreground are distinctly related to the head of the woman in the middle of the photograph and the egg-shaped head quite closely resembles that of the blood-soaked face of a man at the top (right) of the photograph. The third head in *Charnel House* may have been taken from the dark face found at the knee of the woman whose features were used for the right-hand foreground face in the painting. The unusual position of the victim's nose seems quite similar to the way Picasso painted the

258. Pablo Picasso. *The Charnel House*. 1945.
Oil and charcoal on canvas, 78⅝ x 98½ inches.
Collection Museum of Modern Art, New York.
Mrs. Sam A. Lewisohn Bequest (by exchange) and Purchase.

259. Photographer unknown. *Belsen Concentration Camp*
(Mass Grave). 1945. Photograph.
Imperial War Museum, London.

260. Photographer unknown. *Details from Belsen*
Concentration Camp (Mass Grave).

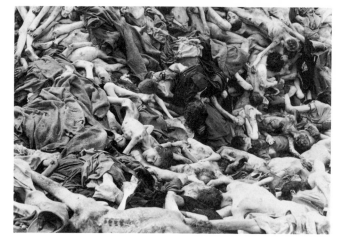

259.

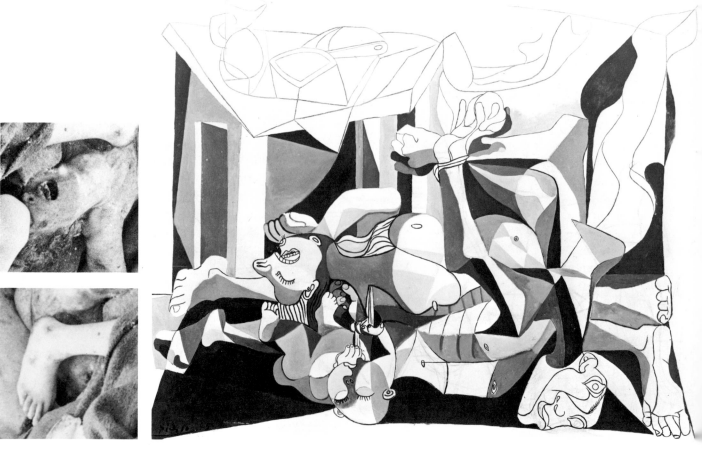

260. 258.

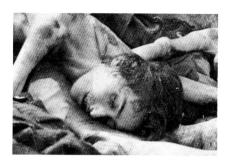

260.

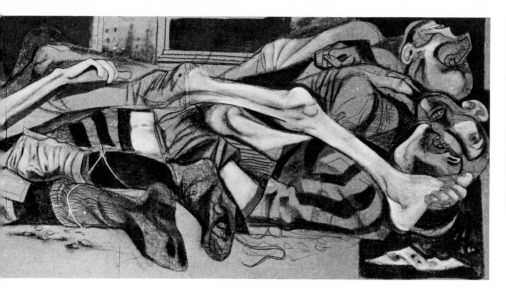

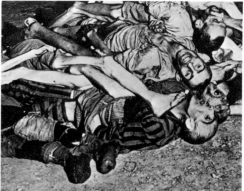

262.

261. Rico Lebrun. *Floor of Buchenwald No. 1.* 1957. Casein and ink, 48 x 96 inches. Estate of Rico Lebrun.

262. Lee Miller. *Buchenwald.* 1945. Photograph. Courtesy Lee Miller (Lady Penrose), Sussex, England.

nose in his picture, in that the nostrils were given unusual prominence along with the open mouth. The leg and foot nearby also seem strikingly like the representation of the same elements in Picasso's painting. As would be expected and as was his practice, Picasso improvised and freely transposed parts of faces, but the photograph seems to have provided him with a pictorial basis on which he based his protest canvas painted in Paris in the last part of 1945.

Picasso was a friend of Lee Miller, now Lady Roland Penrose, who may have shown him a number of her shocking photographs of dead concentration camp inmates. Her pictures were among the earliest taken in concentration camps, and she was one of the first members of the press corps to see Picasso after the liberation of Paris. But the specific photograph mentioned appears to have been the inspiration for *The Charnel House.*

Rico Lebrun, like Picasso, long a painter of humanity's agonies, reacted strongly to photographs of German extermination centers. His deep concern for those who had suffered and died in Germany resulted in his 1955 Buchenwald series. These paintings were inspired by news photographs of dead prisoners in that famous camp. Human bodies, stiff in death, heaped in a pile like so much cord wood, make a startling impression and affront the sensibilities, even when experienced only through a photograph.

Of his Buchenwald series Lebrun said, "I did many precise and lucid drawings using the photographic doc-

umentation available on the subject as a text to maintain and amplify if possible the authenticity of brute force." (261-262) The esthetic success of this encounter is, however, subject to question. Lebrun recognized his peculiar position as an artist attempting to augment the ultimate in "authenticity," the photograph that is impartial and without conscience. He nevertheless apparently felt the need to paraphrase rather than to follow the photograph. As a result he organized a number of elements in his pictures in a more orderly fashion than is found in the photograph. He thus risked the danger of bowing to "artistic" concerns at the cost of de-emphasizing the raw facts he attempted to extract from the photograph.

After seeing the comparison between Lee Miller's photograph of bodies piled up at Buchenwald and Lebrun's *Floor of Buchenwald No. 1*, reproduced in the catalog *The Painter and the Photograph,* the philosopher Raymond Durgnat elaborated on Lebrun's failure to grasp the problem of transcribing this scene:

Lebrun, a sincere and intelligent painter, has missed over and over again telling the details recorded by the camera's "passive" eye and substituted conventions of form, of anatomy, of composition. Almost involuntarily he has brought compositional order into a heap of bodies whose horrid eloquence lay precisely in the "asymmetrical" clutter of thrown-back heads. The photograph reveals that thighs have become thinner than calves, shows the clumsiness of home-made wrappings, stresses the hard pebbles on which the

bodies lie. The painter has fattened the thighs, has given the curve of instep a certain grace instead of horrid unnaturalness, has invented neat. stitchings which turn the rough wrapping into a conventionalized tramp's patchwork, has lost the pebbles in vague scribbles. Most insensitive of all, he has enclosed the heap of bodies in a tidy pattern of abstract shapes. The photograph lets the heap of bodies bleed off one corner of the frame, so that we sense that this is only part of a huger, an infinite horror.

Lebrun is a sensitive painter. But in his involuntary —and in this case "involuntary" means mechanical— concern for "pure form," in his *mechanical* reliance on a certain idiom, he has in fact become blind not to the photograph merely, but to reality. The photographer was not blind. However passive the camera, the photographer chose this "detail," this angle, this exposure (a wrong exposure would have lost the textural qualities), this composition, this clipping of the frame. The photographer has seen, and shows us, Buchenwald. The painter shows us only a painting.

Other painters choosing subjects less likely to grip our imagination have successfully recast photographs into forms that are realistic but less literal than snapshots or newsphotos. In many of these, camera vision still prevails even though the scenes were modified in the translation to canvas.

In the late 1940s the American painter Balcomb Greene turned from geometric abstractions to a more amorphous and poetic form of expression. For the past ten years he has preferred a style which de-emphasizes solid form in favor of romantic moods communicated through vibrating patches of light. In these pictures, shapes merge freely, masking any clear-cut difference between foreground and background.

He achieves pictorial dynamism by establishing barely recognizable passages of ambiguous derivation which tend to merge gradually into forms that suggest rather than delineate specific shapes. Greene, who lives part of the year near Montauk Point, Long Island, has become attuned to the special quality of light filtered by fog. He instills a feeling of mystery in many of his works by the use of soft enveloping light analogous to a moisture-laden environment. (263)

The fact that some of his compositions stem from photographs helps to explain the sometimes concrete, sometimes phantomlike quality of his landscapes and pictures of people. For a number of years Greene has been using his own photographs as guides for paintings. These supply him with ideas for compositions which are related to photography but are totally different from other paintings derived from camera imagery. Although Greene accepts the assistance of the camera, he deplores the general technological emphasis that he feels prevails today. He says, "the artist has never lived in a period in which 'know-how' and devices have so fascinated him and his public—to the detriment of creativity and understanding." It is his feeling that "mechanization of our procedures and of our thinking simply need extraordinary safeguards."

These views explain why Greene usually cancels the precise recording capabilities of his camera and makes prints which have an inordinate amount of contrast between the white and black portions. In these photographs the middle gray tones are minimized, causing the white tonalities to merge with each other. This tends to destroy the explicit quality of the camera's imagery and suggests a free movement of forms.

Discovery of the potency of photographic evidence has encouraged a number of other painters to draw upon this source of naked truth for genre compositions. Francis Bacon uses the informational aspects of photographs for detail, but he also seems inspired by the cumulative visual history of recent events as recorded by the camera. Photography has provided him with a technical imagination, complete with insistent details that reveal slices of time preserved with uncompromising candor.

In addition, Bacon exploits the unmasking possibilities of the photograph. He has made considerable use of the books of sequential stop-action photographs by Muybridge and has also used photographs from other

books and newsphotos. The camera image made ubiquitous by television and picture magazines has brought home to everyone the ugliness of wars, the terror of overwhelming natural disasters, and the horror of personal tragedies of all kinds. The camera preserves cruel events in all their untidiness. Bacon uses the results to paraphrase those disturbing elements in our society that we see in a new dimension through photographs.

In Bacon's paintings from 1945 to 1955, he often used the wide-open screaming mouth. This image has roots in Munch's *The Scream;* and like Lebrun, Bacon has inevitably been inspired by Picasso's *Guernica.* But more specifically, his work is related to photographs of wide-mouthed, frenzied political leaders whose abrasive oratory was a disgraceful adjunct of the European scene before and during World War II. Sir John Rothenstein, Bacon's biographer, has indicated that Bacon was very interested in photographs in the thirties, especially newspaper photographs of Hitler and Mussolini.

Technical photographs and film, as well as newsphotos, have been stimulating for Bacon. *The Crucifixion* of 1933 shows a skull on the ground, as in a traditional Golgotha. This was painted from an X-ray photograph of Sir Michael Sadler's head. Sir Michael was the first important collector of Bacon's work. *Head IV* and *Head VI*, painted in 1949, incorporated cinematic devices—an effect like a "dissolve" in *Head IV* and a fragment from a film in *Head VI*.

The screaming mouth from the close-up of the nurse in the famous Odessa steps sequence in Sergei Eisenstein's film *Battleship Potemkin* inspired Bacon to combine Velasquez' *Portrait of Pope Innocent X* with the moment when the horror-struck nurse is shot pointblank through her spectacles. (264-265) It is significant to note that this painting, in the Palazzo Doria in Rome, was known to the artist only from a black and white photograph when he painted his picture. The reason that Bacon painted the Pope's robes deep purple rather than the traditional wine red may thus be explained by the fact that he had no idea of the colors Velasquez used.

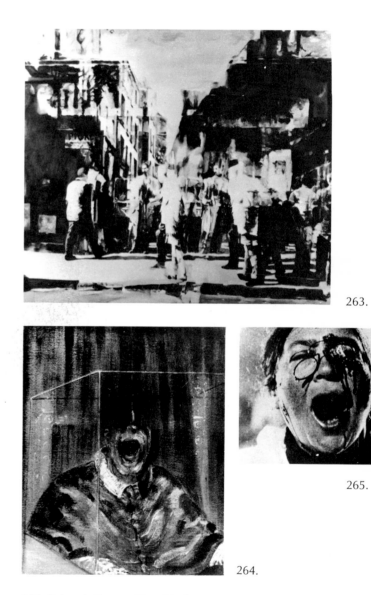

263.

265.

264.

263. Balcomb Greene. *Place Pigalle.* 1964. Oil, 58 x 64 inches. University Art Museum, University of Texas at Austin. The Michener Collection.

264. Francis Bacon. *Head VI.* 1949. Oil, 36¾ x 10¼ inches. The Arts Council of Great Britain, London.

265. Sergei Eisenstein. *A still photograph from Eisenstein's Odessa steps in film, "Battleship Potemkin."* 1925. Photograph. George Eastman House, Rochester, N.Y.

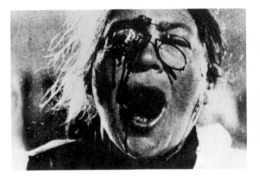

266. Francis Bacon. *Study for a Pope.* 1952.
Oil, 19¾ x 16 inches.
Collection Mr. and Mrs. Beekman C. Cannon,
New Haven, Conn.

267. Francis Bacon. *Study for the Nurse in the Film,*
"Battleship Potemkin." 1957. Oil, 78 x 56 inches.
Private collection, Paris.
Photograph, courtesy Marlborough Fine Art, London.

268. Sergei Eisenstein. *A still photograph from Eisenstein's*
Odessa steps in film, "Battleship Potemkin." 1925. Photograph.
George Eastman House, Rochester, N.Y.

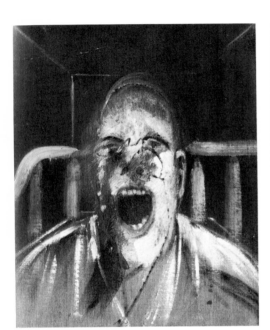

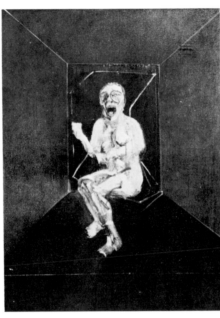

268.

266.

267.

The frame of the close-up of the nurse from Eisenstein's film was a powerful inspiration for Bacon. He painted at least four pictures using the nurse's bloody face, each one quite different than the other. (266-268)

Lucian, the grandson of Sigmund Freud, has been a close friend of Bacon and the subject of a portrait. Bacon's *Portrait of Lucian Freud*, 1951, was inspired initially by seeing a snapshot of Franz Kafka reproduced as the frontispiece in Max Brod's *Franz Kafka eine Biographie*. (269-270) This painting, although taken from a photograph of Kafka as far as pose was concerned, also turned out to be a good likeness of Lucian Freud, due to Bacon's intimate knowledge of the young man. The photograph of Kafka merely set in motion the mental process or gave the painter a physical context as well as a psychological framework in which to create the portrait.

From a photograph of a house in the West Indies Bacon painted *House in Barbados*, 1952. That year the artist also became interested in a book on Africa, *Stalking Big Game with a Camera* by Marius Maxwell, and seems to have derived a portion of his *Landscape* from Maxwell's photograph of an advancing rhinoceros. *Study of a Baboon* may also have been derived from this book, and certainly *Rhinoceros*, 1952 (271-272), was inspired by a Maxwell photograph. Bacon was also stimulated by a photograph when painting *Man Eating a Leg of Chicken*. This composition was based on a candid-camera picture of the Marques de Cueva eating chicken with his fingers.

Bacon's recent paintings of heads in motion also owe a debt to photographs that record with a slow shutter speed the transparent "ghosts" of forms. (273) In Bacon's paintings a cheek appears to spread across a face, as if it had been partially caught in motion during exposure to the lens. The effect of motion is understood because of our familiarity with similar photographic distortions. Rarely, however, can the camera convey

114

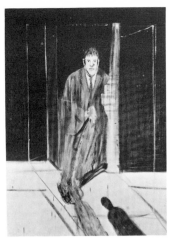

269. 270.

272.

273.

271.

269. Francis Bacon. *Portrait of Lucian Freud*. 1951.
Oil, 78 x 54 inches. Collection Lord Rendlesham, London.

270. Photographer unknown. *Franz Kafka*. 1918. Photograph.
Reproduced from *Franz Kafka eine Biographie* by Max Brod.

271. Francis Bacon. *Rhinoceros*. 1952. Oil, 78 x 54 inches.
Destroyed by the artist.

272. Marius Maxwell(?). *The second ball makes it spin round
and collapse on its forelegs*. c1923. Photograph.
Reproduced from *Stalking Big Game with a Camera in
Equatorial Africa* by Marius Maxwell.

273. Francis Bacon. *Head of a man*. 1960. Oil, 34 x 34 inches.
Penrose Collection, London.

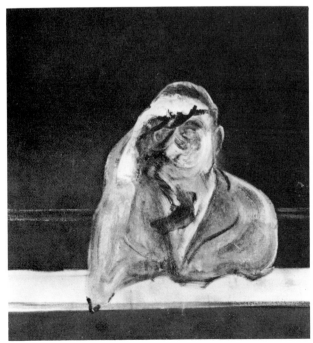

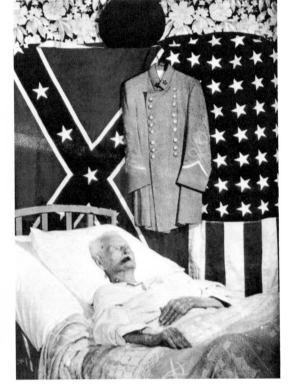

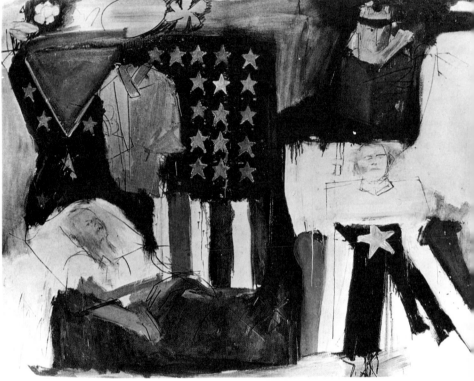

274. 275.

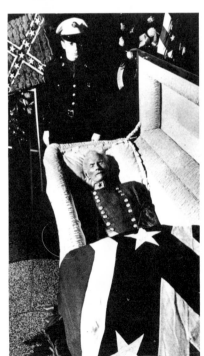

274. Tom McVoy. *Last Civil War Veteran*. 1960. Photograph.
Courtesy *Life*.

275. Larry Rivers. *Dying and Dead Veteran*. 1961.
Oil, 70 x 94 inches. Tibor de Nagy Gallery, New York.

276. A. Y. Owen. *End of the Gallant Rebs*. 1960. Photograph.
Courtesy *Life*.

277. Larry Rivers. *Bar Mitzvah Photograph*. 1960.
Oil, 74 x 62 inches.
Collection Daniel E. Schneider, New York.

278. Photographer unknown. *Larry Rivers' aunt, uncle and
cousins*. 1936. Photograph. Courtesy Larry Rivers,
Southampton, Long Island, N.Y.

276.

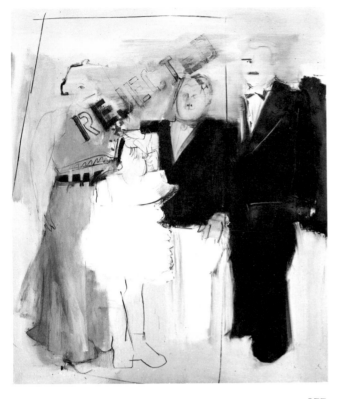

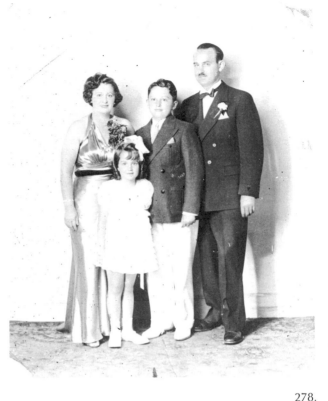

277.

278.

the emotional impact inherent in such a phenomenon as effectively as does Bacon in his canvases.

Bacon says, "One thing which has never been really worked out is how photography has completely altered figurative painting. I think Velasquez believed that he was *recording* the court at that time and certain people at that time. But a really good artist today would be forced to make a game of the same situations. He knows that particular things could be recorded on film; so this side of his activity has been taken over by something else."

Larry Rivers has also taken conventional, commonplace, and even hackneyed events as subjects for his pictures, imposing on them a style that is simultaneously compulsive and fastidious. Segments of realistic and familiar objects have been caught in the glare of his spotlight. By using an admixture of photographic imagery he charges his canvases with an inventory of visual memoranda that balances his considerable skill as an abstractionist with his abilities as a draftsman.

Rivers once said, "I wanted to take something corny, something that has become through familiarity slightly ridiculous, and imbue it with life." Accordingly, he developed a series of compositions around the strong design and color he found in two photographs of the last Civil War veterans published in *Life* magazine. For one of these compositions he organized a kind of diptych picturing two soldiers, one dying and the other already dead. (274-276) The soldiers were represented

only by blurred and tentative brush strokes, as if to mark the slipping away of life, although the flags were treated in a very deliberate and traditional manner.

A photograph of a wedding party or other family gathering often had a profound effect on Rivers. He has manipulated and exploited the accumulated meaning of an icon, such as a formal bar mitzvah picture, to extend the expressive range of the imagery so placidly preserved by the camera. (277-278)

Rivers uses the photograph not only in its emblematic sense as a manifestation of our popular culture but also for its insistent memory. For him the photograph is a static record that he can animate through the facile use of his brush while still retaining distinct vestiges of the realism preserved on film.

The juxtaposition of expressionist handling of pigment and informally arranged imagery gives Harold Bruder's work a feeling of impertinence. Bruder uses snapshots and hopes to retain the casual quality of his sources, whereas Rivers has used professional photos to evoke a sense of mystery. Bruder uses rather low-key color in conjunction with grays and tans, and minor non-retinal distortions of form to suggest the flavor of a camera-captured scene but without complete reliance on photographs. In his seemingly unstudied compositions, elements such as legs are distorted since they are copied from the image recorded on film. The mores and history of people he knows are his concern, and he draws his themes from his family and contemporary middle-class

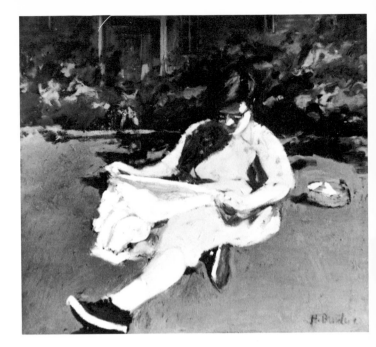

279.

America. (279-280) His work is like a totem pole, setting forth events in the life of his family and friends.

Bruder says of this pursuit:

I've always been deeply moved by family sagas like Thomas Mann's *Buddenbrooks* and Thomas Wolfe's *Look Homeward, Angel.* The heroes in these works grow old as time passes, and I then get to know their children and grandchildren as I once knew them. This intimate glimpse of life motion fleeting but held fast in the work of art gives the art a timeless quality. It is this intimacy which I strive for in my paintings. Snapshots have revealed to me my own family saga. With them I've painted my mother and grandmother as they were in 1916—my wife and her sisters by her mother's side in 1935. I've painted birthday parties, family picnics, and days in the park with my wife and children. For most of all I want to communicate—to tell my story.

From 1953 to 1957 Bruder painted in an abstract style. A little later he developed his current interest in figure painting under the inspiration of Picasso and Balthus. Although initially he painted from his imagination, he was soon using color slides projected on a wall of his studio as a guide. Beginning in 1963, Bruder painted from snapshots of his wife and children, but more recently he has also turned to newsphotos for inspiration. For one of his most successful paintings he borrowed sections of a photograph of the funeral procession of Pope John XXIII, showing the body of the pontiff being carried by attendants through the crowd at St. Peter's Basilica. (281-282) Bruder capitalized on the camera's departure from what we consider "true" perspective. He worked from the unusual viewpoint caught by the camera's eye to bring him into contact with the event. It was his wish to paint a picture in which the Pope was isolated and his massive form covered with symbolic robes and wearing his traditional headdress. The figure of the Pope in the painting is thus both at rest and floating in an atmosphere of peace. The camera recorded a moment in history; the painting, a timeless moment.

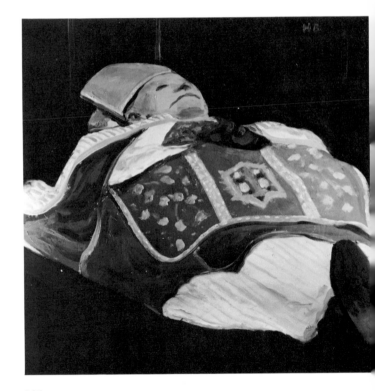

281.

280.

282.

279. Harold Bruder. *Sewing on a Summer Day*. 1962.
Oil, 36 x 40 inches. Collection Harold Bruder, New York.

280. Harold Bruder. *Sewing on a summer day*. 1962.
Photograph. Collection Harold Bruder, New York.

281. Harold Bruder. *The Funeral of Pope John XXIII*. 1964.
Oil, 53 x 53 inches. Collection Harold Bruder, New York.

282. Photographer unknown. *Funeral of Pope John XXIII*. 1964.
Photograph. Courtesy Wide World Photos, New York.

283. Audrey Flack. *War Protest March*. 1969.
Oil, 20 x 30 inches. Collection Audrey Flack, New York.

284. Audrey Flack. *Freedom March*. 1967. Color Photograph.
Courtesy Audrey Flack, New York.

285. Gaines Patterson. *Marcia Reifman*. 1969. Ink sprayed on
paper cutout (photographed in a studio setting), 47 x 30 inches.
Collection Gaines Patterson, Gainesville, Fla.

286. Marcia Reifman. *Gaines Patterson at work*. 1969.
Photograph. Courtesy Marcia Reifman, Miami, Fla.

283.

285.

286.

284.

Audrey Flack exploits the "appearance" of photographs. She faithfully retains the matter-of-fact documentary tone of photographs of groups of people in motion in her paintings. (283-284) If sketched on the site, many details that give life to *War Protest March* would have escaped the artist. While Miss Flack was concerned with a minimum of pictorial inventiveness she did change her representation of the scene in a distinct fashion. The color photographic print she used conveniently crystallized a brief moment in time. This crystallization took place in terms limited by the camera's ability to simultaneously record motion as well as objects, both near and far, with overall clarity. Miss Flack's painting while substantially true, is an interpretation of her model. She added subtle qualities of composition not found in the photograph she chose to copy.

The girl in the lower right-hand corner of the photograph and the Negro boy wearing the Martin Luther King button were recorded out of focus by the camera. Miss Flack, however, painted these two figures with the same degree of sharpness as she did the group in the middle distance, which was in focus in the photograph. She painted the building in the background in a similar manner. The camera recorded its gray blocky walls in a somewhat fuzzy fashion. Miss Flack treated the building with the same degree of clarity as she did the signs in the middle of the composition and the foreground figures. It would have been virtually impossible for the photographer to catch the people who were a foot or so from the camera with the same degree of sharpness as the building which was located over a hundred feet from the lens. The painter felt that overall clarity was pictorially important and therefore sharpened up the near and far parts of her picture without specific reference to camera vision. Miss Flack explains:

I use the photograph because:—it is a drawing aid.—it offers me more time and a new kind of relaxed time in which I can study the picture.—it does not twitch, become irritated, laugh, or move, as human subjects do. I can quietly study it—to further the study of reality,

—it freezes space, color, light, and the light source. I can concentrate on color changes, tonality, light striking objects and space, without being interrupted by the actual changes that are continually taking place in the ever-moving world. The frozen photograph lets me study what is taking place in a given moment, minute, or hour—more intensely and for a longer period of time than I can in the actual world of reality.—it makes inaccessible subjects available for me to paint, such as my painting of the Kennedy motorcade in Dallas five minutes before the assassination. I can calmly study a figure in motion, walking, riding in a car, waving and so forth.—it allows me to particularize. I can zoom in and study details and surface textures.—it creates the illusion of space by the juxtaposition of form. Perhaps the most important aspect of my use of the photograph, and the most difficult to explain, is space. I am fascinated by the way objects butt up against each other, edges hitting, in front, in back, alongside, line meeting line yet never functioning as line.—it creates a world of shadows. Shadows create form, and they play a role in time and space.

Francis Souza, a young artist living in England, carries the concept of borrowing from photographs to its logical conclusion. He uses a specially designed magic lantern to project photographs onto canvas. In reference to this technique, Souza says, "I work a lot from photographs, my figure drawings and paintings are often adopted from commonplace pin-ups. And I often paint my landscapes from photographs. Or rather I *begin* to paint them from photographs. In the end they are mostly collective images of the many places I've known all rolled into one . . . photographs act as a spring board into a subject. So I keep a big collection of magazine photographs."

This practice is also prevalent in the United States. Gaines Patterson, for instance, projects negatives onto large sheets of paper and with an airbrush sprays in the shadow areas in tones of black or in color. (285-286) When spraying in the shadows he reacts to the light areas of the negatives just as light-sensitive photographic paper does, and thus produces pictures that are very photographic in appearance. The camera records

287. Robert O'Dowd. *Hefferton Polaroid.* 1962.
Oil, 60 x 40 inches.
Collection Mr. and Mrs. Allen O. Smith, Arcadia, Calif.

288. Robert O'Dowd. *Hefferton.* 1962. Polaroid Photograph.
Courtesy Robert O'Dowd.

289. Enrique Montenegro. *Two Lady Pedestrians on Parking Lot.* 1962. Oil, 60 x 50 inches.
Collection Enrique Montenegro, State College, Pa.

290. Eliot Elisofon. *Two aboriginal women of New Guinea.* c1960. Color photograph.
Courtesy Peabody Museum, Cambridge, Mass.

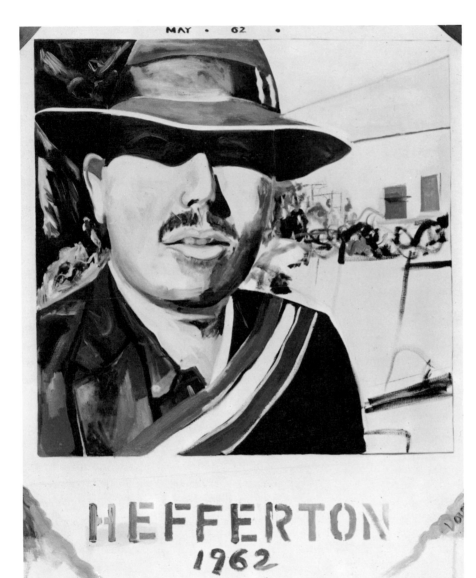

287.

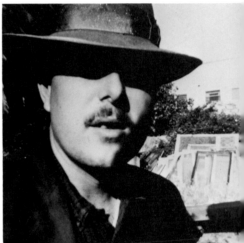

288.

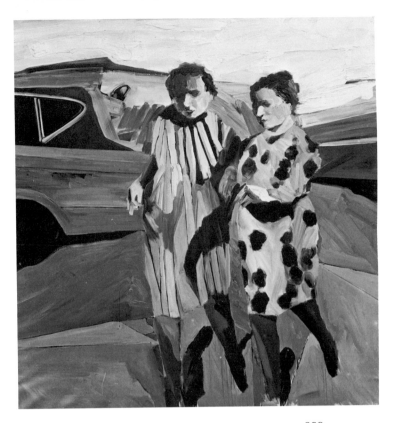

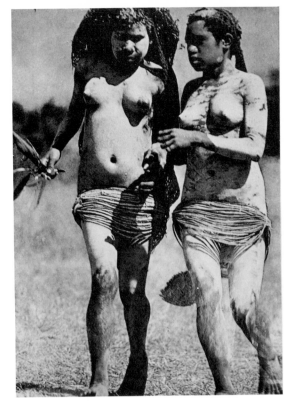

289.

290.

dark and light relationships in a distinctly different fashion than does the eye. Shadows are deeper in tonal value in photographs than in nature (that is, film records shadows darker than the eye sees them), and the edges of dark areas are also more distinct in photographs than in life. Patterson mutes the edges of his shadows, which makes them appear natural, rather than like giant colored enlargements from photographic negatives.

Like a number of contemporary artists, Robert O'Dowd has been fascinated by the images on playing cards, paper currency, and photographs. Although he copies the principal ingredients of his pictures from these static sources, he enlivens his own versions by painterly additions not found in the originals. He acknowledges his debt to the provoking agency, but in his alterations he creates a new context for the familiar forms.

One of the most original examples of this interaction is O'Dowd's painted interpretation of a Polaroid snapshot of the artist Philip Hefferton. (287-288) O'Dowd added elements which significantly changed the meaning of the portrait, for Hefferton was transformed into a Mexican official, complete with the sash of office. Drama was added by emphasizing the deep shadow covering the subject's forehead in the photograph but

which resembles a mask with blank staring eyes in the painting. O'Dowd states, "Working from the photograph is unlike using any other source because of its ability to seize and record an instant in time, taking from the contexture of motion a condition or moment and rendering it stationary. It is this suspension in time, or 'still life' so to speak, which draws me to the photograph."

The pictorial possibilities of ready-made photographic compositions have also inspired Enrique Montenegro, although he has transformed them to a marked degree by adding both rich color and a new point of view. Generally the metamorphosis is so extensive that it is not readily apparent that photographs were his source of inspiration. He has often borrowed figures from a magazine photo and cast them in a new role that is completely at odds with the source of his initial inspiration.

Embodied in the stance of two semi-nude maidens from New Guinea were elements which especially appealed to Montenegro. In the painting made from this photograph he switched the scene to a busy parking lot, dressed the figures, and changed their race. (289-290) These major alterations did not disguise the fact that many aspects of the composition, such as hand gestures and the position of the women's legs, were

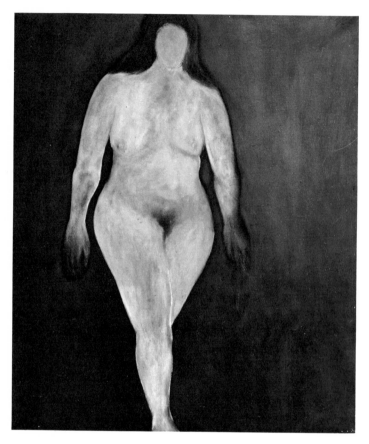

291.

292.

291. Sherman Drexler. *Gertrude Ederle, the Great White Nude.*
1963. Oil, 60 x 50 inches.
Worcester Art Museum, Worcester, Mass.

292. Photographer unknown. *Gertrude Ederle emerging from
the English Channel at Cape Gris Nez, France after her
famous swim from Dover, England.* 1926. Photograph.
Courtesy Wide World Photos, New York.

293. R. B. Kitaj. *Good News for Incunabulists.* 1962.
Oil, 60 x 60 inches. Collection Corrado Levi, Turin.

294. Edward Steichen. *The Front Page.* 1928. Photograph.
Courtesy Captain and Mrs. Edward Steichen,
West Redding, Conn.

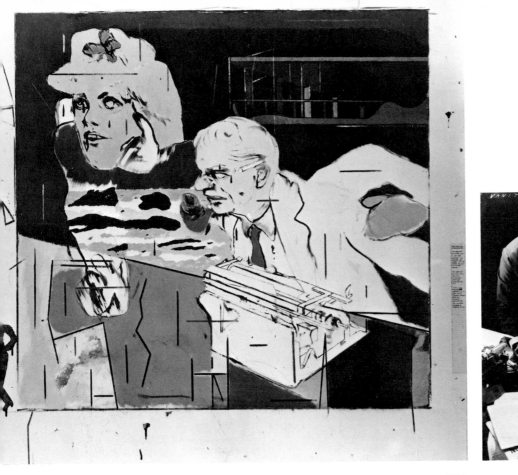

293. 294.

borrowed from the photograph. This is an example of the wondrous process of inspiration which goes on continuously in the visually alert artist's mind as he reacts both consciously and subconsciously to the bombardment of photographic stimuli. *Two Lady Pedestrians on Parking Lot* is an unusually straightforward example of the origin of many recent figure paintings.

Sherman Drexler in his *Gertrude Ederle* followed a path similar to Montenegro's. A photograph of the famous English Channel swimmer provided the impetus for a painting, but the departures from the model are of a major order. Drexler used an exaggerated massing of anatomy and muscularity in the advancing nude figure to represent the physical power necessary to undertake long-distance swimming. This effect is only hinted at in the photograph. (291-292) He has said, "I refer to photographs for the genesis of some of my work —the latent heroism implicit in the human gesture (Rodin's statement) is caught, frozen, saved in photog-

raphy. I want my art to have this moment of stillness."

On the other hand, R. B. Kitaj, an American who works in England, uses a fractured kind of language that often consists of fragments of prefabricated vision derived from photographs. Kitaj borrowed the major elements for *Good News for Incunabulists* from Edward Steichen's photograph of *The Front Page*, the famous stage play by Ben Hecht and Charles MacArthur. (293-294) The painting has little to say, however, about newspaper reporting in Chicago in the 1920s. Kitaj recently related how ideas for such paintings as *Good News for Incunabulists* occur to him:

Many of my pictures have their sources in books . . . often picture-books. It is not easy to pin down the peculiar conjunction of imagery which impresses one after having ploughed through (with, or without intent), ignored, passed by countless combinations which unlock nothing.

Here is a short, *speculative* list of reasons for having used this photo [*Front Page* by Edward Steichen] as a

295.

296.

295. R. B. Kitaj. *An Early Europe*. 1964.
Oil/photo-collage, 60 x 84 inches.
Collection Harry N. Abrams Family, New York.

296. Photographer unknown.
Three Graces by Canova (detail). n.d. Photograph.
Reproduced from *Art News*, New York.

297.

298.

299.

POGANY

POGANY

Genre: Twentieth Century

297. James Strombotne. *Yo-Yo.* 1961. Oil, 60 x 60 inches. Collection Mr. Robert H. Ginter, Beverly Hills, Calif.

298. R. B. Kitaj. *Mort.* Screen print. 1966. 39⅞ x 27¾ inches. Courtesy Marlborough Graphics, New York.

299. R. B. Kitaj. *Pogany.* Screen print. 1966. 40 x 27 inches. Courtesy Marlborough Graphics, New York.

model: 1. The name Steichen is enough to sting an expatriate. 2. The title *Good News for Incunabulists* (a headline in an issue of the *London Times Literary Supplement*) coincided with the discovery of the photo and my chemistry began to bubble . . . getting the Good News on the phone etc. and envisioning a *headline* etc. 3. The streamlined frenzy of the Melvin Douglas, Franchot Tone, city desk era is a memory one is dedicated to and can easily suggest a painting. 4. I'm always on the lookout for a possible stage onto which I can press disparate visual energies which will go on to enact a unique conjunction.

Another example of Kitaj's playful use of history, in this case art history, is found in *An Early Europe.* Here he paraphrased a famous piece of sculpture by Canova, a photograph of which was pasted onto the lower right-hand corner of his composition for comparison and to complete the visual pun. (295-296) Reference is made, in a rather irreverent manner, to Canova's neo-classic three graces, which were metamorphosed by the artist into three strange and somehow menacing characters. In the right-hand figure, he retained the sensuous outline of a classic nude body but he imposed on it a geometric head which huddles with an added character in a desert headdress and glasses. This character is flanked by a figure wearing a workman's apron and over whose cheek falls a black hand, directly derived from the photograph of the left-hand grace, which leads us to the black female figure on the right. This nude, although negative, follows to a large extent the photograph of Canova's sculpture. Are we witnessing a meeting of conspirators? Does this account for the figure escaping or jumping out the window on the right, or is this a scenario for a TV fun show?

The photograph provided a springboard for Kitaj's imagination and, in the context indicated, combines "disparate visual energies." It is unlikely that an encounter with the actual piece of sculpture would have stimulated the creation of this painting, for the artist would not have been limited to but one view, and a closeup at that, as was the case when he worked with

the photograph. There is also the added factor of diminution of scale which permitted Kitaj to readily see in the photograph Canova's piece of sculpture as a total composition.

In addition to basing paintings on photographs Kitaj has made telling use of photographic imagery in his prints. In *Mort* the readily recognized likeness of eight famous artists are combined with incongruent information to create a tongue-in-cheek statement. The print *Pogany* is a play on word associations and refers to the model for Brancusi's famous series of simplified heads created in marble and bronze. (298-299)

The West Coast painter James Strombotne has said of his work, "A newspaper story, a political campaign, a photograph in a book, anything may trigger a painting." Strombotne's painting *Yo-Yo* (297) was "triggered" by two photographs published in David Duncan's book, *The Private World of Pablo Picasso,* and is undoubtedly related to Vladimir Nabokov's *Lolita.* Strombotne's style depends to a large extent on his skills with shallow, abridged forms. The photograph is physically a flat image, and the peculiarities of camera vision tend to compress the world of deep space.

The camera's ability to freeze and summarize moments of spontaneous action provided the key which set in motion the artist's imagination. He kept the poses intact but combined them in a new setting and context. Strombotne has said, "I make studies from photographs which often form the basis for the beginning of a painting just as the drawings which I make directly from nature sometimes do. Working from a photograph sometimes makes me feel like an alchemist since metaphorically I am working with lead and bringing all my powers to bear to turn it into gold."

William Theo Brown's work of a few years ago resembled fragments of an "Instant Replay" on TV since he relied quite explicitly on camera vision for his series of football paintings. Photography can preserve with precision the surge of power present during a peak moment of a game. Out of the disjointed arrangement of

129

300.

301.

tangled varicolored uniforms Brown devised a corresponding exertion of energy in the language of paint. (300-301) The effects he created tally with the original excitement of the game without imparting to his pictures any of the frozen qualities generally found in routine sports photos. He capitalized on the camera's capacity to make exact notations of rapid movement, but his impressionistic versions of the action are pictorially more interesting and in some respects more revealing than the particularized record of the camera.

Elaine de Kooning has also taken over from sports photos some of the imagery for her vibrant compositions. This procedure is not readily apparent in her work, however, for she handles paint in a very free fashion, and the clarity we expect from photographs has been largely subordinated to her slashing style. She employs a variety of action shots, for rarely does one snap of the shutter express the feeling of dramatic movement and flashing color which characterizes a sport such as basketball. Of her pictures she has written:

When I became interested in the image of the human figure in action as in my series of basketball and baseball paintings, I was originally inspired by newspaper photographs, mainly those in the *New York Daily News*. Most of these photographs were undetailed and highly abstract in tones of grey, black and white. The figures were translated into fantastic flat shapes, always unpredictable and always "unrealistic." I began to collect these photographs purely because I admired them for themselves. Then, I got the idea of doing a series of "sports" paintings and began to attend games. The one element not present in the news shots was, of course, color. I began to make quick sketches in pastel, thinking only in terms of color and then began a series of paintings. I tacked up both my color sketches and numerous photographs. My idea was not to use any one sketch or any one photograph but to try to capture the multiplicity of images that occurred in the interaction between them.

James Gill is concerned with humanistic values in his stark paintings. He has increased the cryptic emotional appeal of his work by using newspaper photos as a source of inspiration. He retains the flavor of his sources by subordinating any inclination to "design" his pictures to achieve a greater sense of pictorial organization. His subject matter usually has shock value, is rude, often couched in satirical terms, and frequently is bizarre in a strangely unpretentious way. (302-304)

Gill states:

My studying photographs (mainly newspaper and magazine type) in relationship to my painting and drawing, has made me realize that they have produced or helped to bring about new images in people's "seeing vocabulary." For instance, a blurr can be a moving hand—a black shape on white can be an eye on the face of a man—and often express much more than one could produce drawing the detail of eye, eyebrow, etc. There is also a new vocabulary of foreshortening, perspective and space created by photographs—which hasn't existed before. When I come across a photograph which particularly appeals to me, I study it—analyse it—try to isolate the properties which give it a special quality. These things I become aware of are then at my disposal to use in my painting.

A number of contemporary artists anticipated the recent interest of film producers and fashion designers in the years immediately preceding World War I and the twenties. Photographs provided a way to sample the flavor of life in the United States during the first third of the century. This period in history so dear to the parents and sometimes the grandparents of these artists was largely known to them only through photographs. Although often slightly out of focus, contrasty in tone, and casually composed, snapshots made during these decades provide a means of recapturing the appearance and mood of everyday life.

Despite their fascination with the past, however, artists inspired by vintage Kodak photos rarely paint pictures that are merely enlargements and transcriptions of family mementos in color. Artists tend to paint the scenes they select in their own style, whether it be with a crisp edge, with flat forms, or with free and expressive brush strokes. In the process of conversion

300. William Theo Brown. *Untitled #2*. 1956. Oil,
42 x 68 inches. Courtesy Felix Landau Gallery, Los Angeles.

301. Photographer unknown. *Picture of football game*. 1946.
Courtesy William Brown.

302. James Gill. *The Machines*. 1965. Oil, 72 x 46 inches.
Courtesy Felix Landau Gallery, Los Angeles.

303. Photographer unknown. *President Johnson signing a bill*.
1965. Photograph. Courtesy James Gill, Los Angeles.

304. Photographer unknown.
Vietnamese victim outside embassy. c1965. Photograph.
Courtesy James Gill, Los Angeles.

303.

304.

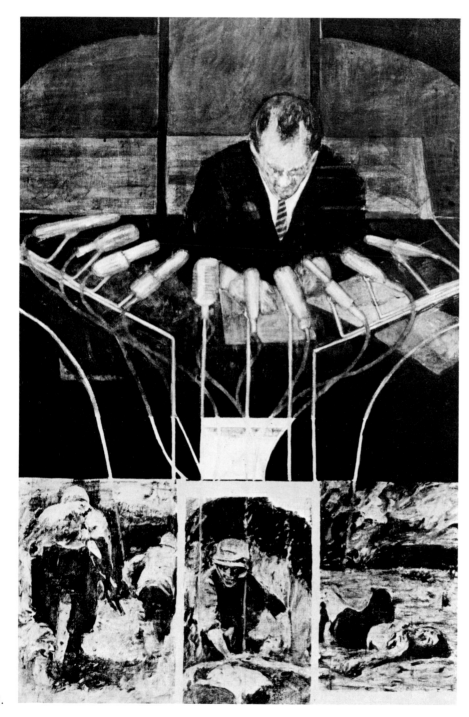

302.

305.

306.

305. John Dowling. *Decoration Day, 1917, I.* 1964.
Oil, 40 x 40 inches. Collection Martin Duberman, New York.

306. Photographer unknown. *Family group on a porch.* c1917.
Photograph. Courtesy John Dowling, New York.

307. Robert Harvey. *Charlie's Dad in Hongkew Park, Shanghai, 1921.* 1964. Oil, 48 x 36 inches.
David Stuart Galleries, Los Angeles.

308. Photographer unknown. *Charlie's dad in Hongkew Park, Shanghai.* 1921. Photograph.
Courtesy Robert Harvey, San Francisco.

307.

308.

132

from photograph to paint, the memory-recall quality of the camera image has been modulated to a marked degree. The true look of old snapshots cannot be imitated, if for no other reason than that they are small in scale and meant for viewing at arm's length in an album or for passing from hand to hand. They are crammed with specific details and so lacking in artistic emphasis, as well as thoughtful placement of highlights and shadows, that only an approximation of these qualities can be carried over into a painting.

It is an interesting phenomenon that photographs made in the early years of the century should stimulate artists in the sixties. Professionally made photographs rarely appeal to painters. Snapshots, however, have gained a new and respected position in the eyes of many painters, both in the United States and Europe as a source of pictorial ideas. The ready-made images that old photographs provide have encouraged contemporary artists to again paint period pictures without self-consciousness.

Robert Harvey, John Dowling, and Ellen Lanyon all work from snapshots but generally are not concerned with the great array of details caught by the camera, for their interest is in the light and shade patterns that were given particular prominence in pictures made with the old folding Kodaks. This contrast between highlights and deep shadows gives portions of snapshots a semi-abstract quality, and it is this peculiarity that seems to fascinate painters.

This can be readily seen in the paintings of John Dowling, who borrows the basic forms for his work from ordinary snapshots. Before he transfers the informal image of a snapshot to canvas he analyzes the major details with an eye as to how he can alter them to achieve greater coherence. He reworks the shapes in the process, creating a modified schematic equivalent of the snapshot.

For instance, Dowling exaggerated the prominence of the flag in *Decoration Day, 1917, I* and made maximum geometric use of the light and shade pattern cre-

ated by the sun's flooding a portion of the scene, but he eliminated the wooden, slatted shade and the bush impinging on the white area occupied by the flag. (305-306) In other words Dowling deleted or relegated to a subsidiary role those elements that cluttered his composition. Thus our attention is directed from one part of the composition to another in a disciplined fashion, rather than ranging freely over the picture, as is possible in the snapshot. Geometric relationships are the primary theme of Dowling's paintings, even though nostalgia has often been the motivating force. His models are only a point of departure, and since they are static and neutral in color, Dowling treats them as a still life made up of semi-abstract forms.

Robert Harvey has said that he uses photographs because it is people he is interested in, and he hopes that contact can be established across time between the people in the snapshots and the people who look at his paintings. It is, however, the disposition of forms that he usually carries over into his paintings, not a folksy sense of people as people. For example, he frequently eliminates any reference to background or environment in his compositions. He also pares away the myriad details found in a snapshot to give clarity to certain shapes, as he reduces the little mementos to their essential forms. His major aim is stylized precision rather than the evocation of the loosely structured arrangement of elements that in photographs stand for trees, grass, sky, and people. He develops the dark areas from snapshots into shapes that demonstrate an independent vitality outside of their descriptive function. In a Harvey painting, modeling is minimized or reduced to planes to flatten out his compositions, for carefully honed elements of design are what he emphasizes.

Harvey may pick from a snapshot a simple shape such as the back of the bench in *Charlie's Dad in Hongkew Park, Shanghai, 1921* and use it as a key element. (307-308) In this painting he elongated the subject's legs far beyond the slight distortion found in the pho-

310.

309.

309. Robert Harvey. *Esther on Landy's Wagon.* 1964.
Oil, 36 x 48 inches. David Stuart Galleries, Los Angeles.

310. Photographer unknown. *Snapshot of Esther on Landy's Wagon.* c1920. Photograph.
Courtesy Robert Harvey, San Francisco.

311. Ellen Lanyon. *Outing II.* 1962. Oil, 20 x 28 inches.
Collection Ellen Lanyon, Chicago.

312. Photographer unknown.
Group photographed while on an outing. c1900.
Photograph. Courtesy Ellen Lanyon, Chicago.

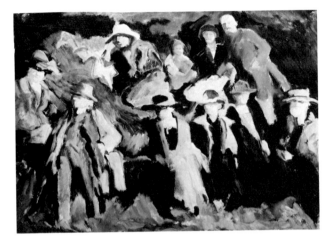

311.

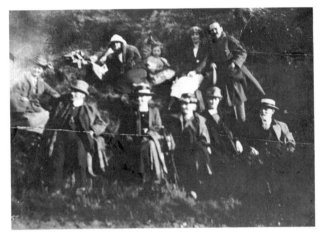

312.

tograph, and he called attention to the verticality of the figure as opposed to the horizontal bench. The man's features were made less personalized and his hat painted parallel to the top of the bench. Harvey made these changes to achieve a sense of esthetic harmony, not to engender a feeling of authenticity. He is a lyrical semi-abstract painter who may think of himself as a humanist but who stresses tightly designed generalizations, as in *Esther on Landy's Wagon*, rather than the multitude of conflicting forms preserved in a snapshot. (309-310)

The random relationships beween the various elements in an unpretentious snapshot stem from the innocence of vision of most Kodak users and therein lies the power of such photographs. They are not works of art and often the forms are neither sharply defined nor clearly separated. Even so, they evoke a true sense of time and place. We can accept as real and become delightfully involved in these fragments of the past at a personal level, even when we have no connection with the people pictured. We feel that the snapshots are a mirror of reality. They evoke a rich storehouse of memories, despite all their unesthetic qualities and lack of clarity.

"Show me a laundry list," said Rossini; "I will set it to music." We can paraphrase, "Show me a snap-

shot; I will make a painting of it." And we may then have the answer to the query, Out of what can come art? The question remains, How often does the painter convert lead into gold when he bases his work on the preexisting forms found in such photographs?

Ellen Lanyon has been especially stirred by the period of her mother's youth, the *Belle Epoque*, when elaborate hats and busily trimmed dresses were in vogue. She uses a heavier pigment than Dowling or Harvey, and her way of applying paint adds a new dimension, both actually and symbolically, to what appears at first glance to be merely sentimental recall. The photographic record permits her to deal pictorially with situations that would be impractical or impossible to arrange in her studio. She has said, "I feel no reluctance in using photos but am aware that they must serve only as an extension of my own creativity and never as a basis for a method which could become so easily pure illustration." Her *Outing II* recalled with nostalgia long-past family activities. (311-312) In regard to this picture she has said:

I was interested in the over-all patterns created by strong light and shadow combinations and by the adaptation of these to thin washes and over-painted areas of impasto. It was an attempt to make paint perform to its richest varieties within a limited color range and to

313. Robert de Niro. *Garbo with Her Hand Raised to Her Head.* 1965. Oil, 40 x 50 inches. Zabriskie Gallery, New York.

314. Photographer unknown. Still photograph from film, *"Anna Christie."* 1930. Photograph (detail). Courtesy Robert de Niro, New York.

315. Richard Hogan. *37.* 1968. Oil, 48 x 36 inches. Collection Kathryn Sullivan, Berkeley, Calif.

316. Photographer unknown. *Little girl in front of 1937 car.* c1937. Photograph. Courtesy Richard Hogan, Albuquerque, N.M.

317. Leland Bell. *La Maison Tellier.* 1961. Oil, 52 x 54½ inches. Courtesy Robert Schoelkopf Gallery, New York.

318. Photographer unknown. *Women from La Maison Tellier.* c1898. Photograph. Reproduced from Francis Steegmuller, *Guy de Maupassant.*

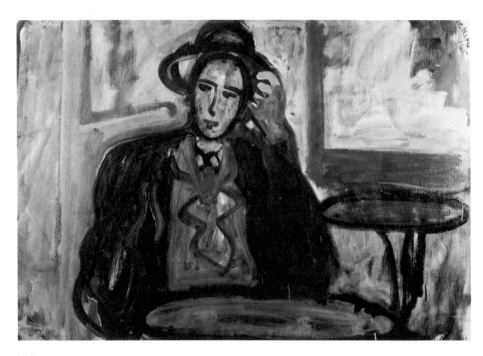

313.

314.

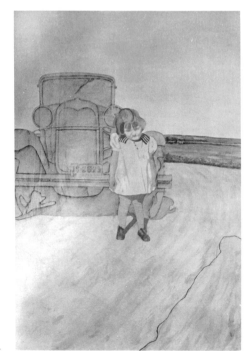

315.

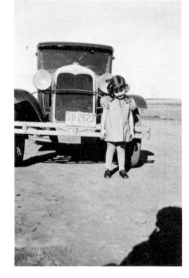

316.

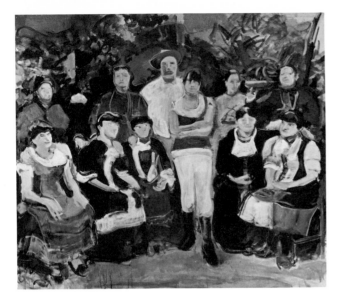

317.

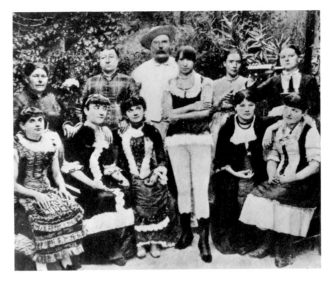

318.

satisfy my desire to create an imagery which would evoke the frozen, nostalgic, gesture. Certain surfaces seem more compatible to certain subjects, I felt that for my purpose the subtle and somehow unique qualities of old photos were ideal.

A few years ago Robert de Niro painted Greta Garbo from an old photograph that he selected as much for the various repetitions of shapes found in it as for the appeal of Garbo in her 1930 role as Anna Christie. (313-314) The numerous oval shapes and the positioning of the actress' hand particularly attracted him, and to these he gave special emphasis in his painting. The painter has said that he found a tragic dignity in some photographs of Garbo, while others left him unmoved. In this case, he was responding more to the combination of romantic subject matter and classical arrangement of forms than to the woman herself.

In another instance, de Niro found inspiration in a photograph of a Moroccan harem in *Flair* magazine. The picture incorporated some of the same characteristics as the Garbo picture and so stimulated de Niro that he used it as the basis for a complete show.

Use of photographs has increased during the past five years as the old taboos about working from ready-made sources have broken down. De Niro's paintings testify to the fact that an artist's vision does not necessarily have to be subservient to the many aspects of his photographic inspiration. He used the photograph as an armature on which to shape something personal and new, not dependent on specific qualities of design or the sense of nostalgia preserved by the camera.

Richard Hogan has been more successful than most artists in evoking the unrehearsed quality of snapshots.

He simplifies his paintings, but his people are intrinsically believable. Hogan is a natural draftsman. For his picture 37, he used a firm outline when painting the old car, the distant landscape, and the shadow of the photographer that appears in the lower right-hand corner of the picture. (315-316) Perhaps this shadow is meant to stand for the viewer of his picture, for Hogan not only represented this shape in line but reversed the tonal quality from a dark area to one that can be filled, psychologically, with the spectator's own form. The little girl standing awkwardly by the front of the car was painted in a slightly different fashion from the emphatically outlined automobile. She was separated from the surrounding forms by a feather edge, and her dress was modeled to give it a lifelike appearance. Hogan did not refine away the reality of the source of his imagery, as far as the child was concerned; he tempered it by using forms that substitute for specific objects without mimicking them. He evaded the tricky business of defining what is truth and what is contrivance by skillfully interweaving an abbreviated summary of non-essentials with the fully realized figure of the girl.

Hogan has said of 37, "The photograph is a sheet of paper modified by tones of gray, but more than that . . . the actual compression of a segment of time . . . the transformation of time into space . . . the illusion of time, the illusion of space . . . the precise quality of descriptive and non-descriptive shape . . . perhaps the nostalgia, the vision of a time I can never know, was the prime attraction of the snapshot . . . now, I seem to see it differently; but it is still an enigmatic object that has infinite possibilities for pictorial development."

137

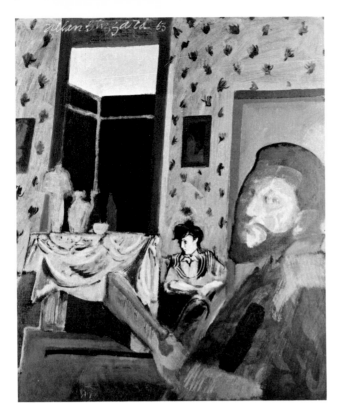

319.

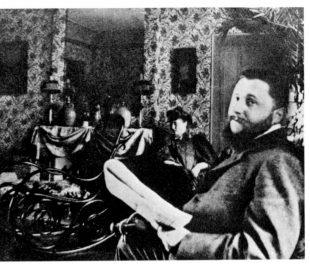

320.

319. Allan Blizzard. *Vuillard's Friends No. 1.* 1963.
Oil, 24 x 20 inches. Collection Allan Blizzard, Claremont, Calif.

320. Édouard Vuillard. *Misia and Thadée Natanson.* c1898.
Photograph. Courtesy Allan Blizzard, Claremont, Calif.

321. Walker Everett. *Goddess of the Liberty Loan.* 1962.
Oil, 30½ x 26½ inches.
Collection Mr. and Mrs. Irving Salloway, Brighton, Mass.

322. Photographer unknown. *Leaders of the Liberty Loan
parade.* 1917. Photograph. Courtesy Walker Everett, New York.

322.

321.

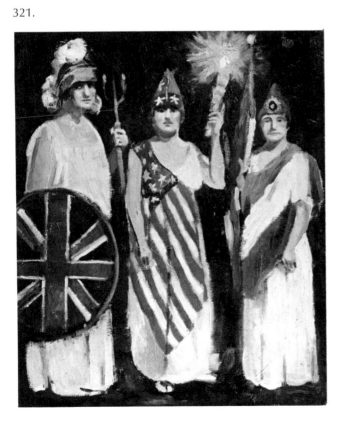

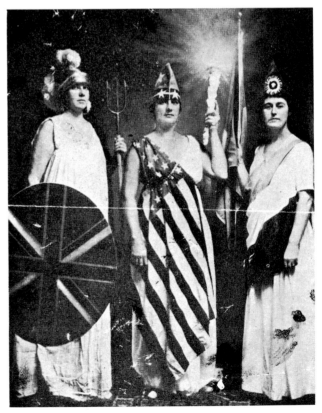

Leland Bell of New York and Alan Blizzard of Los Angeles have also taken photographs as a starting point. For their pictures, however, they chose models from the period just before and after the turn of the century. They also chose rather well-known photographs instead of family mementos. Bell made an interpretive series of pictures after a photograph he found in Francis Steegmuller's biography of Guy de Maupassant. Supposedly this is a group portrayal of the girls in *La Maison Tellier*, the famous Rouen brothel which served as the setting for one of de Maupassant's stories. Bell wrapped the piquant naturalism of de Maupassant in a mantle of romantic imagery suggested by the photograph. (317-318)

In another instance Bell painted from a vintage photograph a canvas titled *Vins et Liqueurs*, which pictures a group of patrons in front of a French cafe. While filled with echoes of the past, his paintings do not embody the illusionary exactness of the photographs. By accepting the general arrangement of the photographic forms, Bell could then concentrate on other elements such as paint, which he applied in a special summary manner, and colors, which he selected for other than descriptive purposes. His colors were invented to suit himself since the photograph offered only the barest clue to the tonal range in the original subject.

Blizzard has utilized photographs related to such well-known early twentieth-century artists as Édouard Vuillard, William Glackens, and Tristan Tzara. (319-320) He has indicated that this course has been followed after considerable thought: "Infinite suggestions are resident in the photographic print for the artist to build on. It puts the world at the artist's fingertips. In addition to all that I simply find photographs sensually pleasing. . . . Our age is the age of the photograph. And since the photograph abounds and confronts us daily in books, magazines, and newspapers and in the form of movies and television, thus constituting so much of our reality, it has a naturally propitious carry-over to painting."

Like the work of Blizzard and Bell, Walker Everett's work represents a romantic estrangement from the contemporary world. This empathy with the past involves a search for a time when life was simple and peace was assured. In his tributes to the past he has translated the formal quality of old photographs into restless patterns of pigment which convey a feeling quite separate from the idea of reminiscence. Everett is involved in an adroit interchange between the concreteness of the photographs and an inclination to express himself in a free painterly style that has little in common with the explicit records made by the camera. The boldness of his execution identifies him with the present, even while he openly embraces the pictorial history of his grandparents. (321-322)

Everett explains his use of photographs in terms of historical precedent:

An artist would indeed be a reactionary if he denied the influence of photography on art—starting with Degas I think—and did not use it when he wished to. The extent of the use of photographs, which reproduce the appearance of one instant from one point of view, rather than a synthesis of different impressions, must be up to the artist himself; he must only remember he is turning out an individual and unique painting, and he must have added *some definite information* or *emotion* to that originally conveyed by the photographs. And as an aid to memory as regards detail, when it's inconvenient or impossible to sketch, they are priceless. I am sure every Renaissance painter would have used them. Pictures such as mine would, of course, be literally impossible without photographs.

In transcribing contemporary images to canvas, the English artist Gerald Laing injected a controlled graphic quality into his Pop art pictures of girls in bikinis and of dragstrip race cars. (323-324) He capitalized on the overall patterns of the halftone dot structure and reproduced by hand large-scale photograph-like paintings. While they have the authentic quality of news and advertising photographs, they are intended to be viewed in the context of art, not merely as photographic enlargements.

324.

323. Gerald Laing. *Beachwear*. 1964. Oil, 96 x 48 inches. Collection Mr. and Mrs. Lawrence Buttenwiesen, New York. Courtesy Richard Feigen Gallery, New York.

324. Photographer unknown. *Advertisement from Italian magazine*. 1964. Photograph. Courtesy Gerald Laing, New York.

325. Gerald Laing. *C. T. Strokers*. 1964. Oil, 60 x 96 inches. Courtesy Richard Feigen Gallery, New York.

326. Photographer unknown. *Dragster owned by C. T. Strokers*. c1963. Photograph. Courtesy Gerald Laing, New York.

323.

325.

326.

From photographs Laing learned a lot about what was going on in California without stirring out of his studio in London. He was familiar with periodicals like *Hot Rod* or *Rod and Custom* and knew from photographs in them about drag racing and race cars on the West Coast long before he left his native England to paint in the United States. This kind of extension of an artist's visual vocabulary is not unusual. (325-326) Painters are visually oriented and often react enthusiastically to photographs of a dramatic nature or of girls in exaggerated poses. Laing says, "The photograph has a credibility which is often more authoritative than everyday experiences. It presents an orderly, 'pruned' image which can be recollected in tranquility and which works within certain pictorial conventions which we are conditioned to accept. The printed reproduction of a photograph has certain gestalt qualities which I find interesting and formally useful."

Laing's paintings from photographs are frequently semi-abstract, even though they appear at first to be objective. We are so accustomed to letting our eye build up a photographic image of dots that, on the first viewing, Laing's pictures have the appearance of enlarged newspaper reproductions of photographs, but they are much more. He uses hand-painted dots to define some elements and creates flat shapes for others in a deliberate attempt to vary the design and texture of his paintings.

When I began using photographs as a starting point I was interested in being able to make figurative paintings with a simple and unequivocal content which were at the same time "un-loaded" from the point of view of previous figurative paintings. This was followed by a series of black and white literal representations of newspaper photographs—this being the type of photograph with which we are most familiar. I used a grid of a predetermined interval and painted black

141

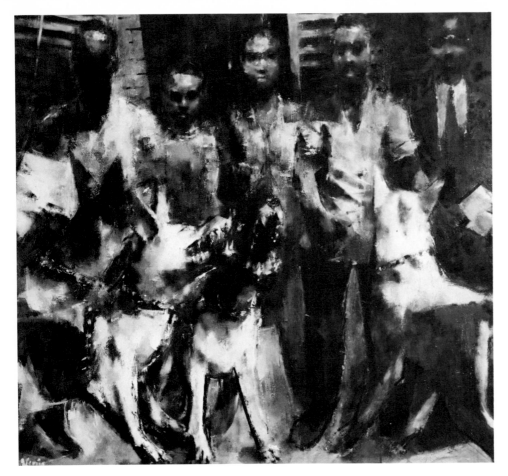

327.

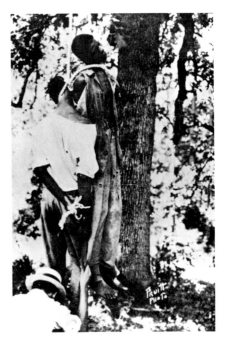

328.

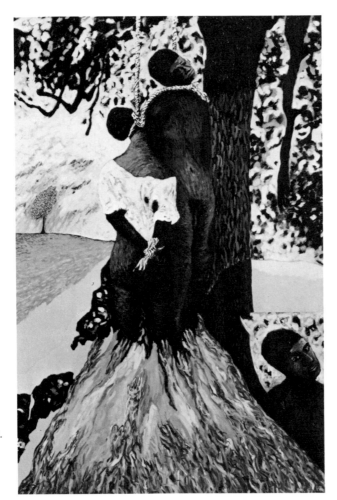

329.

330.

142

327. Jack Levine. *Birmingham '63*. 1963. Oil, 72 x 78 inches. Collection Senator William Benton, New York.

328. Photographer unknown. *Police dog lunges at demonstrator during the protest against segregation in Birmingham*. 1963. Photograph. Courtesy New York *Times*.

329. Claude Breeze. *Sunday afternoon—from an old American photograph*. 1965. Oil, 101½ x 66 inches. (Photograph by John Evans, Ottawa, Canada.) The Canada Council Art Collection.

330. Photographer unknown. *Lynching in Mississippi*. 1935. Photograph. Reproduced courtesy CORE.

dots of various sizes, thus making a half-tone area which described form. This process amounted to drawing with tone, but from my point of view the feeling of "possession by re-creation" was the most important facet of this activity.

Artists like Goya, Käthe Kollwitz, and George Grosz reacted vigorously to political and social injustices through their prints. In a like manner, aspects of the Civil Rights movement have provoked contemporary artists to produce works protesting the treatment of Negroes. Photographs, either seen in the popular press or on TV, have stimulated a number of painters to use their talents as a weapon of protest. Two artists, Jack Levine and Claude Breeze, were aroused by specific newspaper photographs. The cruel candor of these photographs caused the artists to create what they considered to be more meaningful images than the raw documents of violence caught by the lens.

In Levine's painting *Birmingham '63*, only a small part of the photograph which inspired him appeared in his picture. (327-328) On the front page of the New York *Times* he saw a photograph and news report that impressed him immensely. The story concerned Theophilus Eugene (Bull) Connor, Birmingham's Commissioner of Public Service in 1963, who had turned his dogs on Martin Luther King's marchers. The entire situation captured by the camera and the reporters moved Levine to put down in paint his reaction to the conditions in Birmingham. He gave special emphasis to the ugliness of the encounter between the dogs and the Negroes. As Levine has said, "Photography can be a valuable adjunct to the painter, especially for documentation." His painted version of the "documentation" of the events in Birmingham, while dramatic and accurate, somehow does not, however, ring "true." The painting, like most of Levine's work, is somewhat selectively out of focus and therefore seems rather removed from the disorganized setting of the event as it occurred.

Breeze's painting *Sunday afternoon—from an old American photograph* is closer to the photograph that inspired him than is Levine's composition to his source. To a large extent Breeze simply re-created the startling effect of the raw image in the photograph (329-330), which functioned for him as a kind of time machine since the event photographed had occurred twenty-five years earlier. Retained only in part, however, was the crass and bizarre quality of the tragic events recorded on film. In the painting, attention is divided between the way in which the forms are represented and the message the forms are meant to convey. In the photograph our reaction is more immediate, for we do not linger a moment over how the picture was made. It is immediately accepted as an event that took place before a camera. Much of the candor of the original image was sapped by the artifices that the artist brought into play as he unconsciously felt compelled by tradition and training to modify his model. It was his intention to create a symbol, not to represent a specific lynching in Mississippi. Toward this end he introduced a second version of the face of one of the victims in the lower right-hand corner, as if he were asking for an explanation of why such a thing could happen.

A critic writing in *Artscanada* said of this painting, "Not a little of the significance of Breeze's accomplishment in this painting is the fact that he has been able to retain the impact and meaning of the original event, despite the fact that he is working at second hand from it." It is rather difficult, however, to agree with this view.

Breeze changed the composition of his picture in a number of specific ways compared with the photograph and in so doing dissipated much of the emotional grip of the picture. He elected to omit the man pulling down a leg of one of the victims. This man was cold-bloodedly assisting the photographer by holding the bodies so that they would not move during the period the photograph was being made. In its callousness this aspect of the photograph cried out, "This is real." Breeze must have felt that the fire licking at the feet of the lynched Negroes was more effective as a dramatic note than the

331. Howard Kanovitz. *The Dance.* 1965.
Liquitex, 80½ x 70 inches. Collection Allan Patricof, New York.

332. Photographer unknown. *Howard Kanovitz and his wife.*
1965. Photograph. Courtesy Howard Kanovitz, New York.

333. Howard Kanovitz. *Photograph of a seated man, study for "The Dance."* 1965. Photograph.
Courtesy Howard Kanovitz, New York.

334. Photographer unknown. *Howard Kanovitz and his wife.*
1965. Photograph. Courtesy Howard Kanovitz, New York.

335. Howard Kanovitz. *Study for woman holding handbag for "The Dance."* 1965. Photograph.
Courtesy Howard Kanovitz, New York.

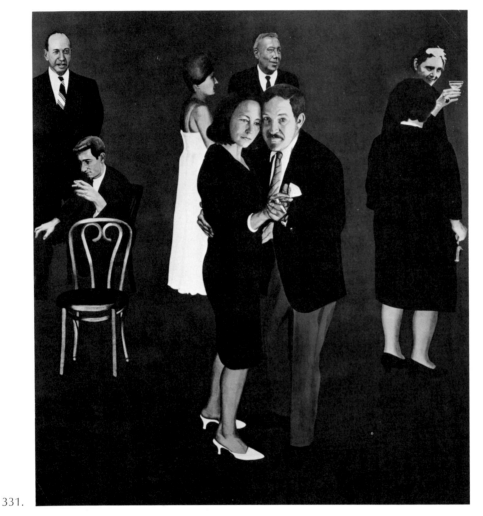

331.

332.

333.

334.

335.

fact that the swaying dead bodies had to be stilled for the camera. The fire introduced by Breeze gave him an opportunity to add a spectacular color passage to further heighten the poignancy of his version of the scene.

The poorly made photograph, nevertheless, is a stronger statement than the stilted and bombastic painting, a stronger statement both about the event itself and the far-ranging implications of the event. The *cinéma vérité* qualities of realism preserved by the camera reach out and grasp us both perceptually and conceptually. Breeze felt he was supplementing the "message" of the photograph by his additions and alterations. But, in fact, his changes weakened the effectiveness of the painting since we do not accept it as authentic and cannot identify in the same deeply meaningful way with the men who were lynched as we do when viewing the photograph.

The success of the Levine and Breeze paintings, sincere as they obviously were, must be measured by their effectiveness as a means of arousing protest. Levine's picture tended to lose its impact in the process of casting the idea into an aesthetically satisfactory format. Because his artistic inflections obscured rather than accentuated the reality of the terror, the force and vitality of the photogaph were only approximated in his painting. The Levine and Breeze paintings, like those of the concentration camps by Picasso and Lebrun, illustrate how difficult it is for artists to use photographs as models when the photographs are emotionally loaded.

In 1966, two years after publication of the catalog *The Painter and the Photograph*, Lawrence Alloway organized an exhibition at the Guggenheim Museum called "The Photographic Image," attracting further attention to the fact that artists in ever-increasing numbers were turning to photographs as sources of inspiration. In mid-1968 the Associated American Artists gallery in New York presented a show titled "Photography in Printmaking," and the mid-August 1968 issue of *Time* devoted the major part of the art section to the use of photographs by a group of prominent and mature New York artists.

One of these, Howard Kanovitz, had seen a reproduction of Derain's painting *At the Suresnes Ball* in the catalog *The Painter and the Photograph* and used the photograph of the Derain picture as a basis for his own painting *The Dance*. (331-335) Kanovitz arrived "at film-fashioned realism by the circuitous route of abstract expressionism." His Abstract Expressionist mannerisms were abandoned in 1962, and about that time Kanovitz began to clip photographs from magazines to provide him with ideas. In 1964 he did a number of large paintings based on newspaper photographs of athletes, jazz musicians, and similar subjects. Later he turned to his family album for ideas, and he now carries a 35-mm camera and makes his own "studies." These he projects onto canvas or tracing paper with an opaque projector. The scenes are then colored to achieve a higher degree of realism. His realism, while based on camera vision, has qualities quite different from those found in photographs. Color is usually flat, low key in value, and unmodulated in less important areas. Frequently only the heads of his subjects are modeled. As part of some of his compositions he includes free standing figures, also derived from photographs. Kanovitz's work confirms Alloway's contention, "it is clear that photography is as susceptible to personal use and interpretation as say, classically derived iconography."

Other New York artists who paint genre subjects in a superrealistic style from photographs are Richard Estes and Joseph Raffael. Estes (one of the best of the lot) paints supermarkets, store interiors, and street scenes. He uses photographs as references, which is understandable, for he frequently paints in great detail store windows, signs, people selecting groceries as seen through display windows, or fractured images reflected in window glass or in the chrome trim of cars. Estes takes his own 35-mm color photographs, often on Sunday mornings when the streets are quiet. He seems to prefer those parts of the city that are run down

336. Michelangelo Pistoletto. *Dog.* 1965. Collage on stainless steel. 47¾ x 39¼ inches.
Collection Mr. and Mrs. Justin Smith, Wayzata, Minn.

and have examples of undistinguished architecture.

Joseph Raffael paints a variety of subjects including details of pieces of sculpture. He says:

With a photograph I am able to paint any image I like because I am able to isolate it from the stream in my head of forever changing images (Thoughts, Visualized) and having arrested it, I can then depict it.

Quite simply, photographs give me images. They aid me through their stilling of, and their fidelity to, the subject. By using photographs I can paint anything I want, whenever I want. In my Vermont or California studio, I can paint a snowscape in the summer, or a wounded Vietnamese. I use the *printed* photograph from magazines and books (anonymous sources) as an objective springboard. The stilled image found through a photograph extends my mind's functioning.

I use the image the photograph gives me as one might use the actual subject. I keep the photograph in front of me, and refer to it constantly. First I draw it very carefully. This can take a long time. I use a brush for this drawing. When the exact composition is crucial, I sometimes grid the canvas and the photograph. At other times, by drawing in a more free-hand way, I may allow the picture to go where it wants to.

Malcolm Morley's paintings were included in the 1969 exhibition "Paintings from the Photo" at the Riverside Museum in New York. Oriole Farb, the Director, in her introduction to the catalog of the show made a good case for the view that "reality" has changed markedly in the past decade as painters have looked closely at photographs. She observed that the studio-bound painter can have almost instant access to a tremendous number of photographs. While these photographs permit an artist the opportunity to study their imagery at leisure, they also remove the subject matter a giant step from "reality" and thus permit the artist to take a detached view of the forms recorded by the camera. When a painter like Morley makes a faithful reproduction of a luxury liner or a French chateau from a photograph he has had time to appraise every aspect of his subject. Possibly as a reaction to his past he tends to select subjects that smack of luxury living. As a

youngster it is said he was jailed for purse snatching and served time in Borstal Prison before getting a fellowship at the Royal College of Art.

As Morley paints he turns the photograph upside down after squaring off his canvas. He then covers up everything except the part he is working on. He accepts or rejects the limitations of sharp or soft focus, that is, he may or may not use exactly the detailed forms preserved by the lens. Morley does not seem concerned with the meaning or content of the subjects he selects, and somehow his impassive pictures possess a sense of reality beyond that of firsthand observation. His pictures are "artifacts" and recall Duchamp's practice of designating a common object as a work of art, which became one because he so decreed it.

In contrast to these modern trompe l'oeil painters, the Italian artist Michelangelo Pistoletto uses photography in a unique fashion. He traces in charcoal life-sized photographs, which he usually takes himself, onto opaque onionskin paper. The drawings are then cut out, pasted on highly polished sheets of thin stainless steel and colored with a rather limited range of pastel tints to give his images a greater sense of reality. It is reality that Pistoletto is challenging. His intention seems to be age-old—to hold a mirror up to life. Since his mirrors already have disposed on them cut-out representations of life-sized people, and in the case of *Dog*, an animal, we are induced to accept this part of the composition as "real." Pistoletto's image is in the room with us, and our reflection appears in the same mirror. (336) Because of the convincing way in which the photographs have been copied, a dialog is set up between the spectator and Pistoletto's hand-made photographs. It is a dialog that evokes strong psychological reactions indicative of the inherent power of reality even when simulated by photographs.

Similar effects are achieved in the work of the Spanish artist Juan Genovés who is strongly influenced by both still and motion pictures of violence, flight from the threat of violence, or premonition of violence linked

337.

338.

to political oppression. (337-338) A form of vision associated with the zoom lens or telescopic sight appears in his works which portray anonymous groups of fleeing people or individuals bound and under guard. Impersonal wire-service photographs or newsphotos made by hand-held movie cameras evoke images that are not quite clear. Through his paintings we are allowed to experience vicariously the flight or arrest of victims of some unknown political upheaval without being given specific details about who these people are or where these events took place.

The chilling response we have to people being herded toward their doom has been established in our minds by seeing thousands of such images on TV or in photographs of war—its prelude, or its aftermath. Genovés' paraphrases of such tragic imagery are generalized to broaden the range of responses to his work. He does this by clustering his representations of those who suffer and by eliminating referential details of the spectacles he paints. His figures seem to have been created with stencils made from photographs and represent, through a few deft strokes of semi-transparent paint, the depreciated value of man tormented in an inferno

of brutality, a condition of life in many parts of the world today.

Using devices of a different sort, Alain Jacquet superimposes a grid of varying patterns over readily recognized images. For his compositions, this French artist poses live models and then photographs them in color. He depends on such works as Ingres' *La Source* and Manet's *Olympia* and *Déjeuner sur l'herbe* for ideas. (339) Pastiches of these masterpieces are modernized for the camera. In addition to changes in the subjects' clothing and in settings, Jacquet makes other deviations from the original to suit his taste, such as substituting a swimming pool for a brook in the forest.

After the photograph has been made, Jacquet selects the colors he wishes to use, which are generally very bright, and the pattern for the overall grid, which may derive from line screens peculiar to European TV—concentric circles, square dots, or triangular dots. His motifs are then turned over to a shop where they are printed by mechanical means. "Cool" and machine-oriented, this procedure reflects his attitudes toward "hand-made" art. Jacquet's prints are a kind of Pop synthesis of effects achieved by Seurat and Warhol.

339.

337. Juan Genovés. *The Cry*. 1967. Oil and acrylic, 35½ x 47 inches. Marlborough Gallery, New York.

338. Juan Genovés. *Dispersion*. 1970. Etching, 12¾ x 17½ inches. Courtesy Marlborough Graphics, New York.

339. Alain Jacquet. *Le Déjeuner sur l'Herbe*. 1964. Photo-screen print. Coke Collection, Rochester, N.Y.

340.

341.

Jim Dine, using a Pop-Surreal kind of representation, is able to change anything he encounters into an emblem. (340-341) Dine took a diagram of a photograph of Dada artists, his spiritual grandfathers, and through a process that could be compared with a film director's use of stage flashbacks, restated the imagery found in the photograph. What resulted is a babble of images that are in a sense neo-Dada with an admixture of Abstract Expressionism insofar as the application of the paint is concerned. Dine used the free brush strokes as symbols, for it was Abstract Expressionism that he both admired and revolted against in this picture, which was probably a means of throwing off or rejecting the influence of his antecedents.

The photograph of the Dadaists that Dine used as a point of departure for *2 Palettes, #1* was taken during their 1922 Congress. By sketchy descriptions and paraphrases he merely parroted the diagram of the photograph and obliterated references to other parts. Two palettes, which frame the group in his canvas, could be interpreted as symbols of the traditional styles of painting that pre-date Dada and against which the Dadaists were in revolt. They may also be seen in a less meaningful vein, for Dine has a predilection for whimsy.

Whatever the case, Dine's painting acknowledges the inspiration that stems from photographs of history. The photograph of the Dadaists served as a reminder to later generations of artists that there were precedents after World War I for many of the concepts that have prevailed in the post-World War II era. An artist like Dine, who is knowledgeable about history, likes to ruminate, is interested in the use of symbols, can relive aspects of the past through a photograph, and reaffirms the ideas of Dada within a new framework of meaning.

The contemporary Italian artist Giangiacomo Spadari searches through newspapers and magazines for photographs that convey a message that can be interpreted as going beyond the anecdote or the didactic

150

342.

340. Jim Dine. *2 Palettes, #1*. 1963. Oil and collage, 72 x 72 inches. Collection Mr. and Mrs. A. I. Sherr, New York.

341. Photographer unknown. *The Constructivist Dadaist Congress in Weimar, 1922*. Photograph.
L. Moholy-Nagy(?). *Diagram of Photograph above*. n.d. Reproduced from L. Moholy-Nagy, *Vision in Motion*, Chicago, 1947.

342. Giangiacomo Spadari. *I Costruttori*. 1970. Acrylic, 60 x 40 inches. Galleria Schwarz, Milan.

purpose for which they were originally made. He is attracted by photographs that reflect the iconography of our time, meaning from 1917 to the present. When he finds a photograph that suits his purpose he reduces it mechanically to tones of intermediate grays to give it a graphic quality. The resulting image is then projected on a canvas and outlined in detail with a pencil. He then, with careful control and with a brush dipped in bright acrylic colors, fills in the simplified shapes that make up the images he has borrowed. This tends to abstract the photographs while still retaining their indelible photographic qualities. In *I Costruttori,* Spadari, who is a leftist, combined a copy of a Fernand Léger painting, a monument to workers, with a copy of a photograph of Lenin and his associates. (342) This expresses through the new use of forms the political philosophy of the artist. The content of such work is understood because it is derived from well-known photographs that are recognizable even when treated semi-abstractly.

5. STOP-ACTION PHOTOGRAPHY

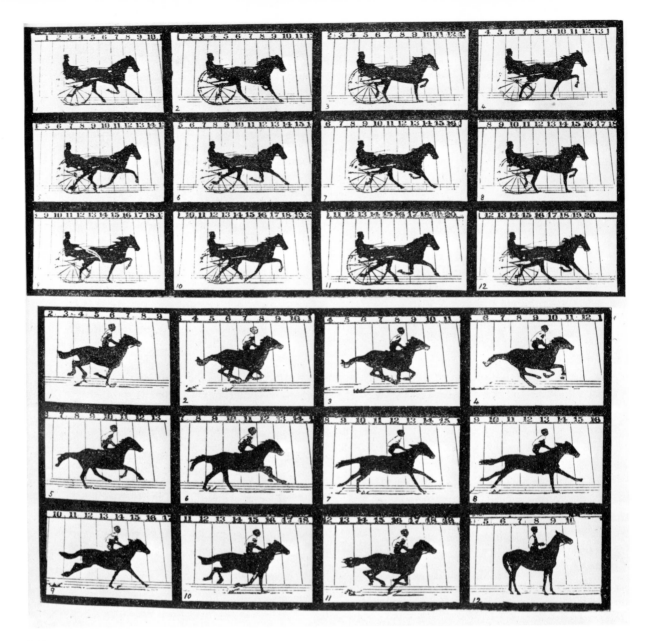

344.

343. Photographer unknown. *Paris street scene* (detail). c1860. Stereo photograph. Coke Collection, Rochester, N.Y.

344. Eadweard Muybridge. *Horses trotting and galloping.* 1878. Wood engravings from photographs. Reproduced in *La Nature.* Prints and Photographs Division, Library of Congress, Washington, D.C.

345. Jean Louis Meissonier. *Portrait of Leland Stanford, Sr.* 1881. Oil, 15 x 11½ inches. Stanford University Museum, Calif.

345.

154

5. STOP-ACTION PHOTOGRAPHY

343.

In the late 1850s short focal-length lenses were developed for stereo cameras which made it possible for the first time to take photographs of people and animals in motion. Even so, lacking high-speed shutters, the cameras could not stop the action of a moving horse's legs in a reliably sharp fashion. This was particularly true if the animal were moving at a right angle to the camera, the situation that presented the greatest amount of relative motion and which most clearly showed the true position of a horse's legs in various gaits.

The first photograph in which the rapid movement of a horse seen in profile was frozen in mid-stride was taken by Eadweard Muybridge in 1872. Muybridge, an Englishman, had made a considerable reputation as a landscape photographer in California before being employed by Leland Stanford, a former Governor of California and a wealthy horseman, to demonstrate that a galloping or trotting horse was not always in contact with the ground. After a number of inconclusive attempts, Muybridge made some successful single pictures of the horse Occident trotting laterally in front of the camera. The photographer used the cumbersome and relatively insensitive wet-plate collodion process, which meant the pictures were not adequately exposed to record maximum details. But even with this handicap, some of Muybridge's photographs plainly showed all four of the horse's feet off the ground, thus settling a long-standing controversy.

Muybridge's work was interrupted in 1874 when he was tried and acquitted of murdering his wife's lover, but in 1877 he resumed his experiments under Stanford's patronage at Palo Alto. In June 1878 in the brilliant California sunshine at about 1/1000 of a second, Muybridge made successful exposures of such horses as Edgington and Occident trotting and of Sallie Gardner running. A thread stretched across the track tripped the shutters as the horses moved in front of a line of twenty-four cameras. The results were first published in October 1878 in *The Scientific American*. Later, cabinet-size photographs of the horses were assembled in a portfolio and widely distributed.

The following year, using an improved electric shutter arrangement, Muybridge photographed even more successfully the sequential action of the legs of the race mare Sallie Gardner and other horses as they galloped over a specially prepared course. These photographs were clear and included precise details. None of the pictures showed the traditional "rocking-horse" position, a convention used by artists for over a thousand years to indicate rapid motion. Muybridge's photographs again recorded all four hoofs off the ground at one stage of the horse's stride and proved once and for all that it was unnatural to represent the legs of a running horse stretched out in front and in back. These successful stop-action photographs of horses in motion gave rise to unforeseen knowledge and excited widespread interest among artists and the public.

In France some of Muybridge's action pictures were reproduced in the form of drawings in the December 14, 1878 issue of *La Nature*. (344) Whether Jean Louis Ernest Meissonier saw these drawings of Muybridge's photographs is not known. But Meissonier, an artist whose work was regarded as the epitome of objectivity, had gone to great lengths to accurately represent horses in action, for they were one of his most important subjects. The French government had constructed a miniature railway next to a race track so that Meissonier could move alongside of and at the same speed as a running horse. By so doing he hoped to accurately sketch the exact positions of a horse's legs in action. When in 1881 Meissonier was invited to see Muybridge's photographs, he at first expressed skepticism about the reliability of such pictures and their usefulness for artists.

Later, Leland Stanford, who was visiting in Paris, commissioned Meissonier to paint his portrait. During the negotiations he showed the painter a large collection of action photographs of horses, dogs, and deer, as well as human beings, all photographed so as to stop their motion. As a consequence of seeing these remark-

able photographs, Meissonier included them in the portrait, and they may be seen on the table behind Stanford. (345) Meissonier was impressed and invited a group of distinguished painters and sculptors to his studio to meet Muybridge, who had accompanied Stanford to Paris. To this special audience Muybridge showed some of the locomotion studies of horses he had made in the United States. The pictures, thrown on a screen in rapid sequence by a zoopraxiscope, created the illusion that the horses were moving. The effect of movement, as well as the revelation of the true action of a horse's legs in motion, greatly impressed the artists; and even academic painters like Cabanel, Detaille, and Gérôme, all present at the Meissonier demonstration, immediately began to paint horses based on what they had learned from the Muybridge photographs. A controversy arose, however, between those who accepted Muybridge's photographs as showing the proper way to represent action and those who felt that the time-honored "rocking-horse" symbol to indicate motion was more artistic.

Dr. Étienne-Jules Marey, a French physiologist, who had also been studying (by other means and for other reasons) the movement of a horse's legs, praised the Muybridge pictures because they so greatly extended man's knowledge of how bones and tendons function in action. Marey said, "Give to artists a series of figures where the truthfulness of the attitudes of a horse in motion is combined with accuracy of form, and you will have done a great service. Some masters have already, in this respect enlightened public taste; once instructed, the public will no longer accept either convention or caprice."

The first major artist to capitalize on Muybridge's photographs was the American Thomas Eakins. An ardent student of human and animal anatomy, Eakins taught drawing and painting at the Pennsylvania Academy. He had followed with great interest the report of Muybridge's attempts to stop the action of running and trotting horses in California and possibly showed his students lantern slides of the first published results of Muybridge's pictures. These photographs also played a role in Eakins' own work.

In 1879 Eakins used Muybridge's pictures as a guide for a major canvas of a rapidly moving coach drawn by four horses. Fairman Rogers, a prominent Philadelphian and enthusiastic horseman, had commissioned the picture which was to be of his own coach-and-four. The artist made a detailed study of Rogers' coach-and-four in action and a wax model of the four horses as well, but he also consulted Muybridge's photographs of the trotter Edgington, made in 1878. (346-347) Had Eakins not done so, he could never have painted so accurately the legs of each horse as they pulled the coach through Fairmount Park in Philadelphia. (348)

The reaction of the public and the press to the exactitude of *The Fairman Rogers Four-in-hand,* otherwise known as *A May Morning in the Park,* was varied, but generally Eakins' quest for scientific accuracy was viewed with disfavor. *The Philadelphia North American* noted:

Mr. Eakins, as a result of his anatomical investigation, and goaded, perhaps, by the remembrance of certain instantaneous photographs of horses in rapid motion [Muybridge's photographs], which recently gave rise to something of a panic among animal painters, has forsaken the method of representing quick action, and has adopted the very different mode of progression revealed by the camera. The result cannot be said to be encouraging. Those of our readers who may remember these photographs will be aware that, even at the highest rate of trotting speed, the attitude of the horse, if it indicated motion at all, was apparently sluggish in the extreme. There is no doubt of its truth in the photograph as a means of study, but there may well be grave misgivings as to the wisdom of its adoption in the finished picture.

In London the artist Joseph Pennell said of what we can presume was Eakins' painting:

If you photograph an object in motion, all feeling of motion is lost, and the object at once stands still. A

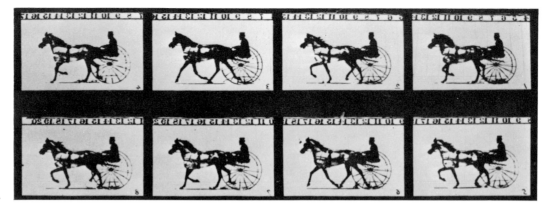

347.

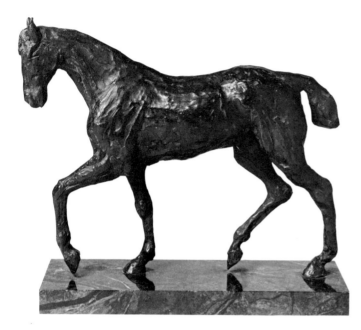

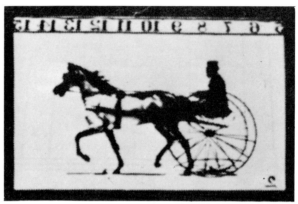

Detail of *above*.

346.

348.

157

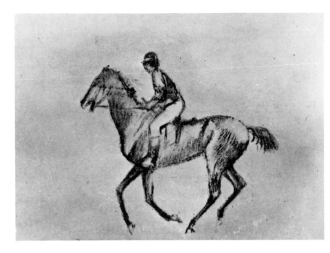

349.

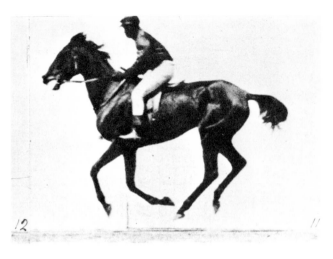

350.

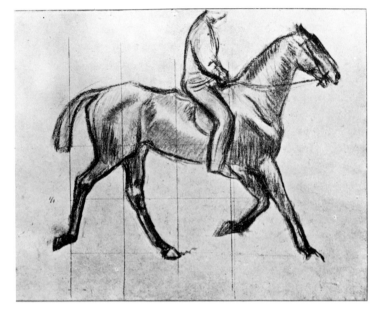

351.

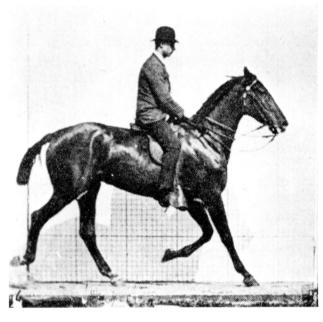

352.

most curious example of this occurred to a painter just after the first appearance in America of Mr. Muybridge's photographs of horses in action. This painter wished to show a drag coming along the road at a rapid trot. He drew and redrew, and photographed and rephotographed the horses until he had gotten their action apparently approximately right. Their legs had been studied and painted in the most marvellous manner. He then put on the drag. He drew every spoke in the wheels, and the whole affair looked as if it had been instantaneously petrified or arrested. There was no action in it. He then blurred the spokes, giving the drag the appearance of motion. The result was that it seemed to be on the point of running right over the horses, which were standing still.

Pennell was incorrect in his statement that Eakins "photographed and rephotographed the horses. . . ." He probably confused Eakins' study of Muybridge's pictures with Eakins' activities as a photographer.

In *The Century* magazine of 1882, Dr. J. D. B. Stillman posed a pertinent question, "it becomes now a curious and not unimportant question to discuss whether or not artists should abandon their old methods of representing the galloping horse and show him in some of his active positions." Dr. Stillman was strongly of the opinion that they should do so: "Perhaps after all it resolves itself into a question as to whether an artist whose purpose it is to represent things as they seem, is

349. Edgar Degas. *Jockey.* c1885. Pastel, 10½ x 13 inches. Reproduced from *Atelier Edgar Degas (3me Vente)*, Paris, 1917. Whereabouts unknown.

350. Eadweard Muybridge. *Annie G. with Jockey, Horse Cantering.* c1885. Photograph. George Eastman House, Rochester, N.Y.

351. Edgar Degas. *Cavalier.* c1888. Charcoal drawing, 19¼ x 24½ inches. *Atelier Edgar Degas (3me Vente)*, Paris, 1917. Whereabouts unknown.

352. Eadweard Muybridge. *Daisy with rider.* c1885. Photograph. George Eastman House, Rochester, N.Y.

justified in adapting his methods to the limitations of the human vision, or whether he should show things exactly as they are, and appeal only to human reason." He made a further wry comment, "there is too much capital invested in works of art all over the civilized world to permit the innovation without a protest."

Favorable comments and adverse criticism of the Muybridge chronophotographs reached a peak in 1887 when a large number of Muybridge's action photographs were published in book form. This eleven-volume work, *Animal Locomotion, an Electro-Photographic investigation of consecutive phases of animal movement*, was the result of Muybridge's work with the new highly sensitive, gelatin dry plates and contained 781 large collotypes. Muybridge's research had been sponsored by the University of Pennsylvania from the spring of 1884 through 1885. Although he was initially concerned with the motion of quadrupeds, Muybridge also began a series of human-action pictures. Both his photographs of animals, borrowed from the Philadelphia Zoological Garden, and those of people were points of view taken simultaneously from three cameras electrically actuated to record twelve successive exposures on dry plates. Among the most important were photographs of nude and clothed males and females going through a variety of activities. Many of the individuals photographed were associated with the Pennsylvania Academy of the Fine Arts. Muybridge's photographs of nudes in action influenced artists as much as did his equine photographic studies. This was true in the nineteenth century and has continued today in ways never anticipated by the photographer.

Muybridge's books had such a great effect on artists that many prominent painters and sculptors bought them for guidance in their work. Among the artists who subscribed to the volumes were the following: in England—G. F. Watts, W. Holman Hunt, Sir John Everett Millais, W. Z. Orchardson, James McNeill Whistler, and John Singer Sargent; in France—J. H.

Gérôme, Puvis de Chavannes, Adolphe Bouguereau, Auguste Rodin, and Jules Dalou; in Germany—Adolphe Menzel and Franz von Lenbach; and in the United States—G. P. A. Healy, Elihu Vedder, J. A. Brown, Thomas Moran, Homer St. Gaudins, Eastman Johnson, C. E. Eaton, and Stanford Gifford.

Edgar Degas is not listed among the original subscribers. He was acquainted with the unusual and asymmetrical stereo photos of horses as they paraded before a race or pulled a coach in the streets. Since they were often moving at a relatively slow pace, the shutters on stereo cameras were able to stop the action of a horse's legs fairly well, and the artist could study the prints later in his studio. It was Muybridge's photographs, however, which prompted Degas to do a group of drawings and pastels that are directly dependent on the fast-acting shutters of the motion cameraman.

Paul Valéry recalled that Degas "was one of the first to study the true appearance of the noble animal by means of Major Muybridge's instantaneous photographs." Like Meissonier, Degas was concerned with the true nature of equine movement. As soon as Muybridge's *Animal Locomotion* was available in Paris, Degas consulted the frames that showed the position of the legs of horses as they moved at a canter or fast trot. He copied a photograph of Annie G. when he sketched *Jockey*. It is curious that he often chose photographs that did not deal specifically with rapid motion. (349-350) Perhaps in such cases he wanted to verify the correct position of a horse's hoofs which, in the case of the rear feet, would be difficult to observe with clarity even if the animal were moving at a rather slow pace.

Degas' *Cavalier* was a study of this kind; it showed the mechanics of motion of a horse's body and legs while pacing. (351-352) In spite of the title of the drawing, the artist seemed to have had so little interest in the rider that he showed him as virtually headless. Another similar picture was listed by Degas' cataloger Lemoisne. This was *Jockey à cheval*, a pastel

sketch which was an "impression rehaussée de couleurs." This indicated that Degas placed his charcoal drawing facedown on a sheet of paper and thus transferred the image to a new surface. The reversed picture was then heightened with pastel tints. He omitted the head of the rider, as in *Cavalier*. Another Muybridge photograph was copied in part by Degas for his drawing *Jockey*. He followed the position of the horse's legs and body rather closely, but disregarded the flowing "unnatural" tail, depicted a white rather than a black rider, and represented the horse's head in a completely different position from that in the photograph. (353-354)

Degas also copied other Muybridge motion photographs rather freely. In his pastel *The Jockey* he combined a frame from Muybridge's *Horse galloping* and a landscape of open fields. (355-356) In this picture Degas utilized one of the phases of a galloping horse's legs, but he altered the angle of the animal's neck and the stance of the jockey, so that the horse in the Degas picture seems to have just been reined in. The horse's neck looks rather awkward, due possibly to the difference in muscular strain between a horse running at full tilt and one that has just been checked by its rider. Degas' representation, partly taken from a photograph, did not overcome this inconsistency. Although in *Jockey à cheval* the horse's tail was given a more conventional treatment than that recorded by the stop-action camera, in *The Jockey* the animal's tail was copied exactly from the photograph. On the other hand, the animal's neck and the angle of the leaning rider were altered to a marked extent.

These photographs probably interested Degas because they suspended motion and gave him a clue as to how he could achieve the effect of instantaneous vision without the excessive drama of arresting his subjects in a state of great strain. Valéry felt that Degas sought "to combine the snapshot with the endless labor of the studio." Even so Degas does not seem to have used these drawings as studies for any known paintings. He

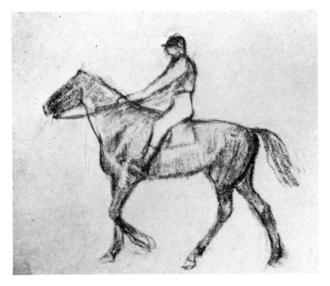

353.

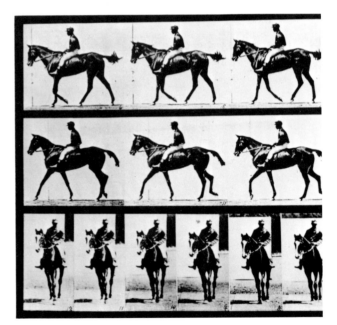

354.

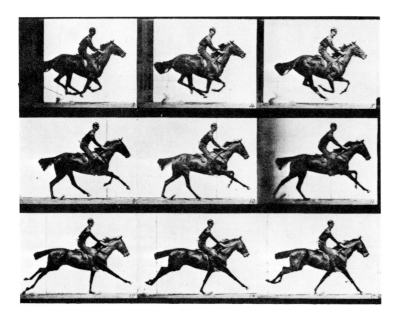

356.

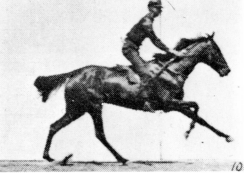

Detail of *above*.

355.

353. Edgar Degas. *Jockey*. Drawing, 8¾ x 10¼ inches.
Reproduced from *Atelier Edgar Degas* (3me Vente), Paris, 1917.
Whereabouts unknown.

354. Eadweard Muybridge. *Annie G. with jockey.* c1885.
Photograph. George Eastman House, Rochester, N.Y.

355. Edgar Degas. *The Jockey*. 1889. Pastel, 12½ x 19¼ inches.
Philadelphia Museum of Art, Wilstach Collection.

356. Eadweard Muybridge. *Horse galloping.* c1885.
Photograph. George Eastman House, Rochester, N.Y.

357.

358.

357. Louis Anquetin. *L'Omnibus*. c1895.
Whereabouts unknown.

358. Photographer unknown. *Coach stop in Seville* (detail).
c1880. Photograph. Coke Collection, Rochester, N.Y.

359. Thomas Eakins. *The Sculptor and His Model*. 1907-08.
Oil, 35¼ x 47¼ inches. Honolulu Academy of Arts, Honolulu.

360. Eadweard Muybridge. *Woman walking downstairs,
throwing scarf over her shoulders*. c1885. Photograph.
George Eastman House, Rochester, N.Y.

did, however, utilize Muybridge's locomotion photographs as models for some of his clay studies of horses in motion. In all likelihood the artist regarded the drawings and clay studies as a way of fixing in his mind the natural order of a galloping horse's legs, so as to be able to accurately paint them at a later date.

Before the 1860s a simple cap that could be removed by hand and then replaced was used to regulate the amount of light that could fall on a photosensitized plate. About 1855 mechanical shutters were introduced; and by 1885 electrically actuated shutters, as fast as 1/1500 of a second, were invented, which revealed phenomena that had been only dimly perceived before. Certainly the most spectacular revelations were the stop-action photographs of running horses made by Muybridge, for these photographs extended human vision. No less an extension of vision were the semi-transparent impressions made on film when a camera's shutter failed to arrest the action of a person moving at a rapid rate, such as the woman in the *Coach Stop in Seville*. Blurred images created in this fashion were regarded as indications of movement and were incorporated in paintings of cityscapes by Monet and other Impressionists before Muybridge made his stop-action photographs. Louis Anquetin, a painter of the generation following Monet, moved in on his subject and painted a close-up of horses' heads and beyond them people moving along the street. (357-358) The phantom-like imagery Anquetin used to evoke a sense of the movement of pedestrians was derived from photo-

graphs. It is not surprising that he should have turned to camera vision for some of his pictorial ideas, for he was a friend of Toulouse-Lautrec and Gauguin, both of whom used photographs as a basis for some of their paintings.

As noted, Thomas Eakins used Muybridge's 1877 photographs of horses in motion as a reference for one of his major compositions. A number of years later he again consulted the photographer's locomotion studies for clues to the accurate treatment of a figure in motion. During his career, Eakins painted three pictures of William Rush, one of the earliest sculptors in the United States, and one of these paintings can be directly linked to a Muybridge photograph. Rush was given an important commission to carve in wood a female nude, as a symbol of the Schuylkill River which runs through Philadelphia.

In 1877 Eakins painted his first canvas of Rush at work on this project, showing the sculptor with mallet in hand, working on the lower portion of a rather neo-classic, draped figure. On a stand, with her back to the viewer, was the nude model. This canvas was painted before Muybridge made his numerous pictures of female nudes in motion.

In 1905 Eakins painted another picture of Rush at work in his studio, titled *The Sculptor and His Model*. In this picture the nude model is shown stepping down from the stand on which she had been posing. This time Eakins used a Muybridge photograph as a reference for the model's movement. (359-360) While the

359.

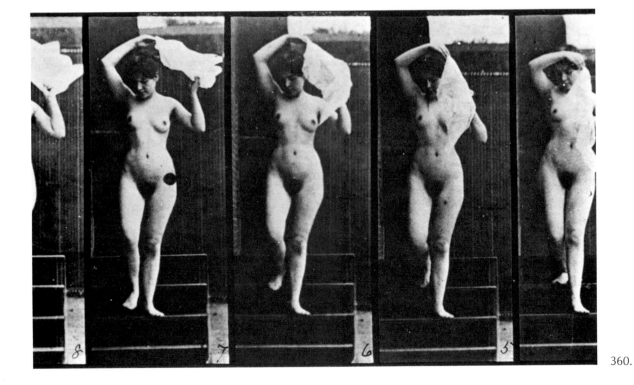

360.

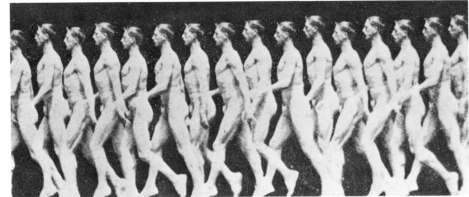

363.

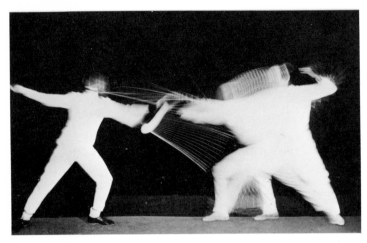

361.

361. Étienne-Jules Marey. *Fencer.* c1883. (Successive photographic images recorded on a single plate, 50 images a second.) George Eastman House, Rochester, N.Y.

362. Étienne-Jules Marey. *Linear graph of running man wearing black and white stripes.* c1882. Photograph. George Eastman House, Rochester, N.Y.

363. Étienne-Jules Marey. *Analysis of walking movement.* 1887. Photograph. George Eastman House, Rochester, N.Y.

364. Marcel Duchamp. *Nude Descending a Staircase, No. 3.* 1916. Colored photograph, 58 x 35½ inches. Philadelphia Museum of Art. Louise and Walter Arensberg Collection.

362.

364.

painter was not totally subservient to the photograph, the model's pose, the position of her legs, and the general appearance of her body and face are all traceable to the motion study. Eakins painted a shadow to the right of the sculptor's left arm, and the same light that cast this shadow should also have darkened the model's left leg and knee, since her right knee was thrust forward, cutting off the light on this portion of her left leg. The reason it did not do so is that Eakins chose to follow rather closely Muybridge's photograph, which was lighted from above. This created an inconsistency in what was intended to be a very objective painting. And then, not completely satisfied with the photograph, Eakins changed the position of his subject's arms to suit his composition.

The scientific techniques introduced by Muybridge for visually studying motion were of interest not only to artists but to men like Étienne-Jules Marey, who adopted many of these ideas for clinical purposes. Thus through Marey, Muybridge came to influence another generation of painters. As Aaron Scharf has indicated, Marey's photographs inspired Georges Seurat in certain passages of at least one of his paintings. And Charles Henry, the physiologist, used some of Marey's chronophotographs to illustrate his experiments in which the movements of various parts of the human form were reduced to rhythmic linear patterns. Henry presented his theories to the French Academy of Science in 1885, and soon afterward the results were published. Seurat's painting *La Chahut*, 1889-90, incorporated Henry's ideas as illustrated in Marey's photographs, and this influence can be seen in the repetition of the figures of the dancers and the flow of their costumes.

In the early 1900s the pioneering French artist Marcel Duchamp became interested in Marey's documentary stop-action pictures. For Duchamp the photograph became the vehicle for transmitting the unseen into terms that were abstracted from scientific reality, while standing for more than impersonal mechanics. Du-

champ once indicated that a photograph of a fencer in action, reproduced in one of Marey's late nineteenth-century books on motion, was the primary image that influenced him to use overlapping geometric forms to present the mechanism of human motion in terms tangent to science. (361) Marey's stick-figure chronophotographic studies and analysis of the walking movement also played a part in some of Duchamp's work between 1911 and 1913. (362-363) Although seemingly almost scientific, Duchamp's work was primarily intended as an aesthetic solution to the problem of dissecting motion.

Philosophy as well as imagery was bound up with Duchamp's use of the photograph. In 1916 Walter Arensberg wanted to buy *Nude Descending a Staircase No. 2*. Because he could not persuade the owner, F. C. Torrey, to sell the painting, he asked Duchamp to make a replica. For this purpose an enlarged photographic print of the *Nude* was made, to which Duchamp applied pastels and India ink. This became *Nude Descending a Staircase No. 3*. (364) This method of copying a painting was quite consistent with Duchamp's interest in anonymous and mechanically created art forms.

At the same time that Duchamp was painting his pictures of moving figures, Giacomo Balla was formulating his version of Futurism. He was encouraged by the chronophotographic experiments carried out in Italy in 1911 by Anton Giulio Bragaglia and his brother Arturo. Incorporated in the first edition of the rare 1912 publication *Fotodinamismo Futurista* is a statement of the ties that related the Bragaglias' photodynamism and Balla's paintings of objects in motion. Balla and the two Bragaglias were closely associated during 1911 to 1913, when the analysis of movement was a primary concern of Balla's. There now seems to be no question that the work of the Bragaglias was connected with that of Balla. His paintings representing successive phases of action were begun in 1911—the Bragaglias undertook their study of photographically blurred and interrupted movement in 1910 and 1911.

365.

365. A. G. Bragaglia. *A Turning Face*. 1911. Photograph. Courtesy Centro Studi Bragaglia-Roma and *Photography Italiana*.

366. Giacomo Balla. *Swifts: Paths of Movement + Dynamic Sequences*. 1913. Oil, 38⅛ x 47¼ inches. Museum of Modern Art, New York.

367. Francis Bacon. *Study from the Human Body*. 1949. Oil, 58 x 51½ inches. National Gallery of Victoria, Melbourne. Photograph, courtesy Marlborough Fine Art, London.

368. Eadweard Muybridge. *Frames from "Men Wrestling."* c1885. Photograph. George Eastman House, Rochester, N.Y.

369. Francis Bacon. *Study of a Nude*. 1952-53. Oil, 24 x 20 inches. Collection Mr. and Mrs. R. J. Sainsbury, London.

370. Eadweard Muybridge. *Frames from "Man performing standing high jump."* c1885. Photograph. George Eastman House, Rochester, N.Y.

366.

With the financial aid of F. T. Marinetti, one of the founders of Futurism, a Rome exhibition of the results obtained by the photographers was organized in 1911 so that all the Futurists could become acquainted with the many parallels between painting and photography. The interaction between photography and Balla's interpretation of various repeated stages of motion can best be seen in his *Swifts: Paths of Movement*. (365-366) This 1913 painting probably came about through the combined stimulation of A. G. Bragaglia's photographs and Balla's earlier knowledge of Marey's work, which he must have encountered while he was in Paris in 1900.

Piero Racanicchi has pointed out that Balla also used photographic vision even before his pre-Futurist pictures. He called particular attention to certain compositions in which angles of view and cropping of format, such as in *Bankruptcy*, 1902, would have been difficult to explain without reference to camera vision.

In more recent times, Francis Bacon has used Muybridge photographs as a starting point to parody con-

temporary man. Many of Bacon's evocative images have come from Muybridge's technical photographs of people and animals in motion. According to Bacon's biographer, Sir John Rothenstein, the earliest surviving example is *Painting*, 1950, which was derived from a composite of a number of Muybridge photographs. The painting seems closest to one of the frames of standing men wrestling. Carried over from the photograph were not only the postures of the men but also a version of the scale that Muybridge set up behind his subjects as a measuring device.

It appears, however, that Rothenstein overlooked *Study from the Human Body*, 1949, which surely was derived from the first photograph on the third register of the series *Men wrestling*. (367-368) The position of the man's neck and shoulder and the prominence of the contour of the cheek of his right buttocks are both repeated in the Bacon painting. Bacon also took from Muybridge's *Man performing standing high jump* a figure of a man with hands raised over his head for *Study of a Nude*, 1952-53. (369-370)

367.

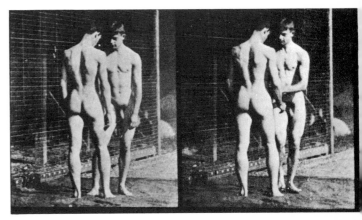

368.

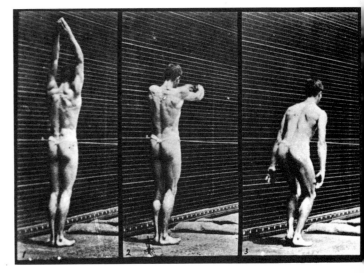

370.

369.

371.

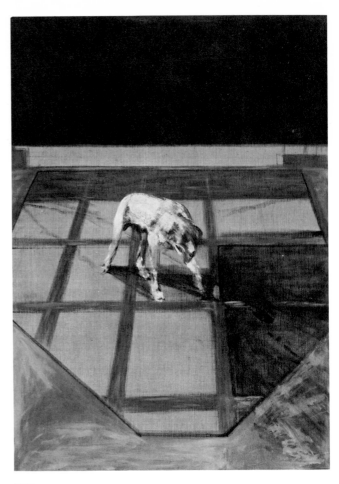

372.

371. Eadweard Muybridge. *Mastiff "Dread."* c1887.
Photograph. George Eastman House, Rochester, N.Y.

372. Francis Bacon. *Dog.* 1952. Oil, 78½ x 54¼ inches.
Museum of Modern Art, New York. William A. M. Burden Fund.

373. Francis Bacon. *Study for Nude.* 1951. Oil, 78 x 54 inches.
Marlborough Fine Art, London.

374. Eadweard Muybridge. *Man lifting and heaving 75-lb.
boulder.* c1885. Photograph.
George Eastman House, Rochester, N.Y.

375. Francis Bacon. *Two Figures.* 1953. Oil, 60 x 46 inches.
Marlborough Fine Art, London.

376. Eadweard Muybridge. *Men wrestling.* c1885. Photograph.
George Eastman House, Rochester, N.Y.

Bacon borrowed quite openly from Muybridge for his numerous versions of *Dog, 1952,* a motion study of an advancing mastiff. (371-372) He did, however, change the content considerably, for the advancing mastiff has a menacing quality in the painting that is quite at odds with the photograph. Also, the feeling in the canvas is that the dog's tongue hangs out in anger, not fatigue, as seems to have been the case in the Muybridge photograph. The artist also slightly blurred the image of the dog to create visual tension and a sense of movement. By placing the animal in the center of his compositions and in an enigmatic setting, Bacon entrapped the viewer's imagination in a way that is distinctly different from the sensation experienced when viewing Muybridge's photograph.

Bacon also turned to a Muybridge photograph for his *Study for Nude, 1951,* copying the taut, coil-spring quality of the man's back and leg muscles as he lifted the heavy boulder. (373-374) Bacon exaggerated the size of the man's upper arm muscles in his free interpretation of the Muybridge photograph. He retained only vestiges of the vertical measuring grid and gave emphasis to the numbers that were meant to serve as a scale for those who were interested in the scientific aspects of the photograph. Bacon's *Two Figures, 1953,* is also based on another picture from the human-locomotion series by Muybridge. (375-376) The photograph shows two wrestlers intertwined, with muscles straining, but Bacon translated this situation into a tense interlude in which the blurred faces and ambiguous positions of the men's arms and bodies created an association having erotically bestial connotations rather than illustrating the sport of wrestling. The objective photographic source remained identifiable, but the meaning of the painting is totally divorced from the source of inspiration.

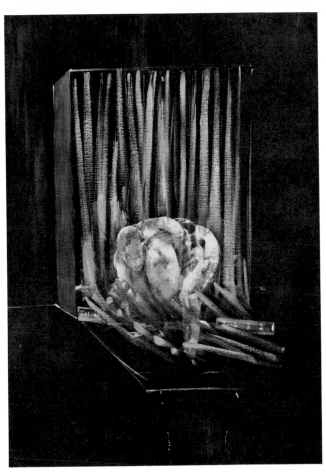

373.

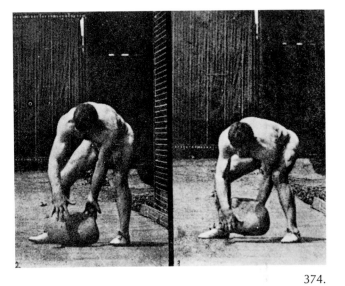

374.

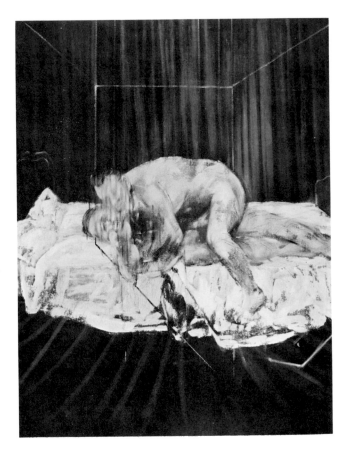

375.

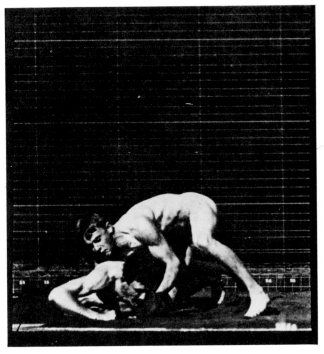

376.

371.

379.

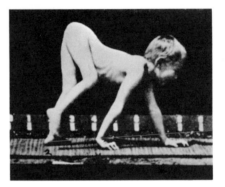

378.

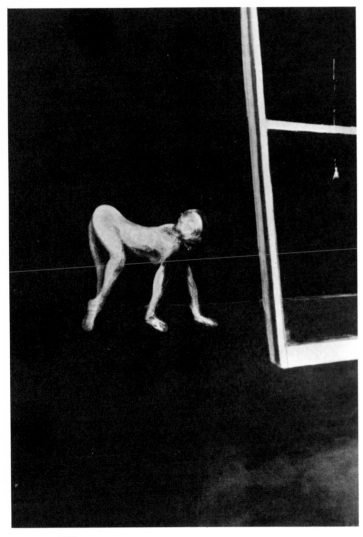

377.

As the title indicates, *Paralytic Child Walking on All Fours (from Muybridge)*, 1961, was painted from one of the photographs of afflicted children that Muybridge made at the request of Dr. Francis X. Dercum of the Pennsylvania Medical School in 1885. (377-378) Bacon turned this extremely objective study into a painting that could have come from a nightmare, for the child appears to have reverted to a sub-human state. This was a very personal and imaginative reaction to the ready-made imagery of the clinical photograph.

As has been mentioned, Francis Bacon's *Dog*, 1952, was inspired by a Muybridge photograph. It is interesting to note that the Italian artist Franco Mulas also turned to the same photograph for two of his pictures. In *Cane sull' autostrada*, 1968, he cast the mastiff Dread in a new role, different both from Bacon's picture and Muybridge's photograph, and also placed him in a new environment. (379) The dog was stylized by Mulas in a somewhat overstrained fashion. By small changes the artist quickened the tempo of the lumbering pace taken by the dog when he was origin-

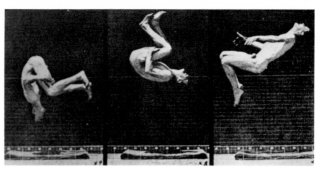

380.

377. Francis Bacon. *Paralytic Child Walking on All Fours
(from Muybridge)*. 1961. Oil, 78 x 56 inches.
Marlborough Fine Art, London.

378. Eadweard Muybridge. *Paralytic child walking on all fours.*
c1885. Photograph. George Eastman House, Rochester, N.Y.

379. Franco Mulas. *Cane sull' autostrada (dog on the highway)*.
1968. Oil, 49 x 60 inches.
Courtesy Il Torcoliere, Galleria e Stamperia d'Arte, Rome.

380. Shusaku Arakawa. *The Comb Cuts into the Jump*. 1964.
Oil and collage, 36 x 24 inches. Dwan Gallery, New York.

381. Eadweard Muybridge. *Man performing back somersault.*
c1885. Photograph. George Eastman House, Rochester, N.Y.

ally photographed. The horizontal lines that appeared in the Muybridge photograph as well as the diagonal plane of the dark background were retained in Mulas' re-creation. In addition, the measuring marks found in the photograph were altered to represent the fleeting images of speeding automobiles on a superhighway. Nevertheless, distinct images from the original locomotion photograph were retained.

Muybridge's photographs have stimulated other contemporary artists. In recent years, Shusaku Arakawa, James Steg, and Allan Blizzard have all turned to these nineteenth-century photographs for qualities they have not found in nature or in contemporary imagery.

Arakawa, a Japanese artist living in New York and Paris, has taken Duchamp's ideas as a model for his paintings. He shunned rational relationships in favor of an escapist pleasure in the unfathomable quality of half-suggested objects. Despite this predilection, however, he sometimes incorporated clearly recognizable photographs in his compositions. The technique he

used was related to the cinema, complete with fade-in and fade-out passages. In *The Comb Cuts into the Jump* he used with quiet audacity the same source of imagery that served Degas, Bacon, and a multitude of other artists—Muybridge's motion studies. (380-381) Specifically, he was attracted to the sequence of a man performing a back somersault. Since he was not satisfied with the simple records of action in the photographs by Muybridge, Arakawa rephotographed them to produce a double-vision pair of pictures. He then set up a dialog between the camera record and stenciled shadows of everyday objects, such as a large hair comb.

By spraying white paint around the comb, he feigned the real object but did not get involved with the exactitude of an illusionistically painted form. Over this mélange of echoes he cast a veil by lightly pigmenting selected areas of a clear sheet of plastic. This ingenious overlaying of his compositions linked Arakawa's work with traditional Oriental art, where realistic and amorphous shapes are often found floating in conjunction one with another.

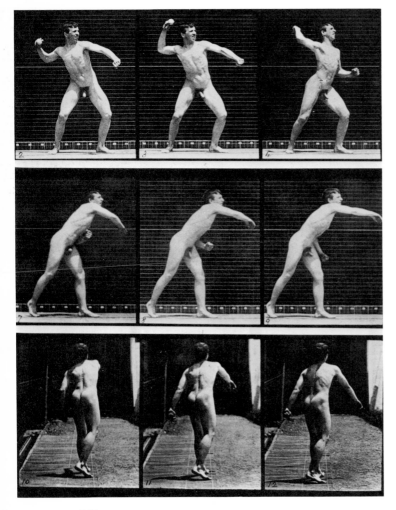

382.

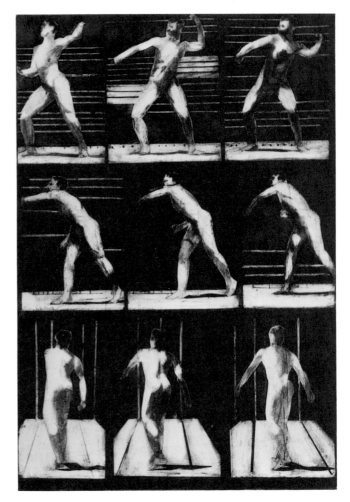

383.

382. James Steg. *Locomotion of Adam*. 1967. Intaglio collage, 36 x 23⅝ inches. Collection James Steg, New Orleans.

383. Eadweard Muybridge. *Man throwing baseball*. c1885. Photograph. George Eastman House, Rochester, N.Y.

384. Allan Blizzard. *Talking Doll*. 1964. Oil, 37 x 33 inches. Collection Allan Blizzard, Claremont, Calif.

385. Eadweard Muybridge. *Frames from "Girl picking up doll from floor and carrying it away."* 1888. Photograph. George Eastman House, Rochester, N.Y.

384.

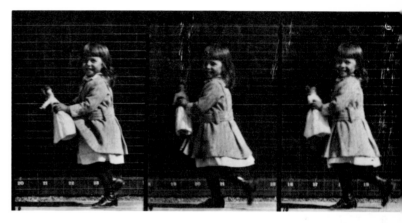

385.

James Steg has also used one of Muybridge's photographs of an athlete. He made four collage intaglio prints from the locomotion studies of a man throwing a baseball. (382-383) Steg recently said:

The use of the nude human figure showing a sequence of action marked my initial interest in the Muybridge photographs. This was in March 1964. I began by projecting the photographs onto a piece of paper with the use of an opaque projector. The images were cut out and pasted to a carborundum-covered piece of masonite. The figures were then "rendered" with washes of carborundum and printed in the usual collage intaglio manner.

With reference to *The Locomotion of Adam*, in comparison to Muybridge's photograph, I feel that I have made another statement. The result conveys an interpretation of the figure that transcends the rigidity of the figures in the photograph. I believe that they express a greater degree of mobility than the caught stance of Muybridge's model. And it goes without saying, the surface of the print gives an added richness to the imagery.

Allan Blizzard was not concerned with the scientific aspects of Muybridge's pioneering pictures, but he was stimulated by the relationships of forms caught in a continuum of movement. He relates how he happened to turn to Muybridge for some of his ideas and specifi-

cally how he used photographs from the motion studies for *Talking Doll*: (384-385)

I should probably say first of all that I can't exactly remember how I learned of Muybridge but got a copy of the Dover publication as soon as I found out about him and began studying it and basing paintings on it right away.

Trying to remember my first experience with the photos I can only say I was really "turned on" by them. The serial repetition of the figures was strangely interesting in the way in which the frozen animation of the figure separates the physical realities of action from the illusion of action and at the same time lets you back up or go forward one "frame" at a time to see carefully what has *changed*. It's like a movie "flattened out."

Also I find a poignant starkness in the figures as they move against the severe and mechanical grid-scale background. In a certain way they share and foretell some of the tragedy and horror of Auschwitz. The figures are stripped down to their raw, grisly *nakedness* (not to be confused with *nudity*), performing various actions which weirdly have nothing to do with being naked.

The peculiar movement-motifs also lend to the strangeness of the Muybridge collection. There is a certain absurdity to the endless parade of figures performing unexpected actions which is terribly fascinating. Really quite Dada. For example: "Woman Turning, Throwing Kiss, and Walking Upstairs" or "Man Walk-

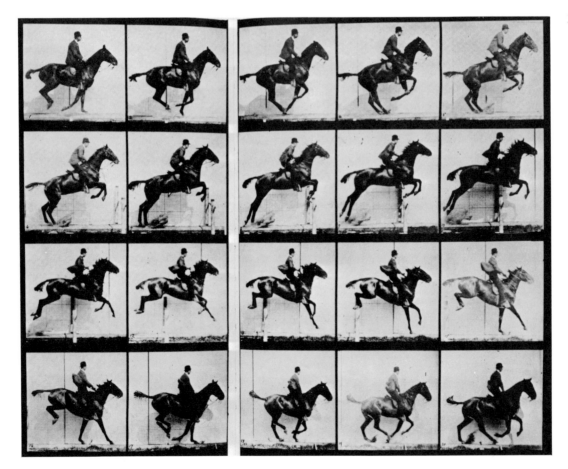

386.

387.

388.

A Master's Master Jump 389.

386. Umberto Bignardi. *Der Blaue Reiter.* 1966.
Pencil and pastel, 28 x 40 inches.
Collection Umberto Bignardi, Rome.

387. Eadweard Muybridge. *Daisy jumping a hurdle.* c1885.
Photograph. George Eastman House, Rochester, N.Y.

388. Kendall Shaw. *A Master's Master Jump.* 1964.
Liquitex, 96 x 52 inches. Tibor de Nagy Gallery, New York.

389. Photographer unknown. *Negative copy print of high jumper by Kendall Shaw.* n.d. Photograph.
Courtesy Kendall Shaw, New York.

ing Downstairs *Backwards*, Turning, Walking away while Carrying Rock" (italics mine). The fact this man is *naked* while doing this makes it stranger still, but when I look at the photos I'm quite upended by the tight-fitting circular hat with the ball on top which the man wears. From my point of view, Muybridge is the first director of the Theatre of the Absurd.

Anyway, as far as this particular painting of mine is concerned (*Talking Doll*), I found all these attractions and stimuli operative as well as the sheer beauty of the way light plays across the child's face and clothing. In making this painting, I used several of the "frames" as I recall (#8 through #10), choosing this face, that leg position and so forth. I don't really believe my painting is particularly *original* and I don't especially care. I put the little girl in a Quasi-landscape and then added the talking-doll hieroglyphics as an afterthought.

From the Muybridge sequence of *Daisy Jumping a Hurdle*, Umberto Bignardi, a somewhat neo-Dada Italian painter, borrowed a number of silhouetted representations of horses and riders in different stages of action. The title *Der Blaue Reiter* is a play on the name of the Munich-based group of avant-garde artists who were associated with Kandinsky before World War I. To make the point explicit, the artist roughly printed the words "DER BLAUE REITER" above one of the drawings of a galloping horse. Scattered among the horses caught in various positions on the ground and

in the air were letters which cancel out the effect of motion on the part of the jumper.

Bignardi used different techniques for each representation of the horse and rider. Frottage, in which he took advantage of the raised grain of a wooden board to get the effect of texture, was juxtaposed with dot outlines followed by schematic light and shade renderings; however, each position of the horseman was treated in a semi-mechanical manner. This is a Pop art game in which we are asked to decipher a puzzle. While based on scientific photographs, Bignardi's painting transcends this fact to the point that any allusion to action is almost completely denied by the translation of a photograph of a running and jumping horse into a static "object" with new and completely two-dimensional characteristics. (386-387)

A number of painters, in no way connected as far as type of subject or individual philosophy is concerned, have directed their attention to simplifying photographs into basic shapes, with little attention to detail and modeling. Photographs of people as well as places have served these artists as basic models.

Kendall Shaw has called this procedure working with "found shapes." In explanation of why he was attracted to certain subjects and why he used photographs as sources for his paintings he has written:

390. Hiram Williams. *Scurrying Searcher*. 1959.
Oil, 96 x 72 inches. Courtesy Hiram Williams, Gainesville, Fla.

391. H. E. Edgerton. *Tennis player*. 1939. Strobe photograph.
Courtesy H. E. Edgerton, Cambridge, Mass.

390.

391.

A man jumps. I also am that man, and with that event I too have jumped. I rejoice in his life; his life extends mine. I paint shapes that were found in that event and re-form its energy. (388-389) The painting is a visual celebration of his living. Unable to include a living man in a painting, I have made paintings from shapes of space which once surrounded men. I do not mean landscapes. In the paintings these shapes are not distorted. They are close to human scale. I want an accurate relation to space shapes that once existed and that were formed by chance. I avoid free or interpretive drawing.

I want no statement of inner man, no frosting of style over figure. No "return to the figure" or "new image of man." In my paintings man is literally the source of his image. Man (includes woman) is a physical man in them, existing only as an area described by the found space shapes. The decision to avoid painting man is emphasized in recent paintings by keeping the figurative areas as raw canvas. I do sometimes develop space shapes in front of the figure (an arm before a torso) as well as to the side of it.

Because I wanted to celebrate such found shapes, the use of sports photographs followed naturally. In them the athlete is in motion, beautiful, physical, vital. Although there are sub-statements of violence, aggression, and cruelty in athletic events and I see them in this way, man's physical presence remains the essence of the sports photograph.

Man in sports displays exquisite grace, and perhaps the camera at 1000/second can see it better than we.

The camera therefore is a fine and sensitive tool which has allowed me to extend the subject matter of my paintings. In addition, the camera permits me to work with the space circumscribed by the figure in these activities and avoid any distortion of that space.

Hiram Williams uses photography in quite a different manner. He freely acknowledges his debt to camera imagery in *Scurrying Searcher*, although whether he was dealing with one figure fused by motion or with many from a single model remains ambiguous. (390)

He altered the appearance of his work for aesthetic purposes and to divorce it from a too obvious link with photography, but scientific photographs can be seen to stand behind his pictorial concepts. (391) He has written, "My idea for a total figure led to stroboscopic pictures. My emotional ability to accept this image as a reality has been determined by my awareness of stroboscopic photographs."

The extension of vision through photography has fascinated the artist as well as the layman. Photographs replaced the quick and inaccurate sketch not only for details but for the overall representation of people and animals as they rapidly moved about or changed their position or posture. With form-frozen action photographs before them, artists are stimulated to expand on the idea of movement as a subject itself, as well as a state of being with unique overtones and implications.

6. PHOTOGRAPHIC EXAGGERATIONS OF FACE AND FIGURE

392. Artist unknown. *Lady with Big Feet: If she ever forgave the photographer who made of her "dainty feet" such barge-like appendages, she was surely more than mortal.* Reproduced from *The Story of Photography*, New York, 1898.

393. Photographer unknown. *J. E. Chartin and Eda Muck.* c1890. Photograph. Coke Collection, Rochester, N.Y.

394. Photographer unknown. *Child and dog.* c1850. Ambrotype. Courtesy Mr. and Mrs. Floyd Rinhart, Melbourne Beach, Fla.

394.

395.

395. Artist unknown. *Die Kunst der Zukunft (The Art of the Future)* (detail). 1859. Lithograph.
Photomuseum, Agfa-Gevaert, Leverkusen, Germany.

392.

393.

6. PHOTOGRAPHIC EXAGGERATIONS
OF FACE AND FIGURE

A normal or short focal-length lens tends to distort the proportions of objects which are close to the camera. This fact was noted early in the history of photography, and in 1853 the following comments were published in Charles Dickens' magazine, *Household Words*:

In the present state of photographic art, no miniature can be utterly free from distortion; but distortion can be modified and corrected by the skillful pose of the sitter, and by the management of the artist. The lens of the camera being convex [in order to diminish the object, and to concentrate the rays of light upon the silver plate], the most prominent parts of the figure to be transferred—those parts, indeed, nearest to the apex of the lens—will appear disproportionately large. If you look through a diminishing glass at a friend who holds his fist before his face, you will find the face very much diminished in proportion to the appearance of the fist. The clever artist, therefore, so disposes his sitter, that hands, nose, lips, etc., shall be all as nearly as possible on the same plane in apposition to the lens. In a sitting figure, hands placed on the knees would seem prodigious—placed on or near hips, no more prominent than the tip of the nose, they would seem of a natural size. It is for this reason that daguerreotypes taken from pictures instead of living figures, are never distorted, because they are on a flat surface.

A few years later, in 1857, Rembrandt Peale noted in an article in *The Crayon*, "photographs may be useful to the portrait painter, making always due allowance for the perspective exaggerations of the camera." By "exaggerations" Peale meant giving undue prominence to a subject's nose, chin, or hands. An unknown author, also in 1857, noted in *Harper's Weekly*, "distortions usually occur in photographic pictures—objects in the foreground being exaggerated, while objects in the background are diminished."

While distortions in landscapes or cityscapes may have been acceptable or unnoticed, true representation of features was expected in portraits, and photographers soon learned to use long focal-length lenses to prevent unpleasant exaggerations. Few early photographs embodying unusual distortions of a person's face, hands, or feet have survived. There was less concern about distortions in representations of animals. The dog's muzzle in the illustrated ambrotype from the 1850s is out of focus and enlarged in scale, which gives the pet an unattractive appearance. (394) Had the dog been a person and his nose exaggerated to this extent, we could readily see why his likeness would not have been handed down to us.

The German cartoon *The Art of the Future* was published two years after Peale wrote his remarks about distortion. This lithograph included a representation of a framed oval photograph of a man whose hands and legs were greatly exaggerated by the camera. (395) This print is an early example of satirical lampooning

397.

396.

396. Nadar. *Le Frileux* (after a painting by Charles Marschal). 1859. Lithograph. Courtesy Aaron Scharf, London.

397. F. Opper. *A Failure*. 1895. Ink drawing. Reproduced from *The Picture Magazine,* London.

398. Photographer unknown. *Man with big shoes.* c1890. Stereo photograph. Coke Collection, Rochester, N.Y.

399. A. B. Frost. *Amateur Photography—Some Results* (detail). 1884. Woodcut. Coke Collection, Rochester, N.Y.

398.

399.

of certain kinds of camera vision. Many more pictorial comments followed, such as Nadar's caricature of Charles Marschal's painting *Le Frileux*, exhibited in the Salon of 1859. (396) In *Le Frileux*, Marschal deliberately incorporated the exaggerated perspective he had observed in pictures made with the camera. Without photographs as a guide he would certainly not have painted the feet of the seated man so much larger than his head.

In the last quarter of the nineteenth century, photographs were made in which the subject's feet were deliberately recorded as disproportionately large. (397) Stereo and single photographs of this kind were particularly in vogue as a novelty in the 1890s. (398) During this period amateur photography was growing in popularity. Beginners had to learn through trial and error what experienced photographers already knew about distortions and the effect of placing the camera too close to a subject. A. B. Frost, for example, drew a cartoon, *Amateur Photography*, for *Harper's Weekly* in 1884 that called attention to the unintentional effects of exaggeration in photographs by novices. (399) Another artist, W. Ralston, in a cartoon drawn for *The Graphic* in 1899, also called attention to this phenomenon. (400)

In the years between World War I and II, well-known artists began to incorporate enlargements of both hands and feet, similar to those recorded by the camera, in their paintings. While similar distortions of hands had appeared in a few paintings of the Mannerist school in the sixteenth century, this was the first time that major artists had used the device extensively for expressive purposes. Pablo Picasso, known for pictorial innovations that were inspired by African art and other non-traditional sources, made effective use of overly large feet and legs in some of his pictures to heighten the effect of figures in motion. As has been mentioned, Duchamp adopted from Marey's stop-action photographs the idea of portraying movement by the use of multi-faceted views, and Balla was stimulated by A. G. Bragaglia's sequential and overlapping photographs of objects in motion. Picasso, however, saw in the optical phenomenon created by a camera's lens a new way of representing the moving figure without resorting to a diagrammatic system. *The Fisherman* of 1917 and *By the Sea* of 1920 are good examples of his use of this kind of exaggeration. (401-402)

The 1899 cartoon in *The Graphic* and the stereo photos of enlarged feet indicate that this kind of camera vision was "in the air." Picasso's friend Jean Charlot,

400. W. Ralston. *First Appearance of Our Kodak.* 1899.
Ink drawing reproduced in *The Graphic*.
Coke Collection, Rochester, N.Y.

401. Pablo Picasso. *By the Sea.* 1920. Oil, 32 x 41 inches.
Collection late G. David Thompson, Pittsburgh, Pa.

402. Pablo Picasso. *The Fisherman.* 1917.
Crayon drawing, 14½ x 9¼ inches. Whereabouts unknown.

402.

400.

401.

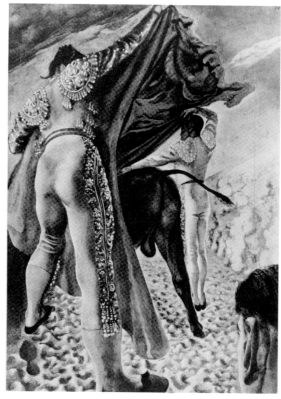

403.

404.

403. Pavel Tchelitchew. *Bullfight.* 1934.
Gouache, 40 x 28½ inches. Collection Charles Henri Ford.

404. Pavel Tchelitchew. *Tchelitchew.* 1934. Drawing.
Collection Edward F. W. James, West Dean, Chichester,
England.

405. Pavel Tchelitchew. *Cover for exhibition catalog.*
1935. Julien Levy Gallery, New York.

406. Photographer unknown. *Man with wheelbarrow.* c1928.
Photograph. Courtesy Werner Graeff, Essen, Germany.

405.

406.

the French-Mexican painter, confirmed that the camera was the source of Picasso's distortions. Charlot wrote, "Picasso got his 'inspiration' to use false perspective from amateur photographs." It took an artist of Picasso's keen perception to capitalize on what was thought by some to be merely amusing or considered an undesirable effect by professional photographers.

Other artists followed Picasso's lead. Pavel Tchelitchew used similar exaggerations in *Harvester, 1928; Bullfight, 1934; Tchelitchew, 1934;* and *Portrait of Lincoln Kirstein, 1937.* (403-404) Distorted recessive perspective became a recurring ingredient in his work after 1928. To achieve a sense of corporeal presence and illusion of great depth, he ballooned the feet and sometimes the hands of his subjects. He may have known the photograph that Werner Graeff published in Berlin in 1929 in the book *Es Kommt der neue Fotograf,* depicting a man with a greatly enlarged foot pushing a wheelbarrow. (405-406) The book was widely circulated and may have prompted Tchelitchew to use

this particular expressive device in a drawing. Photographic foreshortening of this kind increased the sense of nearness and distance in a convincing but somehow dreamlike manner.

Tchelitchew's drawing was reproduced on the cover of the catalog of his first one-man show in the United States, which took place at the Julien Levy Gallery in New York in 1935. This picture is a good example of how an artist's perception may be expanded by using camera vision, rather than his own eyes. In 1938 Tchelitchew completed a very complex composition, *Phenomena,* which portrayed dozens of figures, many of them distorted in the same fashion as the pictures mentioned. Photographs of Charles Henri Ford and others have survived which have a definite link with portions of *Phenomena.*

The camera sees in a fashion that is at odds with human vision. In the cases mentioned, that difference has prompted artists to apply the lessons learned from photography to achieve subjective and symbolic images.

7. LANDSCAPES

408.

407. Artist unknown. *The Sunday Excursion of the Painter.* c1895. Reproduced from original woodblock, 4 x 6 inches. Photomuseum Agfa-Gevaert, Leverkusen, Germany.

408. Honoré Daumier. *Patience is the virtue of asses.* 1840. Lithograph, 9 x 7½ inches. Coke Collection, Rochester, N.Y.

409. Gérard Fontallard. *Talent comes while sleeping.* 1840. Lithograph, 9 x 7½ inches. Coke Collection, Rochester, N.Y.

409.

407.

7. LANDSCAPES

Both the calotype and daguerreotype processes were first used to photograph landscapes and views of architecture because such subjects could be recorded with fidelity during the long exposure time needed to take pictures in the early years of photography.

On January 31, 1839 Henry Fox Talbot, the originator of the first practical negative-positive photographic process, presented a paper on "The Act of Photogenic Drawing" to the Royal Society in London. In this paper he touched on many potential uses for his photographic process, including the fact that amateurs as well as professional artists would find "photogenic drawings" of great value. He noted:

To the traveller in distant lands, who is ignorant, as too many unfortunately are, of the art of drawing, this little invention may prove of real service; and even to the artist himself, however skillful he may be. For although this natural process does not produce an effect much resembling the productions of his pencil, and therefore cannot be considered as capable of replacing them, yet it is to be recollected that he may often be so situated as to be able to devote only a single hour to the delineation of some very interesting locality. Now, since nothing prevents him from simultaneously disposing, in different positions, any number of these little camerae, it is evident that their collective results, when examined afterwards, may furnish him with a large body of interesting memorials, and with numerous details which he had not had himself time either to note down or to delineate.

When asked by François Arago, representing the French government, to comment on the potential value of Daguerre's invention for artists, the painter Paul Delaroche, said:

When this technique becomes known, the publication of inexact views will no longer be tolerated, for it will then be very easy to obtain in a few instants the most precise image of any place at all. The engraver will not only have nothing to fear from the practice of this technique, but also he will come to multiply its results by means of his art. The studies which he will have to engrave will be of great interest to him. He will see

with what art nature is rendered in them, and color interpreted. No doubt he will admire the inconceivably rich finish, which in no way interferes with the composure of the masses, nor does it at all impair the general effect.

As soon as the technique for making daguerreotypes was announced, "sun artists" began to record landscapes and city scenes. They "jammed opticians' shops longing for cameras; everywhere they were seen focusing on buildings. Everybody wanted to take pictures from his window, and he who at first trial got a silhouette of roofs against the sky was happy; he raved over chimney pots, he counted over and over roof tiles and chimney bricks; he was amazed to find the mortar between the bricks; in short, the poorest results gave him unspeakable joy, so new was the process and so marvelous did it seem."

Daguerre had made exposures of Paris boulevards and houses even before the public announcement of his process in August 1839. Sunlit buildings were immobile and reflected a good deal of light, requisites for any photographic subject when exposures of twenty to thirty minutes were necessary to achieve satisfactory results. These long exposures were humorously treated in *Le Charivari* in 1839 by Honoré Daumier in his lithograph captioned *Patience is the virtue of asses* (408) and also by Gérard Fontallard, whose cartoon of a daguerreotypist asleep with watch in hand was an especially wry comment on the length of time necessary for a camera to properly record the rooftops of Paris. (409) Underneath Fontallard's cartoon the following verse was printed:

And when from his dream he then arises,
The works of art, the camera comprises,
Yea, verily Eden is now at hand,
Nature works even while we dream of Slumberland.

Between 1840 and 1844 the optical instrument maker N. M. P. Lerebours had copied a very large number of views of various parts of the world from

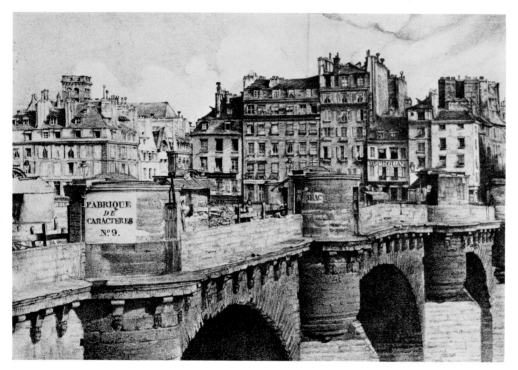

410.

411.

410. L. Marquier. *Le Pont Neuf. 1839.*
Lithograph, 9 x 7½ inches. Coke Collection, Rochester, N.Y.
George Eastman House, Rochester, N.Y.

411. George Read. *Third Street at Chestnut, Philadelphia.* 1842.
Daguerreotype. George Eastman House, Rochester, N.Y.

412. Friedrich von Martens. *View of Paris across the Seine.*
1846. Daguerreotype. George Eastman House, Rochester, N.Y.

daguerreotypes which he published as aquatint engravings and lithographs. In all, a total of 112 plates from daguerreotypes made in Europe, the Near East, and America were engraved on copper for *Excursions Daguerriennes* and distributed by Lerebours.

One of the first prominent artists to make landscape daguerreotypes was the academic painter Horace Vernet who collaborated in November 1839 with his nephew, Frédéric Goupil-Fersquet, in photographing scenes of Egypt with equipment provided and manufactured by Lerebours. At the same time, Pierre Gustave Joly de Lotbinière, a Canadian photographer, was also sent to the Nile by Lerebours. Their pictures and those of other pioneer landscape photographers were then copied onto copper or stone from which large editions of prints were made.

L. Marquier's lithograph *Le Pont Neuf,* done for Lerebours, is an early example of an artist's copying a daguerreotype on stone in a very direct fashion. (410) It should be noted that the prominent signs in Marquier's lithograph are not reversed in his print. Daguerre's process created a mirror, or a reversed image. In portraits this makes little difference, for we all know our own likenesses only from mirrors, and consequently are not disturbed by this reversal. In cityscapes, however, the relative dislocation of a building on its site or the reversal of letters in a sign is disturbing. To prevent this, a prism was used on the early cameras to record the picture in the normal left-to-right relationship. Marquier could have drawn the letters in his lithograph so that they would appear in a natural fashion even though they might have been reversed in the daguerreotype he copied, or he could have worked from a prism-reversed view of this section of Paris.

Handmade copies of daguerreotypes were usually quite literal and often incorporated a feeling of compressed space stemming from early cameramen's use of what we would today consider semi-telephoto lenses. An example would be the early daguerreotype of stores along a Philadelphia street. (411) The lenses of the period also caused a degree of lateral expansion of the image, a phenomenon not experienced when viewing a scene firsthand. Visual characteristics of this kind had their effect on painters. They became accustomed to following the vision of the camera rather than relying on direct observation. An example of this influence of camera vision is found in the photographs of Friedrich von Martens, a German engraver living in Paris.

In 1845 von Martens built a daguerreotype camera that had an angle of view of 150 degrees. (412) To make panoramic pictures with this apparatus, the light-sensitive plate was curved and the lens rotated before it during the period of exposure. This type of wide-angle camera view became very popular and was copied by many topographic artists in drawings and paintings of boulevards and cities.

Jean Baptiste Camille Corot was one of the most prominent landscape painters to change his style under the influence of photography. Upon his death in 1875 over two hundred photographs of various scenes were found in his studio. Although these have now been dispersed and cannot be identified with certainty, it can be readily seen that Corot used aspects of camera vision in many of his later tree-filled landscapes. In his

414.

413.

416.

415.

413. Jean Baptiste Camille Corot. *Landscape with a Great Tree.*
c1860. Drawing, black chalk, 15½ x 19 inches.
Courtesy Art Institute of Chicago.

414. Paul Delondre. *French landscape.* c1856. Calotype.
Coke Collection, Rochester, N.Y.

415. Jean Baptiste Camille Corot. *The Forest of Fontainebleau.*
Oil, 35¾ x 51 inches. Courtesy Museum of Fine Arts, Boston.
Gift of Samuel Dennis Warren.

416. Photographer unknown. *Chateau de Ealey* (detail). 1840.
Daguerreotype. Coke Collection, Rochester, N.Y.

early landscapes there was a decided emphasis on solid massing of architectural elements and explicitly rendered foliage. After 1850 his pictures became tonal in color and indistinct in form. (413-416) In 1856 Corot's drawings were compared with landscape photographs by the painter-photographer Henri Le Secq. R. H. Wilenski noted in 1928 that "Corot was the first French artist whose technique was undermined by an attempt to rival the camera's true vision."

Both the calotype and daguerreotype processes recorded trees in a light, airy, and unsubstantial fashion, due to blurring of the image caused by the motion of the leaves during the long period of exposure. Halation, which tends to dematerialize forms seen against the light, was also a contributing factor in this phenomenon. The influence of these effects is seen in Corot's work. Nor can we fail to note how frequently a gray cast pervades his middle-period paintings, an appearance similar to that observed in daguerreotypes. He shied away from details in his drawings and paintings and represented limbs and even whole trees in a sketchy

fashion, his trees often appearing transparent and out of focus. Both his methods of drawing and painting, as well as his range of colors, seem to be derived at least in part from photographs.

Scharf has suggested that the change in Corot's landscapes took place as the result of his association with a group of artists and photographers who worked in the forest near Arras, France, around 1855. The photographer and painter Constant Dutilleux, to whom Delacroix addressed his 1854 letter mentioned earlier, was one of Corot's friends; Adalbert Cuvelier, the photographer, was another. These men made a number of landscape photographs intended to evoke a sense of romantic naturalism, and in which tree branches were recorded in a vague, undefined manner. In his later works Corot tried to portray the spirit of nature in a sublime fashion and consciously evoked the feeling of wind currents blowing through the leaves. He had seen leaves recorded in a sketchy way by the camera and their appearance must have suggested a pantheistic connotation consistent with his aims.

417.

417. Charles Méryon. *San Francisco*. 1856. Etching, 9 x 39 inches.
Prints and Photographs Division, Library of Congress,
Washington, D.C.

Another of France's greatest nineteenth-century art-
ists, Charles Méryon, said, "a photograph ought not to,
nor ever can enable an artist to dispense with a sketch.
It can only aid him, whilst he works by assurance and
confirmation, by suggesting to him the general char-
acter of the actuality which he has studied, and often
times by discovering to him minor details which he has
overlooked; but it can never replace studies with the
pencil." Méryon made these observations when he was
commissioned in 1857 by his patron, the Duke of
Aremberg, to etch some views of the latter's chateau in
Belgium. A daguerreotype apparatus was provided to
assist Méryon in his work, but how often he used pho-
tographs for this commission is not known. We do
know that in another instance Méryon, for a firm of
French bankers, did a 39-inch-long etching of San
Francisco and its sweeping bay from a series of pano-
ramic daguerreotypes without ever leaving Paris. (417)

Some of the early painters of the American West
found daguerreotypes useful when making their docu-
mentary paintings of the region. John Mix Stanley

196

painted the "West" of Missouri, Minnesota, and Kansas. His paintings of Indians were often taken from daguerreotypes, and his dependence on photographs was noted in the official report of Governor Isaac Stevens, who made a survey of a possible route for a northern railway to the Pacific: "Mr. Stanley, the artist, was busily occupied during our stay in Fort Union with his daguerreotype apparatus, and the Indians were greatly pleased with their daguerreotypes." On his return from the West in 1854, Stanley painted a large panorama based on sketches and daguerreotypes made during his pioneering trip.

Other painters of the region between the Rocky Mountains and the Midwest were Carl Wimar and Seth Eastman, an army officer who had learned to draw at West Point. Eastman's wife Mary wrote of her husband's exploits, "if anything were wanting to complete our opportunities for gaining information that was of interest, we found it in this daguerreotype. Captain Eastman, knowing they [the Indians] were about to celebrate a feast he wished to paint in a group, took his apparatus out, and, when they least expected it, transferred the group to his plate." A decade later Wimar took the first boat bound northwest after spring thaws made travel on the Missouri River possible, and as was his practice carried a camera to augment his sketches.

Albert Bierstadt, who painted in California, in the Rocky Mountain range, and in New England, used photographs to give credence to his interpretations. Bierstadt's brothers, Charles and Edward, were professional photographers, and their stereo views probably inspired some of his New England mountain scenes. In the West he either made or had made stereo pictures of Indians to serve as studies, and stereo views also helped to endow his elaborate compositions of mountains with a feeling of nature, thus evoking grandiose qualities of light and vast space. Bierstadt wrote in *The Crayon* in 1859:

We have taken many stereoscopic views but not so many of mountain scenery as I could wish, owing to various obstacles attached to the process, but still a goodly number. We have a great many Indian subjects.

418.

419.

418. R. H. Tallant. *San Ildefonso Pueblo.* 1886.
Oil, 27 x 40 inches.
Collection Mr. and Mrs. Robert Spears, Albuquerque, N.M.

419. John Hillers. *San Ildefonso Pueblo.* c1878. Photograph.
Coke Collection, Rochester, N.Y.

We were quite fortunate in getting them, the natives not being very willing to have the brass tube of the camera pointed at them. Of course they were astonished when we showed them pictures they did not sit for; and the best we have taken have been obtained without the knowledge of the parties, which is, in fact, the best way to take any portraits.

William Keith, another romantic painter of the American landscape, known for his California and Rocky Mountain canvases, also used photographs. Fidelus Cornelius, Keith's biographer, linked the artist with one of the distinguished photographers of western scenes. Cornelius wrote, "Keith did not disdain to use photographs to give him ideas for his paintings, but, of course, he did not merely copy them. In the early 70's when he was with the well-known photographer, [C. E.] Watkins, in Yosemite and Utah, he got from him many photos of the scenery."

R. H. Tallant, a painter of Rocky Mountain and New Mexico scenes in the 1880s, used photographs as a way of accurately representing the western landscape while remaining in his studio in Denver. His *San Ildefonso Pueblo* is based on John Hillers' photograph of this Indian village located just north of Santa Fe, New Mexico. Hillers' photograph fixed the light at a specific season and time of day for Tallant to study and paint. (418-419) While Tallant was not bound by the location of the mesas and mountains and every little detail caught by the camera, he did adopt wholesale the major part of the view documented in Hillers' photograph, although the mountains do not at all mesh with Hillers' photograph.

For drama Tallant accentuated the prominence of the snowcapped peak that looms over the low hills behind the Rio Grande which flows beside the village. A low blocky complex of adobe structures included by Hillers was left out of Tallant's composition. Nor did Tallant borrow from the photograph the figure of the seated Indian in the foreground. Instead, to give some emphasis to the lower part of his composition, he painted

three Indians working on the fence. The part of the fence close to the bottom of the photograph was, however, quoted in almost every lineament, even though the diagonal portion of the fence was eliminated in the canvas. The shadows on the Indians at the fence and the location of the buildings of the pueblo were persuasively painted, based on Hillers' photograph.

This photograph was taken at least eight years before Tallant painted his canvas. If Tallant had stood and painted this scene in 1886 in the same spot in which Hillers had placed his camera in 1878—on the same day and at the same hour, a coincidence hard to conceive—he would have painted the cottonwood trees larger than he did. The cottonwood grows rather rapidly; and, as can be seen, the trees in Tallant's painting of 1886 are the same size and shape as those in Hillers' photograph of 1878.

One of Tallant's close friends was Fred Chatworthy of Estes Park, Colorado, where the painter lived from 1898 to the year of his death, 1934. Chatworthy was a pioneer color photographer. His autochrome glass transparencies were used by Tallant as sources for some of his Rocky Mountain views. The *San Ildefonso Pueblo* painting is, therefore, only one of Tallant's pictures which can be linked to a photograph.

Frederic Edwin Church, a contemporary of Keith and Bierstadt, also found in photographs a solution to the problem of representing myriad details when painting large and complex pictures in the studio. Church became famous for his spectacular views of South America, North Atlantic icebergs, and Near Eastern themes, as well as picturesque sites in the United States. Photographs played a role in giving Church's imitations of nature the appearance of having been painted after the artist had studied with close attention all kinds of trees and plants before including them in his pictures.

A sepia photograph of Niagara Falls, painted over in oils to give Church the effect of color as well as placement of forms, served him as a study for his large 1867 composition *Falls of Niagara from the American Side.*

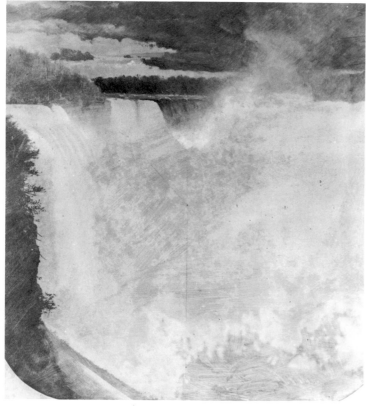

420.

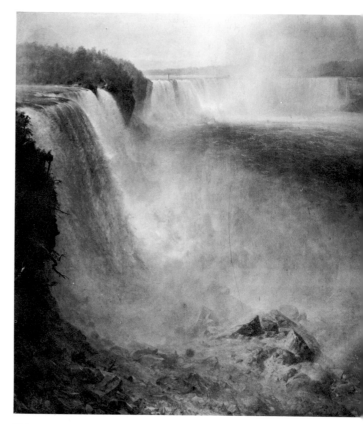

421.

Church reworked the scale of the far shore of the Niagara River and diminished the size of the group of trees to give a greater sense of depth, but the near bank of the falls was faithfully copied from the camera view. The left-hand, root-strewn vertical area of the canvas is also strongly reminiscent of the photograph, as is the misty quality of the pool below the falling water, although here the artist thinned out the mist somewhat to show more distinctly the falls across the river. The coloring applied to the sepia camera study covered up the rocks in the foreground and some details in the center of the photograph, but Church matched his stately, picturesque canvas to the photograph. (420-421)

That Church's art was almost scientifically objective in rendering minute details can also be seen in his canvas *The Parthenon.* The accuracy and the striking three-dimensional effects he achieved in this painting were due in a large measure to the fact that he used a photograph as a guide for the Parthenon and some foreground details. The dramatic disposition of light and shadow was invented, as was the placement of the column on the right used to carry the eye back into the picture. (422-423) The little man included by Church in the middle ground is very small and was added to give a sense of greater depth to the painting. Church also tidied up the foreground and gave the scattered

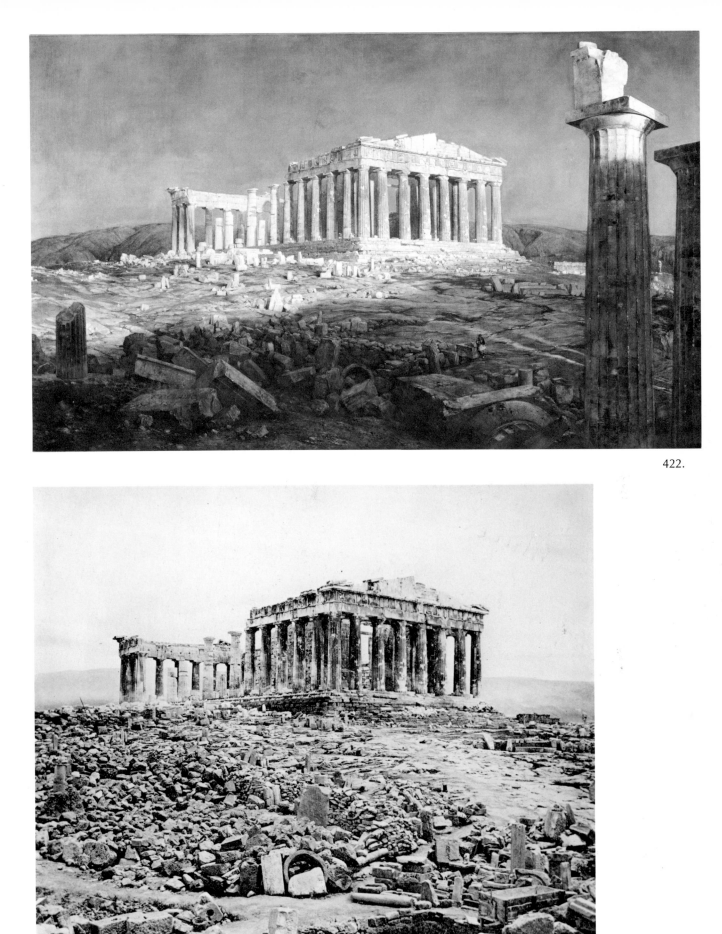

422.

423.

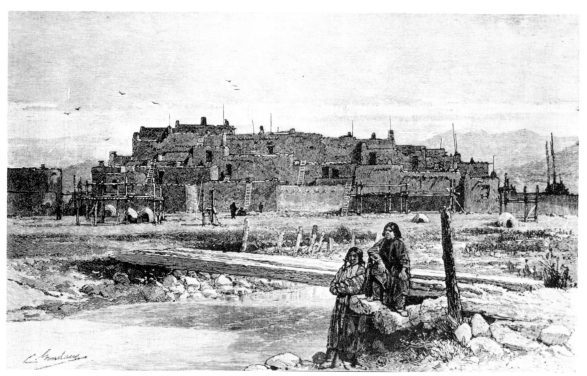

424.

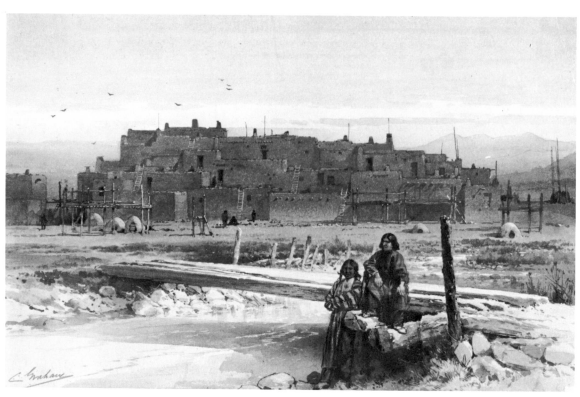

425.

424. Charles S. Graham (?). *Taos Pueblo.* c1886. Woodcut. Reproduced from *Marvels of the New West,* 1887.

425. Charles S. Graham. *Taos Pueblo.* c1885. Pen and ink and gouache, 9 x 14 inches. Denver Art Museum.

426. William Henry Jackson. *Taos Pueblo.* c1884. Photograph. Coke Collection, Rochester, N.Y.

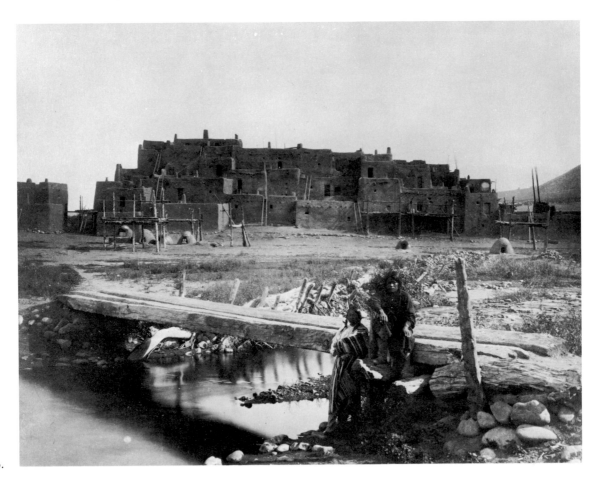

426.

piles of carved fragments each a distinct quality they do not have in the photograph. The fall of light on the temple, the angle of view, the relation of the temple to the horizon and the adjacent building were accepted and copied almost without change by Church when executing this large painting. This was also probably the case with a number of his other pictures of subjects in the eastern Mediterranean region.

About 1883 the pioneer photographer of the Rocky Mountain region and the Southwest, William Henry Jackson, set up his 16 by 20 inch camera in the center of Taos Pueblo in New Mexico. With two Indians in the foreground to add a sense of depth and scale he recorded on his glass plate the great multi-tiered cluster of buildings begun a thousand years ago. Prints from this negative were widely distributed because so many people were interested in seeing a photograph of the ancient Indian dwelling.

When Charles S. Graham decided to paint Taos Pueblo he did not go to New Mexico to view the multitiered buildings, but turned as a guide to Jackson's photograph referred to above. Graham added color and a figure silhouetted against the adobe walls. (425) Other changes made were only minor, such as the po-

sition of one of the Indians in the foreground. For some reason that is difficult to understand, he also changed the natural location of the shadow under the log bridge in the foreground. This causes the other shadows and the splashes of light to appear false.

William Thayer, for his book *Marvels of the New West*, published in 1887, apparently had Graham make a wood engraving of Taos Pueblo based on his watercolor and Jackson's photograph. Although boldly signed "Graham," the print like the painting was virtually a copy of Jackson's photograph. This was unusual; generally when an illustrator copied a photograph in the nineteenth century he acknowledged the fact.

Jackson's photograph is a superb example of an early view of the West. It is a technical and artistic feat of considerable magnitude. With the wet-plate process Jackson used it was necessary to sensitize the large glass plate on the spot. After doing so he captured with sensitivity the patterns of light and shade that define so impressively the massive earth buildings. Graham's copies lack a sense of life and fail to convey a true physical sensation of this place that was caught so convincingly in Jackson's photograph.

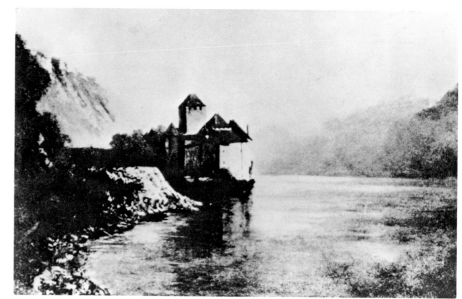

428.

427.

427. John Singer Sargent. *Entrance to Santa Maria della Salute, Venice.* n.d. Oil, 25 x 36¼ inches.
Fitzwilliam Museum, Cambridge, England.

428. Gustave Courbet. *The Château of Chillon.* 1874. Oil.
Musée de Courbet, Ornans, France.

429. Adolphe Braun. *The Château of Chillon.* 1867. Photograph.
Courtesy Adolphe Braun et Cie., Mulhouse, France.

John Singer Sargent, America's accomplished expatriate painter, based at least one of his views of Venice on the solid documentation of a photograph, for his *Entrance to Santa Maria della Salute* is a slightly reworked version of a professional photographic enlargement. (427) In reply to an inquiry about the photograph, the art historian R. H. Wilenski said, "I used to have it—indeed I may have it still somewhere in some inaccessible box of miscellaneous records. It was sent to me soon after Sargent's death by a reader of my 'Modern Movement' who said he had acquired it from Sargent's studio. Placed near a photograph of Sargent's *Salute* of the same size, it was impossible to tell one from the other until one noticed that Sargent had left out the little man selling postcards in the porch."

In view of this evidence, it is not presumptuous to suggest that Sargent may have used photographs in other instances, for there is a photographic look to some of his views of buildings—that is, the shadows are more opaque and sharply outlined than the eye would see them. There is also a degree of distortion in the vertical lines of some buildings in his paintings that suggest camera vision rather than ocular vision.

Apparently a number of English landscape painters also used photographs to supply details or to suggest various arrangements of the elements in their compositions. For example, William Dyce's *Pegwell Bay* was painted from a photograph, according to Miles de Montmorency. Further substantiation of the use of photographs as guides for English landscapes can be found in the minutely detailed canvases of Sir John Everett Millais. As has been noted, Millais used photo-

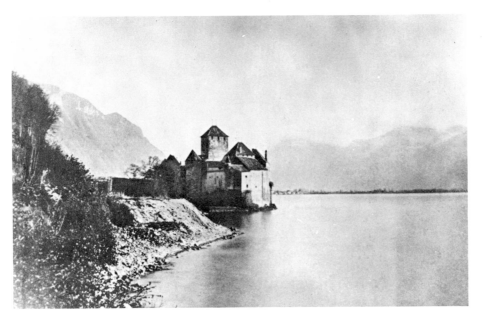

429.

graphs as *aides-mémoire* for his portraits. He also directed his son to photograph interesting landscape areas as possible subjects of paintings. *Murthly Moss* of 1887 and *The Old Garden* of 1888 are examples of this collaboration. Confirmation of this is found in the following quotations from the biography of Millais by another son:

Before commencing this work [landscape of *Murthly Moss*] a day or two was spent in looking around for the best point of view—a quest in which my brother Geoffray's skill as a photographer proved a most valuable help, enabling the artist to see, side by side, the various views that especially attracted his attention, and finally to select what he thought best.

Gilbert Hamerton, in his book *Thoughts about Art*, spelled out various ways in which photography was serving artists in England during the 1860s and 1870s.

The way in which artists ordinarily use photographs is this. When their memoranda from nature are not minute enough, as sometimes from circumstances they cannot be, painters will take a suggestion from a photograph, and *invent* details for their pictures, which the photograph rather suggests than contains. This is the practice of some artists, but one of our most popular painters of winter scenery always works from the photograph alone, and never draws from nature. The study of winter scenery from nature involves, of course, the physical difficulty of resistance to the cold; and it seems natural that a painter who does not use a studio-tent should find painting from photographs in a warm studio pleasanter work than painting from nature in the cold open air of December.

It seems also evident that since the wet collodion process is almost instantaneous, certain memoranda of effects of light may be got by its means which are not

otherwise attainable; as, for example, the complicated shadows of mountains, which it is impossible to draw truly on account of their swift changing. And, to a painter who has to deal with rich architecture, it seems as if the photograph would be a most useful servant, giving him accurate data for every stone in the most elaborately wrought building. No memorandum of cloud form is equal to a photograph, for none other can be true, even in outline, whereas the sensitive collodion will arrest in an instant the flying change of innumerable clouds. And, in matters of foreground detail, when a painter cannot remain on the spot to finish an elaborate drawing from nature,—as, for example, on a Swiss glacier,—the abundant detail obtainable by a collodion photograph in a few seconds will naturally tempt a landscape-painter to encumber himself with a camera.

For this photography, as an art so imperfect, is a wonderfully obedient slave for the collecting of memoranda, if only its one great peculiarity be humoured a little. Photography cannot often give very much truth at once; but it will give us innumerable truths, if we only ask for one at a time. And a large collection of photographic memoranda, taken by a painter for especial purposes, seems likely to be a precious possession for him.

Gustave Courbet used photographic "memoranda" in this spirit in landscapes as well as for some of his genre scenes and portraits. Late in his life, while living in exile in Switzerland, he painted with few alterations the thirteenth-century castle of Chillon from an Adolphe Braun photograph. (428-429) Courbet slightly enlarged the mountains in the background and veiled them in a mist but otherwise he copied almost exactly the setting of Lord Byron's stirring poem "The Prisoner of Chillon."

430.

431.

430. Paul Cézanne. *Melting Snow, Fontainebleau.* c1879.
Oil, 29 x 39⅝ inches.
Museum of Modern Art, New York. Gift of André Meyer.

431. Photographer unknown. *Melting snow, Fontainebleau.*
n.d. Photograph.

A few years later Paul Cézanne took the basic forms for a landscape from a photograph. No passive imitation was involved in this case, however, even though the photograph played a consequential role in *Melting Snow, Fontainebleau.* (430-431) Although the general arrangement of trees and rocks in this canvas coincided with the source, there is no mistaking the artist's characteristic simplification of form to achieve positive cohesion. While he was governed by the placement of many elements in the photograph, the original motif acquired new life and pictorial legibility through his interpretive powers.

As indicated earlier, Degas not only got ideas for his paintings of horses and people from photographs, he also used them as references for some of his rare landscapes. Pierre Cabanne noted that in 1898 Degas visited his friend, the painter Louis Braquavel, at his home near Saint-Valery-sur-Somme, and on that occasion Degas apparently took some views of the countryside and the villages with his own camera. Although by this time Degas was an experienced photographer, he did not always do his own darkroom work. Thereafter he had large prints made of his studies, and subsequently did a series of paintings from them. This was not discovered until after the artist's death when the photographs were found in his studio, and then it was quite apparent he had followed the camera's eye. Cabanne has also indicated that Degas used photographs of Mont-Dore, taken at dawn, as studies for a painting of that mountain.

Open-air photography provided artists with pictures they could copy that had a sense of pulsating life. This was widely recognized and as a consequence the camera became an essential part of an artist's equipment. Landscape painters who had traditionally worked under a sunshade as often as not ducked under the black focusing cloth of their camera to record a scene on glass plates before putting paint on canvas. Artists who did not rely on the camera were in the minority. Many of them became skilled photographers and darkroom

chemists to meet the demand for paintings that were rich in minute details and true to the effects of light as found in nature.

P. H. Emerson in his *Naturalistic Photography* observed that while many painters used photographs the effect was "disastrous":

The influence of photography on painting, on the other hand, has been temporarily nothing short of disastrous, as can be seen by the work of the so-called "tonists." It is a common practice for some painters to take photographs of their models or landscapes slavishly and throw enlargements of these on to a screen, when the outlines are boldly sketched in. Again, it is a practice for some painters to study the delicate gradations of photography, which is, of course, quite legitimate, as this gradation can be equalled only by charcoal. Another influence of photography on painting is that the painter often tries to emulate the detail of the photograph.

These views, published near the end of the nineteenth century, confirm the fact that painters continued to be very much influenced by photography. One of the best photographers in the early years of the twentieth century was Eugène Atget who made thousands of photographs of the cobblestone streets of Paris and the countryside surrounding the city. Despite the fact that a number of writers and historians have alluded to the use of his pictures by prominent painters, no paintings directly related to Atget's views have so far been found.

A. Hyatt Mayor has written, "The artists who bought his photographs included Braque and Utrillo, for Atget discovered poetry in the back alley, at the turn of the trolley tracks, where no one had noticed it before." Even though we cannot point to specific paintings by Georges Braque or Maurice Utrillo for which Atget's photographs served as models, the often-made statement that Utrillo worked from photographs has been substantiated. Jacques-Émile Blanche, a contemporary of Utrillo, in writing about artists who painted from

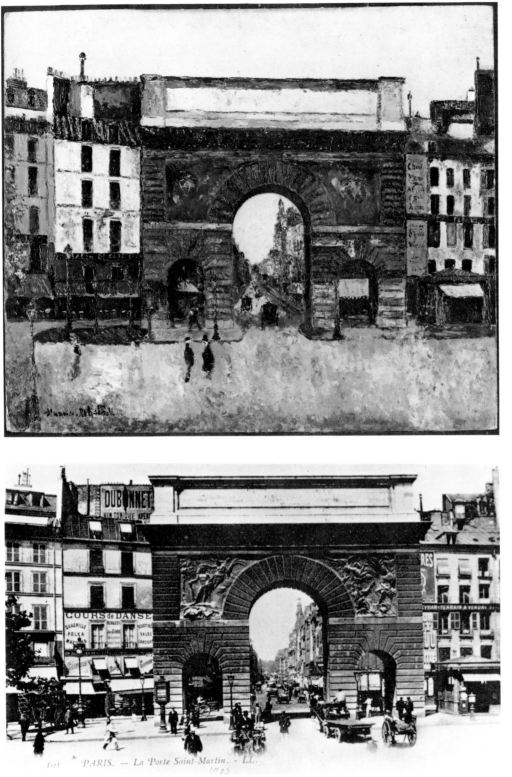

432.

433.

432. Maurice Utrillo. *La Porte Saint-Martin*. 1909.
Oil, 27¼ x 31½ inches. Tate Gallery, London.

433. Photographer unknown. *La Porte Saint-Martin*. 1903.
Photograph.

434. Kasimir Malevich. *Analytical Chart Showing Sources of
Cubism, Futurism, and Suprematism*. c1925.
Photographs, 28 x 38 inches. Museum of Modern Art, New York.

KUBISMUS FUTURISMUS SUPREMATISMUS

434.

photographs said, "Later he (Sickert) used photographs and picture postcards, as Utrillo now does."

A comparison of *La Porte Saint-Martin* with the picture postcard as reference illustrates how Utrillo carried over some aspects of a photo, while rejecting others. (432-433) In the painting, the roofline of the buildings and the tower seen through the rounded opening of the memorial arch match the photograph almost exactly, as do the roofs of the buildings on either side of the freestanding monument. The artist also picked out a detail like the streetlight on the sidewalk to the left and placed it in his picture without alteration, although he did change the spacing of the windows and gave them a different scale. He wanted to concentrate attention on the flat planes of the buildings behind and on each side of the arch, and so he eliminated any specific reference to the large advertisements for "Dubonnet" and "Cour de Dance," recorded so explicitly by the camera. He also merely suggested the sculptured reliefs on the arch and reduced considerably the number of pedestrians and vehicles shown in the photograph.

It is not clear in the photograph that the arch is actually located some distance in front of the combina-

tion business and residential buildings to the right and left of the gateway, for camera vision tends to flatten out such distinctions in perspective. Utrillo uncritically followed the camera's lead, although his own vision might have prompted him to greater discrimination. He knew this section of Paris well and could have set up his easel before his subject, as many artists have done. Like Manet and others, however, Utrillo preferred to begin in his studio with a ready-made schema. In so doing, he carried over to his painting some of the special qualities which camera vision imparts to a subject as it is characterized by light and shade rather than actually observed in space by the eyes.

In 1913 the Russian artist Kasimir Malevich published an article in *The Non-Objective World* calling attention to the fact that aerial photographs provided "the new environment of the artist." (434) He incorporated this same concept in a series of five charts showing that photographs of machines and views of the earth made from airplanes and dirigibles were also sources of ideas for Cubism, Futurism, and Suprematism.

Bird's-eye views made with the camera were not

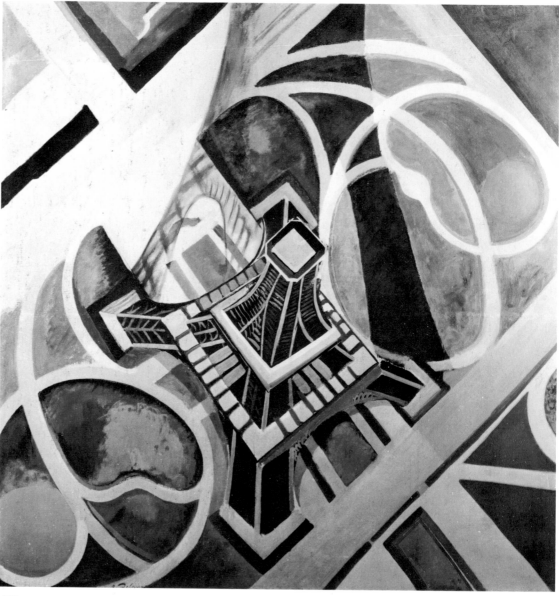

435.

435. Robert Delaunay. *Garden on the Champs de Mars.* 1922.
Oil, 66¾ x 70¾ inches.
Collection Joseph H. Hirshhorn, New York.

436. André Schelcher and A. Omer-Decugis (?). *La Tour Eiffel.*
c1908. Photograph.
Reproduced from *Paris Vu en Ballon et Ses Environs,*
Paris, c1908.

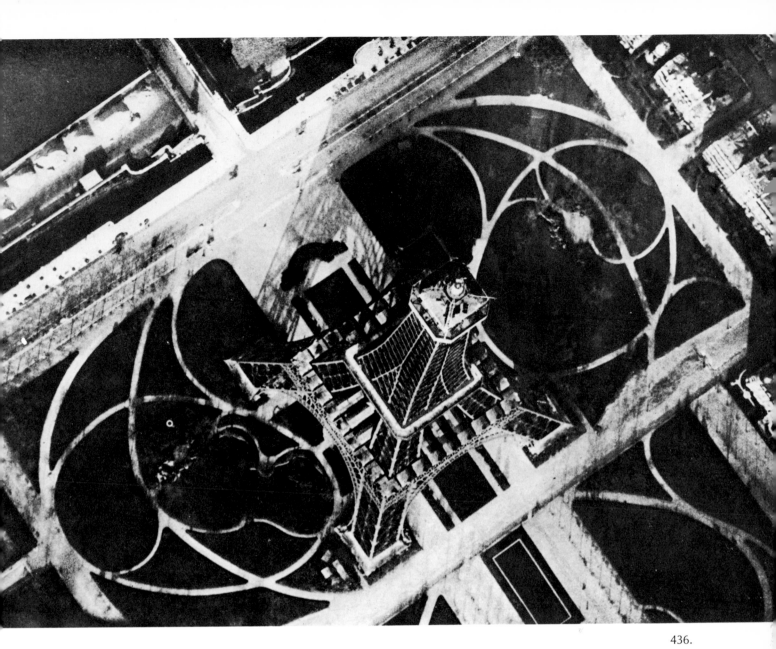

new in 1913. In 1858 Nadar, using the unreliable wet-plate process, had made reasonably sharp photographs from a balloon floating over the French countryside, and in 1860 James Wallace Black photographed a central portion of Boston from a balloon with remarkable success. A half century later, in 1909, a striking aerial photograph was made in Paris almost directly over the Eiffel Tower. This picture, made with a camera suspended from a balloon, created a rather flattened arrangement of forms and gave exaggerated emphasis to certain light and dark elements. In 1922 this image inspired Robert Delaunay to do a painting of simplified geometric shapes based largely on what the camera saw. (435-436)

If the artist had been aloft, the motion of the balloon would have prevented him from sketching the famous landmark with any degree of accuracy. In addition, he would have seen the angles and interlacing patterns of the structure in a different fashion than did the camera. If airborne, the artist would have looked through the steel girders as they thrust up toward him in the sky and would have seen the tower as a distinctly three-dimensional form, not flattened as in the photograph. This is a clear demonstration of the difference between the two kinds of vision. Delaunay accepted the vision of the lens and thus his painting was shaped by the ready-made flat patterns already abstracted from direct experience by the photographic process.

Photography also served as the foundation for more conventional cityscapes and landscapes in the 1920s and 1930s, although this was discussed less and less in public. Working this way was generally frowned on

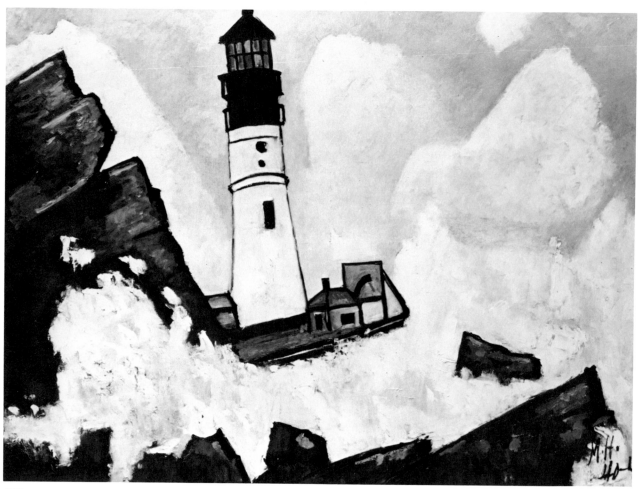

437.

438.

437. Marsden Hartley. *The Lighthouse.* 1940-41.
Oil, 30 x 40⅛ inches.
Collection William A. M. Burden, New York.

438. Ralph Blood. *Portland Head Light.* n.d. Photograph.
Reproduced from *Lighthouses of the Maine Coast and the Men Who Keep Them.*

and if landscapists used photographs, they usually destroyed the evidence afterward.

Fortunately for the sake of art history, we have the photograph from which Marsden Hartley painted *The Lighthouse.* (437-438) As has already been noted, Hartley was one of the few painters able to use photographic portraits of Lincoln as a basis for strong and imaginative paintings. His treatment of the lighthouse was also marked with all the expressive animation we associate with Hartley's best work. At first glance the relationship of the painting to the photograph does not appear strong, which, as may be recalled, was also the case with Hartley's paintings of Lincoln. Close comparison between *The Lighthouse* and the photographic model, however, will reveal striking parallels. Hartley changed or, more correctly, relocated some elements and exaggerated others. Confirming the fact that Hartley used this photograph is the following account from Claire Spencer Evans, a close friend of Hartley's.

The photograph you sent me is a copy of his Portland Light painting taken from the book *Maine Lighthouses.* We have that book in Maine and Marsden saw it there. In fact, he took it up to his room, because I saw it there. He spent the summer with us. I saw the painting Marsden did of the Portland Lighthouse a while later at an exhibition of his work in Washington.

He was very secretive about his work always. The painting he did of the Portland Light must have been a copy of the one in the book; the resemblance is very clear to me. Also I have passed the lighthouse many times on my way to Portland Harbour. It is far out and usually very rough and most rocky. A man in a small boat could take a photograph but it would be almost impossible to paint it or even to sketch it under the same circumstances.

More easily seen is the relationship between Charles Sheeler's paintings and photographs. Such a relationship was understandable, for beginning in 1912 photography was Sheeler's means of livelihood. Well known for his paintings of machinery and America's industrial landscape, Sheeler made effective use of his own photographs as sources of images for paintings in a number of instances, and in one case he was even inspired by a film clip. In 1920 Sheeler and Paul Strand made the film *Manahatta.* Designed to capture the effect of being surrounded by tall buildings in New York City, the film was related in imagery to Dada and Cubist concepts. The photographers used a kind of kaleidoscopic camera action which emphasized overlapping forms and rapid camera movement, then a new idea. A frame from this movie of Manhattan inspired Sheeler to paint a picture that incorporated some of these qualities.

The art historian Milton Brown has said, "In the late twenties Sheeler succumbed to the dominance of the camera. As his vision became chained to photography, he moved from Cubist-Realism to a literal transcription of reality. He gave up the simplicity which Cubism had taught him to see and substituted the accidents and complexities of the camera for those of paint." Despite these negative comments, many feel that Sheeler's eye was sharpened by his work with the camera and his severe paintings of industrial subjects given an authentic sense of dynamic power by reference to photographs. He incorporated crisply recorded details and distortions that vary from what is thought of as normal perspective, thus creating new excitement about the esthetic qualities inherent in utilitarian objects and buildings of all kinds. The tilting over and closing in of the sides of tall structures, an effect produced when a lens is pointed upward, give vitality to his work. *Delmonico Building* illustrates how completely Sheeler assimilated the vision of the camera. (439)

Representations of people were rarely found in Sheeler's paintings, although he included them when he thought they would be useful, as in *Suspended Power.* (440-441) The two figures in this painting were copied from one of his photographs of the installation of a hydroelectric turbine at the TVA station in Guntersville, Alabama. They were included in his painting

439.

440.

441.

442.

443.

439. Charles Sheeler. *Delmonico Building.* 1926.
Lithograph, 9¾ x 6¾ inches.
Courtesy Fogg Art Museum, Harvard University,
Cambridge, Mass. Gift of Meta and Paul J. Sachs.

440. Charles Sheeler. *Suspended Power.* 1939.
Oil, 33 x 26 inches. Courtesy Allis-Chalmers Co., York, Pa.

441. Charles Sheeler. *Generator.* 1929. Photograph.
Coke Collection, Rochester, N.Y.

442. Charles Sheeler. *Cactus,* 1931. Oil, 45⅛ x 30 inches.
Philadelphia Museum of Art. Louise and Walter Arensberg
Collection.

443. Charles Sheeler. *Cactus and Photographer's Lamp,
New York.* 1931. Photograph.
Museum of Modern Art, New York. Gift of Samuel Kootz.

444.

445.

447.

444. Charles Sheeler. *Rolling Power.* 1939. Oil, 15 x 30 inches. Smith College Museum of Art, Northampton, Mass.

445. Charles Sheeler. *Drive Wheels.* 1939. Photograph. Coke Collection, Rochester, N.Y.

446. Charles Sheeler. *Continuity.* 1957. Oil, 29 x 23 inches. Fort Worth Art Association, Texas. Gift of William E. Scott Foundation.

447. Charles Sheeler. *Blast Furnaces, Pittsburgh,* 1952. Photograph.

446.

to dramatize the scale of the giant turbines held aloft by a crane. The overall sharp focus in his photographs carried over to his paintings, bestowing artistic significance on large industrial chimneys and blocks of factory buildings and giving his canvases a clean and ordered look that we associate with professional industrial and architectural photography.

Sheeler tended to tidy up and simplify esthetically unpleasing parts of a composition, as do most painters who work closely from photographic models. This procedure probably harks back to the old ideas that artists should idealize their subjects and may account for the way Sheeler treated the light cord in *Cactus*, compared with the unstudied position of this element in his photograph. (442-443) In a somewhat similar way this may also explain his virtual elimination of the thorns on the cactus plant. On the other hand it should further be noted that when we compare his photograph with the painting, we find that he tilted the flower pot and the table, a device often used by Cubists.

In *Rolling Power*, another of Sheeler's pictures, the major elements were transcribed almost literally from his photograph *Drive Wheels*. Sheeler eliminated in his painting the grease and dirt on the piston box of the engine to get the effect of a smooth surface, thus emphasizing the geometric character of the object. Sheeler's disciplined eye sought out forms that were symmetrical and surfaces that were pristine, for this

was what he "wanted" to see. He probably overlooked the grease. Not so the eye of the camera, with its inability to record selectively. Sheeler also relocated the puff of steam at the bottom of that part of the machinery to better suit his sense of compositional order. (444-445)

Charles W. Millard has written, "Sheeler seems first to have used photographs in the compositions of paintings and drawings in the early twenties. From that time forward, he appears to have found occasional inspiration in his photographs and used them for painting, and increasingly to have photographed with specific intent of making paintings from the results."

In the late forties and throughout the fifties, Sheeler used his black and white photographs as studies of form, while Kodachrome slides provided him with color notes for his paintings. Of this practice Millard says, "when he was in San Francisco he photographed the Golden Gate bridge with the intent of having a record of the color of the bridge and the sky for use in painting when he returned home. He kept a small viewer near him to refer to slides he made while he was working." This explains in part the nature of the colors in many of his post-World War II paintings. Their intensity and lack of subtlety can be readily related to the dyes used in Kodachrome film.

In addition to using color that derived at least in part from color slides, Sheeler found stimulating a rather

448.

449.

448. John Kacere. *Creekside,* 1956. Oil, 42 x 58 inches. Collection James Dixon, New Orleans.

449. Photographer unknown. *Subject unknown.* Photograph (details). Courtesy John Kacere, New York.

450. Fairfield Porter. *A Short Walk.* 1963. Oil, 62 x 48 inches. Tibor de Nagy Gallery, New York.

451. Fairfield Porter. *Walking in the garden.* 1963. Photograph. Courtesy Fairfield Porter, Southampton, N.Y.

450.

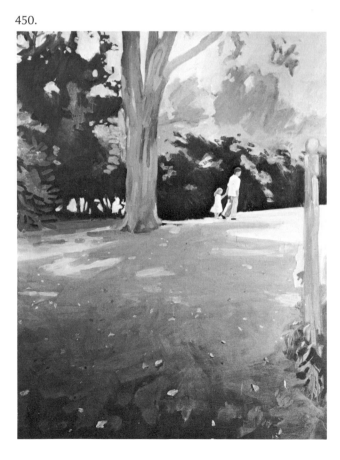

451.

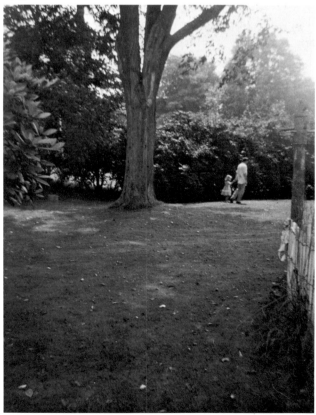

common mistake of photographers—multiple exposures of the same subject. While generally thought of as an oversight or an error, Sheeler capitalized on this phenomenon for esthetic purposes, using superimposition or multiple exposures to add unusual design qualities to his pictures or to bring transparent shapes into play. (446-447)

Between 1950 and 1960, Abstract Expressionism was the style followed by many venturesome artists, and connections with photographs have been very difficult to discover, due to the gestural and informal nature of this style. John Kacere, who came into prominence during these years, has generously given an account of how he and other artists used photographs as a starting point during the fifties. Kacere was a photographer himself during World War II, but he has always felt that the changes an artist makes in a motif are more important than the fact that he evolved his ideas from photographs.

Kacere was often excited by portions of photographs reproduced in periodicals such as *Life* and *Look*. Searching through these magazines he found pictorial possibilities in fragments lifted from the backgrounds of photographs of all kinds of subjects. Photographs as such held little interest for him. He often clipped pieces of photographs and worked on them with black ink and white casein to evolve compositional ideas. He then mounted the fragments on cardboard strips 12 to 20 inches long to facilitate detailed study at a later date. In conjunction with various other kinds of experiences, the clippings provided interesting motifs and suggestions for paintings.

According to his mood or need, Kacere explored certain personally satisfying pictorial associations by this technique, without committing himself to a fully developed canvas. He frequently started a painting from an idea picked up in this way, but the final results were often so removed from the photographic model that little identification with the original source remained. In a few instances, however, the artist's response was

so strong and the original forms so completely satisfying that the finished painting conformed to a marked degree to the original postage-stamp sized fragments of photographs. A good example of this is the 1956 painting *Creekside*. (448-449)

Fairfield Porter, on the other hand, imparts to his landscapes a delightfully realistic feeling of light and substance, couched in terms that are readily intelligible. The material of these illusions is undeniably *paint*, which the artist arranges in small and relatively flat areas to increase the structural set of his compositions. Upon this framework he brings to bear a knowledge of art history, from Paul Cézanne to Willem de Kooning. Although he rarely paints from photographs, magazine reproductions of Porter's paintings *look* photographic. Like all of us he has become so accustomed to camera vision that it no longer appears different from what the eye sees.

The flow of his forms and the merging of his outlines at times have a direct connection with photography. In one case Porter was attracted to a photograph taken by his daughter in the family's Long Island garden. Using this snapshot as a guide, he painted *A Short Walk*. (450-451) Porter was drawn by the possibility of extending the sweeping perspective of the foreground area and using the formal relationship between environment and figures found in the snapshot, but he did not bow to the full view made with the camera. He must have felt that the unselective record it made gave improper emphasis to some of the elements and tended to unbalance the overall composition.

Porter, however, did organize light in this painting in photographic terms—that is, in patches of dark and light pigment. The irregular out-of-focus background suggested to Porter an arrangement of shapes that appealed to his sense of organization. In addition the overall format of the photograph was retained. *A Short Walk* is a painting that superficially corresponds to the camera-recorded schema yet has an enigmatic and poetic quality at odds with the optical witness.

452.

453.

452. Jane Wilson. *Julia in the Park*. 1964. Oil, 55 x 40 inches.
Courtesy Jane Wilson, New York.

453. Jane Wilson. *Julia in the park*. 1964. Polaroid photograph.
Courtesy Jane Wilson, New York.

454. Llyn Foulkes. *Holley's Rock*. 1965. Oil, 65 x 65 inches.
David Stuart Gallery, Los Angeles.

455. Llyn Foulkes. *Chatsworth Hills, Los Angeles*. c1964.
Photograph. Courtesy Llyn Foulkes, Los Angeles.

454.

455.

Related to Porter's use of the snapshot was Jane Wilson's absorption of camera vision in *Julia in the Park*. (452-453) Miss Wilson has found that Polaroid photographs serve very well as notations of motifs she can develop into paintings in her studio. She does not wish to endow her work with the look of a photograph, contrary to the purpose of many painters working from snapshots. When compared with the Polaroid snapshot, her painting of Julia seems flatter and simpler than the photograph. Even so it can be seen that in some places she followed the model quite exactly, in others her placement was fanciful.

Miss Wilson changed the placement of the man in the background and represented him as stooped and slow moving. In the photograph he was just standing around and looking toward the camera. Julia's face is largely covered in the Polaroid picture, but in the painting her features are more clearly shown, thus fostering the sense of a particular individual. Overall, Miss Wilson's blend of fact and fiction does not have the feeling of a snapshot. It is strongly reminiscent of a painting by Pierre Bonnard, replete with subtle compositional devices, rather than being related to the impromptu-moment effect one associates with a picture made casually with a Kodak.

Llyn Foulkes, a Californian, is a painter who works frankly from photographs—many of which he takes himself. As an indication of his liking for photographic imagery, he titled one of his early pictures *Kodak*. It incorporated a series of blurred views of the countryside that recalled photographs made from a moving car.

Both the formats and the subjects of photographic postcards have attracted Foulkes as models for paintings. Sometimes one finds on photographic postcards an image that seems to have been burned into the paper with a harshness that is particularly evident around the edges. This characteristic has been carried over by Foulkes into his paintings. He applies his paint with rags which makes his pictures look as if the forms were imprinted on the surface of his canvas, an effect that also relates his work to photographs.

In his recent landscape paintings he no longer deals with ideas derived from postcards, rather he has painted a series of pictures from his photographs which emphasize outcroppings of rock. Whether alongside a road or by the sea the outcroppings tend to suggest anatomical details. For instance, monochromatically represented against a stark sky is the boulder in *Holley's Rock*. (454-455) There is no clue as to the size of the rock and no sense of environment in this painting. The rock in the photograph is drab and without any feeling of monumentality. In the painting a sense of age and a forbidding rock of infinite size are evoked. In the photo the three O's, one in the word "Holley"

221

457.

456.

458.

459.

222

456. Alfred Young. *Sandia Series: First National.* 1967.
Acrylic, 30 x 80 inches.
University of New Mexico Art Museum, Albuquerque, N.M.

457. Photographer unknown. *Albuquerque, New Mexico.*
c1965. Photograph. Courtesy Petley Studios, Phoenix, Ariz.

458. Roy Lichtenstein. *Temple of Apollo.* 1964.
Oil and magna, 94 x 128 inches.
Collection Mr. and Mrs. Robert Rowan, Los Angeles.

459. Rudolph Burckhardt. *Ruins at Corinth, Greece.* n.d.
Photograph.

and two natural round openings in the rock, appear like eyes looking out at us, but Foulkes felt they would take away from the sheer mystery of the rock. Photographs, skillfully made, might have been used to convey the effects achieved by the artist, but the possibilities for manipulation would not have been so great if Foulkes had worked from photographs incorporating all the qualities he wanted in the painting.

This is one of a number of instances where a relatively characterless photograph has appealed to a painter as a point of departure for a pictorial idea. Only rarely has a sensitively conceived photograph by a major photographer stimulated a painter who was searching for an idea for a painting.

Alfred Young, an English painter who now works in the United States, like Foulkes, finds photographs on postcards stimulating. Rather than restricting the scope of his work through the limitations imposed on him by painting from the limited view recorded by the camera, Young has found that in some cases the opposite is true. He explains:

There are several aspects of photographs on postcards which interest me. In common with other photographs, one is allowed a leisurely examination of a captured instant. Often one is given a view normally inaccessible, such as from an airplane. Sometimes seemingly by accident, there will be present a "coincidence" of forms in a picture that are particularly interesting. This was the reaction I had to a long postcard of the Sandia Mountains and the eastern side of Albuquerque. In the photograph used for *Sandia Series: First National,* (456-457) the coincidence, that of the horizon and the top of the building, triggered interest in spatial problems that became a reason for the painting. The three-color printing process used for this photograph converted the original colors into a new range that, unreal as they might apparently be in their relation to the original, were nevertheless exciting and unique. The all-over focus acted as both a source of information and carried with it that peculiar hallucinatory quality so dear to the Surrealists, that is, evocation of the factual and the dream-like at the same time.

The coincidence referred to above provided me with the stimulus sufficient to beginning the painting. In order to convert this experience into a composition on canvas I made changes to heighten the effect and to do away with the dross, which to me is what the business of painting is about. I used several devices in order to heighten the apparent spatial paradox created by the coincidence of the horizon and the building-top. I increased the importance of the middle ground between them (by use of linear and atmospheric perspective), and gave added importance to the "coincidence." I drew the building in parallel perspective, thus creating a fulcrum upon which the (now) symmetrical mountains could be conceived to balance. It was my intention that the eye should constantly travel from the buildings to the middle ground to the mountain-horizon and jump back to the foreground buildings. The conversion of the horizontal postcard format into an inverted triangle was an attempt to give, at one and the same time, through use of the shape as a perspectival device—at the top, an experience of the vastness of the sky—at the bottom, through inverse perspective, to supplement the painting of the buildings.

It is not surprising to find that Roy Lichtenstein paints from photographs, since he has made a career out of borrowing his forms from all kinds of popular images. Like Young, he limits the range of his color and severely reduces his motifs to simple shapes. In the landscape reproduced he used stark black and white for the temple, a band of yellow in the foreground, and a Ben Day dotted blue sky. In comparison with the photograph of the Greek ruin from which he patterned his painting *Temple of Apollo,* Lichtenstein eliminated most details and any appreciable feeling of the third dimension. (458-459) This posteresque treatment of a motif is typical of the artist's work. When asked how he did a painting of this kind, he replied, "I do them as directly as possible. If I am working from a cartoon, photograph or whatever, I draw a small picture—the size that will fit into my opaque projector—and project it onto the canvas." To enliven the repeated vertical lines that represent the edges of the temple's columns, Lichtenstein painted the member closest to us as if it

460. Richard Artschwager. *Washington Monument*. 1964. Liquitex, 47 x 26 inches. Collection William Zierler, New York. Courtesy Leo Castelli Gallery, New York.

461. Photographer unknown. *Washington Monument*. n.d. Photograph. Courtesy Richard Artschwager, New York.

462. Bob Stanley. *Trees*. 1966. Photograph. (Reversed in reproduction.) Courtesy Bob Stanley, New York.

463. Bob Stanley. *Trees #3*. 1967. Acrylic, 60 x 84 inches. Collection William Bernhard, New York.

462.

460.

461.

were nicked and eliminated the shadow on the left-hand two columns to continue the vertical and horizontal relationships in an uninterrupted fashion.

The camera-documented scene was merely a springboard for his imagination, a readily available photograph of convenient size from which he could abstract a new reality that retains the basic shapes of the temple but little of the meaning or detailed appearance of the setting in Greece. The photograph came from a travel poster urging tourists to visit Greece. The motif of the temple was merely "grist" for Lichtenstein's mill, as soup cans were for Warhol. In keeping with his general procedure, Lichtenstein was lampooning a cliché by draining it of any feeling of reality. He took the pre-existing flat photograph and made of the temple a "design" as cryptic as a modern printed logotype.

Like Lichtenstein, Richard Artschwager has taken a famous motif recorded by the camera's lens and converted it into a stark and totally "cool" image. Artschwager's *Washington Monument* was painted to challenge the "idea" represented by the monument. (460-

463.

461) With mechanical accuracy he reconstituted from a newspaper photograph the bare shape of the stone structure. Ignored were the trees that framed the shaft in the squared-off 5-inch-high photograph, as Artschwager enlarged a portion of the image to a height of 48 inches. Denied also was the commonly understood emotional and symbolic identity of the monument. In its place he created an external diagram of the structure as he patiently rendered in a virtually anonymous manner the shape of the monolith as it thrusts its point into a nondescript sky. While realistic in the sense that the form is easily recognized, Artschwager's representation encourages one to think in terms of an obelisk with intractable characteristics remote from the usual connotations ascribed to the Washington Monument.

Bob Stanley also plays on stark extremes of yellow and black or black and white in his recent paintings. Light in his pictures seems to have etched away the edges of the multitude of jagged leaves and bent limbs that make up his paintings of tree branches. Evoked for many people is a feeling analogous to looking up through a covering of leaves into the sky and sensing a force greater than oneself. In part such a feeling comes about because Stanley's rather large canvases envelop the viewer. In addition the brilliance evoked by his severe contrasts causes one to relate his pictures to shimmering light, an effect often used for dramatic purposes and as a symbol in the history of art and religion. Stanley has written of *Trees #3*: (462-463)

The source photo is one of several hundred I took in Central Park in Dec. 1966 with a borrowed Nikon F camera. I used a Bausch and Lomb opaque projector which reverses the image (when it is projected onto the canvas).
I first used photos in my work in 1957, using newspaper and magazine material for a series of collages which I continued making intermittently until early 1963, when I was first able to incorporate some of the problems into my painting without collage. The paintings since then have all had photographs as their starting point. In 1965 I began taking my own photos with a Polaroid and a Nikon F, and today I work almost entirely from this type of material.

464.

464. Leonard Lehrer. *Formal Garden*. 1968. Oil, 36 x 48 inches.
Collection Leonard Lehrer, Wyncote, Pa.

465. Leonard Lehrer. *Garden*. 1968. Photograph.
Courtesy Leonard Lehrer, Wyncote, Pa.

465.

Leonard Lehrer also bases his paintings, which are largely of landscapes, on the illusory world we associate with photographs. Although he does this almost verbatim, he in no sense trespasses on the work of another, for most of his landscapes are painted from his own photographs. The general arrangement of forms is set when he looks through the view finder of his camera. That highlights and deep shadows and, to a lesser extent, details in his paintings come from camera vision can readily be seen, but they are elaborated to a degree and exaggerated in scale. The exaggerations contribute to a feeling of mystery—related to some of the effects achieved in the film *Last Summer At Marienbad*—for Lehrer paints many views of formal gardens that recall the parterre garden in that film. The shadows in a Lehrer painting claim our attention as we fall under the spell of the stillness he creates in his pruned and ordered views of nature with their strange "vacant" look.

Films and still photographs serve Lehrer as defining agents. Rather than weighing the placement of each form in his paintings, Lehrer accepts photographs as a guide, except in his treatment of such monotonous details as leaves and stretches of grass. He usually simplifies the elements in his paintings in a light-handed fashion. His *Formal Garden* is a model of calculation and a most convincing performance when it comes to mirroring "reality." (464-465)

Lehrer has explained why he uses photographs:

My notions about painting rest primarily on a romantic and idealized vision of the world, and I find that working from the photograph provides me with a great range of visual information consistent with these ideas. The camera, among other things, records moments in time, reduces the range of light values in nature to an equivalent range within its own limits, and uncompromisingly forces actual space into a conforming schema of spatial signs.

I gather the bits and pieces of information afforded me by the photographs (usually my own), account for the uniqueness of the camera's perceptual devices, and

467.

466.

468.

466. Vija Celmins. *Untitled*. 1970. Graphite on paper, 34 x 45 inches. Collection Vadim Kondratief, Los Angeles.

467. Vija Celmins. *Pacific Ocean*. c1970. Photograph. Courtesy Vija Celmins, Venice, Calif.

468. James Hendricks. *Detail Lunar Surface*. 1968. Acrylic, 48 x 48 inches. Courtesy Ruth White Gallery, New York.

gradually weave these and other elements of landscape vocabulary into my paintings. My work deals with a timeless reality and ideas of things, not the appearance of things.

Vija Celmins, whose studio is by the Pacific in Venice, California, draws large pictures of the sea from photographs. (466-467) Even if she were to make many sketches of the water she would be able to catch the look of only a single swell or wave before the moving sea would change its appearance. Because she is interested in the action of a stretch of water and the rhythms of the sea, she, therefore, uses photographs as a guide. The camera arrests every nuance of sea motion for a split second, and the peak and valley of each wave take on concrete form in photographs. Unless a boat, a swimmer, or a piece of driftwood provides a yardstick for measuring the scope of the picture, photographs of the sea are without scale.

Miss Celmins achieves a sense of infinity in her drawings because she uses no means of measuring the space they cover. Although her drawings are almost exact reproductions of photographs, they are also quite abstract. The cadence of movement and the effect of light as it is reflected from each facet of a wavelet become a fascination in her work as they do in nature. In a similar way Miss Celmins makes drawings from photographs of the surface of the moon. She "double exposes" some of the craters to give her pictures added

elements, but the effect of no discernable scale is close to what she achieves in her drawings of the Pacific in a slightly agitated state.

James Hendricks also works from photographs—in his case TV screen photographs. He has been working from NASA photographs for the past three years. First he projects onto canvas the images sent by the automatic cameras. (468) He then finishes the paintings with a photograph in his hand so as to achieve an exaggerated sense of authentic details. Initially he applied paint with a bristle brush then switched to an airbrush, a technique that permits gradation of tones and a closer simulation of the appearance of the moon photographs.

Hendricks' paintings of moonsites and his multiple images of the terrain of the moon—because they are largely based very directly on camera images transmitted by the TV camera mounted on the moon during Lunar, Orbiter, Explorer, and Ranger probes—are very authentic and vividly physical.

In the past year Hendricks has made a study of thousands of photographs at NASA headquarters in Washington including stereo color slides taken by the crew of the Apollo Eleven with an automatic photo-flash camera. These extensions of human vision through the agency of the camera have stimulated his latest works which have a super-real quality that extends beyond the mechanically recorded moonscapes.

8. MIXED MEDIA

469.

470.

469. D. O. Hill and Robert Adamson. *The Rev. John Julius Wood.* 1843. Photograph.
Scottish National Portrait Gallery, Edinburgh.

470. D. O. Hill and Robert Adamson. *The Rev. John Julius Wood.* 1843. Calotype negative.
Scottish National Portrait Gallery, Edinburgh.

471. Artist unknown. Back of *carte de visite.* c1880.
Coke Collection, Rochester, N.Y.

8. MIXED MEDIA

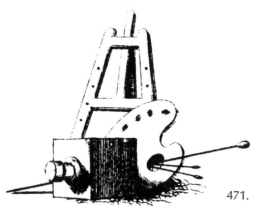

471.

Almost as soon as photography was introduced artists began to add color and make alterations to the camera-made images. David Octavius Hill, the famous Scottish landscape artist who began to work with photography in the early 1840s, in a number of instances, drew on both the paper calotype negatives he and his collaborator used and on prints. In one case a simulated waterfall was drawn beside a photograph of a gamekeeper. In another instance Hill drew a boat on a negative to add scale and a sense of life to a seascape. Also on Hill and Adamson's calotype negative of the Rev. John Julius Wood, no type appears on the cover of the book Wood was holding when photographed. (469-470) There also appears in the negative, behind Wood's head, an iron headrest used to steady the sitter while his likeness was being taken by the camera. Examination of the front of the calotype negative discloses penciled lines used to eliminate the headrest. In addition certain details—such as the Scottish church, the badge, motto, Malta, and 1843 on the book held in Wood's hands—were all carefully drawn on the negative in ink in reverse so that they would appear properly in positive prints made from these retouched negatives. The book was important as a symbol, for Reverend Wood had been serving in Malta in 1843 as chaplain to the 42nd Highlanders. He returned to Edinburgh and joined the ministers who were separating from the state-supported Presbyterian church. Hill posed him for the camera portrait study so as to facilitate the painting of his likeness for the canvas commemorating the separation.

Like Hill many of the early photographers had been artists of one sort or another before they took up the camera. They therefore thought of themselves as artist-photographers and were billed as such in their advertisements. Such a designation carried an aura of prestige and reassured the public that the photographs they bought had artistic quality.

When a photographer did not have artistic training he frequently hired a painter to work with him in the studio. This was merely good business. As commercial cameramen catered more and more to a public avid for portraits, they found that patrons were more impressed with their photographs when they resembled painted likenesses. Not only was it good business to pose subjects in a traditional academic manner but also the addition of color to the silvery surface of photographs heightened the sense of naturalism and commanded a higher price.

Adding color to daguerreotypes was difficult, due to the delicacy of their surfaces. But in the early 1840s J. B. Isenring, a Swiss painter and photographer, perfected a way of applying tints to daguerreotypes with a small camel's-hair brush. Dry powdered pigment was gently laid on the metallic surface which had been prepared by an application of gum arabic to the areas that were to be colored.

When the ambrotype photographic process on glass became popular in the mid-1850s, even more color was used. Cheeks, costumes, and background were often colored, thus giving the face and clothes of sitters a more natural look. Details of jewelry or buttons were also made more realistic by the application of touches of gold paint.

Salt prints of the 1840s and 1850s made from calotype (paper) negatives were often tinted with transparent watercolors. An example of the claims made for this practice is found in a London advertisement by Richard Beard. He declared that his photographs, finished with watercolors or crayons, equaled the best hand-painted miniatures and that the perfection attained in his photographs placed them high among the fine arts. Tintypes and albumen-paper likenesses, introduced in the 1860s, were colored with oil paints. In some cases, to meet the demand for color portraits, life-sized sepia prints were completely covered with pigment to simulate hand-painted portraits.

In his *Manual of Artistic Colouring as Applied to Photographs: A Practical Guide to Artists and Photographers*, published in 1861, Alfred Wall outlined in

472. Artist unknown. *Seated Man with Cane.* c1860.
Oil-painted sepia photograph, 20 x 15 inches.
Coke Collection, Rochester, N.Y.

473. Charles Christian Nahl. *Seated Child.* c1865.
Painted photograph. Courtesy Solanne Antiques, San Francisco.

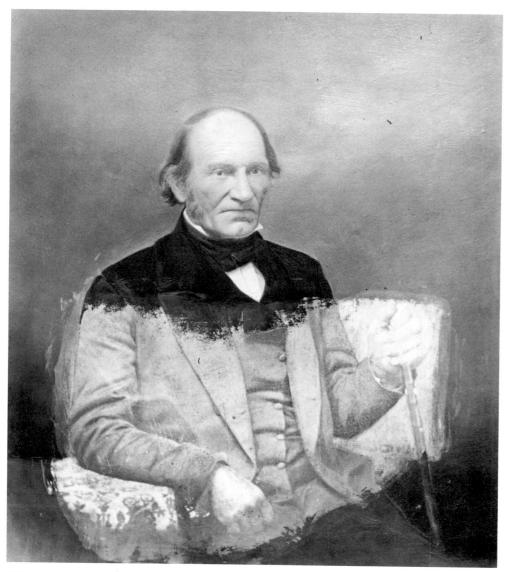

472.

473.

detail ways of enhancing the appearance of photographs by skillful application of color. A former portrait and miniature painter, Wall protested against inferior colorists whose clumsy work had no relationship to either art or nature. He said that photographers admit the beauty of color in painting and that artists admit the truthfulness of detail in a photograph. Through his book Wall intended to teach various ways of combining the color and surface variations possible in paintings with the naturalism possible in photography. His book was extremely influential in England and in America and encouraged the hand application of color to photographs.

Oil-painted photographs were regarded with favor because they were less expensive than oil paintings and did not require long sittings by the subjects. They were also usually more lifelike than the pictures made by most routine portrait painters. Many cherished family portraits, both of individuals and large groups, thought by the present generation to be oil portraits from life are in fact oil-painted sepia photographs. (472) These pictures were rarely signed and were usually done by very mediocre artists.

Occasionally, an exceptional painter such as Charles Christian Nahl worked in this fashion. Nahl, a German, who painted first in New York and after 1850 in San Francisco was so skilled in the application of paint to a photographic print that he produced no inconsistent or indifferently treated passages to contradict the naturalism preserved by the lens. (473)

Usually, however, the artist-photographer was a poseur as far as the artistic quality of his work was concerned. Photographers liked to assume the mantle of artists and frequently used the symbol of an artist's palette and brushes entwined with a camera as part of their advertisements. This emblem most generally appeared on the backs of photographs and on signs used to advertise photographic studios. (474-477)

The mixing of photography with traditional means of representation was not limited to painting over pho-

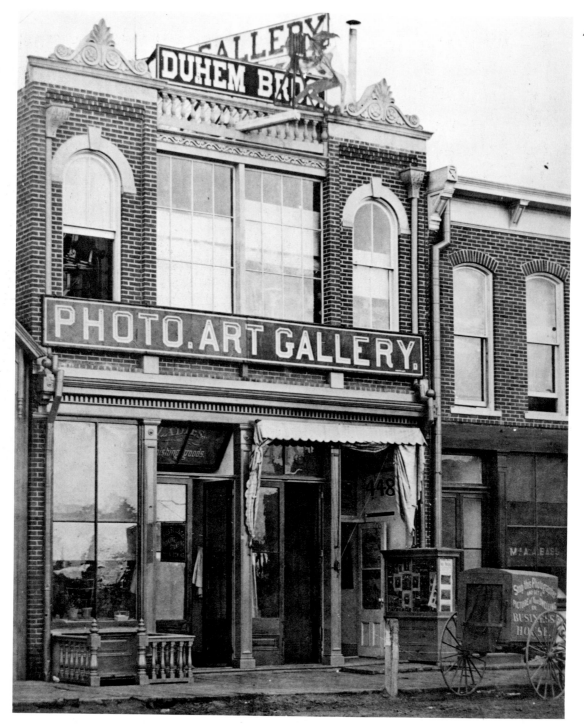

477.

474.

475.

474. Artist unknown. *Late 19th-century advertisement on the back of a cabinet photograph.* Coke Collection, Rochester, N. Y.

475. John Stevens. *Artist and photographer in his studio.* c1865. Photograph. Courtesy Olmsted County Historical Society, Rochester, Minn.

476. Photographer unknown. *Duhem Brothers Photo. Art Gallery.* 1875. Photograph. Courtesy Denver Public Library. Western Collection.

477. Artist unknown. *Emblem on back of photograph.* c1880. Drawing, 1 x 1½ inches. Coke Collection, Rochester, N.Y.

478. Jean Baptiste Camille Corot. *The Artist in Italy.* 1857.
Cliché-verre print, 7½ x 6 inches. Print from original negative.
Collection André Jammes, Paris.

479. Henri Fantin-Latour. *Studio interior.* c1870.
Cliché-verre (paper variation of), 7 x 9 inches.
Collection André Jammes, Paris.

478.

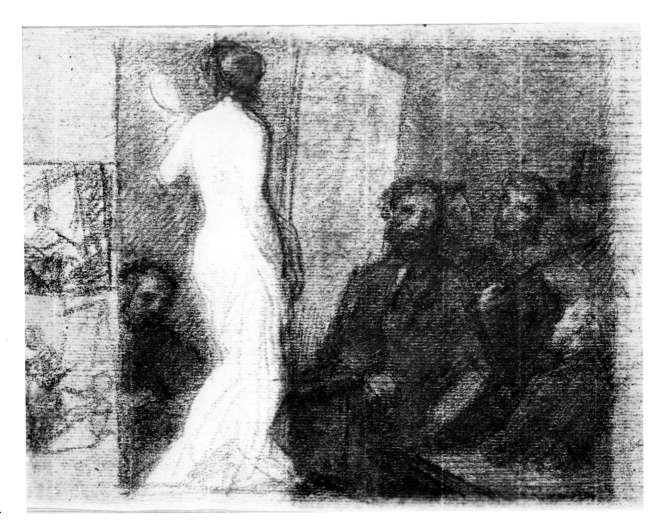

479.

tographs. In the 1850s the *cliché-verre* process, which produced prints that looked somewhat like etchings, became popular. Although invented in 1839 by the English engravers William and John Havell and James Tibbitts Wilmore, the process was not used to any extent until the lithographer-painter Constant Dutilleux reinvented it in France.

A *cliché-verre* print was made by covering a piece of clear flat glass with an opaque coating such as dark varnish. Through this coating an artist would cut a line to the glass itself with a sharp instrument used like a pencil. To make a print, the resulting handmade "negative" was placed in contact with a sheet of photosensitized paper. Light passed through the lines cut into the coating that covered the glass and created a latent image on the light-sensitive paper. The paper was designed in such a way that by measured exposure to daylight and subsequent chemical treatment the image was fixed. This method of making prints combined a knowledge of photochemistry and drawing.

Corot used the *cliché-verre* process extensively. (478) He made editions of over seventy prints by this method during the period from 1853 to 1874. The technique

was also quite popular with a number of Barbizon painters, among them Charles Daubigny, who made at least seventeen prints by this means. In the United States, Asher B. Durand of the Hudson River School used this procedure when making some of his prints.

A version of the *cliché-verre* process was used by Henri Fantin-Latour in the last half of the nineteenth century to produce prints that had the appearance of a soft pencil drawing rather than linear etchings, as was the case with Corot's *clichés-verre*. Fantin-Latour drew on thin paper, in negative values, the image he wished in a print, then had the "negative" printed on photosensitive paper in the same manner as a *cliché-verre*. A wide and soft tonal range was possible with this method. The disadvantage of using paper as a negative was that the inherent texture of Fantin-Latour's paper negative was also printed on the photographic paper along with the drawn image, tending to add an alien note to pictures made this way. (479) Both of these methods of making prints were a means of bypassing, through a photographic process, some of the involved craft routine needed to make intaglio prints on copper or lithographs on stone.

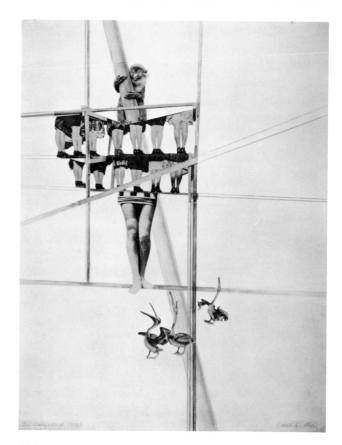

481.

480.

480. Frederick Sommer. *Untitled.* 1962. Smoke on glass negative, 13¼ x 10½ inches. Pasadena Art Museum, Calif.

481. László Moholy-Nagy. *The Structure of the World.* 1927. Photo-collage, 24½ x 19¼ inches. George Eastman House, Rochester, N.Y.

482. László Moholy-Nagy. *Jealousy.* 1930. Montage, 25¼ x 18¼ inches. George Eastman House, Rochester, N.Y.

483. David Hare. *Untitled "Improved photograph."* c1942. Photograph, 12 x 9¾ inches. Museum of Modern Art, New York. Gift of Mr. Bernard J. Reis.

After two decades of popularity during the middle years of the nineteenth century the *cliché-verre* process was little used until the 1930s when Pablo Picasso, in collaboration with Man Ray, made some *clichés-verre* that were notable for their somewhat surreal content. Rather than cutting through an opaque coating, Picasso and Man Ray assembled cloth netting, lace, or other open-textured material on a piece of glass, then painted on selected areas of the glass. The objects assembled and the images painted were printed by contact on photosensitive paper. When developed, the parts that prevented light from reaching the paper appeared as pure white compared to the rich black that came from direct exposure to light. Middle tones resulted when the paint or fabric was semi-translucent and partly held back the light from the photosensitive paper. An example of this process was *The Portrait of D. M.* in which net and lace were placed in conjunction with a sheet of glass painted by Picasso. Since "D. M." refers to Picasso's close friend Dora Maar, a surreal photographer, this way of creating a "portrait" seems most appropriate.

In the United States, Frederick Sommer—under the influence of Surrealism and Max Ernst, whom Sommer met in 1941—has been one of the few artists who have

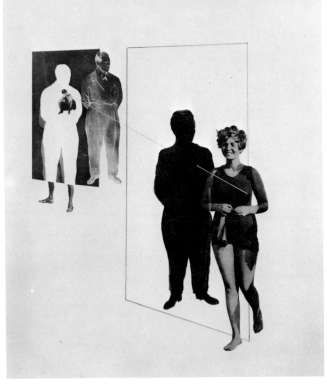

482.

483.

used a version of the *cliché-verre* technique to create lyrical and fantastic prints on photosensitive paper. His technique was to hold a piece of glass over a candle flame so that the smoke from the burning wick was deposited on the glass. He controlled the thickness of the deposit and thus regulated the opacity of the "negatives" made in this way. These smoked negatives were then enlarged by projecting the images that resulted onto photographic paper. (480) At times Sommer cut into the smoke-encrusted surface to give emphasis to one part or another and thus to heighten the impact of his visual statement.

In the late 1920s and more so in the thirties, László Moholy-Nagy, the Hungarian-born Bauhaus teacher, was an innovator in the use of photographs with other media. He made a number of distinguished unmanipulated photographs which explored new points of view, such as shooting directly up at buildings or trees or down on his subject from a perch high above the ground. But his major achievements were the photomontages he fashioned using mixed media. His juxtaposition of photographs of three-dimensional objects and of people with drawn flat forms, which have the appearance of Constructivist designs, resulted in somewhat surreal statements.

In his photomontages Moholy-Nagy developed an effective amalgam which united two kinds of representation. The readily understood transcriptional elements made with the camera infused his works with a seeming matter-of-fact quality, which was then denied by the dreamlike association evoked in the mind of the viewer by the inclusion of strange perspective arrangements and incongruities. He transmuted portions of photographs of all kinds and linear elements into disturbing arrangements such as *The Structure of the World* (481) and *Jealousy*. (482) By coupling photographs that had no logical association with strong geometric forms he stimulated the imagination beyond the evocative power of either straight photographs or hand-drawn geometric elements used independently.

David Hare, an artist known primarily as a sculptor, has experimented with mixed media involving photographs. For publication in the Surrealist magazine *VVV* he greatly altered a photograph of a kneeling nude girl. (483) Hare ingeniously changed the appearance of the photograph to destroy the sense of soft rounded flesh evoked by the image. The effect he achieved is that of shock, for we respond to the "reality" of what remains of the photograph but are repelled by the malaise that seems to be devouring this symbol of sensuous

241

485.

484.

484. Robert Rauschenberg. *Booster*. 1967. Lithograph, 72 x 36 inches. Associated American Artists, New York.

485. Robert Rauschenberg. *The Blue Cloud (Booster Study)*. 1967. Lithograph, 47 x 35 inches.
University of New Mexico Art Museum, Albuquerque, N.M.

242

pleasure. Hare, who had early been connected with the Surrealist movement, created an image as if from a nightmare when he stripped away the flesh of the naked well-formed girl and thereby dehumanized her. Although not so abstract, Hare's model recalls both Dali's ventilated figures and Miró's soft amorphous forms.

Robert Rauschenberg was one of the first American artists in the 1950s to relate paint and collaged photographs. As a member of the second generation of painters in the Abstract Expressionist mode, Rauschenberg developed a personal vernacular different from that of his predecessors. His style was initially based on many of the premises dear to that movement but at the same time he broke with most of their constricting ideas. First and foremost was his rejection of the strict interpretation of space as residing in the actuality of the picture plane. He was not concerned with the idea that the canvas is flat and should remain so. Photography played an important part in his break with this concept.

In works like *Talisman*, Rauschenberg used photographs as apertures through which he introduced vestiges of reality. His concern with verisimilitude was not of primary importance. He was interested in the possibilities of playing the physical properties of paint against the photographic imitations of nature by varying his materials from the thick black pigment of the frame to the smooth gray surfaces of photographs.

At other times Rauschenberg made effective use of applied or transferred photographs to extricate his images from the Abstract Expressionist concern with sweeping gestures and dripping paint and instead restated in a very personal way some Cubist ideas. In *The Blue Cloud* and in other cases where imagery was transferred from reproduced photographs onto canvas or paper, there was a metamorphosis of special significance. (484-485) These pictures deal with aspects of everyday life and are visually akin to the images seen on a poorly adjusted television screen. They are deliberately devoid of convincing depth, either plastic or philosophical. As "paintings" or "lithographs" they may be questioned, but as appropriate symbols of an epoch which is prey to the forces of a technological age they are successful and telling.

His fusion of the photograph with paint or lithographic ink is a recognition of the acquired status of the photograph itself. This new awareness of photography as a substitute for reality satisfies a taste for ideas and images that are immediate, external, and easily understood. The aggregate of bizarre effects he uses seems at first to smack of satire but is really an intuitively assembled album of today's disquietude, for his personal mythology has implications of pressing significance.

Rauschenberg initially transferred photographs found in magazines to drawing paper by coating them with turpentine or lighter fluid and then rubbed the reverse side with a pencil. Later he used commercially made silk screens of photographs he had selected. When silk screening a photograph onto canvas it is possible to mute certain areas and to print one color or one image on top of another, which gives the artist a medium of great flexibility.

For many artists the photograph is reality. Rauschenberg is willing to raid this real world to introduce fragments of it and the illusion of stereometric depth to his paintings and prints—not for their own sake—but for comparison. The tension between the real and the illusion of the real is played upon. He has included actual objects, some flat, others with a positive thrust out into the spectator's space, and he also included photographs. They insinuated that life is a blend of firsthand encounters and a kaleidoscopic range of experiences made familiar through photography. Although he sometimes tipped his hat to the Renaissance concept of picture making, he did so only to assert his independence of such a tradition as he made visual puns involving actual and implied space, internal and external reality, and above all empathy and irony.

Recently Hiram Williams with an unusual intention

486.

487.

488.

244

486. Hiram Williams. *Two Guys.* 1965. Acrylic, 26 x 35 inches. Collection Hiram Williams, Gainesville, Fla.

487. Pablo Picasso and Jacques Villers. *Diurmes-La Chèvre à la Caisse d'Emballage.* 1960. Photograph and paper cutout, 11 x 14 inches. Collection George Wittenborn, New York.

488. Robert Hartman. *House of Mirrors III.* 1964. Oil and photo-collage, 60 x 62 inches. Collection Robert Hartman, Berkeley, Calif.

in mind has collaged photographs of large staring eyes into simplified paintings of heads four feet high. Photographs of an eye evoke a response that is somewhat disquieting, for, although they are a reflection of nature, in a Williams painting they float in an ambiguous space of their own and only after a second look do we realize they are conventionally related to the artist's spare linear representation of a head or a pair of heads. (486)

Williams comments, "At a certain point during the evolution of my imagery, I conclude that I must try to achieve the effect of an entire person and personality by use of only one or two features of the human mask, one or two cheeks, for example; one or two eyes. Technique-wise I'd concluded to paint these features on raw canvas sized with Rhoplex. On one occasion I glued in eyes cut from *Life* magazine; this led me to the use of photographed eyes. I traded a painting for one-hundred eyes in three sizes [taken by the distinguished photographer Jerry Uelsmann], all the right eye of Marilyn Uelsmann, Jerry's wife."

He continues, "What did I gain by gluing in photographed eyes? Firstly, I achieved by this means an astonishing increase in the psychological presence of the images, and, secondly, something vital was added in the contrast between the appearance of raw cotton and the photograph."

Even Picasso has been challenged by the idea of juxtaposing photographs with portions of a composition created by hand. Similar, in a way, to his collaboration with Man Ray in the early twenties are his 1960 decoupage combinations with the photographs of the French cameraman Jacques Villers. (487) These photographs provide a foil for Picasso's flat-shaped animals and people. The painter's cutouts dominate the photograph. The meticulous, illusionistic recording of Villers' camera merely served to vitalize the scissors-formed shapes created by Picasso.

On the other hand photographs combined with paint have provided the California artist Robert Hartman

with a sense of discovery. His work, tinged with romanticism, has history as its subject. In a number of pictures he has merged photographs of the absurdly fragile aircrafts used by pioneer aviators, or turn-of-the-century family snapshots, with seductively painted surfaces and restrained color. (488) Hartman has used Verifaxed photographs because their *photographic* quality could be retained but muted to a certain extent by the Verifax process, which simplifies forms and can be used to partially reverse their negative-positive relationships. Specific references to his subjects are an important part of his pictures, but he likes to begin with a literal photograph and to end with a series of patches of pure pigment without any descriptive connotations. The contradictory nature of this style produces unexpected excitement that while completely fictitious is persuasive due to the indelible quality of photographs.

A conception of photography, not just as a means of evoking secondhand memories but as a purposeful adjunct to painting, is revealed in a recent statement by Hartman:

Photography, or more correctly, a product of photography has affected my work perhaps narrowly if one looks for variety of applications, but very deeply in the matter of meaning, intent and indeed as the very peg on which to hang a whole body of work. Specifically, I was enthralled at first look by the way certain common office copy-machines reproduce material. The possibilities of an image repeated exactly (in some respects) many times, but also transformed in each repetition through the variability in printing from beginning to end of a series—these possibilities were exciting to me. It also became a way to render a photograph less assertively present as a discrete thing, therefore more manageable as a painting element. The photograph's sharpness as a reality-recorder is retained, but it is made bodiless, ethereal, distant. Hence my restricting of it to images of past and no longer attainable things: A Renaissance man—a trio of turn-of-the-century cyclists—those marvelous early airplanes . . . lodestones of revery.

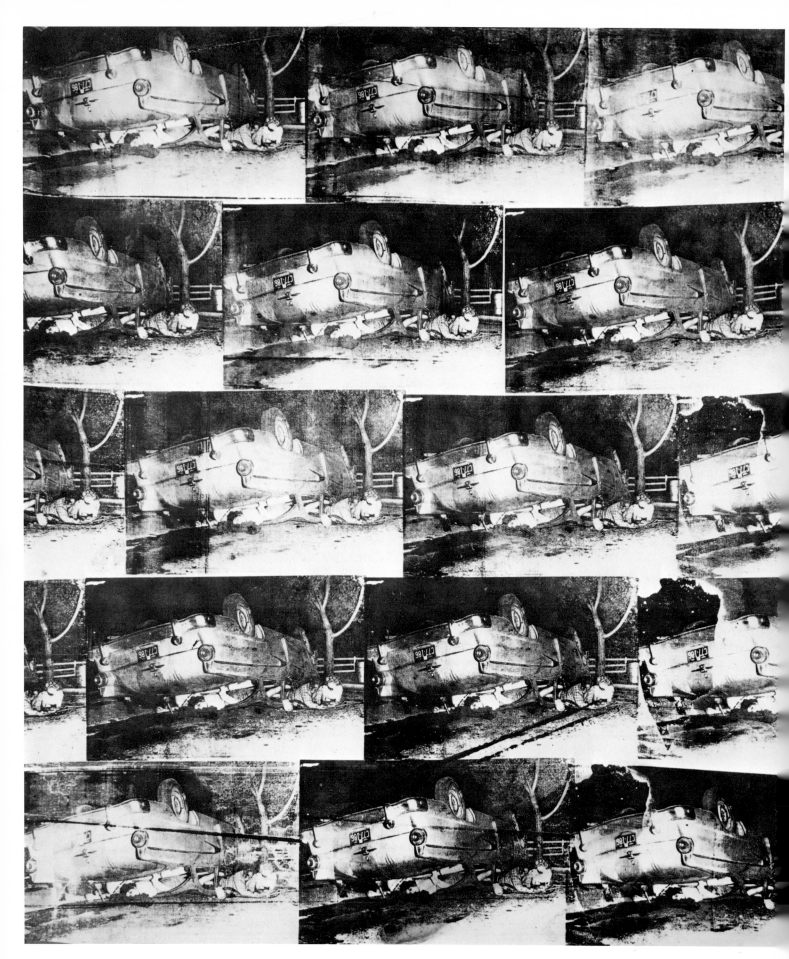

489. Andy Warhol. *Black and White Disaster No. 4.* 1963.
Silk-screened photograph, 104 x 82 inches.
Collection Andy Warhol, New York. Photograph, courtesy
Stable Gallery, New York.

490. Rosalyn Drexler. *The Connoisseurs.* 1963.
Oil on photograph, 9¾ x 7¾ inches.
Collection Harry N. Abrams Family, New York.

490.

Andy Warhol's use of photography is entirely different from that of other artists. He squeezes out of his multi-views a product that is unsentimental, machine made, and astringent. Facsimile silk-screen reproductions of photographs have been used by Warhol as an effective symbol of our time. From the cinema-like repetition of the same scene and from the selection of unvarnished encounters between man and machine, an effective metaphor was born.

The harsh and often haphazard recording of an event by the camera had its historic counterpart in such paintings as Caravaggio's *Conversion of St. Paul.* But carefully rendered genre paintings frequently seem to be ineffective as indicators of life today when we reflect upon the turgid aspect of our times. Warhol has selected an idiom gauged to affront the spectator and candidly "tell it like it is." Even though he performs on a narrow stage, his break with orthodoxy rings truer than most contemporary pictures which deal with more exalted subject matter. He has said, "The reason I'm painting this way is that I want to be a machine, and I feel that whatever I do and do machine-like is what I want to do."

The primary role of Warhol's facsimile reproduction is to portray in non-esthetic terms something of the emptiness of contemporary life. Based on the premise that our technical advances have far outrun moral and esthetic considerations is his repetition of stark single statements. Morbid and gloomy as this may be, it is a provoking stance. Through the use of uniform sameness and a surrender to mechanical means, he places a mirror in our hands that effectively reflects our transgressions. (489)

Rosalyn Drexler has also embraced the photograph as a guide to the tumult and discord of life today. But details are largely canceled as paint overrides the base on which she works so that the images are transformed in such a way that they only vaguely betray their connection with the camera. The drab crassness of commercial photographs and posed news pictures is maintained. These characteristics are altered and distorted for purposes of satire and reexamination. The photographic foundation provides the artist with an armature for exposing a curtness that is potent as both social commentary and artistic invention. (490)

Mrs. Drexler's pictures are intended to evoke news photographs with all their casual qualities. While based, literally, on photographic prints, she intends by the application of paint to lend to these camera-made images the state of grace that we call art.

Mrs. Drexler, who spurns the label, "Pop artist," says, "I work from camera images. I look through newspapers and magazines for photographs, and when one hits me, I can visualize the painting immediately, even to size and color. I blow up the photos and paint right over them. It's a way of using found objects."

The English artist Richard Hamilton, considered by many to have been one of the originators of the Pop art movement, is a master of mixed media. Hamilton very often uses various photographic processes in his work. He enlarges photographs and covers them with unnatural color. In addition he frequently alters them so cleverly by hand that one is unaware of the changes made to suit his purposes. In his mixture of various media, aspects of life today and yesterday are preserved in an unvarnished fashion with colors selectively ap-

491.

492.

491. Richard Hamilton. *My Marilyn*. 1965.
Oil and collage on photograph, 40¼ x 48 inches.
Peter Stuyvesant Foundation, Ltd., London.

492. Richard Hamilton. *I'm dreaming of a white Christmas*.
1967. Oil and cellulose on canvas, 42½ x 64 inches.
Collection Richard Hamilton, London.

493. Harold Cohen. *Richard II*. 1967.
Photo-screen print, 27 x 30½ inches.
Marlborough Fine Art, London.

493.

plied in a highly subjective way. No better example can be cited than his oil and collage on a photograph titled *My Marilyn*. (491) His reasons for treating this subject as he did reveal a good deal about the powerful effect photographs can have on a sophisticated and venturesome artist.

In 1967 Hamilton wrote for the catalog of his show at the Iolas Gallery:

Marilyn Monroe demanded that the results of photographic sessions be submitted to her for vetting before publication. She made indications, brutally and beautifully in conflict with the image, or on proofs and transparencies to give approval or reject; or suggestions for retouching that might make it acceptable. After her death some were published with her markings—a batch by Bert Stern in *Eros*, others by George Barris. The aggressive obliteration of her own image has a self-destructive implication that her death made all the more poignant; there is also a fortuitous narcissism, for the negative cross is also the childish symbol for a kiss. *My Marilyn* starts with the signs and elaborates the graphic possibilities these suggest.

Hamilton's blowup from a magazine reproduction of Barris' proof sheet, by virtue of its size and the cancellation of portions of the photographic likenesses, established a new context for the meaning of the imagery. In addition the hot colors applied in parts of almost all the frames help to make a raw literal statement into one that is perceptive psychologically as well as visually.

For *I'm dreaming of a white Christmas*, Hamilton took a negative color frame from a Bing Crosby movie and copied its forms as exactly as he could. (492) A

negative color frame is orange tinted, and the colors for this painting were derived partly from the negative coloring and partly from a choice made by the artist. A positive print made from a color negative also aided Hamilton in his choice of colors. The fact that all values in the painting were reversed interested Hamilton as did the symbolic aspect of painting such a popular film star in the form of a negative. His meaning was given additional thrust by the title *I'm dreaming of a white Christmas*, a mocking play on the words of Crosby's most famous song.

In early stages of the painting, the negative color frame was used as the basis for a screen print. Finally the painting was photographed on color film by Hamilton, who then used the handmade negatives to make a positive print. Thus the artist commented wryly on a machine image which though copied by hand was made to return to the appearance of a conventional camera-made photograph. Such a turnabout is Duchampian and therefore of great interest to Hamilton, one of the major interpreters of Marcel Duchamp's work.

The use of negative images is not new. They were explored at the Bauhaus in the 1920s in experimental visual workshops conducted by Moholy-Nagy. In recent years there has been a renewed interest in this aspect of photography. Harold Cohen, a friend of Richard Hamilton, not only used a negative image of Hamilton in a screen print in 1967 but combined the reversed tones with a mechanical grid of large and small dots, and had them printed in a variety of colors. The result was Cohen's *Richard II*, from a suite of screen prints titled *First Folio*. (493)

In the first of these prints Cohen used a perfectly

495.

494. Joe Tilson. *Cut out and Send*. 1968.
Photo-screen print and collage, 40¼ x 27½
inches. Marlborough Fine Art, London.

495. Joe Tilson. *Diapositive, Clip-o-Matic Lips*.
Photo-screen print, 20 x 28 inches.
Marlborough Fine Art, London.

496. Martial Raysse. *Simple and Quiet Painting*.
1965. Mixed media including colored
photograph, 51 x 77 x 6½ inches.
Dwan Gallery, New York.

regular grid of violet dots over a modulated back-
ground, the modulations being produced from a giant
blowup of a small part of a photographic negative.
Cohen was pleased to find "that the range of possibili-
ties opened up by using combinations of half-tone
screens [of photographs] was by far wider than any-
thing I could have imagined. The same three screens
printed in different order—fine over coarse or coarse
over fine—or reversals of the same colors—light over
dark, dark over light, transparent over opaque, or the
reverse—made it possible to produce an astonishing
number of images from the same three screens."

The recent use of photography by artists has been
direct, but many have felt that to successfully hold the
viewers' attention photographs had to be juxtaposed
with something else rather than being merely trans-
posed without change into screen prints or lithographs.
(494) The question has been asked, how long a life
does a photographic image have? The English artist
Joe Tilson has answered, "I pin up on my wall a lot of
photographs, taken from newspapers and magazines,
and others taken by myself and friends. Almost none

of these seem to retain a meaning for very long unless the more subjective aspects of my relation to them is very strong. But the same photographs transposed seem to have a different meaning and a longer life."

Tilson got the idea for one of his most successful prints from the format of 35-mm mounted photographic slides. Using acetate and screen printing, which can reproduce a photograph with considerable fidelity, he called attention to the theme of sex as symbolized by the lips and as a sales device for almost any product. Tilson feels that exciting work is being done in mass-produced imagery and protests against the value put on handmade unique pictures just because they are discrete objects. He is stimulated by reproductive techniques used in the graphic arts industry and likes to simulate the effects achieved in high-speed printing processes. In *Diapositive, Clip-o-Matic Lips* he incorporated a part of a print done earlier called *Five Objects in Space* which had in it a star-filled sky. For his print *Diapositive, Clip-o-Matic Lips,* he used to play on the stars in a different environment. (495) In his picture of the mouth, the stars between the teeth were meant to negate some of the insistent photographic qualities of the lips.

Martial Raysse, a young French artist who uses the Pop idiom, applies paint to large blowups of nudes and other subjects. In the highly retouched photographs used in advertising, he recognizes a canon of beauty that says much about contemporary values. He does not mock these values but gives them a new context. With his pictures and objects, he intends to give pleasure, a heightened kind of pleasure similar to that evoked by commercial artists who design for the consumer market. Raysse isolates his version of this sort of thing and arranges for the results to be shown in a gallery or museum. This is not wholly parasitic. Raysse's work opens up to viewers a new awareness of the true nature of plastic surfaces, of lurid pastel and fluorescent colors, and of the fact that sex is used as an agency to sell all kinds of goods and services. (496) He marks his images with his hand as well as his mind. A degree of manipulation and overstatement keeps his photographic world from being quite the same as the wonderworld of advertising.

The Painter and the Photograph 9. FANTASY
AND PROTEST

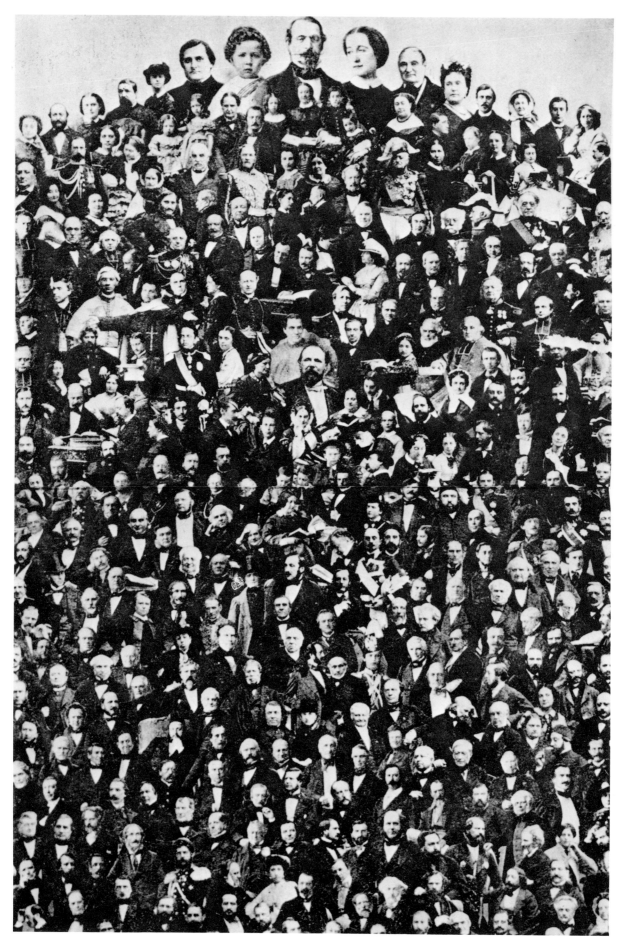

497.

254

9. FANTASY AND PROTEST

498.

In the years after World War I both Dadaists and Surrealists made wide use of the photograph as a source of visual ideas and as a physical component in collages. But even then photo-collages were not new, they had been put together in the nineteenth century to include groups of people, such as the court of Napoleon III in one picture, and to make humorous compositions. (497) However, the first photo-collages which were clearly used for serious artistic purposes were assembled by members of the various Dada groups that were formed in Switzerland and Germany during World War I.

Although the Dada movement was given its name in war-free Zurich, the ideas germinated there soon found their way to Berlin and other German cities. There in 1918 Raoul Hausmann, trained in science and psychology, was the first artist to make extensive use of the photo-collage technique. In pre-war Paris, Cubist collages by Braque and Picasso had often made a play on words. By means of photographs, the post-war Dadaists such as Hausmann, Max Ernst, Paul Citroën, George Grosz, and Hannah Höch made a play on reality—reality simulated by the camera.

The fabric of Germany had been severely rent in 1918 by the defeat of her army in the field and by the starvation of civilians at home. These and other factors caused the spread of Communistic ideas from the East into Berlin. The scene for revolution was set. The Dadaists did not go to the barricades although most of them were Leftists. Rather than throwing rocks they used art to foment political and artistic revolution.

Photographs were regarded by the public as a form of truth, and by questioning the reality of tangible and acceptable values the Dadaists proclaimed their distaste for an entire culture of which "art" was a part. Political authority and empty traditions, as well as the role of the machine in society, were attacked in collages, which were to a large extent made up of photographs. Incorporating photographs, with their strong evocation of physical reality, was a means of ironically destroying the tradition of art as a mirror of reality. The ar-

resting quality of Dada collages reached its height when manipulated photographs were allowed to contribute their inherent sense of authority to a new view of man's relationship to his world. In addition the Dadaists, in combining pieces of photographs, found a way to express a feeling of liberation and voice a grisly sense of nonsense and disorder in their compositions.

It was disorder and change the Dadaists wished to bring about. Their compositions were intentionally eccentric and frequently caustic in meaning. Dadaists found in juxtaposed photographs a ready means of voicing their disillusionment with society. As a form of reality, photographs gave their collages a grip on the imagination of the general community as well as of intellectuals. Citroën patched together a mosaic of photographs of buildings, but more usually photographs of the human figure or parts of it were the principal raw material used by the Dada artists. (499)

This new dimension made possible through photographs was used most successfully in Berlin. Banal visual material was transformed into a kind of super-reality—aerial photographs compared to closeups, perspective view against flat patterns, rough versus smooth, all provided a degree of simultaneity that was closer to life than any direct representation by traditional means.

Hausmann wrote in *Definition of Photomontage*:

The Dadaists, who had invented the static, simultaneous and purely phonetic poem, consequently applied the same principles to pictorial expression. They were the first to use photography as a material to create, with the help of very different, often disparate and antagonistic structures, a new unity that distilled an intentionally new visual reflection from the chaos of the war and revolution

The field of photomontage is so vast that it has as many possibilities as there are different milieux. The milieu is transformed daily in its sociological structure and resulting psychological superstructure. The possibilities of photomontage are delimited only by its supply of forms and by the education of its zone of expression. (500)

497. Adolphe Braun. *The Court of Napoleon III*. c1865. Photo-collage. Courtesy Adolphe Braun et Cie, Mulhouse, France.

498. *Comic Postcard*. c1910. Coke Collection, Rochester, N.Y.

499. Paul Citroën. *Metropolis*. 1923.
Photo-collage, 30 x 11¼ inches.
Prentenkabinet Rijksuniversiteit Leiden, The Netherlands.

500. Raoul Hausmann. *Fotomontage*. 1923. Photomontage.
Courtesy Sidney Janis Gallery, New York.

500.

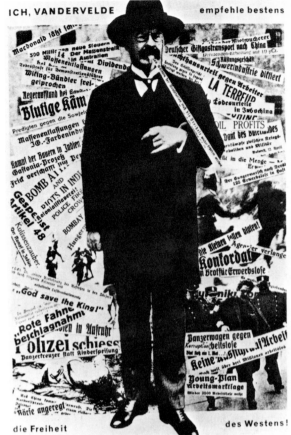

502.

501.

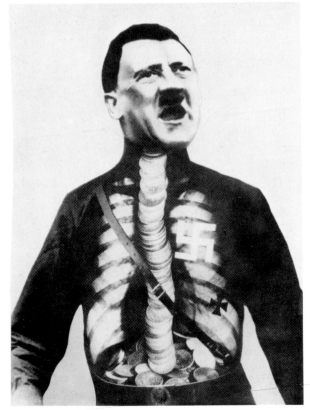

503.

501. Hannah Höch. *Dada-Ernst*. 1920-21.
Photo-collage, 7 5/16 x 6 9/16 inches.
Courtesy Galleria Schwarz, Milan.

502. John Heartfield. *I, Vandervelde recommend best the
Freedom of the West*. 1930. Typophotomontage.
Present whereabouts unknown.

503. John Heartfield. *Adolf the superman swallows gold
and spouts junk*. 1932. Photomontage.
Present whereabouts unknown.

The Dadaists, in Berlin: Huelsenbeck, Hausmann, Heartfield, Höch, Baader, and Grosz; in Cologne: Ernst and Baargeld; and in Hanover: Schwitters, used the photograph in collage each with a distinct approach.

In Berlin the Dada movement was primarily political, rather than literary or artistic. To further the cause of the struggle against the Allied-supported government was its intent and goal. The Dadaist collages were part satirical and anti-rational. Richard Huelsenbeck in the first German Manifesto proclaimed the highest art to be that which in its conscious content presents the thousandfold problems of the day.

As products of modern technology, photographs served as symbols of freedom from the past. They provided a challenge to the nature of reality itself, for the camera-made image assumed the guise of reality to such an extent that participation in an event no longer implied actual presence, which was simply another way of emphasizing disenchantment with traditional political and esthetic values. Furthermore, the very mechanics of making a photograph was used in Dada pictures to demonstrate the thesis that man was losing his will and becoming a lackey of machines.

When asked to comment on some of the contributions made by the Berlin Dada group, Hannah Höch, one of the movement's important members, said:

I believe we were the first group of artists to discover and develop systematically the possibilities of photomontage. We borrowed the idea from a trick of the official photographs of the Prussian army regiments. They used to have elaborate oleolithographed mounts, representing a group of uniformed men with barracks or a landscape in the background, but with the faces cut out; in these mounts, the photographers then inserted photographic portraits of the faces of their customers, generally coloring them later by hand. But the aesthetic purpose, if any, of this very primitive kind of photomontage was to idealize reality, whereas the Dada photomonteur set out to give to something entirely unreal all that had actually been photographed . . . our whole purpose was to integrate objects from the world of machines and industry in the world of art. (501)

In *Der Dada*, the organ of the Berlin movement, collages made with strips of newspaper and photographs composed at random were devised by Hausmann and Heartfield, along with manipulated photographs and caricatures by Grosz. In works titled *The Pimps of Death, Rub out Famine*, and *Triumph of the Exact Sciences*, Grosz cleverly combined photographs with his drawings and paintings for purposes of satire. The war profiteers in Germany in the early 1920s were spending their wealth in a flagrant fashion, and the Leftists were battling to see whether Socialism or Communism would mold the defeated nation. Undisputedly real imagery in the form of photographs was included by Grosz in satirical pictures of fat industrialists and their lascivious ladies. The parts of Grosz's pictures made with the camera were like stage props used to add credibility to his scenes.

The artist who most effectively used the photomontage technique for propaganda purposes, both in the grim post-World War I period in Germany and later as a means of combating the Nazis, was John Heartfield. While surreal and even dadaesque in some cases, his aim was pure satire; his weapon, photographs cleverly jigsawed together. They communicated his message in a direct fashion to all levels of the German population and to the world. (502-503)

To emphasize the excesses and failures of the politicians and their allies, the German High Command, Heartfield created his photographic comments in the 1920s when the Dada movement had declined. Even in the twenties and thirties, as well as after World War II, he continued his denunciations of the bestial acts committed by the Nazis. Through his masterful use of photographs combined from various sources the destructive social and political situation in Germany was revealed in a harsh idiom that was given its thrust by easily identified passages made up of photographic fragments.

In 1933 Heartfield escaped the Nazis by jumping out of a bedroom window and fleeing to Czechoslovakia where he continued making his montages in Prague.

259

504.

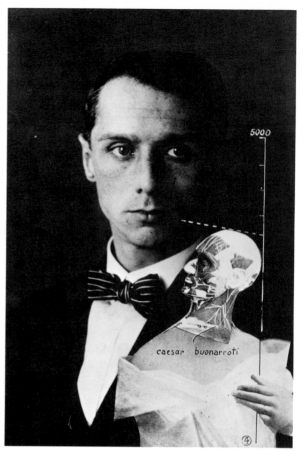

505.

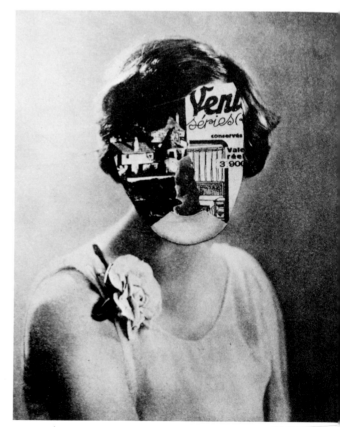

506.

504. Max Ernst. *Loplop Introduces the Members of the Surrealist Group.* 1931. Photo-collage and pencil, 19¾ x 13¼ inches. Museum of Modern Art, New York.

505. Max Ernst. *Dadamax with caesar buonarroti.* c1920. Photo-collage, 7½ x 5 inches. Collection Arnold Crane, Chicago.

506. Édouard L. T. Mesens. *Mask for insulting esthetes.* c1925. Photo-collage. Collection Édouard L. T. Mesens, London.

When Nazi agents again threatened him, he moved to London where he lived for seventeen years. From 1950 until his death in 1969 he made East Berlin his home, where he was a professor at the German Art Academy. Rather than use photos clipped from newspapers as did many of the German montage artists, he obtained large glossy prints from photographic agencies. These were cut and fitted together so as to put in a new context a head from one picture, a body from another, and an environment or setting from a third or yet a fourth photograph. His intense moral indignation, colored always by his frank left-wing views, translated a patchwork of pictures into powerful vehicles of protest against tyranny and injustice.

While the Dadaists in their poetry and collages challenged all traditions, the fragile world of fantasy and dreams became increasingly the subject of art. Ernst, working first in Cologne and later in Paris, was one of the most imaginative of the artists who began as Dadaists and became Surrealists. His irrational assembly of photographs and drawn shapes command attention and evoke a feeling of uneasiness. This feeling stems from our responses to the concreteness of the photographic imagery in opposition to the suggestive but unidentifiable forms created by the artist's brush. The unnerving relationship and staccato image associations evoked by discordant notes in Ernst's collages served to mock convention and thus fostered the central ideas of Dada and Surrealism. Formulated was a world quite different from the politically oriented collages of Hausmann and Heartfield.

Some of Ernst's collages are like a wandering mind that suddenly focuses sharply for a moment on the likeness of a person or a portion of a scene, then slowly loses its clarity causing the image to dissolve into fantastic shapes. Whether the recollections evoked by the photographs Ernst uses are real and take place in the present tense is intentionally left ambiguous. The reality of the photograph says one thing, the painted and drawn imagery says something else.

Ernst's *Loplop Introduces the Members of the Surrealist Group,* 1931, includes a dualistic fusing of varied forms and a play on intuition as well as responses set in motion by exactitude. (504) Parts of the composition are substantially true to nature while others are fanciful. The earlier *Dadamax with caesar buonarroti,* about 1920, links Ernst in a semi-serious manner with great figures from the past, for he was called "Dadamax," short for *Dadaflex Maximus,* by members of the group. (505)

E. L. T. Mesens, the Belgian poet and collagist, said of Ernst's combination of photographs and printed material: "In his *collages,* Max Ernst is far from being principally concerned with plastic construction. With a single stroke he plunges us into the drama by making the elements of our known world confront each other in an irritating manner, thus violating the accepted canons of thought, logic and morality." Mesens' own collages have the same qualities he sees in Ernst's work. In *Mask for insulting esthetes,* Mesens replaced a woman's face with a collage fragment of a photograph of houses juxtaposed with lettering from an advertisement. (506)

In the last two years of World War I and afterward collages in which photographs were included appeared with the signature of a number of painters in addition to the collages done by members of the Dada movement. The photographs served as a wry or odd note in works by Carlo Carra, René Magritte, Oscar Schlemmer, and Joan Miró. Although photographs serve the average viewer as mimes of nature and substitutes for reality, they acted for these artists like spices with a meal. To achieve intentional contradiction, the artists combined patiently executed brushwork with overwhelmingly detailed photographs. Their intentions varied but in general they sought to elicit a conditioned reflex to the photograph as "truth," as set against painted paraphrases of nature or pure abstract forms. The combinations of forms evolved by these artists often had no direct representational role and were

507.

508.

507. Christian Schad. *Schadograph*. 1918. Photograph.
6 x 4½ inches. Museum of Modern Art, New York.

508. Christian Schad. *Schadograph*. 1918. Photograph.
6¼ x 4¾ inches. Coke Collection, Rochester, N.Y.

509. Man Ray. *Untitled*. c1921-28. Rayograph,
11½ x 8½ inches. Coke Collection, Rochester, N.Y.

509.

therefore totally free of any immediately discernible association but nevertheless had a menacing appearance.

Another kind of disjointed picture, in this case involving a philosophic concern with automatism, was Christian Schad's "schadograph." In schadographs, a term coined by Tristan Tzara, elements were combined in an unexpected fashion that while recognizable had the light and dark portions in inverse order compared to their original state. (507-508) Schad's collages, first made in Switzerland in 1918, were created of arranged combinations of inconsequential printed matter such as tickets or fragments of newspapers placed on photosensitive printing-out paper, then exposed to sunlight. His arrangements of opaque and translucent bits and pieces of paper and string were registered as white "shadows" of forms. The reversal of tones that resulted from the picture-making process gave his collages a sense of mystery. Schad's schadographs were independent works of art but also served as studies for forms that were incorporated in the artist's relief constructions and woodcuts. Schad has said, "It's all a matter of choosing the objects and arranging them in such a way as to make them formulate a statement. Now it's possible to orient oneself on whatever one finds in the streets, the bars, and the wastepaper baskets. As far as I'm concerned, one should only use objects that in themselves contain something magical."

In 1921 Tzara showed Man Ray some schadographs. While Man Ray thought of himself as a painter, he made his living by photographing works of art and making portraits with his camera. Seeing the schadographs, being generally susceptible to new ideas, and having an accident which occurred in his darkroom in 1921 resulted in a new art form that he called "rayographs." The first of these images came about by happenstance while Man Ray was working in his darkroom. He recalls that an unexposed "sheet of photo paper got into the developing tray . . . and as I waited in vain a couple of minutes for an image to appear . . .

510.

511.

510. Man Ray. *Observatory Time—The Lovers.* 1930-32.
Oil, 39⅜ x 98½ inches.
Collection William Copley, New York.

511. Man Ray. *Lips.* c1925. Photograph.
Courtesy Man Ray, Paris.

512. Eugène Atget. *Shop Window: Tailor Dummies.* 1926.
Photograph. George Eastman House, Rochester, N.Y.

I mechanically placed a small glass funnel, the graduate and the thermometer in the tray on the wetted paper. I turned on the light; before my eyes an image began to form ... distorted and refracted by the glass more or less in contact with the paper and standing out against a black background." (509)

Man Ray made many more of the curious pictures by placing various objects on photosensitive paper in his darkroom and then exposing the arrangement to a beam of direct light. When the paper was developed in a chemical bath, photographic prints were produced in which light and shade patterns were related with varying degrees of identification with the objects placed on the paper. This strange and fortuitous means of making a picture with abridging quality appealed to the Dadaists and later to the Surrealists because of the suggestive effects that could be achieved without specific reference to reality.

In addition to his light-modulated rayographs, Man Ray made a series of quite straightforward closeup photographs in 1925 which isolated various parts of the human face. One of these inspired his well-known surreal painting *Observatory Time—The Lovers,* 1930-32. (510-511) He wrote in his autobiography, "One of these enlargements of a pair of lips haunted me like a dream remembered: I decided to paint the subject on a scale of superhuman proportions. If there had been a color process enabling me to make a photograph of such dimensions and showing the lips floating over a landscape, I would certainly have preferred to do it that way."

It is worthwhile to note that some straightforward photographs have characteristics that are dreamlike and are therefore evocative on a level quite separate from their documentary value. In 1926 some of Atget's photographs were published in *La Révolution Surréaliste.* Although the photographer was not a member of the Surrealist movement, his pictures such as *Shop Window: Tailor Dummies* made a deep impression on the artists working in this vein. (512) The grinning

512.

265

516.

515.

518.

517.

266

513.

514.

513. Salvador Dali. *Paranoiac Face, Double Image.* 1934. Oil, 7½ x 9 inches.

514. Photographer unknown. *Post card of African village* (interpreted photographic study for *Paranoiac Face*). Photograph. Reproduced from Marcel Jean, *The History of Surrealist Painting.*

515. Salvador Dali. *Composition 1942.* 1942. Watercolor and ink, 14½ x 18 inches. Private Collection, New York.

516. Photographer unknown. *Franklin D. Roosevelt.* 1932. Photograph. Prints and Photographs Division, Library of Congress, Washington, D.C.

517. Salvador Dali. *Santiago El Grande.* 1957. Oil.

518. Yan (Jean Dieuzaide). *Église des Jacobins le "Palmier," Toulouse, France.* c1955. Photograph. Courtesy Jean Dieuzaide, Toulouse, France.

faces of the clothes dummies and the superimposed reflections of buildings and trees located across the street from the tailor's shop appealed to the Surrealists' interest in the dislocation of time and space.

The principal influence of photography on Surrealism other than that in Ernst's work and in some of Man Ray's pictures was on Salvador Dali. He was fascinated by photographs and had the skill to meticulously copy minute details from them. It was easy for him to assimilate the special vision of the camera, and he often cited specific sources of his ideas in readily recognizable form. His *Paranoiac Face*, painted in 1931, was designed to portray at first glance a group of people sitting before a roundtop hut. (513-514) When studied with care and turned sideways, however, the painting changes; and a giant head lying on its side in the sand replaces the original subject.

This disquieting puzzle picture was made to function in this manner by adding a number of elements to a photograph Dali copied. Bushy trees served as hair for the metamorphosed head, a gourd-like form was added to the three center figures to make a chin, the shadow to the right of the hut was darkened to represent the beginning of a neck, and a white pointed headdress was added to a figure on the left. When viewed upright, the figure becomes one eye of a giant head, with the white portion of the reclining native's dress representing the other eye. Dali retained the photographic quality in his

painting to produce a sense of reality and carefully positioned dark and light elements so that they could be read two ways. He thus fostered a visionary shift in meaning, a central idea in the artist's version of Surrealism.

In 1942 Dali painted a series of distorted floating heads in a surreal arrangement that suggested the effect of a dream sequence. On the upper right-hand corner of *Composition 1942* he painted a likeness of Franklin D. Roosevelt from a 1932 photograph. Dali made effective use of the shadows under Roosevelt's eyes and along the side of his nose to progressively transform these features into an amazing variety of fanciful wing-like elements culminating in a reference to da Vinci's well-known drawing of a man equipped with wings. (515-516)

An interesting recent case of law, as well as art history, has involved Dali with the French photographer Yan (Jean Dieuzaide). In Dali's *Santiago El Grande* of 1957, he clearly used the Gothic vaults of the Church of the Palms, Toulouse, France, as a background. (517-518) Yan had given Dali one of his photographs of this church but initiated a suit when he found that the artist had plagiarized his photograph. Point of law aside, it is readily apparent that there are striking similarities between parts of Yan's photograph and Dali's painting. Since it is unlikely that the human eye could independently conceive this optically distorted arrangement of

267

521.

522.

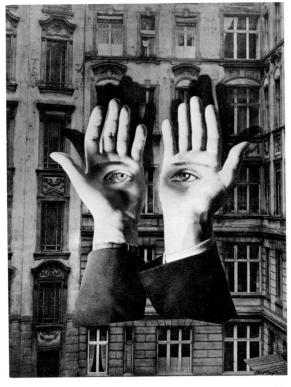

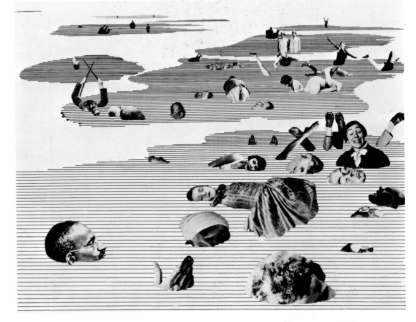

520.

519.

519. Herbert Bayer. *lonely metropolitan*. 1932/33.
Photomontage, 14 x 11 inches.
Collection Herbert Bayer, Aspen, Colo.

520. Kurt Kranz. *Immersed Ones*. 1931.
Photo-collage, 19⅝ x 24¾ inches.
Courtesy Herbert Palmer, Los Angeles.

521. Lucien Clergue. *Gypsies in Saintes-Maries-de-la-Mer*.
1961. Photograph. Courtesy Lucien Clergue, Arles, France.

522. Jean Cocteau. *Via Crucis* (detail). 1960. Fresco.
St. Peter's Chapel, Villefranche-sur-Mer, France.

architectural elements, Dali must have used the photograph as he had done in the instances cited previously.

From 1919 to 1933, when the Nazis forced the Bauhaus to close, it was the focus of very imaginative ideas about industrial and graphic design, and photography played a major role in the teaching procedures. In addition to the collage experiments carried out by Moholy-Nagy, much was achieved in the same medium and in multi-image pictures by Herbert Bayer working at the Bauhaus. (519) While related to Surrealism, the dominant mode of the twenties, Bayer's designs had a distinctive feeling of fantasy and often a touch of humor or irony that separated them from most other collages.

Kurt Kranz was another *assembleur* who, in the thirties and later, continued the tradition of photo-collage that reached meaningful heights during the Dada period. Fragments of photographs of sometimes identifiable personalities, such as Gandhi and the French comic Fernandel, were pasted onto the surface of his compositions. In one collage these fragments float in a strange space evoked by parallel horizontal lines

that describe islands or, more nearly, mud flats or patches of quicksand in which all humanity seems to be sinking. (520)

Jean Cocteau, poet and sometimes painter, created late in his life a strange religious allegory in fresco for St. Peter's chapel at Villefranche-sur-Mer on the French Mediterranean coast. He had been associated with the early Dadaists and Surrealists and undoubtedly had some of their ideas in mind, for he based parts of his composition on a slapstick photograph of gypsies by the well-known photographer Lucien Clergue. The subject of the painting and his source of ideas were poles apart, and yet from this incongruous pairing Cocteau produced the central portion of the *Via Crucis*. (521-522) He was particularly responsive to the photograph's representation of the man with his tongue stuck out. He also borrowed the profile of the child behind the man wearing the hat, as well as the girl onlooker. In the painting these were metamorphosed into a helmeted Centurion and a female figure carrying a vessel on her shoulder.

523. Paul Wunderlich. *Joanna Modelling.* 1968.
Lithograph, 23¼ x 16⅛ inches.
Associated American Artists, New York.

524. Karin Székessy. *Joanna modelling.* 1968. Photograph.
Associated American Artists, New York.

525. Paul Wunderlich. *On a Rainy Afternoon.* 1967.
Drawing and gouache. 20 x 26 ½ inches.
Associated American Artists, New York.

526. Paul Wunderlich. *On a rainy afternoon.* 1967. Photograph.
Associated American Artists, New York.

527. Paul Wunderlich. *Seated Model.* 1968.
Lithograph, 19¾ x 25½ inches.
Associated American Artists, New York.

528. Karin Székessy. *Seated model.* 1968. Photograph.
Associated American Artists, New York.

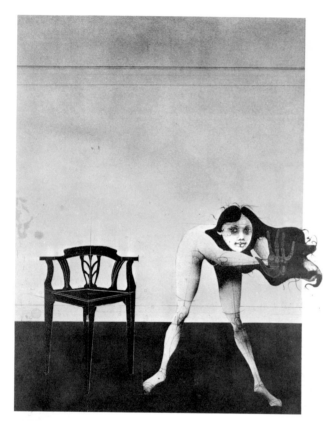

523.

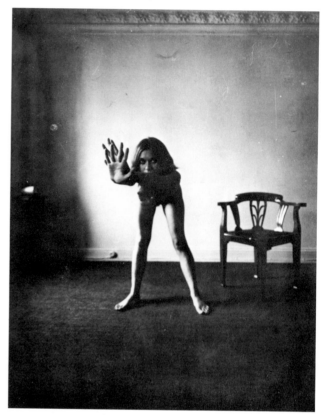

524.

525.

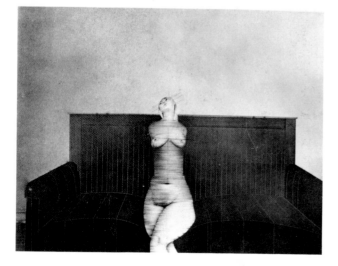

526.

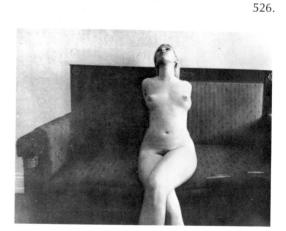

527.

528.

529.

530.

531.

529. Valerio Adami. *Il Vecchio Timido e L'Adultero in Piscina.*
1966. Oil. Courtesy Galleria Schwarz, Milan.

530. Photographer unknown. *Ambassador John Cabot Lodge
seated by swimming pool.* 1966. Photograph.
Published in *Time.*

531. Joseph Cornell. *Untitled (Breton Collage).* 1966.
Photo-collage, 16 x 12½ inches.
Collection Susan Sontag, New York.

272

Paul Wunderlich of Germany, whose bizarre prints inevitably cast him in the role of a latterday Surrealist somewhat in the Daliesque vein, has used posed photographs as the basis for a number of his prints and paintings. Especially in his implicitly erotic themes he has found photographs of young girls a useful point of departure for his unusual compositions. In particular the photographs of Karin Székessy, Wunderlich's wife, have been used to create variations on old themes. The setting for her photographs was frequently the artist's home which is furnished with examples of Victoriana, art nouveau, and oddly shaped furniture and accessories. She directed her camera, often with suggestions from Wunderlich, at models as they assumed unusual poses against and among these props. The resulting photographs seem to have unleashed the creative energies of the artist. Distortions involving enlargements and elongations of limbs in these pictures were more heroic than demonic. They derived from the deliberate placing of a hand or leg close to the camera lens to create distortions. (523-528)

Wunderlich made effective use of the photographs which disregarded the natural proportions of the human body. A master with the pencil, he could have worked out in numerous sketches the exact degree of deformity that suited his purpose. However, having before him a photograph which already incorporated exaggerated foreshortening made for easier solutions to pictorial problems. In addition the photographic sources tended to give his pictures a sense of conviction that was more evocative than highly imaginative and grotesque distortions would have been. In addition his attention was focused on planes of figures, which tend to flatten out in photographic prints. He would most likely have failed to see these qualities as readily when exposed to a model's live, soft, rounded shape.

In recent years the Italian Valerio Adami has created a group of pictures with zany surreal qualities closer to the Marx Brothers than to Dali or Wunderlich. With a sharp eye for the poetic fantasy that can reside even in mundane subject matter, Adami has found in press photographs and his own photographs many fruitful ideas. (529-530) The shaping influence of the camera is not apparent unless the sources of his imagery are known. Although Adami's fantastic synthetic world is derived from film-recorded forms, he paradoxically denies this fact by using hard linear contours with flat planes and almost excludes middle tones. He intends his pictorial mirages, metamorphosed from photographs, to change ordinary reality into configurations in which "time and space spread out into new psychic action."

Joseph Cornell, box maker extraordinary, encountered Surrealism at the Julian Levy Gallery in New York in 1931. Although he never formally studied art he has made collages that are powerfully evocative. Meeting the many Surrealists who came to New York from Europe during World War II stimulated his already developed interest in creating enigmatic situations by assembling a variety of objects in boxes. His acquaintance with the Surrealists shaped the nature of his work, which parallels in many ways that of Ernst, Dali, and Man Ray. It is fitting that one of Cornell's imaginative assemblages combines a ragged-edged version of Man Ray's solarized portrait of the major Surrealist poet and theorist André Breton with an illusionistic three-dimensional faceted shape. (531) The resulting composition seems to be a play by Cornell on ideas evoked by the strange, part-negative, part-positive photograph of Breton combined with a cutout photograph of rock crystal. In addition there is the provocative fact that the greatest American Surrealist, Man Ray, provided the original solarized likeness.

Raoul Ubac, who exhibited with the Surrealists and had his work reproduced in their magazine *Minotaure*, explored successfully various photographic techniques that evoked unreal beauty. He was one of the first photographers to discover the poetic possibilities of assembling two sheets of film—one positive and the other negative—of the same subject slightly off register. The misalignment of the two sheets of film caused

532.

533.

532. Raoul Ubac. *Fossil of the Paris Stock Exchange*. 1937.
Photograph. A.D.A.G.P. Permission to reproduce 1971 by
French Reproductions Rights, Inc.

533. Raoul Ubac. *The Triumph of Sterility*. 1937.
Solarized photograph. A.D.A.G.P. Permission to reproduce
1971 by French Reproductions Rights, Inc.

534. Allen Jones. *Women*. 1965. Lithograph, 27½ x 22¼ inches.
Courtesy Paul Cornwall-Jones, London.

535. Bert Stern. *Elizabeth Taylor*. 1965. Photograph.
Courtesy Bert Stern, New York.

274

534.

535.

prints made from them on photographic paper to give the impression of bas-relief. (532) He also made some impressive solarized photographs. He first photographed figures in a conventional fashion, then during the time the negatives were being developed in the dark he flashed them momentarily with light, causing some parts to reverse and others to be emphasized through sharp outlines. (533) Prints made from these negatives show both negative and positive passages which give them a strange enigmatic visual quality. Man Ray also used this technique for his Breton portrait, incorporated in Cornell's composition, to divorce it and other portraits from the persuasive reality of camera-made likenesses.

Allen Jones, one of England's leading Pop painters and printmakers, has used photographic imagery extensively in his work, but rarely considered is the close relationship much of his work has with Surrealism. By photolithography he transfers parts of photographs to paper virtually intact, to be then linked with his drawings. In *Women,* he mechanically reproduced Elizabeth Taylor's bust and by elaborate permutations gave her two sets of lips and uncoiled the serpent between her breasts to swim like a spermatozoon or a penis between

two pairs of lips. (534-535) The strange geometric face Jones drew remains sensuous even when emphasis on Miss Taylor's eyes and nose was completely eliminated. By the title *Women,* Jones implies that this lithograph somehow is a prototype of the "idea" of women in the minds of many men. Jones' emblem has been given its zest and credibility by the photographic portion that is immediately recognizable as a sex symbol.

Artists in both the Dada and Surrealism movement found collages to be an effective means of expression. The illusions provided by fragmented photographs transformed ordinary subject matter into objects of fantasy and protest. During the early period from 1918 to about 1935 when collages were first being made, the creation of contradictory images was the aim of Dadaists and Surrealists. A blend of identifiable elements—some photographic, some not—was combined into strange fetish-like objects. The reciprocal influences of one kind of imagery on another caused disquieting reactions in viewers. The artists who worked with collages in this early period widened the range of possibilities inherent in collections of photographs or pieces of photographs pasted together in unexpected associations.

275

536.

536. Tom Wesselman. *Still Life No. 15.* 1962.
Oil and photo-collage, 84½ x 72½ inches.
Collection Mrs. A. B. Sheldon, Lexington, Nebr.
Courtesy University of Nebraska Art Galleries, Lincoln.

The *collageurs* of the 1960s had a very different conception of what could be achieved by combining photographs. Their aims often related to social problems, and they worked to hold up a fractured mirror to materialism, segregation, war, and war's erosion of the human spirit.

Tom Wesselman directs attention to the material emphasis in contemporary American life by collaging photographs or reproductions of photographs as a part of his pictures. The photographs are of items for sale in supermarkets, appliance stores, and drugstores. His *Still Life No. 15* celebrates hedonism, for the collage has as its subject the illusionism associated with the world of TV commercials and magazine ads in *Good Housekeeping* and *Life.* (536) In his pictures, Wesselman parodies America's middle-class meringue-like existence and the importance people attach to *things.* He does this by emphasizing the idealized reality of billboard photography and the display-color photos found in popular magazines.

The arrangement of skillfully falsified camera-made records in *Still Life No. 15* is primarily intended to reflect upon today's mindless acceptance of sameness, a sameness that increasingly permeates everything to the detriment of individual choice or taste. The artist is saying the reality of the manipulated photograph is merely another aspect of today's processed world. In *Still Life No. 15* the national flag was combined with a portrait of George Washington, an apple for Mom's apple pie, a steak for Dad, a view of rich farmland and a well-kept barn, and a bottle of Four Roses whiskey. These items—some painted, some photographed—are dear to the heartland of America and represent heirloom ideas. Wesselman has raised both the items and the ideas they evoke to the status of icons of a sort. To signify, for example, that all items in the picture are part of the "Great American Dream," he carefully painted the American flag. His deceptively banal "statements" are potent as satire and, like the pioneering Dadaists, he is sharply questioning established values.

Romare Bearden, once a student of George Grosz at the Art Students League, is another artist who has been unusually successful in transforming bits and pieces of photographs into effective social comments about life—in his case life in Negro ghettos, for Bearden is a Negro. (537) His compositions have a level of tangibility that, while formally broken up in a somewhat Cubist fashion, read like a collection of short film clips taken at varying distances from his subjects. He takes pieces of photographs and reassembles them in a relationship of a different order and scale than that which prevailed when the subjects were first recorded by the camera. Bearden thereby achieves a graphic technique that is both original and effectively full of life—a life that is tender and tragic. After he has arranged his pasted-up photographs, he copies the arrangement with a camera so that it can be blown up to proportions large enough for exhibition.

These "projections," as Bearden calls his compositions, retain the immediacy of newsphotos and, through his use of optical shifts and arrangements similar to jigsaw puzzles, cover much more ground factually and metaphorically than a group of photographs presented in a conventional fashion. "I did them," Bearden has said, "out of a response and need to redefine the image of man in terms of the Negro experience I know best." The results are "something personal, something universal."

A link between the technique of collage and what could be called "neo-surreal" imagery has been devised by Wallace Berman, an important catalytic thinker and artist of southern California. His pictures are composed of photographs cut and spliced together with painted images. The manner in which they are made is similar to the way collages are assembled, but the finished prints somewhat resemble reproductions of paintings. To achieve this effect, Berman runs his "collages" through a Verifax machine, which tends to unite the forms and give them a common surface. In his prints, Berman exploits the whole range of Pop cul-

537.

537. Romare Bearden. *Jazz 1930's (New York) Savoy.* 1964.
Photo-collage, 34⅞ x 48 inches.
Courtesy Cordier and Ekstrom Inc., New York.

538. Wallace Berman. *Scope.* 1965. Photo-collage Verifax print,
16 x 18 inches. Collection Dennis Hopper, Taos, N.M.

539. Wallace Berman. *Sound Series #2.* 1967-68.
Photo-collage made with Verifax machine and acrylic,
12½ x 13½ inches. Collection Wallace Berman, Los Angeles.

538.

539.

ture recorded by the camera, including Jean Harlow, nudes, Castro, Mohammed Ali, the head of a horse, jazz musicians, as well as photographs of engineering achievements and views of nature. (538-539)

Before Berman began to make Verifax pictures, he included photographs in sculpture that he had assembled from scraps of material. With the Verifax machine he could make multiple pictures composed of scraps and get the kind of altered photographic images he wanted for his purposes. Using camera images and a Verifax machine does not necessarily make for mechanical or precise pictures. In fact, the prints Berman makes with this equipment have a "handmade" grainy quality, somewhat like that found in intaglio prints.

Berman has learned to control the chemicals that form the pictures in the Verifax machine so that he can get prints of various colors of brown. An important part of this process is the aging and treatment of the chemical developer and fixer that he uses. The tone of brown he gets is esthetically important to him. It also

plays a major role in framing his compositions and holding them together. The prints are often actually negatives of positive pictures that have in their makeup a good deal of white, which in Berman's prints ends up as passages of rich brown. That is, in the original they show dark in places that are light, and vice versa in the prints. In addition to the negative pictures, he has produced a number of impressive prints that are not reversed in tone.

Berman can adjust the Verifax to print his photocollages in such a way as to get more, or less, contrast, as well as a regulated degree of clarity of detail. Nor is either the aggrandized sense of reality in Madison Avenue photographs or the candor of conventional camera vision lost in translation from the original collages, qualities which provide clues as to what the artist intends to convey in his prints. Unlike those who make etchings, lithographs, or screen prints, Berman is interested in only a single print. He does not make editions of a print, so that each one of his works is unique.

540.

541.

540. Verlon (Willy Verkauf). *Situation No. 23*. 1961.
Photo-collage, 31 x 22¼ inches.
Courtesy D'Arcy Galleries, New York.

541. Verlon (Willy Verkauf). *Situation Humaine*. 1960.
Photo-collage, 31 x 22 inches.
Courtesy D'Arcy Galleries, New York.

542. Jess (Collins). *When My Ship Come Sin*. 1955.
Photo-collage, 30 x 38 inches.
Collection Jess Collins, San Francisco.

280

542.

The Austrian picture dealer Willy Verkauf who goes by the name of Verlon when working as an artist, combines photographic fragments with applied pigment in a style that recalls some Dada collage-montage arrangements. The philosophy of this artist grew out of his experience with the tragic era of Hitler and World War II. In Verlon's pictures, the physical reality of the photographic print is dominant. This is a tacit recognition that the machine-made picture has assumed the status of an independent symbol both as a physical material and as a means of experiencing special qualities of vision. The impersonal and uniform surface of a photographic print, coupled with haunting figures and staring skulls, is intended to be synonymous with man's condition today. This is not the machine-idol concept of the post-World War I period but is a subtle way of coming to grips with the machine as an all-embracing environment seen not firsthand but through the lens of the camera.

All of Verlon's pictures have a brooding presence about them and spell the doom of man's individuality. (540) His images, however, tend to have a dated look, as technological advances make obsolete the stern symbolic forms he has selected. He sounds the alarm, but the message is only dimly heard. A mask torn from crumpled paper and applied to a surface encrusted with a mosaic of cut-up photographic prints bears too close a resemblance to a horror movie poster to sustain conviction. His more subtle *Situation No. 23* assumes the status of a primitive fetish and marks the *Situation Humaine* with disquieting overtones. (541)

Jess (Collins), like Verlon, cuts photographs apart and reassembles them. In his hands these objective transcripts of the camera's eye become a ritualistic encounter and acquire an uncanny new life. With feelings of a romantic poet, Jess manipulates a union between the exactness of photographs and the fantasy of dreams. The perverted puzzles that result are anonymous mutations of a mythical universe. (542)

In explanation of how he fashions his work Jess has written:

Drawersful of snapshots in every home, pagesful of photoprints in most magazines and newspapers, wallsful in every museum, art or otherwise—all sights on the universe that involves the painter. This is the Disseminated Still Life. The photo that acts for me as materials, models, guides, masters, are those manufactured in millions, those discarded in dustbins, those coming from no-knowledge, those ultra selfconscious, those that march themselves into my files . . . each with a special intensity of spirit somewhat within its borders, caught by the camera. As I see it the still has had its life and here has gone Beyond.

281

543. Peter Klasen. *Zone Interdite.* 1965. Acrylic, 95 x 63 inches. Musée d'Art Moderne, Paris.

544. Peter Klasen. *La Machine à Laver.* 1966. Acrylic, 76¾ x 38 inches. Collection Fumagalli, Monza.

545. Bruce Cody. *The Balcony.* 1969-70. Intaglio print, 23 x 18 inches. Courtesy Bruce Cody, Stevens Point, Wis.

546. John Catterall. *Cumulus.* 1969. Color intaglio print, 28 x 22 inches. Courtesy John Catterall, Dubuque, Iowa.

543.

544.

545. 546.

Peter Klasen's pictorial ideas are fueled by photographs. He has been responsive to all kinds of photographs, including split wide-screen movies and TV freeze frames. Faithfully retained in his paintings is the fiction of the lens we too often accept as fact. (543-544) The pictorial impersonations he paints reflect the psychological texture of our disordered life. New perspectives are gained from his pictures which in their various parts reflect a minimum of invention, for they are intended to be impersonal reports. Klasen freely mingles people and things as seen by the cold eye of the camera. The freshness he brings to this imagery, with its undifferentiated focus and sharpness, comes from his cutting and splicing the vignettes into fragments, as if taken from a wide-eyed observer's hour-by-hour recording of his life. Klasen deftly exploits vulgar candid photographs as well as the slightly sardonic, tongue-in-cheek photography used in advertising. The high level of the tangibility of his imagery not only testifies to his skill but is a most effective means of converting daydreams into nightmares.

Bruce Cody is one of a number of American printmakers who have turned to photographs for all or parts of their imagery. To call attention to the paradoxical aspects of modern society, he blends incongruous images with strange bits of architecture derived from photographs. (545) The allegorical language he uses is given its thrust by deep black lines that set off the geometric forms as well as the representations of people. He achieves these effects by transferring photographs directly onto his zinc plate, then strengthens the line by allowing acid to eat deep into the metal. In some cases to further accent a passage he uses aquatint to modulate dark tones. He may also cut by hand

directly into the plate with an engraving tool, and to print subtle tones use a soft ground etching technique. The variety of methods used to create his prints does not destroy the photographic characteristics that impart to his work a sense of conviction even though his subjects are outside the bounds of reality.

John Catterall is another printmaker in this country who has been greatly stimulated by photographs. He uses parts of them almost unaltered in combination with drawings to give his work a relevance to today's problems. Of his print *Cumulus* he has written: (546)

I have long been aware of the curious dual role the photograph plays in both representing visual experience and providing direct visual experience. More than simply representing a cropped one-eyed view of another time—another place, certain parts of some photographs become more strongly fixed in our memory than does the photograph in which they appear. The Indians in *Cumulus* are Sioux chiefs photographed at the signing of the treaty of 1851 at Ft. Laramie. In the dark areas of the lower parts of the middle two figures I have etched a half-toned image of a photograph of the huge rock formations between Cheyenne and Laramie, Wyoming (an unintentional coincidence). The Sioux chiefs in this print appear in a photograph that also includes three interpreters. The image of the chiefs became isolated in my memory like a photographic image within a photograph, both representing and providing visual experience. I am from Wyoming; much steeped in Plains Indian history, and this image symbolizes to me much of the romantic view which distorts the clear vision needed of the present-day American Indians who are facing complex problems.

Paul Sarkisian seems to dream in photographs. (547-551) His highly personal and imaginative paintings are large—usually over ten to twelve feet high—and

547. Paul Sarkisian. *Homage to John Altoon*. 1970.
Acrylic, 117 x 153 inches.
Courtesy Michael Walls Gallery, San Francisco.

548. Leon Izmerlian. *John Altoon and Babs Altoon*. 1968.
Photograph. Courtesy Paul Sarkisian, Los Angeles.

549. Paul Sarkisian. *Study for "Homage to John Altoon."* c1969.
Photograph. Courtesy Paul Sarkisian, Los Angeles.

550. Paul Sarkisian. *Study for "Homage to John Altoon."* c1969.
Photograph. Courtesy Paul Sarkisian, Los Angeles.

551. Paul Sarkisian. *Study for "Homage to John Altoon."* c1969.
Photograph. Courtesy Paul Sarkisian, Los Angeles.

547.

551.

550.

549.

548.

552. James Strombotne. *The Ladies of Rue . . .* 1963.
Oil, 60 x 65 inches. David Stuart Galleries, Los Angeles.

553. Photographer unknown. *Girls in the brothel in the rue d'Ambroise.* c1893. Photograph.
Courtesy James Strombotne, Los Angeles.

554. Lucas Samaras. *Box with Bird.* 1964. Construction with photograph. Collection Jon Streep, New York.

554.

553.

552.

related to both Pop and Surrealism. In these large-scale pictures he includes wonderfully lissome life-size nudes as "witnesses" to his allegories. His basic sources of imagery are photographs, many of which he takes himself. With a projector he throws on canvas the imagery he combines from many photographs in an almost "collage" fashion, then outlines each form with pencil. With masterful brush work or an airbrush he then applies color with finesse and finish. The colors he prefers are brilliant blues for the sky, and white saturated with light for fleecy clouds, and for the nudes he chooses yellows, pinks, or soft grays applied monochromatically in photographic tones to separate them from the reality of the informal and sometimes baffling ménage of people and *things*. Sarkisian is a poet who can combine perfectly reasonable subjects with uninhibited nude figures who seem to have wandered onto a stage where a film was being shot and were then invited to stay because they added such a delightfully human touch to the scene.

James Strombotne, whose work could also be defined as Pop-Surreal, turned to a photograph of a group of nude prostitutes when painting a recent canvas. This picture, which is from a photograph made in the 1890s, indicates that a painting from a snapshot can be independent of the source even though many qualities were borrowed from a photograph. (552-553) The photograph Strombotne selected was of women from a brothel on the Rue d'Ambroise in Paris. While he depended on the sepia-toned photograph for some details and the general placement of the figures, in his painting he changed the flavor of the imagery caught by the camera.

More witty than penetrating, Strombotne's picture incorporated a blend of Pop art and nostalgia for the period when Art Nouveau was in vogue. In his painting Strombotne eliminated one figure, stressed the bulging contours of all of the brothel inmates, and stylized the setting to get away from the flowered background found in the photograph. What survived was not a mere reflection of the source but a composition of strong formal relationships quite different from the somewhat pathetic photograph. There is a lack of modeling in the faces and legs of the women in the inferior photograph. This suggested to Strombotne the pattern of flat shapes he exploited pictorially. Had his models been alive and posed before him in the same positions he would not have been as aware of the graphic potential of these qualities, and in all likelihood would have painted a distinctly different kind of picture than he did. The artist would have been influenced by what his eyes saw, that is, solid contoured forms rather than the flat shapes suggested by the photograph. Like many artists who work from photographs, Strombotne redefined the information he found in his source and gave it a new connotation; without the photograph he would not have had the creative impulse to begin the composition that became this painting.

In some instances three-dimensional works have photographs incorporated in them. Directly descended from Dada and Surreal collages is Lucas Samaras' *Box with Bird*. (554) The repeated-portrait photograph was skillfully interwoven with three-dimensional objects in a box covered with bright-colored yarn in a flowing design. The meaning of the box is felt intuitively, without analysis, and the flat photographs play a special role in this context, for they constitute a link with the spectator. The deep-set eyes look out and force the spectator to try to decode the enigmatic assembly of objects.

Photographs have been used by artists working in almost every vein to yield fresh and sometimes startling ideas. When imaginatively used they can be tapped as a material out of which fantasy and dreamscapes may be created. They can also persuade us to accept facets of a picture as if the forms within physically existed before our eyes. And as reliable reference to reality, photographs make it possible for artists to treat the element of time in new ways thus investing even prosaic subject matter with a sense of drama.

10. PHOTOGRAPHS
AS CATALYSTS

557.

558.

555. *Back of French carte-de-visite.* c1885.
Coke Collection, Rochester, N.Y.

556. Paul Klee. *Hauptweg und Nebenwege* (Highway and
Byways). 1929. Oil, 32⅝ x 26⅜ inches.
Collection Frau Werner Vowinckel, Munich.
Courtesy Wallraf-Richartz Artz Museum, Cologne.

557. Robert Partin. *Whale.* 1964. Oil, 50 x 40 inches.
North Carolina Museum of Art, Raleigh.

558. Photographer unknown. *Automobile bumper* (detail). n.d.
Photograph. Courtesy Robert Partin, Fullerton, Calif.

555.

556.

10. PHOTOGRAPHS AS CATALYSTS

Photographs have acted as catalysts as well as a source of explicit information for artists. Paul Klee must have been thinking of geometrically defined fields as recorded in aerial photographs when painting his *Highway and Byways* of 1929. (556) The angle of view in this picture is one experienced only from the air and often when a plane is in a banking turn. Since Klee was connected with the German air force during World War I, it seems reasonable to surmise that he had been exposed to aerial photographs at that time and later could have seen many photographs taken from airplanes.

The way in which Graham Sutherland was stimulated by photographs is documented more explicitly. While doing his crucifixion for St. Matthew's Church in Northampton, Sutherland suffered from a lack of inspiration. The study of photographs of people held in World War II concentration camps released him from this period of apathy. Another instance of creative stimulation by photographs is found in the coincidence of imagery that has been apparent in the work of Brassaï, the French photographer, and his friend, the painter Jean Dubuffet. Brassaï's work includes many photographs of drawings incised on walls by children and unusual examples of latrine art. These are very close in spirit and form to the sophisticated figurative works of Dubuffet's early period.

The American painter Robert Partin was inspired by photographs of a different kind when painting some of his pictures although, when initially encountered, his work does not appear to be related to photography in any way. Nevertheless he used the catalytic effect that can come from seeing photographs of familiar objects out of their normal context. He has found that photographs of ordinary objects can assert an unusual authority when their forms are seen upside down or askew in other ways. Cutting up portions of photographs suspends the original meanings of the shapes and allows one's imagination to deal freely with the material. Partin has found particularly appealing the monochromatic range of tones in black and white photographs and the screening used in reproduction processes. The dots that break up lights and darks in a reproduction grid suggested to him shimmering effects of light, which he transformed into the semi-abstract impressionistic composition *Whale*. (557-558)

This painting grew out of a sudden awareness that a fraction of an advertising photograph of an automobile bumper could mean other things. When turned on its side, a small segment of this picture suggested to Partin a stratification of forms and tones that seemed to have promise as a pictorial idea. By chance this arrangement, when seen in an upright position, assumed the appearance of a large fish. Partin was surprised and pleased by this revelation which he feels was conditioned by his frequent thoughts of the sea and its life. When

559.

561.

560.

559. John Kacere. *Metamorphosis, A Series*. 1964.
Pencil, 8½ x 6½ inches. Coke Collection, Rochester, N.Y.

560. Kay Harris. *Apple*. c1960. Photograph.
Courtesy John Kacere, New York.

561. Photographer unknown. *Portion of an advertising photograph*. n.d. Photograph.
Courtesy John Kacere, New York.

562. August Vincent Tack. *Spring Night*. c1930.
Oil, 68¾ x 43½ inches.
The Phillips Collection, Washington, D.C.

562.

painting the picture, he reversed the values to emphasize the newly discovered connotation. The many small particles of paint he used to evoke his meaning were inspired by the dots in the screened photograph. He felt they accentuated the feeling of light reflected from bubbles that the artist associated with a moving whale seen only for an instant as it passed an opening in an aquarium or the porthole of a ship.

John Kacere is another artist who has sought inspiration of this kind from photographs. He has followed the practice of drawing from photographs for many years. Frequently forms have been synthesized in his drawings from different photographs to such an extent that the meaning of a drawing may be totally divorced from the photographs from which he starts a composition. One of the best examples of this procedure is found in Kacere's variations on the theme of two separate photographs—one of a halved apple, the other of a large brass key. (559-561) Out of the two independent photographs he developed a highly symbolic group of drawings which are obedient to the camera's eye only in a surface sense. The photographs provided the artist with clues to forms that were altered to suit his mood.

Kacere was not a pioneer in this kind of metamorphosis. August Vincent Tack, known as a painter of portraits and of religious themes, evolved some very unus-

ual semi-abstract paintings from photographs in the mid-thirties. On a visit to Death Valley, California, he became very interested in the light and shade patterns formed when sunlight revealed the irregular texture of the alkaline soil found in the region. Tack photographed the rough ground and had the results enlarged ten or fifteen times to serve as studies for paintings. (562) The enlargements were turned over to Tack's assistant, William Wilfred Bayne.

Bayne recalls, "I spent many monotonous hours making perforated replicas of them. These enlarged photographs were naturally somewhat vague in outline, and to determine the contours I had to use my own initiative. When the perforated duplicates of the photographs had been laid upon the panels and the clotted contours rubbed through, my next task was to strengthen them with a fine brush. At this point Mr. Tack took over, and in the privacy of the upper studio, filled in the spaces indicated by the strengthened contours with various colours." The paintings, unless one knows their origins, appear as maps or vague charts; however, when seen in the context of Bayne's information they can be related to the original subject from which they were derived.

Sources of inspiration for an artist can thus come from many kinds of mundane and unexpected sources. An arrangement of forms that was meant to represent

**IT'S COMPACT
IT'S CONVENIENT
IT'S KIWI**

large flannel polishing cloth, heavy duty

564.

563.

565.　　　　　　　　　　　　566.

one thing may suggest to the artist other relationships and other meanings. A play on words in conjunction with an interest in unusual shapes can start the process of creativity.

Witness to this is one of Steven Cortwright's lithographs, which is a variation on a Kiwi shoe polish ad. (563-564) If the artist had encountered the polish applicator itself, rather than a profile view of it in a photograph, he probably would not have reacted as he did. The sawtoothed outline assumed by the plastic applicator in the jar appealed to Cortwright, and he converted it into a large, bright lithograph that bears little resemblance to the shoe polish ad except in the title he chose for his work. The meaning has been altered completely and given sexual connotations.

Congruences of imagery may be the result of exposure to like subjects, mutual interest in the same motifs, or similar states of mind. In such manner Emerson Woelffer was undoubtedly swayed at one point in his development by the photographs of his close friend Aaron Siskind. While no single photograph exercised an influence on Woelffer, his canvas *Homage to Aaron* is related to the collective group of Siskind's pictures which deal with dislocated lettering and portions of commercial signs. This affinity was a natural outgrowth of a common concern for certain

configurations. The influence was more unconscious than overt but shows how a painter's use of a motif may come from a pictorial source absorbed from secondhand experience.

The American painter and lithographer Clinton Adams has often used photographs in his work, not as a primary source of images but rather as an aid to memory or as a secondary reference. While working on his *Enchantress* series of lithographs he often browsed through photographs of female nudes and in some cases used such photographs quite directly as a basis for specific lines and forms. One of the ten lithographs that make up his recent suite, *Venus in Cibola*, was derived from the standpoint of form from one of Eliot Porter's photographs of Glen Canyon in Utah. (565-566) The symbolic connotation of this print is readily decipherable when the title of the suite is considered. While abstract, the forms relate quite directly to the Venus theme suggested to Adams by the rock formation and the falling water in Porter's photograph.

Photographs affect artists in more strange and stimulating ways than is commonly supposed. They can evoke a flood of memories, work inward to cause an artist to probe the strength and depth of his responses to reality as well as serve to inspire the use of new forms only known to him through the lens of a camera.

11. CONCLUSION

11. CONCLUSION

568.

567. Janicat. *Photographer and Painter.* c1880.
Photograph. George Eastman House, Rochester, N.Y.

568. Artist unknown. *The Tools of the Landscape Photographer.*
Reproduced from *La Pratique en photographie.* 1890.
Coke Collection, Rochester, N.Y.

The influences of photography on art have been many and complex these past one hundred and thirty years, a fact that has been both misunderstood and disregarded. The artist Joseph Pennell wrote in 1893, "I don't think photography has had any influence upon modern art at all—that is, upon the art of men like Whistler, Degas, Chavannes. . . . The use of photographs by artists, however, is a very different matter, and I do not propose to give away the tricks of the trade. By refraining I have no doubt I shall receive the silent blessings of the multitude of [artists] among whom I find myself." Pennell was not very perceptive, for, as has been indicated, Degas was greatly influenced by camera vision. In addition to influencing the form of "reality" painted by many artists, photographs had other more far-reaching effects. The direction of modern art was modified by the vision of the camera, and many artists felt compelled to express themselves in abstract rather than in traditional illusionistic terms.

Early in our century the French critic Félix Féneon said, "the painter of today has been freed by photography, still and motion, of the tedious utilitarian mission which devolved upon his colleagues of yester years to reveal to me the exterior in its many details."

Picasso told his friend, the photographer Brassaï, "When you see what you express through photography, you realize all the things that can no longer be the object of painting. Why should the artist persist in treating subjects that can be established so clearly with the lens of a camera? It would be absurd, wouldn't it? Photography has arrived at a point where it is capable of liberating painting from all literature, from the anecdote, and even from the subject. In any case, a certain aspect of the subject now belongs in the domain of photography. So shouldn't painters profit from their newly acquired liberty . . . to do other things?"

Georges Braque expressed a similar view when he said to the poet Apollinaire, "painting is getting closer and closer to poetry, now that photography has freed it from the need to tell a story."

Frank Kupka, the initiator of Orphism and a pioneer in the development of non-figurative painting, saw in photography "a faithful, therefore realistic representation of nature, which frees painting from imitative tendencies and permits it to travel its own path which is increasingly departing from realism." It is true that photography relieved painting of certain traditional functions. At the same time the camera also gave expression to a whole new range of visual experiences. It became an intermediary between firsthand observation and work in the studio.

Paintings based on photographs usually have specific characteristics and are painted by artists who are interested in realism—a kind of realism that is made of component parts that can be manipulated. More often than not the artists who work from photographs are not truly interested in creating pictures that can be directly compared with nature.

As Lawrence Alloway has said, "The photograph-users are artists whose finished work is a sign-aggregate, consisting of the conventional sign of the source and the usurped signs re-contextualized as art. Photography-derived art, no matter how realistic the photograph being copied, and no matter how faithfully it is rendered, is single-source art. It is the transposition of flat signs to a flat surface."

Before the invention of modern cameras and high-speed film it was not possible to evoke so readily the impact of direct confrontation. Now camera-made pictures make it possible for an artist to vastly expand the world he can study, and thus a new reservoir of ideas is opened up to him. By selective manipulation of the images provided by the camera, artists can incorporate in their work elements beyond the scope of the human eye or personal experience. Deriving ideas from photographs is certainly an admissible way for an artist to be stimulated. He must, however, balance mechanical objectivity with aesthetic subjectivity.

The danger in the enticing practice of painting from photographs is that it may limit the artist's freedom and submerge his personal vision to such an extent that it becomes difficult to phrase his pictures in terms that are not dependent on the way a lens casts an image on film or how a shutter catches a figure in motion. However fertile photographs may be as stimulation, their use carries a considerable measure of risk, for they can have a debilitating effect on the artist who accepts their aid without discrimination. Dependence on a camera can dry up the inspiration that comes from extended personal observation.

Ever present is the danger of falling into the trap of merely illustrating the photograph with all its limitations as an object itself. John Sloan recognized this when he said, "One trouble with a great many contemporary artists who are using photographs for documentary details is that they are drawing directly from the photograph—repeating all the visual distortions."

The camera sees only a very limited aspect of the subject and even this is in terms that are at odds with human vision. Thus, camera vision supplies an accurate description of parts, but the photographer has stolen some of the creative responsibility from the artist who relies wholly on the dispassionate dictates of a mechanical recording device. This was the view held by many respected critics.

The well-known American painter Yasuo Kuniyoshi made at least one lithograph from a photograph in the 1940s, which is not surprising since he was at times a professional photographer. But after the edition of one of Kuniyoshi's prints derived from a photograph had been completed, he decided to destroy all the pictures because they did not have enough of his imprint on them to satisfy his creative instinct. He recognized that the camera's imagery had been too overriding.

Carl Zigrosser in recounting this incident wrote, "In this [Kuniyoshi's] instinct was sound, for the values emphasized by the camera lens are never those of the creative artist's vision." Zigrosser felt that when there is collaboration between an artist's eye and the camera's eye the artist must dominate if a painting or print made

from a photograph is to be more than the mere application of paint to a pictorial idea that essentially already existed on film. This concept is being seriously challenged today in cases in which a minimum of invention deliberately takes place when an artist works from photographs.

In looking back one cannot deny that photography's influence on painting has been beneficial in some instances and limiting in others. However, one finds difficulty in seriously accepting Jack Levine's impugning of photography for the prevalence of nonrepresentational painting in the last fifty years. He seems to misunderstand the reasons why many painters have turned their backs on illusion as a goal in painting. He has said, "Challenged by the instantaneous 'truth' recorded by the camera, the artist gives up and paints abstractions."

Nor can one believe the thesis proposed by the critic John Canaday in the New York *Times* that "the camera's reproductive eye robbed painting of its primary reason for being and forced it little by little into the isolated position it now holds in our lives."

Canaday was not the first to advance this concept. His friend Zigrosser also expressed this idea in 1937, "By its success in objective documentation it [photography] has driven the artist to find an outlet on the subjective plane, as it were, to analyze and synthesize his own feelings, to explore the resources of symbolic expression and psychological nuance."

What Canaday and Zigrosser seem to have overlooked is the fact that photography, even completely objective photography, provides a vast range of images to draw upon for ideas. The illustrations in this book attest to this fact.

Photographs have aroused some artists to throw off the baggage of tradition, and some paintings from photographs have redeemed realistic figurative painting as an exciting mode of expression. Artists working in this fashion have not found it is necessary to narrowly comply with the imagery in photographs to benefit

from its influence. They know that a firsthand naked eye view of the world has its limitations. Realizing this, artists have turned to a combination of the eye and the lens to create new kinds of visual expression that are both relevant to their need as individuals and to contemporary life.

Perhaps the analogy drawn by the French poet Louis Aragon best expresses what is happening today and what will prevail tomorrow. "In the future, the photograph will not be the model for the painter in the old sense of academic models, but his documentary aid in the sense in which, in our day, files of daily newspapers are indispensable to the novelist . . . the painter of tomorrow will use the photographer's eye."

Photographs preserve the ugly as well as the more pleasant aspects of life. Vicarious knowledge has been forced on us by the proliferation of picture magazines, the enormous expansion of photo-journalism, and the ubiquitous television image. In such imagery a new excitement resides which has been given breadth and is made decipherable through camera vision, a vision that has now become a part of the artist's vocabulary.

This is a free-wheeling kind of language that in its unvarnished qualities represents a special kind of truth. It has been borrowed by artists from vapid advertising photographs, banal snapshots, and brutal newsphotos. In such imagery there is an element of primitivism that suggests there is a resemblance between the Cubist's reaction to African sculpture and many a contemporary artist's involvement with the photograph. It was not necessary for Picasso to understand the folklore of Africa or the history behind the sculpture to be inspired.

Likewise the painter is often estranged from personal involvement with the subjects of his source photographs. He may take his ideas from a momentarily arrested everyday scene or event in outer space caught by an automatic camera. What provokes an artist's interest cannot be predicted even by himself; and today's photographs are so geared to life that one can learn more from them than from life itself.

NOTES

page ix

Newhall is quoted from "Photography and the Artist," *Parnassus*, vol. 6, no. 5, Oct. 1934, p. 24. His later remarks are quoted from "The Daguerreotype and the Painter," *Magazine of Art*, vol. 42, no. 7, Nov. 1949, pp. 249-51.

Schwarz is quoted from "Art and Photography: Forerunners and Influences," *Magazine of Art*, vol. 42, no. 7, Nov. 1949, pp. 252-57. Scharf's major contribution is *Art and Photography*, London, 1968.

The other relevant books are Jean Adhémar, *Un Siècle de Vision Nouvelle*, Paris, 1955; Otto Stelzer, *Kunst und Photographie*, Munich, 1966; André Vigneau, *Une brève histoire de l'art de Niépce à nos jours*, Paris, 1963; and J. A. Schmoll, *Malerei nach Fotografie*, Munich, 1970.

The three books dealing with artists who have used photographs are Charles W. Millard, *Charles Sheeler, American Photographer*, Washington, D.C., 1968; P. H. Hefting and C. C. G. Quarles van Ufford, *Breitner als fotograaf*, Rotterdam, 1966; and Friedrich Luft, *Mein Photo-Milljoh*, Hannover, Germany, 1967. For a thesis and a dissertation, see Douglas Keller, "Degas' Use of the Photographic Image in His Art," unpublished M.A. thesis, University of Kansas, 1966; and Elizabeth M. Cock, "The Influence of Photography on American Landscape Painting, 1839-1880," unpublished Ph.D. dissertation, New York University, 1967.

page xi

Genauer is quoted from "Painting What the Camera Saw," New York *Herald Tribune*, Oct. 25, 1964, p. 33.

page 3

For general comments on the camera obscura, see Jean-François Revel, "Les instruments d'optique à l'aide des grands maîtres," *Connaissance des Arts*, no. 114, Aug. 1961, pp. 70-77; and Helmut and Alison Gernsheim, *The History of Photography*, New York, 1969, pp. 17-29.

For da Vinci's description of a camera obscura, see *Codex Atlanticus*. MS. is in the Biblioteca Ambrosiana, Milan. For description of the image projected by a camera obscura, see Edward MacCurdy, *The Notebooks of Leonardo da Vinci*, vol. 1, London, 1938, p. 243. Cardano's description was first published in Hieronymus Cardanus, *De Subtilitate Libri xxi*, book 4, Nuremberg, 1550.

Porta's suggestion appears in *Magis Naturalis*, vol. 4, 1558 (Naples edition).

The first description of a lens fitted to a camera obscura is found in Danielo Barbaro, *La Pratica della Perspettiva, Opera molto utile a pittori, scultore ed architetti*, Venice, 1569.

For information on Vermeer's use of a camera obscura, see A. Hyatt Mayor, "The Photographic Eye," *Bulletin of the Metropolitan Museum of Art*, Summer 1946, pp. 15-26; Lawrence Gowing, *Vermeer*, London, 1952; and Ludwig Goldscheider, *Vermeer*, London, 1958. Charles Seymour's comments on Vermeer and the camera obscura are in "Dark Chamber and Light-Filled Room: Vermeer and the Camera Obscura," *Art Bulletin*, vol. 46, Sept. 1964, pp. 323-31. See also Heinrich Schwarz, "Vermeer and the Camera Obscura," *Pantheon*, Munich, May-June 1966; and Daniel A. Fink, "Vermeer's Use of the Camera Obscura—a Comparative Study" to appear in *Art Bulletin*, Dec. 1971.

page 5

Gravesande is quoted from C. A. Jombert, *Méthode pour apprendre le dessein*, Paris, 1755, p. 139.

Regarding the use of the camera obscura by Italian view painters, see Zanetti, *Della pittura Veneziana*, 1777, Venice, p. 77; W. G. Constable, *Canaletto, Giovanni Antonio Canale*, vol. 1, Oxford, 1962, pp. 161-62; Mieczyslaw Wallis, *Canaletto the Painter of Warsaw*, Krakow, 1954, p. 12; H. Allwill Fritzsche, review in *Burlington Magazine*, Feb. 1937; and Francesco Algarotti, *An Essay on Painting Written in Italian*, Glasgow, 1764, pp. 63-64. Camera obscuras were used by both amateur and professional artists. There is in the Science Museum, London, a camera obscura used by Sir Joshua Reynolds; and preserved at Monticello, Thomas Jefferson's home in Virginia, is a camera obscura used by that famous statesman and inventor. Even after the introduction of photography artists found this device useful; for instance, there was a camera obscura included in the inventory of effects of the American painter William Sidney Mount when he died in 1868.

For details of Daguerre's career as a painter, see Helmut and Alison Gernsheim, *L. J. M. Daguerre*, New York, 1956. For reports on the public reaction to photography, see Scharf, *Art and Photography*, op. cit., pp. 7-8. For a further summary of the initial reaction to the introduction of photography, see Erich Stenger, *The March of Photography*, translated by Edward Epstein, London, 1958. Arago's statement is quoted from Stenger, *The March of Photography*, p. 121.

page 7

Delaroche's statement is in a letter he wrote to Arago. The letter is now in the George Eastman House collection.

Morse's statement comes from his letter to a cousin, Feb. 14, 1841, in the Library of Congress collection. His lecture is quoted in part in M. A. Root, *The Camera and the Pencil*, Philadelphia, 1864, pp. 390-92.

Poe's observations appear in "The Daguerreotype," *Alexander's Weekly Messenger*, Jan. 15, 1840, p. 2; also in *Burton's Gentleman's Magazine*, vol. 6, Apr.-May 1840, p. 192.

Cole is quoted from Louis L. Noble, *The Life and Works of Thomas Cole*, edited by Elliot S. Vesell, Cambridge, Mass., 1964, p. 210.

page 9

Delacroix's statement, May 21, 1853, is quoted from Eugène Delacroix, *The Journal*, translated by Walter Pach, New York, 1948, p. 314. Delacroix's mention of Ziégler is found in *The Journal*, Sept. 17, 1850. Durieu's photographs were commented on in *Correspondence*, vol. III, pp. 195-96. Trapp's comments are quoted from F. A. Trapp, "The Art of Delacroix and the Camera's Eye," *Apollo*, vol. 83, no. 50, Apr. 1966, p. 283. Delacroix's essay was written in 1850 and is quoted from Beaumont New-

hall, "Delacroix and Photography," *Magazine of Art*, vol. 48, no. 7, Nov. 1952, p. 300. See Eugène Delacroix, *Oeuvres littéraires*, edited by G. Crès, Paris, 1923, vol. I, p. 16. Notations of Delacroix's posing models appear in Raymond Escholier, *Delacroix, peintre, graveur, écrivain* (3 vols.), vol. III, 1926-29, p. 202. Delacroix's letter of Mar. 7, 1854, to Dutilleux is translated in Newhall, "Delacroix and Photography," from E. Moreau-Nélaton, *Delacroix raconté par lui-même* (2 vols.), vol. II, Paris, 1916, pp. 144-45. See also Van Deren Coke, "Two Delacroix Drawings made from Photographs," *Art Journal*, vol. 12, no. 3, Spring 1962, pp. 172-74.

page 11

Hunt is quoted from Robert Hunt, "Useful Application of Abstract Science," *The Art Journal*, vol. 5, Jan. 1, 1853, p. 14.

The remarks quoted from *The Crayon* appear in the issue of Mar. 14, 1855, p. 170.

Mary Ann Dwight is quoted from her *Introduction to the Study of Art*, New York, 1856, p. 24.

Baudelaire's statements are quoted from "Salon of 1859," *Art in Paris 1845-1862: Salons and other Exhibitions*, translated and edited by Jonathan Mayne, London, 1965, pp. 152-54.

page 12

Gautier on the Paris Salon of 1861 is quoted from *L'Abécédaire du Salon de 1861*, Paris: E. Dentu, 1861, p. 297, translated by Beaumont Newhall in "The Daguerreotype and the Painter," *Magazine of Art*, vol. 42, no. 7, Nov. 1949, p. 251. Gautier on etchings is quoted from *Société des Aquafortistes*, Paris, 1863, in the Preface to F. L. Leipnik, *A History of French Etching From the Sixteenth Century to the Present Day*, London, 1924, p. 106.

The Turner statement is from William Rothenstein, *Men and Memories: Recollections of William Rothenstein*, New York, 1931, p. 318.

Millet is quoted from Julia Cartwright, *Jean-François Millet*, 2nd ed., London, 1902, p. 161.

Gernsheim's statements appear in Helmut Gernsheim, *Creative Photography*, London, 1962, p. 101. See also Gustave Havard, *Les Contemporains*, vol. 8, 1853, noted by Eugène de Mirecourt in his biography of Ingres, p. 24. Ingres' statement to Flandrin and Amaury-Duval was noted in Michel Braive, *The Era of the Photograph*, London, 1966, p. 128. This comment by Ingres appears in another context in earlier publications: George Besson, *La Photographie Française*, 1936; and in Louis Cheronnet, *Petit Musée de la Curiosité Photographique*, 1945.

Courbet's letter in translation appears in Gerstle Mack, *Gustave Courbet*, New York, 1951, p. 126; the complete letter in French is found in Courbet, *Lettres*, p. 52. See also Georges Riat, *Gustave Courbet*, Paris, 1906, p. 124. For further information about Courbet's use of photography, see Scharf, *Art and Photography*, op. cit., pp. 97-104.

Courbet would have been following a normal procedure if he painted the nude for his grand allegorical canvas from a photograph. Translated by W. Griggs from *La Lumière* in 1855 are the following remarks: "When the painter has conceived his picture and is about giving form to his conception, some model is necessary in which he may find the soft outlines of the flesh, the play of muscles, motion, life. Here photography comes forward with its rich resources and presents them to the artist. He may collect together in his portfolio, casts (photos) showing every attitude, every character, every variety of nature. There can be obtained at the present day, special models, male and female, for photographers (to photograph) for artists who purchase these valuable studies." From "Photography and Its Various Applications to the Fine Arts and Sciences," *The Photographic and Fine Art Journal*, June 1855, p. 173.

In 1896 Hector MacLean wrote in England, ". . . it behooves every painter—and especially those whose livelihood depends upon their artwork . . . to seriously ponder each . . . for himself, firstly, whether all things considered, he is likely to arrest the full development of his artistic faculty by leaning upon photographic supports; and secondly, can he afford to travel slowly while the great majority are making free and full use of all the help they can get out of the camera?" Hector MacLean, *Photography for Artists*, London, 1896.

page 13

Baudry is quoted from the introduction to *Le Camp des Bourgeois*.

Courbet did a drawing of Proudhon on his deathbed based on a photograph by Carjat. Although the drawing was made as an illustration for the periodical *La Rue*, it was not published. Courbet is quoted from Gerstle Mack, *Courbet*, New York, 1961, pp. 195-96; see Gaston Delestre, *Gustave Courbet*, Hotel de Ville d'Ornans, 1962, item no. 79.

pages 13-15

Renoir's views appear in Jean Renoir, *Renoir, My Father*, translated by Randolph and Dorothy Weaver, Boston, 1962, p. 178.

page 15

Hartmann's statement is quoted from Sadakichi Hartmann, *The Whistler Book*, Boston, 1910, pp. 163-64.

Moore's comments are quoted from George Moore, *Modern Painting*, London, 1894.

In 1889 the following comments were published regarding the benefits that could be derived from combining the brush with the camera. "Today, open-air photography imbues the artist's work with fresh pulsating life, offering him a thousand valuable hints. . . . The camera now forms an essential part of studio equipment; out of doors it stands next to the painter's easel. If formerly the painter was only active under his sunshade, now he puts his head just as often under the black focussing cloth. In a hundred cases, if you go into a modern painter's studio you will find that the owner is busy in the darkroom. Artists who do not use the camera are in the minority. . . ." Karl Raupp, "Die Photographie in der modernen Kunst," *Die Kunst für Alle*, 1889, p. 325, translated by Helmut Gernsheim in *The History of Photography*, op. cit., p. 433.

page 19

Arago's statement in translation appears in Helmut and Alison Gernsheim, *L. J. M. Daguerre*, op. cit., p. 98. It originally appeared in *Rapport de M. Arago sur le Daguerréotype*, Paris, 1839, p. 50.

For information about Adamson's role in the making of the Hill and Adamson calotypes, see D. B. Thomas, *The First Negatives*, London, 1964.

For Brewster's letter, refer to *The First Negatives*, p. 34.

page 21

Schwarz's opinions are stated in Heinrich Schwarz, "William Etty's 'Self Portrait' in the London National Portrait Gallery," *The Art Quarterly*, Winter 1958, p. 391.

Fuller is quoted from Agnes A. Fuller, *George Fuller, His Life and Works*, New York, 1886, p. 14.

The note on miniature painting is from the *Home Journal*, as reported in *The Crayon*, vol. 4, 1857, p. 44.

The quote ". . . like a bird before a snake . . ." is from Harry B. Wehle, *American Miniatures*, New York, 1937, p. 69.

page 22

Tuckerman's comments are quoted from Henry Tuckerman, *Book of the Artists*, New York, 1867, p. 398.

For a thorough analysis of the role of Holgrave, see Alfred H. Marks, "Hawthorne's Daguerreotypist: Scientist, Artist, Reformer," *Ball State Teacher's College Forum*, vol. III, Spring 1962, pp. 61-74.

The remarks about the frankness of the lens are quoted from *The Living Age*, vol. 9, 1846, p. 551. The article is one reprinted from the *Christian Watchman*, probably of the same year.

Emerson is quoted from his *Journals, 1841-1844*, Boston, 1911, pp. 110-11.

The Southworth and Hawes daguerreotype of William Henry Harrison's likeness which seems to have served Albert Hoyt as an inspiration for his portrait of the President could possibly be a photograph of a lost painting.

page 25

Brady to Morse comments appear in an unpublished letter in the J. Pierpont Morgan Library, New York.

page 27

Fairman's comments are quoted from Charles E. Fairman, *Art and Artists of the Capitol of the United States*, Washington, D.C., 1927, p. 294.

For information on Sully's use of photographs, see Edward Biddle and Mantle Fielding, *The Life and Works of Thomas Sully*, Philadelphia, 1921. Listed are a number of portraits painted from photographs; among them: Mr. Barber, 1853, deceased, from a daguerreotype; Mrs. Barber, 1855, from a daguerreotype; Mrs. Black, 1862, deceased, from a photograph; Mr. Brattle, 1855, deceased, from a daguerreotype; Miss Dobbin, 1854, from a daguerreotype; Miss Eastman, 1869, from a daguerreotype; Empress Eugénie, 1863, from a photograph; Mr. Freland, 1856, from a daguerreotype; Charlotte Godey, 1847, deceased, from a daguerreotype; Dr. Thomas Hodgkins, 1858, from a photograph; Mrs. Anna Blackwood Howell, 1855, from a daguerreotype; Mrs. Kingsby, 1859, from a daguerreotype; Miss Link, 1856, from a daguerreotype; Mr. Lockwood, 1850, from a daguerreotype; Señor Henzenga Messchert, 1871, from a daguerreotype; Mrs. Picot, from a photograph; Gioachino Antonio Rossini, 1863, from a daguerreotype; Mrs. Charles Shields, 1854, from a calotype; Alfred and Manuella Sully, 1851, from a daguerreotype; Mr. Triechel, 1849, from a daguerreotype; Daniel Basriel Warner (Negro President of Liberia), 1864, from a photograph.

page 28

For details of Carpenter's life as a photographer, see Francis Carpenter, *Six Months at the White House*, New York, 1866.

Lincoln's early opponent Stephen Douglas was the subject of a number of portraits, some of which are from photographs; see Robert Taft, "The Appearance and Personality of Stephen A. Douglas," *Kansas Historical Quarterly*, vol. 21, 1954, pp. 8-33.

page 33

Not only did the 1864 Brady studio picture serve Eaton as a source for a painted likeness of Lincoln but the same photograph was used by Victor D. Brenner when he modeled the President's features for the long-serving 1-cent piece.

The Newberry Library, Chicago, has in its collection a seated portrait of U. S. Grant by Healy that is almost identical to Healy's portrait of Grant in *The Peacemakers*. For another picture of General U. S. Grant from photographs, see James R. Lambdin's portrait reproduced in Van Deren Coke, "Camera and Canvas," *Art in America*, vol. 49, no. 3, 1961, p. 69.

page 35

For details about *The Arch of Titus*, see William H. Gerdts, "Church, Healy, McEntee: The Arch of Titus," *The Museum*, Newark, N.J., vol. 10, no. 1, Winter 1958, pp. 18-20.

Healy's profile, head-and-shoulder portrait of Franklin Pierce in the collection of the New Hampshire Historical Society, Concord, seems to be from a Southworth and Hawes daguerreotype in the George Eastman House collection.

page 39

For comments on the use in Italy of photographs by painters, see Bernardo Celentano, *Due settennii nella pittura*, Rome, 1883, p. 255.

Page is quoted from Joshua C. Taylor, *William Page, The American Titian*, Chicago, 1957, p. 225.

page 41

For other examples of the use of daguerreotypes as models for paintings of prominent Americans, see Andrew Oliver, *Portraits of John Quincy Adams and his Wife*, Cambridge, Mass., 1970, pp. 300-01; here are reproduced two oil paintings and an engraving of John Quincy Adams that were based on daguerreotypes by Messrs. Bishop and Gray, Utica, N. Y., photographers. The daguerreotypes are now in the collection of the National Portrait Gallery, Washington, D. C.

For other portraits of Webster from photographs, note the following quotations:

"There are two pictures of Webster sitting against a tree, wearing one of his favorite big soft hats. One faces to the right and is called *Webster at Marshfield*, by Healy, and the other faces to the left and is called *Webster at Franklin*, by Ames. This is surely the Barnum show of 'pay your money and take your choice;' for both have evi-

dently been copied, with some variations, from the same original, and what apparently is a daguerreotype."

Chester Harding painted a portrait of Daniel Webster for Samuel Bexter Bradford of Boston at New Bedford, Massachusetts in 1845, immediately after the famous statesman's return from his second term in the Senate.

"Another identical portrait was owned by Mr. W. W. Scranton of Scranton, Pennsylvania. 'Painted for Webster's 2nd wife,' a duplicate of this is given in the published proceedings of the Webster Centennial at Marshfield in 1882 by the Webster Historical Society. The inscription reads 'From a daguerreotype taken at Franklin, New Hampshire, July 1852 and presented to Stephen M. Allen by Mr. Webster. The last picture from life taken of Mr. Webster.' " "Life Portraits of Daniel Webster," McClure's Magazine, vol. 9, May-Oct. 1897, p. 624.

page 45

Hacker is quoted from Inge Hacker, "Discovery of a Prodigy," *Bulletin, Museum of Fine Arts, Boston*, vol. 61, no. 323, 1963, p. 29.

Winslow Homer's later interest in photography is discussed briefly in Philip Beam, *Winslow Homer at Prout's Neck*, Boston, 1966, pp. 74-76.

Eakins painted a number of portraits from photographs including a portrait of his mother in 1874. This was painted from a daguerreotype after her death. See Lloyd Goodrich, *Thomas Eakins: His Life and Work*, New York, 1933, p. 4. In *McClure's Magazine* there are references to Eakins using photographs when sculpting horses for the Memorial Arch in Prospect Park, Brooklyn. In the same article it is noted that Eakins used War Department photographs taken by Brady's studio when painting likenesses of Lincoln and Grant. Goodrich in his biography of Eakins also notes that the artist went to West Point and made photographs of the cadets (on horseback) to serve as studies for the Memorial Arch commission, p. 107; see also vol. 5, no. 5, October 1895, p. 422.

J. Laurie Wallace, who was a fashionable portrait painter of Omaha, Neb., in the 1890s, had been a student of Thomas Eakins and the subject of several of his photographs. Wallace, like Eakins, often used photographs as a basis for his paintings.

page 47

Duchamp-Villon was not the first well-known sculptor to use a photograph as an inspiration. Rodin's commemorative bust of Victor Hugo was done from photographs as was Bourdelle's bust of the Polish poet Adam Mickiewicz.

page 49

Schwarz is quoted from Heinrich Schwarz, "Daumier, Gill and Nadar," *Gazette des Beaux-Arts*, vol. 49, 1957, pp. 89-106.

There are two daguerreotypes of Balzac in the pose reproduced. One is the reverse of the other. One is in the Bibliothèque Lovenjoul, Chantilly, and the other is in Musée de la Maison de Balzac, Paris.

Richardson is quoted from John Richardson, *Édouard Manet: Paintings and Drawings*, London, 1958, p. 20. Manet used a photograph in at least one instance as a means of developing one of his paintings into an etching. The etching created in this fashion was from *Printemps*, a canvas of 1884. Alain De Leiris outlined in his Ph.D. thesis the steps taken in this case, "A photograph was made of the original painting. This was printed in reverse on very thin paper. Since the back side was to receive a drawing it was coated by some kind of glue size in order to prevent blotting. The photograph was then arranged so that the light could pass through the mechanical image (photograph), this was then traced with pen and chinese ink. Size: 12-5/16 x 8-3/8 inches. The process was then to photograph this and reduce it to the size of approximately 6 x 4-1/4 inches. This was done to retain the spirit and proportion of the original. How often this was done by Manet and other artists we do not know." Alain De Leiris, "The Drawings of Édouard Manet, A Factual and Stylistic Evaluation," unpublished Ph.D. thesis, Harvard University, 1957.

Bernard is quoted in Jean Vallery-Radot, Introduction to *Un Siècle de Vision Nouvelle*, Paris, 1955, p. 5. For comments on Cézanne's portraits, see Sara Lichtenstein in *Master Drawings*, vol. 4, 1966. Miss Lichtenstein has pointed out that Cézanne worked from two (c1857) Durieu photographs when drawing Delacroix's head. The Cézanne portrait of Delacroix in the Musée Calvert Avignon is certainly a free interpretation of the Durieu photograph. The link between the sketch of Delacroix in the Offentliche Kunstsammlung, Basel, and the photograph made by Durieu is easier to see.

See also John Rewald, "Chocquet and Cézanne," *Gazette des Beaux-Arts*, ser. 6, vol. 74, July-Aug. 1969, pp. 33-96.

page 50

For a reproduction of the photograph by Rupert Potter used by Millais to assist him when painting the drummer boy for *An Idyll*, see Mary Bennett, "Footnotes to the Millais Exhibition," *The Liverpool Libraries, Museums and Arts Committee Bulletin*, vol. 12, 1967, p. 59. I am indebted to Mary Bennett, Keeper of British Art, Walker Art Gallery, Liverpool, for information regarding Millais' use of photographs. Millais is recorded in Beatrix Potter's diary as saying in 1884, "All artists use photographs now." See Beatrix Potter, *The Journal of Beatrix Potter from 1881-1897*, transcribed from her writings by Leslie Linder, London, 1966.

In the last half of the nineteenth century many other English artists made use of photographs.

See David Loshak, "G. F. Watts and Ellen Terry," *Burlington Magazine*, vol. 105, no. 728, Nov. 1963, pp. 476-85; and Mrs. Russell Barrington, *The Life, Letters and Works of Frederick Leighton*, London, 1906, vol. 1, p. 205, in which is found the comment that artists like Watts used photographs intelligently but many did so unintelligently.

Another prominent English academic painter who relied on photographs was Alma-Tadema. There is in the library at the University of Birmingham a large collection of photographs bought as studies for paintings. He often used photographs of accesso-

ries and architecture to achieve a sense of authenticity when painting classic subjects. For instance, the sphinx in *The Bath* and the lamp in *At Lesbia's* were transcribed from photographs.

See also Jeremy Maas, *Victorian Painters*, London, 1969, for a perceptive chapter on the use of photographs by prominent English Victorian artists. Of particular interest is Maas' chapter, "The Effect of Photography," in which he links a photograph of Carlyle with Maddox Brown's famous painting *Work* and comments on John Brett's use of photography.

pages 50-53

Von Herkomer is quoted from Hubert von Herkomer, "Franz von Lenbach: An Appreciation," *The Studio*, vol. 34, no. 153, Dec. 1905, p. 195. For information on the use of photographs by Lenbach and Stuck, see J. A. Schmoll, *Fotografische Bildnisstudien zu Gemälden von Lenbach und Stuck*, Essen, 1969; and J. A. Schmoll, *Malerei nach Fotografie*, op. cit. For an early reference to Lenbach's projecting photographs on canvas, see Karl Raupp, *Die Kunst für Alle*, op. cit., p. 325.

page 55

See Jean S. Boggs, *Portraits by Degas*, Berkeley and Los Angeles, 1962, p. 16; and Jean S. Boggs, *An Exhibition of Works by Edgar Hilaire Germain Degas*, Los Angeles, 1958, p. 29.

The Tannenbaum quote is from her letter to the author, May 1964. See also Libby Tannenbaum, *James Ensor*, New York, 1951, pp. 78ff.

Self-portraits with symbols of death seem to have been rather popular in the last quarter of the nineteenth century. Among others there is Arnold Bocklin's *Self-Portrait with Death as a Fiddler*, 1872, and Louis Corinth's *Self-Portrait with the Image of Death*, 1896.

pages 55-57

The comment about van Gogh is found in Walter Pach, *Vincent Van Gogh*, New York, 1936, p. 20.

For reproduction of Gauguin's portrait of his mother, see André Leclerc, *Gauguin*, New York, n.d., p. 7. I am indebted to the distinguished anthropologist Bengt Danielsson for information about Gauguin's use of photographs in the South Pacific.

pages 61-63

Mucha is quoted from Jiri Mucha, "Alfonse Mucha," *CAMERA*, no. 11, Nov. 1969, pp. 18, 23, 63.

page 63

For further details of Steichen's portrait of Morgan, see Carl Sandburg, *Steichen the Photographer*, New York, 1929, pp. 5-7.

Regarding Picasso's use of photographs there are indications that as early as 1909 Picasso made photographs and used data taken from them in his drawings. Picasso's friend Elliott Paul included in an article published in 1928 in the magazine *Transition* a photograph of the village Horta de Ebro that seems to have been the inspiration for the painter's *Maison sur la Colline*, 1909.

page 67

Kantor is quoted from his letter to the author, May 1964.

page 71

Elaine de Kooning is quoted from her letter to the author, May 1964.

page 73

Warhol first used silk-screened photographic imagery in 1962. Using this technique, he reproduced on canvas a photograph of the film actor Troy Donahue. For reproductions of other Warhols created in this fashion, see Rainer Crone, *Andy Warhol*, New York, 1970.

page 75

Close is quoted from Cindy Nemser, "An Interview with Chuck Close," *Artforum*, vol. 8, no. 5, Jan. 1970, pp. 51-55.

page 79

Rejlander is quoted from Helmut Gernsheim, *The History of Photography*, op. cit. p. 246. The comment regarding Rejlander's photographs is found in O. G. Rejlander, "On Photographic Composition," *The Liverpool and Manchester Photographic Journal*, Liverpool, vol. II, no. 8, Apr. 15, 1858, pp. 94-95.

Sutton is quoted from T. Sutton, "On Some of the Uses and Abuses of Photography," *Photographic Notes*, vol. 8, 1863, p. 16.

For further information on the use of photographs by British painters, see Helmut Gernsheim, *Masterpieces of Victorian Photography*, London, 1951, p. 11. For quotes about Frith, see Nevile Wallis, *A Victorian Canvas: Memoirs of W. P. Frith*, London, 1957.

page 81

Rossetti is quoted from *Dante Gabriel Rossetti: His Family Letters*, with a Memoir by William Michael Rossetti, Boston, vol. 2, 1865, p. 172.

For further details about Nègre, see André Jammes, *Charles Nègre Photographe 1820-1880*, Paris, 1963.

Scharf in his *Art and Photography* discusses at length Manet's use of photographs for his painting of *The Execution of the Emperor Maximilian*, pp. 42-49.

The statement about Degas' use of a photograph in painting *Carriage at the Races* is based on a letter to the author from Dr. Heinrich Schwarz, March 1957, in which he said, "Degas' painting, *Course en Province* [another title for *Carriage at the Races*], 1873, in the Boston Museum is based on information which I owe to Charles Sterling who, in turn had learned from Alexis Rouart, son of Degas' intimate friend Henri Rouart (died 1912), that Degas himself had told his father the painting derived from a photograph."

page 83

Cabanne's statement is found in Pierre Cabanne, *Edgar Degas*, translated by Michel Lee Landa, New York, 1958, p. 29. Additional evidence that Degas used photographs as studies may be found in the Philadelphia Museum's 1932 exhibition catalog on Degas, with an Introduction by Agnes Mongan, p. 52: "The following photographs were found in Degas' studio and were presumably taken by the artist himself or under his direction." These included two photographs of women ironing, one of

cliffs by the beach, and one of trees by a road.

Regarding Tissot's use of photographs, see Henri Zerner, David S. Brooks, and Michael Wentworth, *James Jacques Joseph Tissot*, Providence, R.I., 1968.

pages 83-85

For reproductions of the photographs Eakins used as studies for *Drawing the Seine* and *Hauling the Seine*, see Gordon Hendricks, *Thomas Eakins: His Photographic Works*, Philadelphia, 1969, pp. 51, 53.

pages 86-89

Robinson is quoted from John I. H. Baur, "Photographic Studies by an Impressionist," *Gazette des Beaux-Arts*, vol. 30, Oct.-Nov.-Dec. 1946. For further details about Robinson's use of photographs, see John I. H. Baur, *Theodore Robinson, 1852-1896*, Brooklyn, 1946. There is much evidence that Robinson was not exaggerating when he commented that the use of photographs by painters was "in the air."

For example Édouard Detaille, the late-nineteenth-century genre French painter, used photographs extensively as studies for his paintings of Napoleon's campaigns. André Jammes has in his collection in Paris photographs by Atget that were used by Detaille to paint more accurately the ruts worn by wheeled vehicles on country roads. Detaille also used posed pictures made as studies for specific compositions. One is of two men dressed in military uniform posing beside large wheels. They were photographed to show the position taken by men when pushing cannon wheels out of mud. Another shows a drummer boy in Napoleonic costume posed on top of a box. He was photographed from below to serve as a model for the part of a painting that portrays a drummer boy coming over a hill toward the viewer. The late-nineteenth-century Italian painter F. P. Michetti was an enthusiastic photographer. He often paraphrased in paint his photographs of people posed especially to fit into his painted compositions. See Carlo Bertelli, "Le Fotografie di F. P. Michetti," *Musei E Gallerie D'Italia*, no. 36, Sept.-Dec. 1968.

pages 89-91

Regarding Khnopff's paintings, see Francine-Claire Legrand, "Fernand Khnopff—Perfect Symbolist," *Apollo*, vol. 85, no. 62, Apr. 1967, pp. 278-87.

page 91

Gauguin frequently worked from ready-made imagery. See Bernard Dorival, "Sources of Art of Gauguin from Java, Egypt, and Ancient Greece," *Burlington Magazine*, vol. 93, Apr. 1951, pp. 118-23.

Lautrec is quoted from Gerstle Mack, *Toulouse-Lautrec*, New York, 1942, p. 356. For another source of information about Toulouse-Lautrec's use of photographs, see François Daulte, "Plus vrai que nature," *L'Oeil*, Oct. 1960.

page 95

Derain is quoted from Sam Hunter, *Modern French Painting*, New York, 1956, p. 131.

Man Ray is quoted from Man Ray, *Self-Portrait*, London, 1963, p. 221.

page 97

For reproductions of Rousseau's drawing of himself as a young man and the photograph he copied, see Roger Shattuck, *The Banquet Years*, New York, 1961, plate IV. For reproductions of *The Cart of Père Juniet* and the photograph Rousseau used, see Dora Vallier, *Henri Rousseau*, New York, 1964, plates 156-57.

page 99

Lillian Browse is quoted from *Sickert*, London, 1960, p. 48. Wilenski is quoted from Lillian Browse, *Sickert*, with an essay by R. H. Wilenski, London, 1943, p. 31.

page 102

Another well-known painter of the American West who used photographs as a guide was Henry Farny. See Robert Taft, "Henry F. Farny," *Kansas Historical Quarterly*, vol. 16, Feb. 1950, p. 28.

page 107

I wish to express my appreciation to Mrs. Gladys Hansen, Senior Librarian, Department of Rare Books & Special Collections, San Francisco Public Library, for searching out the Mooney photographs.

Reginald Marsh, Ben Shahn's contemporary, took many photographs in the Bowery and on Coney Island. These served as notes for many of Marsh's lively figure paintings. No study has been made as yet of the extent Marsh used his photographs for his own paintings.

For a reproduction of Shahn's mural, in which he incorporated jumping basketball players taken from photographs, see Cecil Beaton, *Cecil Beaton's New York*, London, 1938, p. 200.

Shahn is quoted in a caption to one of his photographs in "Photos for Art," *U.S. Camera*, vol. 9, no. 4, May 1946, p. 31.

Shahn is quoted from Selden Rodman, *Portrait of the Artist as an American*, New York, 1951, p. 93.

page 109

The child on crutches in Shahn's mural is probably from Henri Cartier-Bresson's *Child Playing in Ruins of Seville*, 1937. See Rodman, *Portrait of the Artist as an American*, for reproductions of this painting and other examples of Shahn's use of photographs. For early comments on Shahn's use of photographs in his paintings, see also Jean Charlot's article in *Hound and Horn*, July-Sept. 1933.

For additional examples of Cloar's use of photographs, see "Catalogue of Paintings by Carroll Cloar," *Burrow Library Monograph*, No. 6, Southwestern at Memphis University, Memphis, 1963. See also Sidney Tillim, *Carroll Cloar*, Art Gallery, SUNY Albany, 1968.

The famous illustrator Norman Rockwell has long depended on photographs to capture gestures in a convincing fashion. See *Norman Rockwell Illustrator*, Marion, Ohio, 1970.

For a good example of the use to which illustrators have put photographs, see John Grath, "The Artist and the Camera," *U.S. Camera World Annual, 1968*, New York, 1967, pp. 28-32.

George Pratt, the film historian, has pointed out that Picasso seems to have been aware of a still from Eisenstein's film *Battleship Potemkin* when drawing for *Guernicá* the figure of the woman carrying the dead child, whose head hangs upside

down. See plate 92 in Beaumont Newhall, *Photography: A Short Critical History*, New York, 1937, for reproduction of this still.

pages 111-12

Lebrun is quoted from *Rico Lebrun Drawings*, Foreword by James Thrall Soby, Berkeley, c1961, p. 18.

For Durgnat's complete article, see Raymond Durgnat, "Fake, Fiddle and the Photographic Arts," *The British Journal of Aesthetics*, vol. 5, no. 3, July 1965, p. 277.

Greene is quoted from his letter to the author, Mar. 1964.

pages 112-13

The major biography on Bacon is John Rothenstein and Roland Alley, *Francis Bacon*, London, 1964.

Regarding the influence of film imagery on painting, Fernand Léger said in 1931, "These new instruments [cameras] have given us a new outlook. The close-up of the cinema is the consecration of this new manner of looking at things." Quoted in James Johnson Sweeney, "Léger and the cult of the close-up," *The Arts*, vol. 18, no. 8, May 1931, p. 563.

Sam Hunter was the first person to call my attention to Bacon's reliance on photographs.

page 117

Bacon is quoted from a conversation between Francis Bacon and David Sylvester, broadcast by the BBC, Oct. 21, 1962, and published under the title "The Art of the Impossible" in full in the London *Sunday Times Magazine*, July 14, 1963, and in part in *Creative Camera*, Dec. 1968, p. 442. For further comments on Bacon's use of photographs, see John Russell, *Francis Bacon*, Greenwich, Conn., 1971.

page 118

Bruder is quoted from his letter to the author, May 1964.

page 121

Flack is quoted from Oriole Farb, *Paintings from the Photo*, Riverside Museum, New York, 1969, p. 9.

Souza is quoted from Mervyn Levy, "F.

N. Souza, the human and the divine," *Studio International*, vol. 167, no. 852, Apr. 1964, p. 136.

page 123

O'Dowd is quoted from his letter to the author, Mar. 1964.

page 125

Drexler is quoted from his letter to the author, July 1964.

pages 125-29

Kitaj is quoted from his letter to the author, Jan. 1964.

page 129

Strombotne is quoted from his letter to the author, May 1964.

See David Duncan, *The Private World of Pablo Picasso*, New York, 1958, pp. 120, 127.

page 130

De Kooning is quoted from her letter to the author, Mar. 1970.

Gill is quoted from his letter to the author, Mar. 1963.

pages 135-37

Lanyon is quoted from her letter to the author, Aug. 1963.

page 137

Hogan is quoted from his letter to the author, Nov. 1969.

page 139

Blizzard is quoted from his letter to the author, Jan. 1964.

Everett is quoted from his letter to the author, Oct. 1963.

pages 141-43

Laing is quoted from his letter to the author, May 1969, and from the notebook he kept during 1964-68.

page 143

Levine is quoted from his letter to the author, Dec. 1967.

Andy Warhol made photo-screened images on canvas of the confrontation between the police and the blacks in Birmingham in 1963. Warhol's pictures were collectively titled *Race Riot*.

The quotation about Breeze's painting is

from Barry Lord, "Sunday Afternoon," *Artscanada* (formerly *Canadian Art*), no. 104, Jan. 1967, p. 13.

page 145

For comments on the use of photographs by printmakers, see Jacob Kainen, *Photography in Printmaking*, New York, 1968; and Van Deren Coke, "Photo/Graphics," *Image*, vol. 14, no. 2, June 1971. The quote about Kanovitz is from "Realer than Real," *Time*, Aug. 16, 1968, p. 44. See also B. H. Friedman, "Focus as Physical Reality," *Art News*, vol. 63, no. 6, Oct. 1966, pp. 47-49.

Alloway is quoted from the checklist for the exhibition "The Photographic Image," Guggenheim Museum, New York, 1966.

page 147

Raffael is quoted from Oriole Farb, *Paintings from the Photo*, op. cit., p. 10.

For comments on Pistoletto's work, see Sidney Simon, "Michelangelo Pistoletto," *Art International*, vol. 10, no. 6, 1966, pp. 69-71; and Martin Friedman, *Michelangelo Pistoletto: A Reflected World*, Minneapolis, 1966, which includes a selected bibliography.

page 149

For comments on Genovés' work, see José L. Castillejo, "Photographic Realism: On the Painting of Juan Genovés," *Art International*, vol. 10, no. 6, Summer 1966, pp. 34-39. See also *Genovés* catalog, Marlborough-Gerson Gallery, New York, 1967.

The American artist Jack Nims, among others, is using the technique of posing models to be photographed so as to resemble famous paintings out of the past. He then has the photographic imagery enlarged to billboard size. His *Homage to Piero*, shown at the Whitney Museum in New York in 1971, is a good example.

page 151

For comments on Spadari's work, see *Spadari*, Galleria Schwarz, Milan, 1970.

The title of Léger's painting is *The Builders* [of the Revolution].

page 155

In the *Philadelphia Photographer* (vol. 16, Jan. 1879, p. 22) a notice was published

describing firsthand a group of photographs of horses in motion made by Muybridge.

pages 155-56

Meissonier recollected his meeting with Stanford as follows: "Meanwhile, towards the autumn, some American dealer, I have forgotten which, brought a certain Mr. Leland Stanford, a former governor of California, and his wife, to my studio. He asked me to paint her portrait. My first impulse, of course, was to refuse, but he began to talk about the photographs of horses in motion, and said they were his. He had even spent 100,000 dollars on the work, so a friend who was with him said, and the photos which had reached Europe were a mere nothing. He had hundreds of others, far more interesting, not merely of horses in motion, but of oxen, stags, dogs and men. He had photos of these last fighting, wrestling, jumping from the trapeze, etc." Meissonier is quoted from Vallery C. O. Gréard, *Meissonier*, translated by Loyd and Simmonds, London, 1897, p. 211.

page 156

Marey is quoted from Aaron Scharf, *Art and Photography*, op. cit., p. 166.

The quote about Eakins' painting *A May Morning in the Park* is from *The Philadelphia North American*, Nov. 19, 1880.

pages 156-58

Pennell is quoted from a talk he made to the London Camera Club, later published in the *British Journal of Photography*, 1891, p. 677.

pages 158-59

Dr. Stillman is quoted from George E. Waring, "The Horse in Motion," *The Century*, vol. 24, no. 11, May-Oct. 1882, pp. 386-88.

page 159

Valéry is quoted from Paul Valéry, *Degas Danse, Dessin*, Paris, 1965, p. 79. For reproductions and comments on Degas' drawings of horses from photographs, see Paul André Lemoisne, *Degas et son oeuvre* (4 vols.), Paris, 1946.

page 160

Valéry, *Degas Danse, Dessin*, op. cit.

page 165

Scharf's comments appear in his *Art and Photography*, op. cit., p. 177. See E. J. Marey, *Développement de la Méthode Graphique par l'Emploi de la Photographie*, Paris, 1884. See also W. I. Homer and Aaron Scharf, "Concerning Muybridge, Marey and Seurat," *The Burlington Magazine*, vol. 104, Sept. 1962, pp. 391-92. Duchamp wrote the author in Dec. 1963 that he had been influenced by Marey's chronophotographs of fencers. For further illustrations of the influence of Marey's photographs, see Otto Stelzer, *Kunst und Photographie*, op. cit., il. no. 104, p. 108.

pages 165-66

For the influence of photography on Futurism, see Aaron Scharf, "Futurism—States of Mind + States of Matter," *Studio*, vol. 173, no. 889, May 1967, pp. 244-49.

For further comments on the Bragaglias, see Piero Racanicchi, "Fotodinamismo Futurista," *Popular Photography Italiana*, no. 67, Jan. 1963, p. 47.

pages 170-71

See Dario Micacchi, *Franco Mulas*, Il Torcoliere-Galleria e Stamperia d'Arte, Rome, 1968.

page 173

Steg is quoted from his letter to the author, Mar. 1968.

Most artists today know of Muybridge's pictures from seeing *The Human Figure in Motion*, Introduction by Robert Taft, Dover, New York, 1955.

pages 173-75

Blizzard is quoted from his letter to the author, Feb. 1969. For another Bignardi after Muybridge *(Man Running,)* see *Art International*, vol. 10, no. 6, Summer 1966, p. 99.

pages 175-77

Shaw is quoted from his letter to the author, Aug. 1965.

Williams' quote is based on his statement to the author, May 1961.

page 181

Dickens(?) is quoted from Charles Dickens(?), "Photography," *Household Words*, vol. 7, 1853, p. 59.

Peale is quoted from Rembrandt Peale, "Portraiture," *The Crayon*, vol. 4, 1857, p. 45. The 1857 comments on distortion are quoted from "Photography," *Harper's Weekly*, vol. 1, no. 42, Oct. 17, 1857, p. 659.

page 183

Nadar's lithograph *Le Frileux* is from his "Jury au Salon de 1859," *Journal amusant*, June 4, 1859, p. 6.

page 187

Charlot is quoted from *The Daybooks of Edward Weston*, vol. 1, edited by Nancy Newhall, Rochester, N.Y., 1962, p. 57. For reproductions of Tchelitchew's work which seems related to photography, see Parker Tyler, *The Divine Comedy of Pavel Tchelitchew; a biography*, New York, 1967, pp. 186-87.

page 191

Calotypes as well as daguerreotypes served as studies for landscapists. D. O. Hill not only painted portraits from calotypes but also used them as a guide when painting landscapes. See Katherine Michaelson, *A Centenary Exhibition of the Work of David Octavius Hill 1802-1870 and Robert Adamson 1821-1848*, Edinburgh, 1970, pp. 30, 50. She records the fact that Hill painted from calotype studies the foreground figures in his *Edinburgh Old and New from the Castle* and the general panoramic view of the city. Talbot is quoted from Henry Fox Talbot, *Some Account of the Art of Photogenic Drawing or the Process by Which Natural Objects May be Made to Delineate Themselves without the Aid of the Artist's Pencil*, London, 1839, p. 11.

Delaroche is quoted from the *Bulletin de la Société Française de Photographie*, Apr. 1930, pp. 115-16, translated by Beaumont Newhall in *Image*, vol. 11, no. 6, 1962, p. 26.

"Jammed opticians' shops . . ." is quoted from M. A. Gaudin, *Traité pratique de photographie*, Paris, 1844, p. 7.

page 193

Charles Daubigny, one of the most prominent Barbizon painters, etched a landscape from a daguerreotype for Lerebours' *Excursions Daguerriennes*, vol. 2, Paris, 1843. The marine painter Eugène Isabey bought, presumably as studies, the unusual daguerreotypes by Hippolyte Macaire of Le Havre, who was able to photograph seascapes showing waves in action and steamships with smoke coming out of their funnels. This is based on information found in Baron Gros, *Quelque Notes sur la Photographie*, Paris, Jan. 1850. See also "Héliographie sur Plaques: Épreuves Instantanées," *La Lumière*, no. 58, Oct. 1851, pp. 1, 139.

Concerning L. Marquier's lithographs, see Beaumont Newhall and Robert Doty, "The Value of Photography to the Artist, 1839," *Image*, vol. 11, no. 6, 1962.

page 195

Henri Le Secq's comments about Corot's drawings appear in Ernest Lacan, *Esquisses Photographiques*, Paris, 1856.

Wilenski is quoted from R. H. Wilenski, *The Modern Movement in Art*, London, 1935, p. 95.

Arago when speaking to the French Academy of Sciences in 1839 about the characteristics of the daguerreotype process noted that for recording moving objects the process was inadequate. He said, "The foliage of trees [in a daguerreotype], always being more or less agitated by the air, is often but imperfectly represented." *The* [London] *Athenaeum*, no. 587, Jan. 26, 1839, p. 69.

For Scharf's comments about Corot's association with photographers, see Aaron Scharf, "Camille Corot and Landscape Photography," *Gazette des Beaux-Arts*, vol. 59, Feb. 1962, pp. 99-102.

page 196

Méryon is quoted from Philippe Burty, *Charles Méryon*, translated by Marcus B. Huish, London, 1879, p. 18. Méryon also etched some portraits from photographs: a printer named Guerand; Louis Bezeul, the

Breton archaeologist; and a man named Benjamin Fellon.

In regard to his picture of Benjamin Fellon, Méryon said, "I have made it after a good photograph which I have most faithfully reproduced, apart from a few slight modifications which I introduced in order to accentuate certain characteristics so as to make the face more interesting." Loys Delteil, *Charles Méryon*, translated by G. J. Renier, London, 1928, p. 39.

page 197

Stevens is quoted from Isaac L. Stevens, *Narrative and Final Report of Explorations for a Pacific Railway* (2 vols.), Washington, D.C., vol. 1, 1853, p. 87; see also p. 103.

Josiah Gregg, a friend of Stanley, suggested that the painter had a knowledge of photography as early as 1846. See *Diary and Letters of Josiah Gregg*, edited by M. G. Fulton, Norman, Okla., 1941, pp. 181-88.

Mary Eastman is quoted from Mary Eastman, *Dahcotah; or, The Life and Legends of the Sioux around Fort Snelling*, New York, 1849, p. xiv.

pages 197-99

Bierstadt is quoted from *The Crayon*, Sept. 1859, p. 277.

For an informative exposition of Bierstadt's use of photographs, see Elizabeth Lindquist-Cock, "Stereoscopic Photography and the Western Paintings of Albert Bierstadt," *The Art Quarterly*, vol. 23, no. 4, Winter 1970, pp. 361-78. *The Crayon* (Nov. 1859, p. 349) reported, "Bierstadt has returned from the Rocky Mountains to New Bedford, and has brought with him much material in sketches, photographs, and stereoscopic views."

page 199

Cornelius is quoted from Brother Cornelius, *Keith, Old Master of California*, New York, 1942, p. 78.

The American landscape painter Fitz Hugh Lane, in at least one instance, worked from a surviving photograph. He squared off a photograph of the side-wheel steamer "Harvest Moon" so that it could be included in his drawing *Looking up Portland Harbor*. Both the photograph and the drawing

are in the collection of the Cape Ann Historical Association. For an illustration of the photograph and drawing, see Barbara Novak, *American Painting of the Nineteenth Century*, New York, 1969, p. 118.

page 203

For further information on Church's use of photographs, see Elizabeth M. Cock, "The Influence of Photography on American Landscape Painting, 1839-1880," op. cit.

page 204

Wilenski is quoted from his letter to the author, June 1958.

A note about Dyce's use of photographs is found in Allen Staley, "William Dyce and Outdoor Naturalism," *Burlington Magazine*, vol. 105, no. 728, Nov. 1963, pp. 470-76.

page 205

Millais is quoted from John Guille Millais, *The Life and Letters of Sir John Everett Millais*, London, 1905, p. 310.

Hamerton is quoted from Philip Gilbert Hamerton, *Thoughts About Art*, Boston, 1871, p. 123.

page 207

For comments on Degas' use of photographs as models for landscapes, see Pierre Cabanne, *Edgar Degas*, op. cit. As noted in Scharf, *Art and Photography*, p. 147, Cocteau said he knew Degas colored photographs of landscapes with pastels. See Jean Cocteau, *Le Secret Professional*, Paris, 1922.

Emerson is quoted from P. H. Emerson, *Naturalistic Photography*, New York, 1899, p. 12.

Mayor is quoted from A. Hyatt Mayor, "The World of Atget," *The Metropolitan Museum of Art Bulletin*, vol. 10, no. 6, p. 170.

page 209

Blanche is quoted from Jacques-Émile Blanche, *Portraits of a Lifetime*, New York, 1938, p. 48.

For further comments on the use of photographs by Utrillo, see Ronald Alley, "Notes on Some Works by Degas, Utrillo and Chagall in the Tate Gallery," *Burlington Magazine*, vol. 100, no. 662, May 1958, p. 171.

page 211

There is in addition to the oil by Delaunay a lithograph of the Eiffel Tower taken from the same photograph. See Joseph Delteil, *Allô Paris*, Paris, 1926. I am indebted to Beaumont Newhall for calling to my attention Delaunay's use of the photograph made of the Eiffel Tower from a balloon.

page 213

Mrs. Evans is quoted from her letter to the author, Mar. 1966.

The information about Sheeler basing a painting on a frame from the film *Manahatta* was disclosed in an interview the author had with Paul Strand, June 1969. The title of the picture Sheeler painted from *Manahatta* is *Church Street El.*

Brown is quoted from Milton W. Brown, *American Painting—From the Armory Show to the Depression*, Princeton, N.J., 1955, p. 119.

page 217

Millard's information about Sheeler's use of photographs was based on a conversation with Mrs. Sheeler after the artist's death. See Charles W. Millard, III, "Charles Sheeler: American Photographer," *Contemporary Photographer*, vol. 6, no. 1, 1967, p. 55.

page 223

Young is quoted from his letter to the author, Mar. 1967.

Lichtenstein is quoted from *Roy Lichtenstein*, Pasadena Art Museum, 1967 (catalogue), p. 12.

page 225

Stanley is quoted from his letter to the author, Feb. 1968. Bob Stanley does not limit himself to landscape motifs. His *Swing*, 1966, is based on a somewhat erotic photograph which he Xeroxed to obtain a limited range of tones. The abbreviated imagery thus obtained was then paraphrased in paint.

pages 227-29

Lehrer is quoted from his letter to the author, Apr. 1970.

page 233

For a summary of research on Hill and Adamson, see Katherine Michaelson, *A Centenary Exhibition of the Work of David Octavius Hill 1802-1870 and Robert Adamson 1821-1848*, op. cit.

page 239

A major work on the *cliché-verre* is by Gérmain Hediard, "Procédés sur Verre," *Gazette des Beaux-Arts*, Nov. 1903, p. 408.

I am indebted to André Jammes for information about Fantin-Latour's use of the *cliché-verre* process.

Regarding Corot's use of the *cliché-verre*, see Alfred Robaut, "Procédés sur verre," *L'Oeuvre de Corot*, vol. IV, Paris, 1905, pp. 129 ff. Also see Étienne Moreau-Nélaton, *Histoire de Corot et ses oeuvres*, Paris, 1905, pp. 150 ff.

page 240

For a reproduction of *The Portrait of D. M.*, a *cliché-verre*, see Alfred Barr, *Picasso: Fifty Years of his Art*, New York, 1946, p. 95.

pages 240-41

For additional illustrations of Sommer's smoked negatives, see Gerald Nordland, *Frederick Sommer*, Philadelphia, 1968.

page 241

For additional illustrations of Moholy-Nagy's photomontages, see *Moholy-Nagy*, edited by Richard Kostelanetz, New York, 1970, which has an extensive bibliography.

page 243

For additional illustrations of Rauschenberg's use of photographs, see Lawrence Alloway, *Rauschenberg: Graphic Art*, Philadelphia, 1970.

page 245

Williams is quoted from his letter to the author, Oct. 1968.

Hartman is quoted from his letter to the author, July 1964.

page 247

Drexler is quoted from Grace Glueck,

"Art Notes: Try Your Supermarket," New York *Times*, Apr. 25, 1965.

Warhol is quoted from G. R. Swensen's interview with Warhol, "What is Pop Art?" *Art News*, vol. 62, no. 7, Nov. 1963, p. 26.

page 249

Hamilton is quoted from Alexander Iolas, *Richard Hamilton*, Paris, 1967.

In a February 1970 letter to the author, Hamilton said, "My source was a Paramount 'Panavision' colour negative (probably from the film 'Holiday Inn' but I'm not sure). Originally I used the 35mm negative in a lecture called 'Glorious Technicolor, Breathtaking CinemaScope and Stereophonic Sound' (itself a quote from a Hollywood musical—maybe 'Silk Stockings'). The lecture was a survey of technical advances in the entertainment industries in the 50's. I've had the negative, and also a positive projection print, for about ten years.

"The image has many attractions for me, some of these overlap those of other paintings. In the first place the technical problem of painting in reverse colour and the possibilities of optical reversal through an after image resulting from prolonged staring at the painting were novel (at the time I began consideration of the subject Jasper Johns had not made his colour negative flag—I didn't let this deter me). There are colour prejudice overtones. Bing Crosby in negative is racially reversed—an American Negro? Is he dreaming of a White Christmas? Colour reversal also makes the style of his clothing less discreet and conventional, i.e. more Negroid? Bing Crosby would not wear a black shirt and a white hat. There is also considerable ambiguity in this particular negative which I take to be due (in some measure) to the fact that the lighting of the subject is a multi-directional studio illumination rather than 'natural' light.

"Bing Crosby assumes here an archetypal father figure aspect. His relationship to the boundaries of the frame is significant and also his posture moving out as the frame toward the spectator."

See also Richard Hamilton, "The Marriage of Brush and Lens," *Creative Camera Owner*, no. 42, Dec. 1967, pp. 320-34. The

314

American artist Guy Johnson paints over montaged photographs to achieve Surreal effects and evokes something of the feeling one finds in Hamilton's work.

page 250

Cohen is quoted from his letter to the author, Mar. 1970.

pages 250-51

Tilson is quoted from Joe Tilson, "Five Questions Answered," *Art and Artists*, vol. 4, no. 3, June 1969, p. 35.

page 251

For further reproductions of Raysse's work and critical comments, see Otto Hahn, "Martial Raysse ou La Beauté Comme Invention et Délire," *Art International*, vol. 10, no. 6, Summer 1966, pp. 78-83.

page 254

In the George Eastman House collection there is a *carte-de-visite* by Disderi's studio of this same montage of the court of Napoleon III. Whether it is the original or a copy of Braun's montage is uncertain.

page 255

For other examples of postcards made from montaged photographs, see A. Jakovsky, *A Picture Postcard Album*, London, 1961.

Hausmann is quoted from Hans Richter, *Dada Art and Anti-Art*, New York, 1966, p. 116.

page 259

Höch is quoted from Edouard Roditi, "An Interview with Hannah Höch," *Arts Yearbook 6*, New York, 1962, p. 32.

pages 259-61

For further reproductions of Heartfield's photomontage, see Aaron Scharf, "John Heartfield, Berlin Dada and the Weapon of Photomontage," *Studio International*, vol. 176, no. 904, Oct. 1968, pp. 134-39; Paul Overy, "The Montage-Paster Heartfield," *Art and Artists*, vol. 2, no. 11, Feb. 1968, pp. 30-33; and the book by Heartfield's brother, Wieland Herzfelde, *John Heartfield: Leben und Werk*, Dresden, 1962.

page 261

Max Ernst re-worked a photograph in 1920 titled *Landscape to My Taste*. For a reproduction of this work see Werner Spies, *Max Ernst: Frottages*, London, 1969.

Future research will undoubtedly indicate that some of Max Ernst's imagery was derived from scientific photographs.

Mesens is quoted from E. L. T. Mesens in the Preface to a catalog of the Max Ernst exhibition, held at Knocke-le-Zoute, Belgium, 1953.

page 263

Schad is quoted from Christian Schad, *Dada Schad*, Galleria Schwarz, Milan, 1970, p. 8.

Man Ray is quoted from Man Ray, *Self-Portrait*, op. cit., p. 128.

page 265

Man Ray is quoted from Man Ray, *Self-Portrait*, op. cit., p. 255.

page 267-69

For details on Dali's presumed use of Yan's photograph, see Albert Plecy, "Le langage de l'image 8," *Point de Vue—Images du Monde*, vol. 15, no. 572, May 1959, p. 18.

Dali also made, in 1939, a large collage—43½ inches wide—of a photograph of Shirley Temple's face on the body of a sphinx in the Dead Sea. For a reproduction of the Dali collage, see Marcel Jean, *The History of Surrealist Painting*, London, 1960, p. 261.

page 269

For additional illustrations of Bayer's photomontages, see "Herbert Bayer of the Bauhaus," *Creative Camera*, no. 53, Nov. 1968, pp. 404-07.

page 273

For further reproduction of Adami's use of photographs, see *Adami*, Galleria Schwarz, Milan, Oct.-Nov., 1965.

page 277

For further information on Bearden's work, see Romare Bearden, *The Prevalence of Ritual*, New York, 1970.

page 281

Jess is quoted from his letter to the author, Apr. 1964.

page 283

For further reproductions of Klasen's work, see Franck Venaille, "Peter Klasen 'Tilt,'" *Horus*, no. 1, 1968, pp. 27-28.

Catterall is quoted from his letter to the author, Apr. 1970.

page 291

For further information on Sutherland's use of photographs, see Douglas Cooper, *The Work of Graham Sutherland*, New York, 1961.

page 293

Bayne is quoted from William Highberger and Nathaniel Sims, *August Vincent Tack*, Deerfield, Mass., 1968, p. 16.

page 299

Pennell is quoted from "Joseph Pennell on Photography," *The Studio*, June 1893, pp. 87-95.

Féneon is quoted from *Les Oeuvres de Félix Féneon*, translated by Francis K. Loeppel, Paris, 1958, p. 51. This came to my attention in *Arts*, Jan. 1957, vol. 31, p. 16.

Picasso is quoted from Brassaï, *Picasso and Company*, New York, 1966, p. 46.

Braque is quoted from Michel Georges-Michel, *From Renoir to Picasso: Artist in Action*, translated by Dorothy and Randolph Weaver, Boston, 1957, p. 96.

page 300

Kupka is quoted from K. Frank Tiege, *Blok*, vol. 2, 1948, pp. 77-82.

Alloway is quoted from Lawrence Alloway, "Notes on Realism," *Arts Magazine*, Apr. 1970, p. 26.

Sloan is quoted from John Sloan, *Gist of Art*, New York, 1936, p. 155.

Zigrosser is quoted from Carl Zigrosser, *The Artist in America*, New York, 1942, p. 124.

page 301

Canaday is quoted from John Canaday, "Camera vs. Painter," the New York *Times*, Sec. 2, June 10, 1962.

Zigrosser is quoted from Carl Zigrosser, *The Book of Fine Arts*, New York, 1937, p. 165.

Aragon is quoted from Selden Rodman, *Portrait of the Artist as an American*, op. cit., p. 92. Originally published in *Art Front*, Jan. 1937.

INDEX

by Eleanor B. Coke